BUY THIS BOOK

Buy This Book brings together an outstanding international collection of writings on advertising and consumption. The work is based on new historical, textual and ethnographic research and adds substantially to the theoretical and case study literature in the field.

Contributors from Britain, continental Europe and North America consider the history, industry practices, textual strategies and public consumption of advertising, and changes in consumer imagery and identity. Eschewing a uniformity of approach and perspective, *Buy This Book* confirms the interdisciplinarity of this expanding area of study. It also shows how a focus on consumption interrogates assumptions within disciplines. The book includes analyses of British and American consumption since 1945; the consumer as the imaginary subject of advertisers; the challenge of the Benetton campaigns; music, image and nostalgia in advertising; the marketing of Latino culture; safe sex and pleasure in condom advertising; the family and consumption in postwar Europe; power dressing; politics and negative advertising in North America; adultery and the promotion of cars.

Illustrated with over twenty images, *Buy This Book* constitutes an invaluable resource for researchers, teachers and students.

Contributors: Roberta J. Astroff, Monika Bernold, Colin Campbell, Andrea Ellmeier, Joanne Entwistle, Pasi Falk, Paul Jobling, Stephen Kline, Reina Lewis, Celia Lury, Frank Mort, Sean Nixon, Stephanie O'Donohoe, Katrina Rolley, Kim Christian Schrøder, Don Slater, Michael Smee, Barbara Usherwood, Alan Warde, Andrew Wernick.

Editors: Mica Nava, Andrew Blake, Iain MacRury and Barry Richards are all associates of the Centre for Consumer and Advertising Studies based jointly in the Department of Cultural Studies and the Department of Human Relations at the University of East London.

BUY THIS BOOK

Studies in advertising and consumption

*Edited by Mica Nava,
Andrew Blake, Iain MacRury
and Barry Richards*

London and New York

First published 1997
by Routledge
11 New Fetter Lane, London EC4P 4EE

Simultaneously published in the USA and Canada
by Routledge
29 West 35th Street, New York, NY 10001

Typeset in Times by
Florencetype Ltd, Stoodleigh, Devon

Printed and bound in Great Britain by
Biddles Ltd, Guildford and King's Lynn

British Library Cataloguing in Publication Data
A catalogue record for this book is available from the British Library

Library of Congress Cataloging in Publication Data
Buy this book: studies in advertising and consumption/edited by
Mica Nava . . . [et al.].
p. cm.
Includes bibliographical references and index.
1. Advertising – Social aspects. 2. Consumer behavior.
3. Consumption (Economics) – Social aspects. I. Nava, Mica.
HF5821.B89 1996
659.1′042–dc20
96–15071
CIP

ISBN 0-415-14131-1 (hbk) 333748
ISBN 0-415-14132-X (pbk)

659.1042/NAV

CONTENTS

LIST OF ILLUSTRATIONS

FIGURES

TABLES

NOTES ON CONTRIBUTORS

Roberta J. Astroff teaches media and cultural studies at the University of Pittsburgh, USA. Her work focuses on the production of ethnic, racial and national categories in the media and public policy documents. She is currently working on a book about this process in media, museums and marketing in the USA.

Monika Bernold is a lecturer in the Department of History at he University of Vienna. She is co-editor (with Andrea Ellmeier) of *Familie: Arbeitsplatz oder Ort des Glucks?* (1990) and has written widely on cinema, television and popular auto-biography.

Andrew Blake teaches cultural studies at King Alfred's College, Winchester. When time allows he plays the saxophone and writes music. His wide interests are reflected in his books, *Reading Victorian Fiction* (1989), *The Music Business* (1992) and *The Body Language: The Meaning of Modern Sport* (1996).

Colin Campbell is senior lecturer and head of the Department of Sociology at the University of York, UK. He has written widely on sociological theory, culture and cultural change, religion and the sociology of consumption. He is author of *The Romantic Ethic and the Spirit of Modern Consumerism* (1987), *The Myth of Social Action* (1996) and co-editor (with Pasi Falk) of *The Shopping Experience* (1997).

Andrea Ellmeier is a lecturer in the Departments of History and Contemporary History at the University of Vienna and a researcher at the International Archive for Cultural Analysis in Vienna. Her publications include articles on consumer history, the female consumer and European cultural politics. She is co-editor (with Monika Bernold) of *Familie: Arbeitsplatz oder Ort des Glucks?* (1990).

Joanne Entwistle is senior lecturer in communications and cultural studies at the University of North London. Her current research is a sociological and ethnographic investigation into the relations between gender, the body and dress, looking in particular at how women dress for work.

Pasi Falk is senior research fellow and docent in the Department of Sociology at the University of Helsinki. He is author of *The Consuming Body* (1994) and co-editor (with Colin Campbell) of *The Shopping Experience* (1997). His current research on the history of civilisation and illness will be published as *Modernity Syndrome* in 1997.

Paul Jobling is a senior lecturer at Staffordshire University, UK, and is currently researching the objectification of the body and the pleasure of spectatorship in fashion photography for his PhD at the University of Warwick, UK. He is

co-author (with David Crowley) of *Graphic Design: Reproduction and Representation since 1800* (1996) and has published articles and reviews in *The History of Photography* and *Print Quarterly*.

Stephen Kline is professor in the School of Communication at Simon Fraser University, Canada, and director of the Media Analysis Laboratory. He is co-author (with William Leiss and Sut Jhally) of *Social Communication in Advertising* (1990) and author of *Out of the Garden* (1993). He is currently researching and writing a book, *It Just Feels Right*, about changes in advertising and the structure of feeling in consumer culture.

Reina Lewis teaches in the Department of Cultural Studies at the University of East London. She is author of *Gendering Orientalism: Race, Femininity and Representation* (1996) and co-editor (with Peter Horne) of *Outlooks: Lesbian and Gay Sexualities and Visual Culture* (1996). She has written a number of articles on lesbian culture and criticism.

Celia Lury is a senior lecturer in sociology at Lancaster University, UK. She is author of *Consumer Culture* (1996) and has a special interest in the brand. She is currently exploring developments in the definition of intellectual property in the advertising industry, including the establishment and maintenance of logos and trademarks.

Iain MacRury is a research assistant in the Department of Human Relations and an associate of the Centre of Consumer and Advertising Studies at the University of East London. He is currently working on a PhD on psychosocial aspects of advertising reception.

Frank Mort is a reader in cultural history at the University of Portsmouth, UK. He has also taught in the Department of History at the University of Michigan, USA. He is author of *Dangerous Sexualities* (1987) and *Cultures of Consumption: Masculinities and Social Space in Late Twentieth-Century Britain* (1996).

Mica Nava is a reader in the Department of Cultural Studies and co-director of the centre for Consumer and Advertising Studies at the University of East London. She is author of *Changing Cultures: Feminism, Youth and Consumerism* (1992) and co-editor (with Alan O'Shea) of *Modern Times: Reflections on a Century of English Modernity* (1996). Her current research is on the orientalism of commerce and women consumers.

Sean Nixon teaches media and cultural studies in the Department of Sociology at the University of Essex, UK, and is the author of *Hard Looks: Masculinities, the Visual and Practices of Consumption* (1996).

Stephanie O'Donohoe is a lecturer in marketing at the University of Edinburgh. Her research on consumers' advertising experiences has been published in the *European Journal of Marketing*, the *International Journal of Advertising* and the *Irish Marketing Review*. She is currently writing a book on the responses of young adults to advertising.

Barry Richards is professor and head of the Department of Human Relations at the University of East London and co-director of the University's Centre for Consumer and Advertising Studies. He is author of *Images of Freud: Cultural Responses to Psychoanalysis* (1989) and *Disciplines of Delight: The Psychoanalysis of Popular Culture* (1995).

Katrina Rolley is a freelance fashion historian. She has written extensively on dress as an expression and communication of lesbian activity. She is the principal author of *Fashion in Photographs 1900–1920* (1992) and is currently working on a book entitled *The Lesbian Dandy: The Role of Dress and Appearance in the Construction of Lesbian Identities.*

Kim Christian Schrøder is associate professor in the Department of Languages and Culture at the University of Roskilde, Denmark. He is co-author of *The Language of Advertising* (1985) and *Medier og Kultur* (1996) and co-editor of *Media Cultures: Reappraising Trans-national Media* (1992). His published work includes a cross-cultural study of *Dynasty* audiences and a qualitative study of media use in Denmark.

Don Slater is a lecturer in sociology at Goldsmiths College, University of London. He has researched and written extensively on advertising, theories of consumer culture and photography and is currently working on the sociology of leisure and hobbies. Recent publications include *Consumer Culture and Modernity* (1996).

Michael Smee is senior lecturer in psychosocial studies in the Department of Human Relations at the University of East London. He has taught social theory, developmental psychology and the sociology of culture since the early 1970s. His research interest is in culture transmission and reproduction.

Barbara Usherwood lectures in postwar retailing and historical and theoretical aspects of graphic communication at the Institute of Design, University of Teesside, UK. Recent publications include 'The Design Museum: Form Follows Funding' in *The Idea of Design*, edited by V. Margolin and R. Buchanan (1996).

Alan Warde is a reader in sociology at Lancaster University, UK. Recent research has focused on the sociology of consumption, currently with special reference to food. He is author of *Consumption, Food and Taste* (1996) and has been involved in an empirical study of eating out in the UK, funded by the Economic and Social Research Council, which will be completed in 1996.

Andrew Wernick is a professor of cultural studies and sociology at Trent University, Canada. Publications include *Promotional Culture: Advertising, Ideology and Symbolic Expression* (1991), *Shadow of Spirit: Religion and Postmodernism*, co-edited with Philippa Berry (1992), and *Images of Ageing: Cultural Representations of Later Life*, co-edited with Mike Featherstone (1995). His current projects are the social in contemporary French thought and the representation of time in contemporary culture.

INTRODUCTION

Buy this Book[1] originated at a three-day conference entitled 'Changes in Advertising and Consumption Since the 1950s', which was organised by us (now the editors of this volume) under the aegis of the Centre for Consumer and Advertising Studies at the University of East London in 1994. Although we were confident, as we sent out calls for papers, that this then still-emerging area of intellectual concern was important as well as exciting, we did not anticipate the extensiveness of the response (which ranged from as far afield as Scandinavia, North America and the Pacific Rim), nor the high quality of the many contributions we selected for the conference and in many cases subsequently, for this collection. It has become clear that the production of this book – from the planning of the conference to the date of publication – has spanned a period during which consumption and advertising have gained enormously in terms of scholarly interest and visibility (see for example, Falk 1994; Miller 1995; Carter 1996; Lury 1996; Mort 1996; Nava 1996; Nixon 1996; Slater 1996; Warde 1996; Campbell and Falk 1997[2]). Thus, as we complete the editing work and write this introduction, the key political-theoretical issue may no longer be to insist to the wider academic world that these themes and their associated conceptual innovations be awarded the recognition that we think they merit. This is increasingly happening. The issue today is rather to consider how the focus on consumption – and in this case advertising as one aspect of it – both interrogates assumptions within specific disciplines and demands a reassessment of the relationship between disciplines.

This is not something that can be decided, or even argued very far, in a brief introduction. Nevertheless it is important to point out, as we draw out the implications of this particular collection, that the work here derives from a much broader range of formal disciplines or approaches – art and design history, psychoanalysis, cultural studies, social history, philosophy, sociology, media studies, politics and business studies – than is normally the case in a volume with the thematic and conceptual coherence (albeit not univocal agreement) of this one. Thus consumption is a new meeting place, a point of intersection which facilitates encounters

1

between disciplines. Moreover as a result of these intellectual, sometimes confrontational, exchanges, some of the fundamental assumptions and parameters of the distinctive disciplines have been or are being transformed. In sociology, for example, the gaze switches from production and class to how commodities are bought, understood and used as markers of social identity. Meanwhile the focus of media studies moves from public broadcasting policy and programme content to how audiences consume. In each case therefore disciplines have been expanded, if not wholly altered, by their uptake of consumption.

Feminism has made a major contribution to these changes by insisting always on the significance of the minutiae of everyday life, on the political and theoretical recognition of what women do and want and how they are perceived, whether in the kitchen, the bedroom or the department store. The attention to these hitherto relatively marginalised areas of social, economic and fantasy life has not only centre-staged the experience of women, it has also impelled academics to ask different kinds of theoretical questions about taken-for-granted grand narratives and what counts as important in their distinctive disciplines. Hence the emergence of debates about the politics of representation across a range of forms: the study of popular (women's) genres and the associated questions of mass culture, and mass readership and spectatorship (see for example, Radway 1986; Winship 1987; Huyssen 1988; Stacey 1994; Ang 1996). Shopping, which is overwhelmingly the remit of women and was until a few years ago ignored by cultural theorists, is now increasingly acknowledged as a highly complex and intellectually rewarding field of study: an essential component in the cycle of industrial production (and therefore of the development of modern capitalism) and part of the elaborate network of significations which compose the iconography and scopic regimes of modernity, it has also played a significant part in the constitution of twentieth-century ideas about citizenship and in the current politics of the environment. Shopping as one aspect of consumption is thus no trivial pursuit (see for example, Carter 1984, 1996; Bowlby 1985, 1993; Nava 1992, 1996).

An instance of a traditional discipline on which the study of consumption has had a major impact is history. Over the last decade many contemporary historians have become convinced of its importance, and the turn has transformed the study of the industrialising process in the West and its global consequences. Daniel Miller has argued that consumption is now being acknowledged as 'the vanguard of history' (Miller 1995: 1): in a world in which the shopper's demands, instantly registered at point of sale, have abolished seasonality and (for most) scarcity in food, power is on the side of the shopper, and we therefore need a new language of 'consumer citizenship' to maintain the demand-led revolution. Historians can now provide a more adequate (if, no doubt, teleological) foretelling of this moment. Studies such as Fernand Braudel's three volumes on

capitalism, civilisation and material life (Braudel 1981, 1982, 1984) and Simon Schama's magisterial survey of Dutch culture (Schama 1987) have explored the strengthening of consumer demand in Europe, while McKendrick, Brewer and Plumb (1982) were in the vanguard of an argument that the consolidation of British consumption and demand in the seventeenth and eighteenth centuries is the crucial formant of industrial production. The psychic structuring behind this process, the fantasy of desire which produces consumption, has been explored in an influential text by Colin Campbell (1987), a contributor to this volume, who also emphasises the significance of demand in the formation of modernity. The clear point of differentiation in all this work is the view of an emergent consumption indissolubly linked with trade and empire in ways which transformed the domestic cultures of the imperial powers.

Whether internal disciplinary transformations such as this, and the current attention to consumption across disciplines, are sufficient to erode disciplinary boundaries is partly a decision which will be taken locally, by academics and administrators within university faculties. At present, however, consumer studies appears to have a future less as a discipline in its own right than as a multidisciplinary *site* for critical analysis which makes possible theoretical links across subjects. Our own Centre for Consumer and Advertising Studies is one among a growing number of university research units, email networks and web pages which attempt to do this.[3] In any case interdisciplinarity is in itself no guarantee of innovative thought and we must be wary of reintroducing new grand narratives that are presumed to operate in unfettered and unspecific ways across terrains (Miller (1995: 1) agrees that his thesis of consumption as the new vanguard of history might well appear to be just such a narrative).

Nonetheless, the engagement and exchange between disciplines and approaches can be enormously productive and it is precisely the interdisciplinary nature of the cultural studies project – the refusal to accept existing parameters – which has generated such exciting critical intellectual work since the early 1980s, responsible not only for reformulating what counts as knowledge and the way in which we understand cultural forms and formations but also for transforming the very structures of academia (see for example, *Stuart Hall: Critical Dialogues in Cultural Studies*, edited by Morley and Chen 1996). Something similar is going on in relation to consumption. Yet here there seem to be even greater possibilities of making theoretical breaks, of thinking differently, of making links across and between quite diverse intellectual orthodoxies, because of the wider range of perspectives that are brought to bear. We will have to see how these develop. In the mean time, more modestly, this book constitutes one of the sites on which these disciplines meet.

Advertising, on which many of the chapters in this book focus, is an integral part of twentieth-century consumption, though, importantly, is not

confined to it. Formally and ontologically it is also inextricably linked to art, politics and education. Nevertheless, despite these other functions and connections, theoretically it has tended to be demonised through its association with capitalism and the selling of commodities. The classic text in this respect is Packard's comment on the 'hidden persuaders' in the American advertising industry (1981, first published in 1957). Judith Williamson's (1978) book on how advertising images make meanings is probably still the most theoretically innovative and substantial to come from Britain, yet it too falls squarely within this category. The British industry itself remains relatively unstudied, partly as a consequence of the agencies' carelessness about their own material histories – few maintain adequate archives – but also as a result of the historians' and sociologists' disdain. (The chapters in Part II of this volume are part of an attempt to rectify this – particularly Celia Lury and Alan Warde's comments on agency operations; see also Mica Nava's account in Part I[4]). The more general argument that we put forward here is that advertising is crucial to our sense of the present, whatever its relation to products advertised and their consumption, and that while advertising should be studied in parallel with consumption, it must also be studied in relation to *interpretation*. Certainly the ability of the reader of advertising to decode it within her or his own semiotic order – to use it for comic, or erotic, entertainment, as demonstrated here in the chapters by Stephanie O'Donohoe, and Reina Lewis and Katrina Rolley – underlines the necessity for the cultural study of advertising, even as it reinforces the importance of advertising as a form of representation in the contemporary world. A site of cultural production and representation which permits the construction and deconstruction of patterns and assumptions and the consumption of images, sometimes alongside a refusal of their referents, advertising is a companion to consumption but cannot be unproblematically subsumed within it, either by scholars or advertisers and their clients.

The authors we present here, whatever their disciplines, share a number of common concerns, but despite the thematic centrality of consumption and advertising there is no uniformity of argument or perspective. There is no unified theoretical project. Some chapters complement others, while a few more polemical entries contest generally accepted meanings or theoretical positions. What we attempt to do here is to present a picture not of the current archive of knowledges, nor even of the way existing knowledges can be amplified in order to accommodate consumption (as Miller's book does); our object is to offer an indication of the debate which is now in the process of producing new theories and new knowledge about the histories of advertising and consuming practices, about textual specificity and intertextual relativity. The chapters in Part I of the book identify some of the main concerns structuring the contributions that follow and articulate some of the distinctive positions and approaches in the

spectrum of intellectual work in this field, but they do not delimit what comes later. Most of the subsequent pieces present independent research and develop arguments in innovative ways which extend the academic field. Nevertheless Part I focuses on and synthesises some of the key issues.

Opening the section, Frank Mort insists on the importance of historical specificity and definitional clarity in the study of mass consumption and advertising and warns against an uncritical uptake of the Americanisation thesis. His own work here focuses on Britain in the 1950s and early 1960s, and particularly on the deliberately traditional methods deployed in the promotion and retailing of menswear, and on the reservations expressed by British advertisers about North American style hard-sales techniques. By emphasising the distinctiveness of the British route to mass consumption, Mort also challenges some of the more orthodox theorising of consumption in relation to power and poses a more Foucauldian alternative in which the commercial domain is explored in relation to the cultivation of a secular self. Mica Nava's chapter also explores the limitations of current theoretical conventions, in this case of recent work on advertising – much of it textual analysis – which appears to assume a Fordist coherence between the meanings produced by advertising imagery and the economic organisation of society. Nava argues that research into the production practices of the advertising industry and into the ways in which ads are consumed by the public reveals a much more haphazard and postmodern process than the political economists allow. Advertising should be understood as part of a much broader regime of late twentieth-century cultural representation and promotion which includes cinema, journalism and even politics. In her concluding section Nava speculates on what might be the psychic genealogy of the fascination and repudiation expressed by so many cultural critics towards advertising and why advertising images seem so often to be blamed for the injuries of commodity capitalism.

Don Slater argues, from within a more philosophical tradition, against the postmodernist and Foucauldian turn in consumer studies (of which the previous authors are examples) and urges a return to critical theory, a reassertion of the notion of needs and a politically theorised distinction between 'real' and 'false' needs. He acknowledges that these concepts are impossible to define in absolute terms, that they can only be understood in relation to common notions of cultural value, and proposes therefore a Habermasian communicative rationality through which the desired forms of life can be democratically agreed. Pasi Falk offers a more historicised mode of argument. Tracing broad developments in advertising codes over the last one hundred years, he draws attention to a significant break in representational conventions since the late 1980s and the emergence of what he calls the Benetton-Toscani effect. This refers in general terms to a spectacular aesthetic expressed in a negative register, and more

specifically to the ecumenical themes of racial and national boundaries, birth, AIDS and the environment which are the hallmark of the early 1990s Benetton series of catastrophe ads. Their mode of depicting the 'reality' of politics has profound implications for our understanding of the relationship of advertising to the politics of representation.

Probably the best-known piece of writing to emerge from the Frankfurt School – both the most influential and the most argued against – is the essay by Adorno and Horkheimer on the culture *industry* (1973). Yet despite this seminal emphasis on the organisation of production, most recent work has tended to focus on the products of the industry, on advertisements and films, rather than the industry itself. The second section both highlights the richness of the marketing and advertising institutions as sources for studies of consumer culture and indicates some of the kinds of analysis available in the scrutiny of these spheres. An emergent phenomenon is the new 'symbolic professional' or 'cultural intermediary'. The chapters in this section relate the lives (or 'lifestyles') of these figures to their practices in the workplace and their contribution to changing cultures. Sean Nixon examines data from advertising agencies and practitioners in the 1980s to trace the emergence of new 'regimes of masculinity' within the industry. Drawing on the new style magazines and new modes of masculine self-presentation, the chapter examines the negotiations and renegotiations inside the advertising sector between traditional and new formations of corporatism and between a new (gendered) ethic of lifestyle connoisseurship and business entrepreneurship. (These themes complement Jo Entwistle's story of 1980s women's wardrobes and 'power dressing' later in the book.)

Celia Lury and Alan Warde offer a rather different slant on notions of dress as disguise. Their polemical and entertaining analysis of the market research industry suggests that, often, so-called innovations in market research techniques are simply ways of dressing up uncertainties about the evanescent consumer and that academic approaches to advertising have inherited or replicated these perceptions. Lury and Warde propose a counter-intuitive thesis in which they argue controversially that advertising and research techniques enable manufacturers to overcome their own lack of certainty about the unfathomable consumers upon whom they depend for success and that the reassuring picture of the consumer offered by the agencies and researchers to their clients is often imaginary. Roberta J. Astroff, in 'Capital's Cultural Study', also thinks about the interface between research and commerce and about the imaginary consumer evoked in market research, which draws on the discursive economies of market rationality, race, culture and nation. Specialists in US Latino culture, using ethnography, attempt to deliver coherent profiles of market segments to satisfy the *producer*'s perception that they must target different groups differently. Astroff argues that despite the use of social

science techniques, the business community remains ignorant about the diversity of the Latino culture they are hoping to define.

The third section of the book focuses on campaigns and products, with a broad emphasis which recognises the importance of politics and political systems to any consideration of advertising or consumption. It opens with Stephen Kline's study of the impact of political-image management and advertising on the election process. Considering in particular the question of 'negative message' advertising, he discusses the results of research into audience responses to this type of political advertising. Kline supports the claim that these forms of advertising have had, precisely, a negative effect, increasing the cynicism of the electorate not only towards politics and politicians but also to such representations as political advertising. Paul Jobling addresses a rather more positive transformation. In 'Keeping Mrs Dawson Busy' he charts the advertising-led transition of the condom – from an object of embarrassment to one of desire. Exploring the mean ings which are or have been ascribed to the condom, and addressing pertinent questions of gender, race, age and sexuality, he evaluates the ostensible paradox between health and pleasure in the re-hygienised sexuality of the AIDS-threatened world.

Barbara Usherwood examines recent changes in marketing strategies and consumer address within the 'home-interiors' section of the British magazine market. The chapter looks in particular at the launch of *Elle Decoration* in 1989, and argues that this magazine shifted the boundaries of the genre in a number of ways. Not only did it use new forms of visual and verbal address, it also promoted new values in relation to home deco-rations and furnishings. These features are situated in relation to the innovative 'global but local' marketing strategies of the transnational publishing project of which the British version of *Elle Decoration* was a part. Monika Bernold and Andrea Ellmeier end the section with an exam-ination of a much longer project: the Austrian state's deeply politicised relationship with television. This consumer good became an aspirational symbol for an emerging consumer society. Through a publicly controlled medium, ideas of the family and home were propagated, and a strongly gendered notion of 'the consumer' was developed which played its part in the orientation of postwar Austria to Western rather than Eastern Europe.

The three chapters in Part IV on textual strategies offer detailed analyses of specific aspects of advertisements. Andrew Wernick's lyrical deconstruction of a timeshare advertisement, in which a number of Beatles motifs are intertextually appropriated, is the occasion for a discussion of the role of nostalgia in contemporary advertising. Noting how the adver-tisements of the 1950s tended to emphasise progress and futurity, this chapter examines the cultural significance of contemporary advertising's preoccupation with nostalgic themes and the past. Drawing on semiology,

deconstruction and psychoanalysis, Wernick charts different narratives of nostalgia and illuminates their significance for an audience which was young in the 1950s – and for academic theories of advertising. In 'Listen to Britain', Andrew Blake foregrounds the difficulties in analysing music, a powerful component of much advertising. Discussing the role of music in televisual and cinematic forms in a British culture dominated by American models, he then confronts the uncomfortable relationship between sound and image in some recent British television advertising. In many of these texts, he argues, the black presence in British culture is audible but invisible. Through a reading of Paul Gilroy's influential book *The Black Atlantic* (1993), Blake proposes that even when nominally 'white', British culture has its own Atlantic connection, and that it is unthinkable outside this relationship. British television advertising is also Iain MacRury's focal point. Examining a number of car advertisements which playfully suggest the possibility of adultery, but then close in an ambiguous celebration of heterosexual monogamy, MacRury suggests that these ads express both anxiety and enjoyment in the consumption of goods. This phenomenon is related both to the creative and sales strategies of the advertising industry and car manufacturers, and to wider psychosocial transformations of Britain in the 1990s.

The fifth section is concerned with the ways in which readers situate themselves in relation to advertisements: with the ways in which ads are consumed, by people whose often sophisticated intertextual preparation enables them to decode them against the grain offered by the advertisers. Stephanie O'Donohoe reports on an aspect of her ethnographic study of young people which confirms that they routinely draw on their knowledge and experience of other texts (including ads) in their reading of particular advertisements. These young adults are highly 'literate', and use ads as part of the entertainment stream, consuming them independently of the products they are supposed to represent. Reina Lewis and Katrina Rolley describe a rather different path, in which there is a semi-complicit 'lesbian chic' operating among photographers, models and readers of young women's fashion magazines. Whether playfully or directly, narcissistically or erotically, messages are constructed and read through differently sexualised filters: the female gaze, including the lesbian gaze, takes pleasure in the images offered by the magazine. Kim Christian Schrøder meanwhile discusses readers of 'corporate advertising', that aspect of the genre which tries to sell companies rather than products. He suggests that the response of readers (who usually know what companies *do* as well as what they *say* they do) to these efforts is increasingly negative, and argues that corporations must change their practices, not simply their advertising, if they wish to convince sceptical consumers of their good practices.

It is a tenet of the study of consumer culture that it allows us to examine the relations between acts and styles of consumption and the identities of

consumers. The final three chapters allow consideration of this key claim. Jo Entwistle's analysis of women's power dressing in the 1980s charts the emergence of an ethic demanding that women joining the workforce dress for success according to the findings of the science of clothing management. Her account explores the relationship between 1980s feminism and 1980s ideologies of entrepreneurship and technologies of the performing self. She points to the new style and rationale of consumption and its capacity to announce new sets of work-based identities for women. Mike Smee's chapter explores changes in consumption and identity based on systematically gathered empirical material. Revisiting, in the 1990s, his own 1970 study of the education and cultural reproduction of teenagers from various class fractions, Smee juxtaposes data across a time span of twenty years to chart changes and continuities in cultural participation, access and consumption. He demonstrates that whilst the era has experienced significant sociocultural reformulations, the redistributions of 'cultural capital' amongst these groups do not support any over-radical claim that traditional sociological variables (and enquiries) are obsolete. The world has changed, he agrees, but not as much, or as significantly, as postmodernist cultural analysts sometimes claim. Colin Campbell's chapter also serves as a kind of warning. His intervention argues against the more grandiose theoretical generalisations about the social meanings of consumption. He offers a provocative and sobering critique of the axiom around which this final section of the book is organised and questions the validity of theories of consumption advanced by thinkers like Veblen and Bourdieu whom, he argues, promote too strongly the idea that acts of consumption are important predominantly as communications about social, cultural and personal identity. He urges that the study of consumption relinquish its uncritical adoption of linguistic metaphors in depicting the meanings of purchases and argues that simply because a meaning can be ascribed to a piece of social action, this is not a discovery of its true meaning or its meaning to the participating agents. Care must be taken not to privilege denotive meanings above all other forms or to apply to the analysis of actions a theoretical framework derived from the study of objects.

Buy This Book thus sets out a range of arguments about the histories and meanings of advertising and consumption at a moment when the study of consumption has become the vanguard of many intra- and interdisciplinary projects. We hope that it both contributes to the general excitement about the area and generates further developments in the establishment and growth of consumer and advertising studies.

<div style="text-align:right">

Mica Nava, Andrew Blake, Iain MacRury
and Barry Richards

</div>

NOTES

1 The title, we gratefully acknowledge, was suggested by our colleague Linda Rozmovits.
2 Of these, Campbell, Falk, Lury, Mort, Nava, Nixon, Slater and Warde are contributors to this book.
3 See for example: email list 'consumer-studies@mailbase.ac.uk'; and web page 'Consumer Culture Research Site http:\\www.gold.ac.uk\~soa01ds\consumer.htm'.
4 The History of Advertising Trust archive in Norfolk is also an attempt to rectify this.

REFERENCES

Adorno, Theodor and Horkheimer, Max (1973) *Dialectics of Enlightenment*, London: Allen Lane.
Ang, Ien (1996) *Living-Room Wars: Rethinking Media Audiences for a Postmodern World*, London: Routledge.
Bowlby, Rachel (1985) *Just Looking: Consumer Culture in Dreiser, Gissing and Zola*, London: Macmillan.
Bowlby, Rachel (1993) *Shopping with Freud*, London: Routledge.
Braudel, F., translated by Mirian Kochan (vol. 1) and Sian Reynolds (vols 2 and 3) (1981, 1982, 1984) *Civilisation and Capitalism in the 15th–18th Centuries*, London: Collins.
Campbell, Colin (1987) *The Romantic Ethic and the Spirit of Modern Consumerism*, Oxford: Blackwell.
Campbell, Colin and Falk, Pasi (eds) (1997) *The Shopping Experience*, London: Sage.
Carter, Erica (1984) 'Alice in Consumer Wonderland', in A. McRobbie and M. Nava (eds) *Gender and Generation*, London: Macmillan.
Carter, Erica (1996) *How German Is She? National Reconstruction and the Consuming Woman in the FRG and West Berlin 1945–1960*, Ann Arbor, MI: University of Michigan.
Falk, Pasi (1994) *The Consuming Body*, London: Sage.
Gilroy, Paul (1993) *The Black Atlantic: Modernity and Double Consciousness*, London: Verso.
Huyssen, Andreas (1988) *After the Great Divide*, London: Macmillan.
Lury, Celia (1996) *Consumer Culture*, Cambridge: Polity.
McKendrick, N., Brewer, J. and Plumb, J.H. (1982) *The Birth of a Consumer Society*, London: Europa.
Miller, D. (ed.) (1995) *Acknowledging Consumption: A Review of New Studies*, London: Routledge.
Morley, David and Chen, Kuan-Hsing (1996) *Stuart Hall: Critical Dialogues in Cultural Studies*, London: Routledge.
Mort, Frank (1996) *Cultures of Consumption: Masculinities and Social Space in Late Twentieth-Century Britain*, London: Routledge.
Nava, Mica (1992) *Changing Cultures: Feminism, Youth and Consumerism*, London: Sage.
Nava, Mica (1996) 'Modernity Disavowed: Women, the City and the Department Store', in M. Nava and A. O'Shea (eds) *Modern Times: Reflections on a Century of English Modernity*, London: Routledge.
Nixon, Sean (1996) *Hard Looks: Masculinities, the Visual and Practices of Consumption*, London: UCL Press.

Packard, Vance (1981) *The Hidden Persuaders*, Harmondsworth: Penguin (first published in 1957).

Radway, Janice (1986) *Reading the Romance*, London: Verso.

Schama, S. (1987) *An Embarrassment of Riches*, London: Collins

Slater, Don (1996) *Consumer Culture and Modernity*, Cambridge: Polity.

Stacey, Jackie (1994) *Star Gazing: Hollywood Cinema and Female Spectatorship*, London: Routledge.

Warde, Alan (1996) *Consumption, Food and Taste*, London: Sage.

Williamson, Judith (1978) *Decoding Advertisements: Ideology and Meaning in Advertising*, London: Marion Boyars.

Winship, Janice (1987) *Inside Women's Magazines*, London: Pandora/Routledge.

Part I

THEORIES AND HISTORIES

1

PATHS TO
MASS CONSUMPTION
Britain and the USA since 1945

Frank Mort

Consumption has loomed large in the historiography of most postwar Western societies. Historians and social scientists have identified domestic, private sector demand as central to economic and cultural change in Western Europe and North America from the early 1950s. Together with economic growth, full employment, political consensus and the rise of the welfare state, the intensified impact of the world of goods has become enshrined as one of the master-narratives of this period. Yet arguments about the precise significance of consumption have varied enormously. The most cursory review of the literature reveals that there is little consensus about the term. Consumption has been the subject of multiple interpretations and frequently its meanings have been disputed. Economists and economic historians have foregrounded the role of Keynesian-based demand management, understood in the context of the offensive against socialist versions of the command economy, the move to fiscal regulation and the stabilisation of postwar international trade (Worswick and Ady 1962; Alford 1988; Cairncross and Watts 1989; Cairncross 1992). Business historians have highlighted a different set of variables. Here, what has been emphasised have been the shifts in productive organisation and output which underpinned the upsurge of consumer demand. The accelerated take-up of the technologies of mass production by the consumer industries – flow-line assembly, deskilling and standardised product design – have been seen by many as providing the framework for the crystallisation of the mass market (Davy 1967; Wells 1968; Adeny 1988; Geddes 1991).

In Western Europe, arguments about the coming of a mature consumer society, or the society of affluence, have often been tied to a still broader polemic about the impact of 'Americanisation'. There has been a widespread assumption that, during the 1950s, European business increasingly looked towards the advanced techniques of selling derived from the USA. The growing role of advertising and marketing – those twin engines of

modern consumerism – has been at the heart of such accounts. For commercial culture has been identified with a distinctive secular ethic which achieved its most developed forms in the USA. More politically nuanced interpretations (often originating in the modernising projects of social democratic parties in Britain, West Germany and Sweden) have pointed up the ways in which the language of formal politics defined consumption as part of the new postwar settlement, via a debate over living standards and the achievements of consensus and social progress (Crosland 1956; Bogdanor and Skidelsky 1970).

Finally, sociologists and cultural historians, during the period and since, have examined the impact of changing consumption patterns on key groups targeted by the consumer industries. The relationship of affluence to regional and generational change within working-class communities, its effects on women's roles and experience and on the crystallisation of new youth identities has been studied almost obsessively (Abrams 1959; Willmott and Young 1960; Zweig 1961; Goldthorpe et al. 1969; Hall and Jefferson 1976; Birmingham Feminist History Group 1979; Hebdige 1979; Wilson 1980; Steedman 1986). Taken together, these histories have embraced a general thesis: namely, that from the early 1950s, the advanced industrial economies entered a new phase of organisation and management which had far-reaching effects on social and cultural life.

The purpose of rehearsing these widely differing accounts is not to engage in a detailed appraisal of their approaches. At stake is a more fundamental point for the analysis of consumption. Despite their sophistication, a persistent difficulty shadows almost all of the perspectives: this is, the recurrent tendency to generalisation. Consumption is evoked as a meta-concept, used to explain the most disparate historical phenomena. At once part of a thesis on industrial and commercial restructuring, the character of the postwar political settlement and the recomposition of class, gender and generational identities, consumption is mobilised as a composite and synthetic term. What is at issue is the persistent tendency to over-generalise about particular cycles of demand and their social and cultural significance. The problem is by no means specific to the postwar period. Aided by similar explanatory models, historians have been busy identifying successive revolutions in consumption across Europe and North America from the late eighteenth century. Ranging in focus from Georgian London and pre- and post-Haussman Paris, to the department-store culture of early twentieth-century Manhattan, or the world of inter-war Middle America, the idea of consumption as the motor of large-scale economic and social transformation has featured as a recurrent explanatory device. Notions of the birth and subsequent growth of modern consumption have been dogged by a lack of analytical clarity. The search for an inclusive theory to define the meaning of consumer societies is part of the problem, rather than its solution.

Faced with the burden of over-generality, much recent work in consumption studies has moved towards a more concrete and grounded focus. Rather than attempting to tell the whole story about consumption in any given period, the task remains to deconstruct this monolithic concept into its more precise and differentiated parts. Such an approach treats consumption practices as distinct. It explores what the economist Ben Fine has termed the 'commodity specific chain connecting production distribution marketing . . . and the material culture surrounding these elements' (Fine 1993: 600; see also Fine and Leopold 1993; Mort 1996). It then becomes possible to distinguish between different moments in the consumer cycle – commodity manufacture and design, advertising, marketing, packaging, shopping and so on – seeing them as the product of specialised forms of commercial and professionalising knowledge. Identifying the various practices which shape the circulation of goods, this framework enables meaningful comparisons to be made between different sectors of the consumer economy. It also encourages a more precise understanding of historical change than is embraced by the perennial idea of the consumer revolution.

Yet an emphasis on specificity is not the whole story. Particular networks of provision are not self-contained entities, neatly sealed off from other areas of economic and social life. As Paul Glennie and Nigel Thrift have suggested, consumption chains are leaky (Glennie and Thrift 1993). There are interactions across different cycles of demand and between these and other practices outside the sphere of consumption. In the postwar period exchanges of this type occurred at numerous levels. Advertisers and marketers worked with a wide variety of goods, making ongoing comparisons between them. Interrelations between commercial professionals and other experts in adjacent areas, such as social science or psephology, resulted in frequent overlaps of knowledge. There is also strong evidence to suggest that consumers themselves did not view their activities in the marketplace as wholly isolated. The rituals of shopping, or the projection of the self through personal goods, intersected with other fields of social action, especially at the level of everyday life. Many of these interconnections become obvious once consumption practices are explored concretely, in particular environments. It is, therefore, not adequate to understand consumption in any given period as simply the agglomeration of different commodity chains. There are broader histories to be written, in conjunction with more specific narratives. Consumption studies needs to deal in both lines of development.

What follows is a working through of these general insistences in a case study centred on the 1950s and early 1960s. Examples are drawn from a specific sector, the menswear clothing industry, and from a series of distinctive moments in the consumer cycle – especially retailing and advertising. The aim is to confront a number of the expansive theses which have been

17

rehearsed about postwar consumption. These include an assessment of the dynamics of the so-called mass market and the nature of its address to specific populations; the extent of the impact of American forms of commercial culture on British markets and finally, some measure of the shifts in the professional practice of advertising during the period. The conclusions are provisional, the product of work in progress, but at each stage they present a more complex picture of consumer change than is covered by generalised accounts of affluence and prosperity.

THE COMING OF THE MASS MARKET?

Mass distribution marts, the logical outcome of machine and mass production, are a boon and a blessing to the people.

(M. Burton 1935: 13)

In their heyday, from the 1930s through to the early 1960s, the British menswear clothing multiples might be read as characteristic examples of Fordist enterprise, embracing batch production which provided the infrastructure for the crystallisation of mass consumption. Household names such as Burton's, Hepworth's and the Fifty Shilling Tailor dealt in huge runs of standardised products, apparently serving a uniform market. Backed by a hierarchical and centralised business culture, these firms organised their retailing on a national scale. The quintessential product of the menswear sector, the mass-produced suit, has been read as an emblem of mass society – projecting an image of both cultural democracy and collective masculine uniformity (Cohn 1989: 258–9; Gosling 1992; Mort and Thompson 1994). By the mid-twentieth century, the suit could be portrayed as egalitarian: it endowed *all* men with the aura of respectability. As Sir Montague Burton, chairman of the leading menswear outfitters, put it in 1935: when men were dressed in Burton's suits, vertical class hierarchies separating customers were blurred. Every man could now achieve the highest standards of personal taste (M. Burton 1935; Sigsworth 1984).

Yet on closer inspection, menswear retailing provides an eloquent testimony to the partial and extremely uneven character of the British transition to mass consumption. Though Sir Montague Burton lauded the arrival of the mass market, the picture inside his firm told a different story. Size, scale and nationwide coverage were certainly characteristic features of Burton's performance. The company's precise market share is not recorded, but from the 1930s Burton's was the largest manufacturer and retailer of tailored menswear in Britain (The Monopolies Commission 1967; Honeyman 1993). Even as late as 1961, in the opinion of the Economist Intelligence Unit, Burton's remained the 'biggest brand name in men's suits' (Economist Intelligence Unit 1961: 26). In terms of market

position, the 'tailor of taste' lay almost in the dead centre of men's clothing retailing. Obviously distanced from the genuine bespoke trade of London's Savile Row and upmarket competitors like Aquascutum or Simpson's, Burton's claims to taste and affordable elegance also differentiated it from firms such as the Fifty Shilling Tailor, where the emphasis was almost exclusively on price. Occupying prominent sites in over six hundred branches across the British Isles, Burton's shops were landmarks in town and city centres (Sigsworth 1990; Honeyman 1993). With characteristic fittings in marble, oak and bronze, designed to connote quality and solid worth, the masculine atmosphere of a Burton's shop was unmistakable. As the writer and broadcaster Ray Gosling nostalgically recalled in his memories of the 1950s: 'Men talking to men. . . . This was the sound all over Britain on Saturdays as I remember. Customers standing on the silent, polished wooden floor. Legs akimbo, arms up. Keep it perfectly still. Misters respectfully measuring misters' (Gosling 1992; see also Hattersley 1994). This image of a collective masculine culture parallels all of those other representations of gendered mass society during the period: workers at the factory gate, trades union delegates, the football crowd.

Yet underpinning this confident and all-embracing picture of mass consumption was a series of arrangements which deviated substantially from the blueprint. The most obvious of these was to be found in the manufacturing process itself. At Burton's, the suit was never quite a mass-produced commodity, not even for the bulk-selling market. Clothing multiples, or what was known as the wholesale bespoke trade, continued to imitate the aristocratic protocols of the genuine bespoke tailors of Savile Row in their approach to customers (R. Burton 1962; General Secretary of the National Association of Outfitters 1962; *Men's Wear* 1962). In reality, Burton's suits were factory made, employing strictly standardised procedures. Customers' individual measurements were fitted to predetermined shapes and sizes (long-thin, medium, short-portly, etc.) to facilitate batch production. However, 'Sir' was measured by Burton's salesmen with all of the ritual to be found in a traditional tailoring establishment. This ideal of dignity and decorum was epitomised in the preferred profile of the company's salesmen. Positioned at the interface between customer and retailer, the art of salesmanship was to be approached with high seriousness. All excess was to be avoided through restraint and quiet good manners. As Burton's famous memorandum to staff counselled: 'Avoid the severe style of the income tax collector and the smooth tongue of the fortune teller. Cultivate the dignified style of the "Quaker tea blender" which is a happy medium' (Sigsworth 1990: 51; see also Burton's 1953).

It was this personalised approach to selling which guided Burton's address to their customers. The firm's emphasis was as much on continuity and tradition as on innovation. A company which operated within the broad parameters of mass retailing clung steadfastly to a localised

19

strategy for advertising and marketing as the most effective way of reaching customers. Until well into the 1950s, Burton's approach to commercial communications was conceived predominantly in local terms, with advertising positioned as close to the point of sale as possible. The window display, the role of the salesman, the location of the store on the high street, together with announcements in the regional press, were seen as the most effective forms of promotional culture (Burton's 1952). Guidelines issued from head office in Leeds to the branches repeated this formula endlessly in the early 1950s. The impression made on customers by a well-dressed shop window could not be matched:

> A well dressed window is a greater selling force than a newspaper and other forms of publicity combined. To neglect the greatest selling asset ... is unworthy of a progressive businessman ... the shop window is better than a picture, for the prospective customer sees the original. Ten thousand words could not convey the same description that a good window does.
>
> (Burton's 1953: 55)

What was emphasised was the superiority of direct techniques of selling over national publicity. The shop front conveyed an immediate sense of visual excitement, an atmosphere of variety and an invitation to purchase which advertising could not hope to match. Burton's argument was that adverts only created verisimilitude; it was the tangible reality of commodities on display which was the major selling asset. The point is important, because the composite blueprint of national advertising, as the medium disseminating commercial information under the conditions of mass consumption, has oversimplified the structure of the British market. Traditional techniques of retailing remained central for many firms during this period of consumer modernisation.

The varied patterns of so-called mass consumption become even more apparent when they are read alongside the consumer images which were circulated in the menswear market. From the 1930s through to the mid-1950s selling techniques relied on one clearly identifiable symbol of masculinity. This was the image of the gentleman (see Figure 1.1). The emblem not only dominated the advertising of the clothing multiples, it also shaped the approach to customers at the level of the shop floor. Such an icon represented the peculiarly negotiated discourse of modernity preferred by many British commerçants and entrepreneurs. At Burton's, the gentleman was a hybrid: a retailing compromise between traditional codes of social honour and more up-to-date democratising influences. The gentlemanly conception of masculinity was formal and fixed. The ideal was of full adult manhood, indeterminate in age, but secure in position. In press advertising and pattern books, Burton's gentleman might appear in different milieus – about town, as well as on the way to the

When deviating from printed instructions given at the foot of this page, do not quote the number, but write all the instructions on the respective lines and squares on the order form.

Style No. 40B

S.B. RAINCOAT, S.B. lapels, fly front, button 3, centre vent to button, ⅛″ stitched edges, ⅛″ raised seams, with raised armholes, split sleeves, 3 buttons on cuffs, vertical through pockets, inside ticket pocket, lined full unless otherwise ordered. Proofed interlining cape in shoulders.

Figure 1.1 Burton's advertisement: the image of a gentleman, undated.
Source: 'The Trend of Fashion: Exclusive Designs by Burton's', Burton's Archives, West Yorkshire Archives Service, Leeds, Box 136

21

office – but his standard pose was always upright, if not stiff. He was depicted either solo or in dialogue with other men, linked by the bonds of a shared masculine culture. In manners and self-presentation this was a decidedly English world view. It was taken as given that the gentleman always appeared correctly dressed; for clothes were a public sign of social esteem.

Burton's gentlemanly type was in part the legacy of nineteenth-century languages of class. Clothes as an expression of status, manners as visible markers of distinction: these rituals were grounded in a vertical model of class relations. The ensemble was retained by the company well into the postwar period. In menswear at least, the coming of the mass market drew on forms of aristocratic symbolism, reworking them for a general public. After 1945, there was a more democratic tinge to the marketing of men's clothes. Burton's gentleman was now projected as a variant of 'John Citizen'. Depicted serving in the armed forces, or against the municipal landscape of the town hall, he was quite literally 'everyman', demanding clothes for his particular role in life (Burton's undated). In the mid-1950s, this advertising theme underwent a further sea-change as more casual and relaxed imagery began to dominate Burton's retailing. A proliferation of styles and settings displayed men in a variety of leisure milieus. The care-free motorist in his sports car, or the jet-age traveller were just two of the preferred roles.

Such proliferating images of masculinity marked an effort to stimulate demand via an emphasis on fashionability. It also represented an attempt to address a particular slice of the market – younger men. Yet, Burton's new profile was neither a youth nor a classic teenager; it predated those identities and amounted to a fashion-conscious young adult man. This was an extremely negotiated British variant of consumer modernity. Historians investigating commodity culture in West Germany, Sweden and Italy in the same period have identified similar compromise patterns of commercial modernisation (Carter 1996). What they point to is the fact that the so-called paths to mass consumption are plural and diverse and that the pace of transformation is often extremely uneven. There is no single model of change.

THE AMERICANISATION THESIS

A related set of arguments needs to be rehearsed about the impact of American models of consumption on European societies in the postwar period. American prototypes of modern consumer society have exercised a paradigmatic function for entrepreneurs, as well as for intellectual critics of commercial culture, for much of the twentieth century. In a European context, the dissemination of modern consumer forms has usually been linked to versions of an Americanisation thesis. The American economy

introduced many of the major technological innovations associated with the mass market in goods. Assembly-line production, nationwide distribution and Taylorist management techniques have all been strongly identified with American methods of economic organisation. The USA has also been cast as the centre of diffusion for some typically modern consumer products such as automobiles, processed foods and Hollywood cinema. The political and economic task of reconstruction facing the war-torn societies of Western Europe after 1945 made the demand for American capital and technology all the more urgent. Marshall Aid in West Germany provided the most dramatic example of the alignment of American investment with a cultural programme generated by Cold War politics. But almost all of the West European democracies took American mass society as a major point of reference – either to provide a positive vision of the future, or against which to define alternatives. Furthermore, the USA generated an immense literature on consumer systems, which, for at least half a century, was seen as indispensable for studying related phenomena elsewhere, especially in Europe. Commercially minded intellectuals in the 1930s and 1940s, such as the young British social scientist Mark Abrams and the Viennese sociologist Paul Lazarsfeld, gravitated to American commercial institutions with strong traditions of integrated social and market research, such as those in New York and Chicago (Abrams 1951; Bulmer 1985; Converse 1987).

Much of the commercial knowledge generated in the USA was shot through with broader political assumptions, especially about the ways in which the uniquely abundant consumer-orientated productivity of that nation would replace or transform the rigid class-based hierarchies of European societies with more harmonious and democratic communities of consumption. The corollary to those optimistic versions of an American future was the periodic critiques of consumerism launched by European intellectuals. From the high moral ground occupied by T.S. Eliot and the Scrutiny group in the inter-war period, through the anxieties of liberal figures in the 1950s, to the more aggressive stance of the West German counter-cultural and anti-consumerist movements of the late 1960s and 1970s, European assaults on commerce were frequently posed as attacks on the hegemony of the American way of life (F. Leavis 1930; Q. Leavis 1932; Thompson 1943; Marcuse 1964).

Yet, closer inspection of the European dialogue with the USA points to an altogether more complex relationship between American models of commercial society and systems of provision across the Atlantic. The history of British advertising in the 1950s provides a striking case in point. The launch of commercial television in Britain, in September 1955, brought to a head an already heated debate among political and cultural commentators about the creeping effects of adman admass, the waste-makers and other sweeping charges made against a consumption-mad

23

society (Priestley and Hawkes 1955; Greenwood 1957–8; Slater 1957–8; Corden 1961). Television advertising was viewed by its opponents as ushering in an American culture of mediocrity, hidden costs and sinister methods of persuasion. Anxieties were compounded by the aggressive expansion of American-owned multinational advertising agencies in Britain, via acquisitions, mergers and takeovers. Companies such as Young and Rubicam and Foote, Cone and Belding led the assault. By 1960, there were twelve American-based agencies in London, controlling 30 per cent of all aggregate billings (West 1988). Vance Packard's exposure of American selling methods in *The Hidden Persuaders* (1957) merely seemed to confirm existing apprehensions. These were further aroused by pronouncements from the New York motivational researcher, Ernest Dichter, whose manual *The Strategy of Desire* (1960) advocated a subliminal role for advertising to reshape human character, in the interests of economic efficiency and social integration.

The history of the cultural critiques of affluence is well charted. Yet much less is known about the ways in which European business actually negotiated American influences. Once again, the evidence suggests a more nuanced picture. British advertising professionals remained sceptical of techniques imported from New York's Madison Avenue, not on account of any cultural hostility, but for sound business reasons. John Hobson, founder of the influential John Hobson and Partners agency and a president of the Institute of Practitioners in Advertising, noted how the producers of early television commercials quickly grasped that British audiences demanded a specific type and style of advertisement, which was not provided by the American 'hard-sell' model. Hobson observed that 'American experience and examples were not altogether helpful . . . the hammer blow commercials of [their] Agency men were not considered suitable for the British public, who, it was thought, would not welcome this degree of hard sell in their living rooms' (Hobson 1986). This acknowledgement of culture specificity – that markets could not be treated entirely as multinational entities – was taken up by the Conservative MP Ian Harvey, in his free-market defence of advertising, *The Technique of Persuasion*. Harvey observed that advertising was international only in principle and artistic form; national and local characteristics made it essential to vary the appeal and the methods in which the appeal was made (Harvey 1951: 89). According to the British agency, Crawford's, a company with a reputation for a stylish, art-directed approach in the 1950s, it was precisely the mismatch between American selling methods and the British character which had propelled domestic agencies to develop their own distinctive approach to commercial communications. Aggressive selling shifted goods for a time, Crawford's remarked. Ultimately, however, such methods set up their own forms of resistance in the minds of consumers, because to the European outlook, they lacked good taste (Crawford's International 1963).

This positive emphasis on the specificity of European markets was upheld even by those British businessmen who admired American commercial methods. Sir Montague Burton travelled widely throughout North America in the pre- and postwar years, assiduously noting the economic and cultural benefits delivered by modern consumer society (M. Burton 1935; M. Burton 1943). Yet as we have seen, his own firm retained methods of selling which were distanced from American consumer technology. As Sir Montague's successor at Burton's, Lionel Jacobson, concluded in 1957, American systems would not work easily in a British market (Burton's 1957). The story of postwar commercial society does need to be written as an international and comparative history. Purely domestic narratives of change will not do. But such an account also needs to highlight the multifaceted nature of the exchanges between national economies and cultures. Simplified models of American hegemony in world markets have ignored these reciprocal dialogues.

THE PERSUASION INDUSTRIES: ADVERTISING AND THE REFLEXIVE SELF

Do these insights force a revision of the dominant accounts of postwar consumerism? Is there a different type of history to be written which foregrounds the diverse paths to mass consumption? Historians might fruitfully begin by re-examining the forms of professional knowledge which orchestrated the society of abundance. In dealing with what might be termed commercial rather than official experts, the researcher confronts a number of immediate difficulties. At a practical level, there is the lack of any codified archive. Rarely do we encounter the systematised records which are preserved for the genteel professions, such as the law or medicine. There is still no authoritative account of British advertising, marketing or retailing, either from within the ranks of the entrepreneurs or from academic historians. Difficulties have been exacerbated by the stance of commercial practitioners themselves, who have been notoriously disinterested in their own history. In the postwar period, what has usually dominated their concerns has been an obsessive presentism. When advertisers and marketers have turned to examine their projects in the context of longer-term social trends, the dominant model has been one of perpetual innovation. This account understands commercial change as both cyclical and totalising. As such it functions as a variant of the more generalised image of the 'consumer revolution', which we have identified as a recurrent motif in narratives of modern society. Repeated claims for this state of permanent revolution prompted John Hobson, looking back on his own career in 1986, to question this rhetoric of constant innovation. As Hobson put it, not constant change, but perhaps *plus ça change* (Hobson 1986: 433). Yet the high point of Hobson's own career in the

25

late 1950s and early 1960s was a significant moment of transformation in the consumer industries. New forms of commercial expertise were produced by a distinctive cadre of professionals. These shifts were focused around an expansive debate about the aetiology and motivations of key groups of consumers.

The expansion of British advertising from the mid-1950s has usually been attributed to a number of interlocking factors. General conditions of postwar economic growth, especially in domestic markets, encouraged an upsurge of knowledge and information dedicated to the stimulation of demand (Tunstall 1964; Pearson and Turner 1965; Henry 1977; Nevett 1982). Journalists John Pearson and Graham Turner defined these years as a period of 'increased volatility' for those who sought to grasp the changing nature of commercial communications (Pearson and Turner 1965: 9). Early attempts to rethink the nature and the effects of advertising, in both Britain and the USA, were predominantly economic. Yet in many cases, their arguments led inexorably to the domain of culture and psychology. Refuting the logic of marginal utility theorists such as Pigou and Marshall (who had denounced advertising as a misuse of productive resources and an added burden of hidden costs for producers and consumers alike), economic commentators influenced both by theories of imperfect or monopolistic competition and by the growing impact of Keynesianism, focused on the advantages to be gained from extraneous interventions into the market. Advertising's role in stimulating demand for consumption goods, in regularising output and flattening the booms and slumps of the trade cycle, thereby contributing to a general lowering of prices and increasing quality, were among the standard themes an-nounced by the new apologists for promotional culture (Rothschild 1942; Bishop 1944; Brandon 1949). These themes, announced in the context of the international politics of the cold war, inscribed a ritual defence of the free society against socialist versions of the planned economy in Western Europe and the spectre of totalitarianism in the east. The rhetoric was of consumer knowledge providing an important antidote to the Huxleian nightmare of 'progress' and 'the plan' – in the interests of 'health, beauty, pleasure and the common good' (Brandon 1949: ix).

Yet as these polemicists were only too aware, advertising also touched on an issue which classical economics could or would not answer. As F.P. Bishop, member of the Council of the Advertising Association and general manager of *The Times*, saw it, the products of one manufacturer were never quite the same as those of another (Bishop 1944: 154). Variations in taste and subjective preference drew the consumer into complicated decisions of discrimination and choice. Such an acknowledgement led on to an even more significant point which implicitly refuted one of the basic tenets of economic theory. It appeared that where consumption was concerned, the concept of *homo economicus* – rational, calculating and

26

always perfectly informed – was far from true. Consumers were usually equipped with very imperfect knowledge of the marketplace and were easily influenced and persuaded. The young economist E.A. Laver concluded as early as 1947 that even for those on small incomes, 'biological necessities' (such as food, clothing and shelter) accounted for only a portion of their incomes. With the rest consumers invariably sought to buy 'psychological satisfaction' and to express their individual personalities (Laver 1947: 14–15). From an economic standpoint, advertising could be seen to create utility by 'moving and arranging minds' (ibid.: 49).

It was arguments of this type, about advertising's appeal to the emotive elements in human behaviour, which provoked the much-publicised attacks on the insidious nature of affluence on both sides of the Atlantic. But the actual influence of ideas about psychological and cultural persuasion on the direction of British advertising in the 1950s was more prosaic. John Hobson's own company was at the forefront of efforts to match advertising's message to the social transformations which he believed had been set in train by the postwar upsurge in demand. Hobson's influential text, *The Selection of Advertising Media*, first published in 1955, laid out his arguments in full. Acknowledging the profession was 'still an inexact science', Hobson believed that in addition to a battery of quantifiable data on markets and audiences, agencies also needed much 'more complete knowledge on the workings of the mind and the emotions' (Hobson 1961: 12). The critical element here was what he termed the 'atmosphere' of the message. Atmosphere essentially involved subjective indicators, in particular the mood of consumers and their emotional response to products. While other features could be measured, 'atmosphere' demanded a more 'intuitive and perceptive' approach.

It would be wrong to overestimate the influence of this new form of advertising theory. It was by no means universally accepted. For David Ogilvy, reviewing recent trends in 1963, 'plain language' and sound informational content remained far more critical to the professional's brief than what he dismissed as mere 'aesthetic intangibles' (Ogilvy 1987: 126). Nonetheless, agencies such as Hobson's or Crawford's were representative of a distinctive current within British advertising from the late 1950s, in which emotive and creative factors played an important role. A spate of celebrated television and press campaigns, for commodities as diverse as cars, cigarettes, food products and lager beers, testified to the impact of this formula. Advertisements designed by the London Press Exchange for cars and motor fuels were among the earliest British attempts to sell via the triple utopias of modernity, sex and status. Their 1963 account, *Getaway People*, for National Benzole, carried the message of 'petrol for the with-it people', the 'people who did good things' (Pearson and Turner 1965: 42). While the vision of the new Ford Anglia car, produced in the same year, was anchored by the caption 'Beauty with Long Legs',

27

accompanied by an image of a veiled and aloof woman with a bare midriff. A different language of modernisation was evident in J. Walter Thompson's long-running narrative about *Katie and the Cube* for Oxo Ltd. Beginning in 1958, the agency told an ongoing tale about the domestic adventures of a young modern housewife and her husband Philip – a family on the lower rungs of the executive ladder, who were decidedly 'semi-detached people'.

Among Hobson's contribution to these campaigns were two commercials addressed to younger men. Their acquisition of Ind Coope's Double Diamond pale ale account from the London Press Exchange in 1963 involved an upgrading of the product. The traditional format of beer advertising (what was dubbed the masculinity of the saloon bar) was displaced by more modern codes of manliness. 'Double Diamond – The Beer the Men Drink', pictured men in a world of 'affluence and jet-age leisure': surfing, parachuting, water-skiing and mountaineering (Pearson and Turner 1965: 149). A contrasting stance was adopted in the agency's Strand cigarette advertising for W.D. and H.O. Wills which had appeared three years earlier. Here, the individuality of the 'youth generation' was captured by an atmosphere of 'loneliness'. What John May, a member of Hobson's team, who carried the successful slogan 'You're Never Alone with a Strand', suggested was a 'hyperconsciousness', an 'entirely independent way of living' among the young (ibid.: 163). Drawing on the 'loner' theme pioneered by Hollywood cult figures such as Marlon Brando and James Dean, the actor in these cigarette commercials was shot in a variety of states of solitude. In one Strand advert, he was filmed leaning against the wall of London's Chelsea Embankment, in another standing on a deserted Brighton beach. In both cases, the settings reinforced what May termed a symbolic style of independence.

Atmospheric advertisements of this type reflected the soundings taken by market researchers on the social transformations which they believed had been set in train by the shift in consumption patterns. Central to these discussions were the linked themes of status, gender and individuality. Hobson's own musings on the marketing criteria used for the analysis of class were informative in this respect. Acknowledging that the conventional five status graduations, A to E, remained a touchstone for the advertising industry, he nevertheless insisted that class categories were in urgent need of revision. Echoing the writings of New Left thinkers such as Raymond Williams and Edward Thompson, Hobson insisted that class now needed to be understood not simply as an economic indicator but as a cultural variable, involving ways of life or 'lifestyles' (Hobson 1961: 22). Moreover, markets and consumer preferences were complicated by the emergence of what he termed 'special-interest groups', defined by age or by leadership position within the community. Hobson's point was reinforced in a report issued by the Market Research Society's working party

in 1963, which concluded that growing professional confusion about the issue of class was in part the result of its ever-expanding reference points within the social sciences (Tunstall 1964: 139–40).

Taken together these debates marked attempts by the commercial industries to renegotiate the terrain of consumption in the postwar years. As such their knowledge about the changing identity of the consumer was framed by specific historical circumstances. But this moment of change might also be profitably situated in the context of longer-term transformations in the structuring of identity. The sociologist Anthony Giddens, addressing the characteristics of late modernity, has argued that within contemporary Western societies identity has not only been linked to movements of self-affirmation, but has also become integrated into lifestyle decisions made about the self. The net effect of this project has been to produce social selfhood as a reflexively organised endeavour, which extends deep into the individual (Giddens 1991. 32, Giddens 1992). Giddens' concept of lifestyles is more broadly conceived than its understanding by the postwar consumer professionals. It embraces all those spheres of everyday life in which individual appraisal has displaced more external rules of authority. Nonetheless, the history of commercial society in Britain as elsewhere in the 1950s and 1960s does display an increasing trend towards the self-dramatisation of identity.

CONCLUSION

Yet this movement towards an enhanced role for individuality under the conditions of postwar consumption was not the result of some smooth meta-logic of the late modern epoch. It was dependent on much more specific strategies. It is here that we return to the problems of over-generality attendant on many of the accounts of modern consumption with which we began. The management of the society of affluence was formed at the intersection of a number of commercial and intellectual systems of entrepreneurship – the product of knowledges and forms of expertise which were backed by distinctive institutional programmes. Our excursion into the organisation of particular market sectors in Britain reveals the extent to which this moment of economic and cultural modernisation was much more piecemeal and ad hoc than has frequently been assumed. Methods for producing and circulating key consumption goods, together with their attendant cultural symbolism, rested as much on traditional technologies as on any dynamic blueprint for the future. Furthermore, while there were significant lines of connection between the leading industrial economies, in terms of the circulation of commodities and forms of knowledge, national developments continued to modify this international dialogue. Mass consumption needs to be rethought in the light of these particularities.

One critical response to my appeal for historical specificity in consumption studies might be to point out that such a call to detail loses sight of what has been most productive about the more abstract debates. Since Thorstein Veblen's treatise on *The Theory of the Leisure Class* (1899), a significant achievement of these general sociological studies has been to place consumption as a constituent part of the power relations integral to modern societies. Does the type of historical archaeology I propose vacate the terrain of power, implicitly returning commodities to the comfortable sphere of freedom, leisure and self-fulfilment? My emphasis on the need for concreteness is partly driven by a scepticism about the existing models of power which have been employed to address consumption. Simply put, the problem is that consumer systems have repeatedly been theorised as a power effect of something else. Whether this appears as the unequal structures of production, and their attendant forms of alienation and false consciousness, or as status inequality, or as the degeneration of cultural values, what characterises such accounts is less an interest in the power dynamics of consumption than in consumption shedding further light on forms of authority which are essentially exterior to it.

Michel Foucault's discursive model of the specificity of power – its immanence and irreducibility – provides a useful alternative framework with which to address consumer systems. As Foucault insisted, relations of power are not in a position of exteriority with respect to other types of relationships (economic processes, knowledge relationships, sexual relations), but are inherent in the latter (Foucault 1979). Following Foucault, we might add that power relations in the field of consumption are not simply the reflection of other networks, they are integral to this arena: the product of the combined effect of its knowledges and strategies, alliances and social movements, resistances and forms of experience. The historian's task is to map the changing nature of these relations; not to search for the motor or engine of consumption elsewhere. Foucault did not of course apply his insights on the dispersed archaeology of power to the sphere of commercial or market-based transactions. His principal object was the genealogy of modern structures of governmentality, associated with the emergent field of 'the social'. Consumption points the historian towards a different object and territory. This is an area which I would provisionally classify as the commercial domain. Less systematised than the traditional public sphere, it has been formed at the intersection of business and intellectual entrepreneurship, involving the management of persons and families and, crucially, the cultivation of the secular self. The later twentieth century is centrally about the consolidation of this commercial field. The task remains to map its multiple histories.

REFERENCES

Abrams, M. (1951) *Social Surveys and Social Action*, London: Heinemann.

Abrams, M. (1959) *The Teenage Consumer*, London: London Press Exchange.

Adeny, M. (1988) *The Motor Makers: The Turbulent History of Britain's Car Industry*, London: Collins.

Alford, B. (1988) *British Economic Performance 1945–1975*, Basingstoke: Macmillan Education.

Birmingham Feminist History Group (1979) 'Feminism as Femininity in the Nineteen-Fifties?', *Feminist Review* 4.

Bishop, F. (1944) *The Economics of Advertising*, London: Robert Hale Limited.

Bogdanor, V. and Skidelsky, R. (1970) *The Age of Affluence, 1951–1964*, London: Macmillan.

Brandon, R. (1949) *The Truth about Advertising*, London: Chapman and Hall.

Bulmer, M. (1985) in M. Bulmer (ed.) *Essays on the History of British Sociological Research*, Cambridge: Cambridge University Press.

Burton, Sir M. (1935) *Globe Girdling: Being the Impressions of an Amateur Observer*, vol. 1, Leeds: Petty and Sons.

Burton, Sir M. (1943) 'American Aspects of Industrial Relations', in Sir M. Burton *The Middle Path: Talks on Collective Security, Arbitration and Other Aspects of International and Industrial Relations*, Leeds: Petty and Sons.

Burton, R. (1962) Letter, *Financial Times*, 23 January.

Burton's (1952) 'Circular letter to Branch Managers', Burton's Archives, Box 5, Leeds: West Yorkshire Archive Service.

Burton's (1953) *Manager's Guide*, Burton's Archives, Box 5, Leeds: West Yorkshire Archive Service.

Burton's (undated 1940s or early 1950s) *Pattern Books*, Burton's Archives, Box 136, Leeds: West Yorkshire Archive Service.

Burton's (1957) 'File marked Tip Top Tailors', Burton's Archives, Box 182, Leeds: West Yorkshire Archive Service.

Cairncross, A. (1992) *The British Economy since 1945: Economic Policy and Performance, 1945–1990*, Oxford: Blackwell.

Cairncross, A. and Watts, N. (1989) *The Economic Section 1939–61: A Study in Economic Advising*, London: Routledge.

Carter, E. (1996) *How German is She? National Reconstruction and the Consuming Woman in the FRG and West Berlin 1945–1960*, Ann Arbor, MI: University of Michigan.

Cohn, N. (1989) 'Today There Are No Gentlemen', in N. Cohn *Ball the Wall: Nik Cohn in the Age of Rock*, London: Picador, pp. 261–4.

Converse, J. (1987) *Survey Research in the United States: Roots and Emergence 1890–1960*, Berkeley, CA: University of California Press.

Corden, M. (1961) *A Tax on Advertising?*, London: Fabian Society Research Series no. 222.

Crawford's International (1963) *How to Break into World Markets*, London: W.S. Crawford Ltd.

Crosland, C.A. (1956) *The Future of Socialism*, London: Jonathan Cape.

Davy, J. (1967) *The Standard Motor Car 1903–1963*, privately printed.

Dichter, E. (1960) *The Strategy of Desire*, London: T.V. Boardman and Co.

Economist Intelligence Unit (1961) 'Men's Suits', *Retail Business* 4(46), p. 26.

Fine, B. (1993) 'Modernity, Urbanism and Modern Consumption', *Society and Space* 11, pp. 599–601.

Fine, B. and Leopold, E. (1993) *The World of Consumption*, London: Routledge.

Foucault, M. (1979) *The History of Sexuality*, vol. 1, *An Introduction*, trans. R.

Hurley, London: Allen Lane.

Geddes, K., with Bussey, G. (1991) *The Set Makers: A History of the Radio and Television Industry*, London: BREMA.

General Secretary of the National Association of Outfitters (1962) letter to the *Financial Times*, 26 January.

Giddens, A. (1991) *Modernity and Self-Identity: Self and Society in the Late Modern Age*, Cambridge: Polity Press.

Giddens, A. (1992) *The Transformation of Intimacy: Sexuality, Love and Eroticism in Modern Societies*, Cambridge: Polity Press.

Glennie, P. and Thrift, N. (1993) 'Modern Consumption: Theorising Commodities *and* Consumers', *Society and Space* 11, pp. 603–6.

Goldthorpe, J., Bechhofer, F., Lockwood, D. and Platt, J. (1969) *The Affluent Worker in the Class Structure*, Cambridge: Cambridge University Press.

Gosling, R. (1992) 'Gosling on the High Street', Radio 4, 10 July.

Greenwood, A. (1957–8) Speech to Parliament, 'Supply Committee – Consumer Safeguards', *Parliamentary Debates (Hansard)*, fifth series, vol. 591, cols 402–12.

Hall, S. and Jefferson, T. (1976) *Resistance through Rituals: Youth Subcultures in Post-War Britain*, London: Hutchinson.

Harvey I. (1951) *The Technique of Persuasion: An Essay in Human Relationships*, London: The Falcon Press.

Hattersley, R. (1994) 'Gone for a Burton', *Independent*, 8 April, p. 19.

Hebdige, D. (1979) *Subculture: The Meaning of Style*, London: Methuen.

Henry, H. (1977) 'Some Observations on the Effects of Newsprint Rationing (1935–1959) on the Advertising Media', *Journal of Advertising History* 1(1) pp. 18–22.

Hobson, J. (1961) *The Selection of Advertising Media*, London: Business Publications Ltd, 4th edition.

Hobson, J. (1986) 'The Agency Viewpoint 2', in B. Henry (ed.) *British Television Advertising: The First 30 Years*, London: Century Benham, pp. 423–35.

Honeyman, K. (1993) 'Montague Burton Ltd: The Creators of Well-Dressed Men', in K. Honeyman and J. Chartres (eds) *Leeds City Business 1893–1993: Essays Marking the Centenary of the Incorporation*, Leeds: privately printed, pp. 186–217.

Laver, E. (1947) *Advertising and Economic Theory*, London: Oxford University Press.

Leavis, F.R. (1930) *Mass Civilization and Minority Culture*, Cambridge: Gordon Frazer.

Leavis, Q.D. (1932) *Fiction and the Reading Public*, London: Chatto and Windus.

Marcuse, H. (1964) *One-Dimensional Man: Studies in the Ideology of Advanced Industrial Societies*, London: Routledge and Kegan Paul.

Mort, F. (1996) *Cultures of Consumption: Masculinities and Social Space in Late Twentieth-Century Britain*, London: Routledge.

Mort, F. and Thompson, P. (1994) 'Retailing, Commercial Culture and Masculinity in 1950s Britain: The Case of Montague Burton, the "Tailor of Taste"', *History Workshop* 38, pp. 106–27.

Nevett, T. (1982) *Advertising in Britain: A History*, London: Heinemann.

Ogilvy, D. (1987) *Confessions of an Advertising Man: The All-Time Best Seller about Advertising*, London: Pan, revised edition, first published 1963.

Packard, V. (1957) *The Hidden Persuaders*, London: Longmans, Green and Co.

Pearson, J. and Turner, G. (1965) *The Persuasion Industry*, London: Eyre and Spottiswoode.

Priestley, J.B. and Hawkes, J. (1955) *Journey Down a Rainbow*, London: Heinemann-Cresset.

'Pseudo Bespoke by Multiple Shops' (1962) *Men's Wear*, 10 December.

Rothschild, K. (1942) 'A Note on Advertising', *The Economic Journal* LII, pp. 112–21.

Sigsworth, E. (1984) 'Burton, Sir Montague Maurice', in D. Jeremy (ed.) *Dictionary of Business Biography*, vol. 1, London: Butterworths.

Sigsworth, E. (1990) *Montague Burton: The Tailor of Taste*, Manchester: Manchester University Press.

Slater, H. (1957–8) Speech to Parliament, 'Supply Committee – Consumer Safeguards', *Parliamentary Debates (Hansard)*, fifth series, vol. 591, cols 443–9.

Steedman, C. (1986) *Landscape for a Good Woman: A Story of Two Lives*, London: Virago.

The Monopolies Commission (1967) *United Draperies Stores Ltd and Montague Burton: A Report on the Proposed Merger*, Cmnd. 3397, London: HMSO.

Thompson, D. (1943) *Voice of Civilization: An Enquiry into Advertising*, London: Frederick Muller.

Tunstall, J. (1964) *The Advertising Man in London Advertising Agencies*, London: Chapman and Hall.

Veblen, T. (1899) *The Theory of the Leisure Class: An Economic Study in the Evolution of Institutions*, New York: Macmillan and Co.

Wells, F. (1968) *Hollins and Viyella: A Study in Business History*, Newton Abbot: David and Charles.

West, D. (1988) 'Multinational Competition in the British Advertising Agency Business, 1936–1987', *Business History Review* 62(3), pp. 467–501.

Willmott, P. and Young, M. (1960) *Family and Class in a London Suburb*, London: Routledge and Kegan Paul.

Wilson, E. (1980) *Only Half Way to Paradise: Women in Postwar Britain*, London: Tavistock.

Worswick, G. and Ady, P. (eds) (1962) *The British Economy in the Nineteen-Fifties*, Oxford: Clarendon.

Zweig, F. (1961) *The Worker in an Affluent Society: Family Life and Industry*, London: Heinemann.

2

FRAMING ADVERTISING
Cultural analysis and the
incrimination of visual texts
Mica Nava

In this chapter I shall explore how, and also speculate why, advertising has been framed – that is to say set up, incriminated – in a number of (broadly Marxist) cultural studies critiques and constructed as *the* iconographic signifier of multinational capitalism, and therefore in some ethical sense, beyond redemption. This kind of political conclusion, which assumes a particular relationship of the advertising image to the economic organisation of society, is frequently based on what appears to be a dissociated critical approach, that is to say textual analysis, often of single ads. As a method it presupposes that the truth not only of the ad itself but also of its history and relationships – of the cultural practices involved in its authorship and the diverse ways in which it is read and understood – can somehow be revealed by peeling back sufficient layers of visual meaning. Yet paradoxically, this kind of approach often excludes the material processes of production and consumption from the field of knowledge. My intention is to explore these conceptual issues in the context of current debates between cultural theorists and political economists, and finally to reflect a little on the nature of our cultural fascination with the advertising form.

THE STATE OF THE DEBATE

As is well known, one of the most crucial theoretical issues on the left and in cultural studies has been the relationship of the symbolic to the material and economic order. The advent and extensive, if contradictory, influence of postmodernist theories, with their insistence on the attenuation of these relationships and the impossibility of grand narratives of economic determination, has led in recent years to an increasing, and sometimes exclusive, intellectual focus on signification and the symbolic. This tendency has in turn incurred tough criticism from a number of cultural critics who, as Martyn Lee has put it in a recent article in *Media,*

Culture and Society, want to counter the fashionable academic uptake of postmodernism with its 'flights of fancy in the stratosphere of consumer culture' and return to 'theoretical fundamentals', that is to say the productive sphere (Lee 1994: 526).[1] In his article Lee makes it clear that he and others with whom he aligns himself are particularly targeting studies of consumption (which, erroneously, they seem to assume deal only with texts and the symbolic[2]). This is the context in which he urges what he calls 'a serious reconsideration of production' and a 'recoupling of production and consumption' in order to return to a 'critical Marxist political economy'.

Jim McGuigan is another of this group of back-to-basics cultural critics who in his book *Cultural Populism* attacks what he calls the 'new revisionist tendency' or 'cultural revisionism' in analyses of consumption and also argues forcefully for a return to a 'political economy of culture which insists upon a determinate relationship between the production and consumption of symbolic forms' (McGuigan 1992: 5).[3] This is also, in broad terms, the standpoint of Fredric Jameson who in his influential essay on postmodernism and the market criticises the tendency within cultural studies to produce textual analyses of advertising and other representations without talking about 'real markets' (Jameson 1993: 264). In short what is assumed by these authors and this general theoretical position (and inevitably I simplify) is that an analysis of production will reveal a correspondence, or at least a clear articulation, between the economic organisation of society – in this instance multinational capitalism – and the cultural and symbolic, or as Jameson has put it, between the logic of the marketplace and the cultural dominant; it will provide the theoretical substance for a revival of a Marxist politics.

How do these assumptions about the presumed ubiquity of depoliticised postmodernist approaches in critical work on consumption and the symbolic measure up when we look at recent studies of advertising? Is it really the case that production and the economic are ignored or overwhelmed by 'postmodernist stratospheric' speculation about the meanings inscribed in texts? If production *is* taken into account, what kind of production and, importantly, of what? How far does the consumption of ads figure in these studies?

Most theoretical work on advertising has until recently been embedded in what Lee (1993) has usefully called a Fordist (or mechanistically modernist) way of conceptualising the economy, state power and the subject. This conceptual Fordism is rooted in intellectual preoccupations about mass society, dominant ideology and manipulation, and includes among its main thinkers Marxists of the Frankfurt School like Adorno and Horkheimer (1973) and Marcuse (1964) (for their condemnation of mass culture and the 'cultural industry'), Louis Althusser (particularly in his structuralist mode) (1971) and specifically in relation to advertising, the

journalist Vance Packard (1981). What all these have in common (according to Lee) is a theoretical position which presupposes an economic and political order of such power that

> it seemed that everyday culture and social identity could now be manufactured at the whim of big business and the state apparatus ... that social consciousness itself could be produced almost as effortlessly as the assembly lines were producing automobiles or bars of soap.
>
> (Lee 1993: 98)

In this totalising and deterministic schema no intellectual justification seems to exist for disaggregating the different moments in the production and consumption of advertising. They are part of a monolithic force which the helpless consumer/spectator/subject is incapable of resisting. Here I want to explore how far this kind of conceptual model still operates as a baseline in studies of advertising in the 1990s.

Judith Williamson's classic and still highly influential study of 1978, although not included by Lee in his category of Fordist thinkers presumably because of the significant ways in which it breaks with this tradition by, in principle, opening up the possible textual readings available to the reader,[4] nevertheless at the same time continues to conceptualise consciousness and the primacy of the economic in conventionally Fordist terms. According to Williamson (1978: 13) consumers are persuaded to buy goods against their real class interests because they are unable to escape the false meanings invoked by advertising. 'Real' production refers to the production of commodities; the producers and production processes of the advertisements themselves are perfunctorily dismissed: 'Advertising has a life of its own. ... Obviously people invent and produce adverts, but apart from the fact that they are unknown and faceless, the ad in any case does not claim to speak for them, it is not their speech' (ibid.: 14). In her focus on textual signification and her insistence that authorship has no relevance for our understanding of advertising, Williamson identifies herself as part of a broader post-structuralist momentum which over the following fifteen years was to merge with postmodernism[5] and lay the groundwork for much of the subsequent critical work on advertising.

RECENT WORK: INCRIMINATION CONTINUES

What is interesting about this most recent work is how far it continues to fall into the broadly Marxist/Fordist conceptual genre, despite the appropriation of a postmodernist style. Thus at first glance, it would seem a good target for the accusation of 'cultural revisionism' because of its preoccupation with the deconstruction of signification and its failure to consider the market. Yet at the same time it makes Fordist *assumptions*

about the relationship of the economic to the symbolic and about the malleability of the consumer. I will argue that paradoxically these internal contradictions have occurred just because of the theoretical neglect of the production and consumption of advertisements as products in themselves.

In order to demonstrate this conceptual slipperiness, this movement between Fordist and postmodernist theorisation, I want to look briefly at three recent books. The first is Thomas Richards' *Commodity Culture of Victorian England: Advertising and Spectacle 1851–1914*, which is concerned to establish the consolidation of capitalism's 'semiotic hold' over England (1991: 3). For Richards advertising is largely to blame for this and indeed for the spread of capitalism and the rise of commodity culture more generally (a claim of course contested by historians of consumer culture: see Brewer and Porter 1994). Advertising as a system of representation is not separable from capitalism, and is therefore unable to escape moral and political condemnation. Richards' book is suffused throughout with nostalgia for an idealised, imaginary pre-capitalist past in which, it is claimed, commodities played no part in cultural discourse. Advertisers as agents – that is to say the people who make ads – are ambiguously constituted in the book: they are both present and absent. Thus on page 7 Richards claims advertisers 'dug their pincers deep into the flesh of late Victorian consumers . . . and sucked consumers, especially women, into the vortex of a master–slave dialectic'. In this melodramatic account advertisers are constructed as monstrous as well as material; a couple of pages later, however, they are much less embodied. Here Richards argues that advertisers must be considered, 'not as subjects constituting discourse but as discourse inscribing subjects, *not* as a locus of authorship and authority', and that this will be his method (ibid.: 12–13); (and indeed in a footnote he goes on to berate Michael Schudson (1993) – whose book on advertising remains one of the best in my opinion – for his concern with the trivia of what goes on in the boardrooms of agencies). So we see here, in Thomas Richards' book, a piece of work that is post-structuralist/postmodernist in its epistemological claims and discursive approach yet deeply Fordist in its totalising presuppositions about the relationship of spectacle to capitalism and about the gullibility of the consumer.

And it is worth noting briefly that here, as elsewhere in this genre of literature on advertising and consumption, the consumer who is gullible and easily duped by the machinations of the advertisers is usually explicitly female. Feminists have also played a part in the construction of this kind of theoretical perspective in which women are produced as victims, but since the early 1980s, particularly within cultural studies, the focus has increasingly been on the ways in which (women) consumers, spectators and readers of texts are, on the contrary, often active and discriminating.[6]

This latter perspective remains unaddressed by the critics of advertising and consumption that are being reviewed here. Indeed it may well be that their reassertion of the importance of political economy is in some contradictory sense a part of a wider denial of the intellectual work of feminists over the last two decades. Regrettably there is no room to develop these ideas here, but I have argued elsewhere (Nava 1996) that concern about the passive consumer may well have been generated in the first instance as a response to anxieties about the feminisation of consumption and the imagined pleasure and power offered to women by excursions to the shops and cinema in the early decades of the twentieth century – to the increasing *activity* of women – and that this concern has made a significant contribution to the formation of an intellectual climate, and Fordist theories, in which the consumer and mass culture are disdained .

The second book I want to look at in the context of my argument about how advertising has been conceptualised is Robert Goldman's *Reading Ads Socially* (1992). This book (highly praised by Douglas Kellner) consists almost entirely of breathtakingly stratospheric textual analyses of specific ads and groups of ads, yet the theoretical framework (at least at the beginning of the book) is unequivocally Fordist/Althusserian: 'Advertising is a key social and economic institution in producing and reproducing the material and ideological supremacy of commodity relations', Goldman states. The task he has set himself is to understand 'the grammar of meaning in ads' in order 'to grasp their deeper ideological significance' (ibid.: 2). But his polemical conclusions appear to precede the readings he produces; his decodings confirm over and over again his neo-Marxist thesis about 'the political economy of commodity sign production' (ibid.: 9) and the knowingness and intentionality of the advertisers. Although he gestures to the contribution spectators can make to the meanings that are produced, there are no 'real' unruly readers here who might produce different conflicting meanings; nor are there 'real' producers of advertisements. And like Richards, the readers he thinks are most targeted and he is most concerned to protect, are women. In the final two pages of the book, almost as an afterthought, he addresses the question of production (and like Lee et al., complains that production has been backgrounded in textual analysis: 'postmodernism ... fails to go beyond the 'texts' into the relations and practices that condition and inscribe the texts' ibid.: 228). But it is the production of the *commodity* that he briefly examines – the conditions of production of Reeboks themselves – not the production of the images which advertise Reeboks and which he so angrily and tirelessly deconstructs.

About two-thirds of the way through the book Goldman starts to address the issues raised by theories of postmodernism in his development of the idea of the more ironic knowing ads that 'wink' at the spectator. This new position though is a deeply dystopian Jameson-type

postmodernism. There is no interpretive openness here, no 'infinite inter-textual play of signifiers'. Meta-narratives are not abandoned. Ambiguity in ads, argues Goldman, is no more than a masquerade – it is deliberate, part of the conspiracy: 'a function of market imperatives to seek commodity difference'(ibid.: 212). Yet the market he lays claim to remains elusive, out of frame. Despite the theoretical-political conclusions and the passionately critical polemic, there has been no 'recoupling of production and consumption'.

The singling out of advertising by these two authors, their simultaneous contempt and fascination and their conviction that advertising, of all instances of visual communication in contemporary consumer culture, is somehow uniquely powerful and culpable in the perpetration of desire and production of commodity signs, is, as I have already pointed out, still surprisingly widespread. Armand Mattelart's *Advertising International* (1991) is one more example of a book which starts off from more or less the same political premise, but which has as its object of study the inter-national operations of the advertising industry, not the production of meaning in images. What is interesting here is that, despite the gloss on the back cover about the domination of international conglomerates and the attempt to demonstrate that the universalisation and commodification of culture has been caused by advertising, Mattelart is constantly brought up against the impossibility of his own totalising argument by the research that he himself has done. Thus his book also contradictorily (and usefully) reports on the failure of advertising campaigns and on the scepticism of much of the industry and its disseminating media about the effectivity of advertising; Mattelart quotes William Lever (of the Lever Brothers agency) in this respect: 'Half the money I spend on advertising is wasted. The trouble is I don't know which half.' (Mattelart 1991: 213).

So paradoxically, investigations into the process of the production of ads and the recommended 'recoupling of production and consumption' in relation to ads – urged on us by the critics of 'cultural revisionism' and produced in this instance by Mattelart against the thrust of his own argument – actually seems to suggest a far more complex and haphazard situation than the back-to-theoretical-fundamentals thesis would seem to predict. To what extent is this confirmed by other research? And what are the theoretical implications?

THE PRODUCTION OF ADS

In order to understand the relationship of advertising imagery and cam-paigns to commodity production and political economy we must have some sense of the assumptions and operations of advertising and publicity as cultural industry. My argument in this section will be that the picture of the advertising industry which emerges with remarkable consistency

from its own accounts, its trade magazines, interviews with workers at all levels and also from a few rare academic studies, is one of far more extensive demoralisation, fragmentation and suspension of belief than the 'Fordist' interpretive communities can accommodate within their theoretical paradigms.[7]

Over the last decade the advertising industry (not only in Britain) has increasingly suffered a crisis of confidence. Exacerbated by the recession of the early 1990s, this has precipitated a re-evaluation by both clients and agencies of the effectivity of advertising as a way of promoting sales. The formal and informal investigations which have been carried out by companies and their clients under the pressure of the new financial constraints have demonstrated remarkably little correlation between sales and the amount of money spent on advertising (Mattelart 1991; Brignull 1992). Indeed, as growing numbers in the industry are ready to concede, advertising is as much about promoting the corporate image of a company (or institution) to its rivals, clients and employees as it is about selling commodities to the consumer. In this sense it would be more appropriate to compare advertising operations to the status-enhancement function of corporate buildings (for instance, the acclaimed Lloyd's building in London), company or institutional logos, employment policies and executive payment levels, and accordingly to assess them by a much wider range of design and commercial-administrative criteria.

One of the most important objects of concern for critics of advertising since the 1950s has been market research, commonly assumed (without much supporting evidence) to be able magically to yield information which will enhance the production of commodity signs and sales. Yet scholarly research into its history, epistemology and methods – into market research as a regime of knowledge – is negligible and where it exists tends not to break from the theoretical orthodoxies I have outlined.[8] In fact, a brief examination of current market research practices in the advertising industry reveals that much of it is by academic standards surprisingly disreputable – a point not inconsistent with the industry's low estimation of its predictive value. It is often undertaken to convince clients that agencies are worth investing in and may form part of a package which includes the creation of the adverts themselves. Sometimes a research report is promoted as a product in itself, despite its minimal value in relation to sales, and sold to other agencies in order to enhance their commercial credibility with prospective clients. An instance of this is the McCann-Erickson Youth Study of 1988, a massive and much-publicised longitudinal survey produced by one of the largest multinational advertising agencies in the world, which compared 1970s findings with new research and claimed that 15–19-year-olds in Britain constituted a distinct generation, the New Wave Young, who were markedly different in their values from the previous generation.

In order to promote the research a number of expensive conferences were organised (Nava 1988) at which the senior vice-president of the agency (billed as a graduate of the London School of Economics presumably to persuade prospective clients of her academic respectability) delivered a paper and issued smartly designed press-packs to all delegates so that they might have a taste of the much longer study. However, the twenty-page summary (no date or page numbers) indicated an astonishingly unrigorous piece of work with contradictions in every section. The conclusions drawn by the researchers often bore no relation to their own data. For example, under the heading 'Morals and Values', the summary report claimed that Britain was now a 'post-permissive society' in which 'sex outside marriage is seen as wrong'. Yet it also announced on the same double-page spread that '10 per cent fewer girls today than ten years ago think it is wrong' and 20 per cent more girls 'might do it'.[9] Another unconvincing interpretation of the data is offered in relation to ideas about sexual equality. According to the report's own figures, 62 per cent of young women in 1988, compared with 38 per cent ten years earlier, believed that 'women should fight for total equality', yet this is construed to mean that 'It is no longer necessary to ape men, because young women have developed a separate value system.' It is hard to imagine what kind of purpose research like this has outside the commercial negotiations between clients and agencies. Even if it were able to represent the 'values' of young people with some accuracy, it tells us nothing about how these values should be incorporated into textual strategies of representation in advertising or how young people with these different values interpret ads; nor does it reveal what the relationship is of advertising to sales and the market.

It should not be assumed that, because of their location in the industry, all advertising workers take studies of this kind seriously. Many market researchers, like their colleagues in universities, have lost confidence in narratives of scientific truth and are becoming cynical about the value of their work and the possibility of correct or even useful answers; nonetheless, in the face of the current job situation, they are prepared to abide by professional conventions. In comparison, the creative sector in advertising agencies has always been more openly sceptical. At the same conference the creative director responsible for the British Telecom ads publicly ridiculed not only the event and the concept of a New Wave Young but research in general. The limit of his own investigation, he told the audience provocatively, was a chat with his niece and nephew to find out which ads they liked the best. (Displaying commendable family loyalty, they reported that his were their favourites.) A media contractor from another major agency confirmed this perspective when he expressed an off-the-record view that the confidence of the industry in research and advertising was extremely low and there was now increasing agreement

that media coverage of products was the most effective way of promoting sales. Research in this context functioned as a ritual which legitimised the existence of the agencies and facilitated the production of ads.

Market research was also held in low esteem by workers in the creative department of the London branch of the multinational agency Saatchi and Saatchi, who said in interview that they thought it 'just a fucking joke ... a load of client-serving bollocks paying lip service to objectivity' (Fretten 1992: 27).[10] Some advertising professionals articulate their scepticism and worries about the industry more formally, in writing and at conferences (Lury 1994), and even in narrative form within the ads themselves. An ad produced in 1989 by the agency of which Adam Lury is a partner showed a couple making love on a sofa with a television flickering in the background; the accompanying slogan said: 'Current advertising research says these people are watching your ad. Who's really getting screwed?' This ad, addressed to clients and promoting the agency which made it, was unusual in making a direct connection between the issue of research and the content of ads. But although much cited for its insubordination and wit, its market effectivity was probably minimal – in fact Thames Television withdrew its £5 million account from the firm (Mattelart 1991: 153).

Links between research departments and 'creatives' are these days likely to be far more tenuous than represented in this ad, partly because of the increasing fragmentation and 'flexibility' of the industry and the associated growth of small independent companies competing for creative briefs. But even prior to the present restructuring of the industry (which occurred in the late 1980s and early 1990s partly as a consequence of the pressure to reduce costs), creative departments operated relatively independently within the larger companies and were staffed by graduates from art and film courses. This tendency has been consolidated over the last few years, with the near collapse of the British movie industry and the growth of temporary contractual relationships between large television commissioning departments and small production companies which take on work from advertising agencies, or sometimes directly for the client, or for television, as it becomes available.

So, the organisation of production and, now more than ever, the cultural intermediaries and aspiring movie-makers – the *producers* of ads – are blurring the demarcation between advertising and other cultural forms. Creative decisions are based on experience and intuition, not on anything as grand as a 'science' of commodity signs. Visual codes used in ads operate across cultural forms. In general the approach of small production companies to the making of ads is not significantly different from the approach to the making of corporate videos, party political broadcasts, pop promos or AIDS information films.[11] In this, as in the production of other kinds of film and video, the concern is to win the recognition

of peers and the public and to ensure more work. There is nothing partic-
ularly new about these objectives. Ads have for a long time been assessed
according to criteria that bear no relation to marketing. The ultimate acco-
lades in the world of advertising are, as in other areas of art, performance
and cultural production, the prizes and recognition awarded by peers –
by juries drawn from the creative sectors of the industry. The criteria in
play are likewise those of other areas of cultural production such as tech-
nique, aesthetics, inventiveness, humour, narrative, even politics. The 1995
Campaign gold award for the best campaign of press advertising went to
the Commission for Racial Equality series produced by Saatchi and
Saatchi (art director Ajab Samrai Singh) (*Campaign* 28 June 1995) (see
Figure 2.1). As Lury has put it, 'awards juries do not incorporate market-
place effectiveness into their judgements *in any form whatsoever*' (original
emphasis, Lury 1994: 92; see also Nava and Nava 1990).

This picture of the imperatives of cultural practice involved in the
production process of the ad thus seriously contests the notion of a deter-
mining meta-narrative of sales. It also challenges the assumed specificity
of the form. The critiques mounted by Lee, Goldman, Richards and
McGuigan et al. seem to presuppose that as a consequence of the unique
relationship between advertising and commodities, advertising imagery
can easily be distinguished at a formal level from all other cultural repre-
sentations. Yet what we see is that the ways in which meanings are encoded
in visual texts operate much more widely, across a range of discursive
economies. Indeed the ability to decode ads at all relies on a familiarity
with references produced and consumed elsewhere, on an effacement of
boundaries between ads and other forms.

CONSUMPTION

It will probably not come as a surprise to hear that those who stress the
importance of production and markets and the 'recoupling of production
and consumption' have not done much work on consumption themselves.
For instance, Goldman's elegant and provocative textual decodings are
intended to reveal the ideological language through which ads are able
to 'hail' the spectator. However, whether spectators are indeed hailed,
that is to say whether they identify with and are persuaded by the ads,
or indeed, more mundanely, even begin to understand the complex mean-
ings that Goldman claims the ads contain, is not addressed. But Goldman
is not alone in overlooking this aspect of what ads mean to people. The
fact is that very little ethnographic work has been done anywhere which
might confirm or not the interpretations and projected readings of authors
like Goldman and Richards.[12]

The theoretical disjuncture between analysing symbolic meaning on the
one hand and exploring the interpretations of 'real' audiences on the other

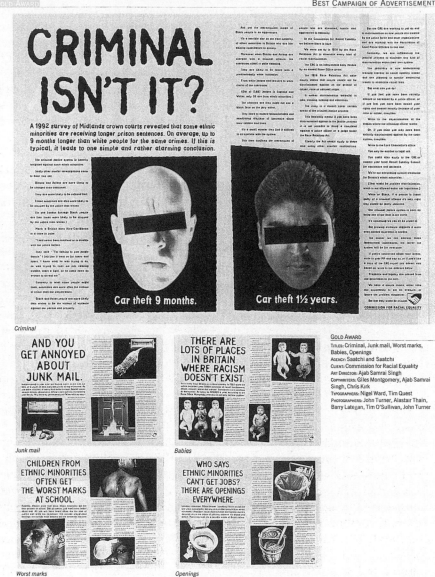

Figure 2.1 The Commission for Racial Equality advertisement produced by Saatchi and Saatchi, 1995.

Source: *Campaign* 28 June

is not confined to studies of advertising. For instance, within feminist theoretical work on film, the tendency to focus almost exclusively on (often psychoanalytic) readings of texts has existed in tension with a feminist cultural studies approach which focuses on how popular texts are made sense of and consumed. (Jackie Stacey's work on Hollywood cinema and female spectatorship (1994) has been extremely useful in unravelling and reconciling these two perspectives.) Part of the project of this paper has been to highlight the lack of connection between symbolic analyses of ads and ethnographies of readers/consumers.

The advertising industry has of course carried out its own market research on how people respond to ads, but access to this data is limited and, as I have already pointed out, a critical reading of market research methods and epistemology has yet to be done. In the mean time there are fragments of research from media studies, cultural studies and anthropology that give some insight into the consumption of ads, and none supports the Fordist theorists. Ethnographic work on television viewing demonstrates the impossibility of understanding or measuring how people respond to what they look at, or indeed of establishing whether people going about their business in their own homes look very attentively at all (as the ad described above, of the couple on the sofa, graphically represented to us) (Ang 1992). New domestic technologies like videos and remote controls mean that watching television is now more selective and sporadic than ever before, and ads, unless particularly pleasurable, are fast-forwarded at maximum speed by bored and sceptical viewers (Nava and Nava 1990; Ang 1992).

What evidence we do have indicates that ads, like other texts, are in any case polysemic. That is to say, when people do watch ads, their aesthetic responses and their interpretations of what the ads are trying to say and whom they are addressing are not at all consistent or uniform. The multinational ad agencies themselves are well aware of the diversity of cultural responses; there is no tendency towards globalisation in the production and transmission of the ads themselves. Corporations are forced by cultural difference to have local offices and producers. *Campaign*, the British advertising trade magazine, reports regularly on different national, cultural and aesthetic codes about food and alcohol consumption, clothes and hats, hairstyles and hair colours (in France redheads are for some reason presumed to smell more, so advertisers are warned against using them for fragrance ads, *Campaign* 13 May 1994). Studies done in Trinidad by Daniel Miller have shown that readings *within* cultural and social groups are also idiosyncratic and contradictory. And of course if we then take into account knowledge of other texts, fashion, individual preference, psychic formation and all the other factors which make for diverse readings, what emerges is much greater interpretive openness than the textual analyses allow.

But it is not just how people interpret what ads are trying to say that is significant. It is also whether they are 'hailed' by them, whether they see themselves in the ad, whether the ad makes any impact. In fact the very pervasiveness of ads – the experience of being continually bombarded by signs – can operate against the creation of pleasure and desire. Cynicism and boredom about ads are widespread and part of a more general neurasthenia of postmodern culture. In fact the battle of the advertisers to overcome this boredom is what has led to the creation of so many witty, sophisticated, intertextually referenced and visually appealing ads. This has in turn produced more discriminating and skilful consumers, who (as research into the consumption of ads by young people has shown, Nava and Nava 1990) will consume the 'best' ads as cultural products in themselves, as they do video clips, movies and magazine images. And they will deploy the critical interpretive expertise, honed in the reading of ads, across a range of cultural forms. Lash and Urry (1994) describe this complex modern formation as heightened 'cognitive and aesthetic reflexivity', part of the new cultural competencies generated by the information society.

This kind of analysis confirms once more that ads cannot be detached from what Wernick (1991) has so fruitfully conceptualised as 'promotional culture'. This refers to the complex of communications embracing not only commodities in the conventional sense but also politics, educational institutions and the self. Promotion, argues Wernick, is a 'rhetorical form diffused throughout our culture' (Wernick 1991: vii).[13]

CONCLUSION?

It is paradoxical therefore that an examination of the production and consumption of ads, instead of leading us back to Marxist fundamentals, as Lee (1993, 1994) Clarke (1991) and McGuigan (1992) et al. would hope, *confirms* the move into postmodernism.[14] Ads belong to the scopic regimes of late twentieth-century life, to regimes of representation and regimes of consumption and looking that extend beyond the immediate iconography of capitalism, that are heterogeneous, differentiated, fragmented, yet part of the ubiquity of the visual and the pervasiveness of new forms of communication and cultural promotion. They cannot be collapsed into the production of commodities or interpreted as a key signifier of multinational capitalism. They do not constitute a unique cultural form.

So if this is the case, why is it then that advertising seems to elicit so much moralistic disapproval?[15] Why is it so frequently singled out as the bad object of the critic's gaze, even today, when the intellectual climate is ethically and politically so uncertain, and the pleasures of popular consumption so much more widely acknowledged? Why is advertising

so much more incriminated than, say, cinema, magazines or corporate architecture? Why, additionally, are some critics so provoked by the idea of commercial exchange, by the association of imagery and buying?[16] These are large questions and my observations here are brief and tentative. Nevertheless both questions and reflections are worth offering in order to interrogate the complex processes involved in the development of intellectual work and in the uptake of theoretical positions.

One fruitful way of beginning to think about these issues is suggested by the work of Roger Silverstone on television (1994). So far the link between advertising and television has barely been touched on, yet the antipathy and desire evoked by advertising images cannot be disentangled from the complex modern history of our relationship to television. Silverstone, in an innovative and fascinating first chapter, has argued that in the late twentieth century this item of domestic furniture and transmitter of stories operates as a kind of transitional object, comparable, in (Winnicottian) psychoanalytical terms, to the breast and teddy bear, in that it functions as a kind of protective-defensive ritual to provide security and ward off social anxieties. Moreover, like other transitional objects, it is able to withstand attempts to destroy it; it can be turned off and on at will. Could it be the case that the ambivalent yet often surprisingly intense responses to advertising, the construction of the ad as a very bad yet quite seductive object with extensive socio-psychological powers, is in some sense a displacement from a much more fundamental infant relationship to television?

There is one last associated speculation which I think offers some insight into the fascination exercised by advertising. This emerges from the complex and contested history of the visual. Despite the pervasiveness of imagery in late twentieth-century culture and the ocularcentrism (Jenks 1995) of modern Western thought, the pleasures of looking have often felt peculiarly illicit, and indeed, iconophobia – the prohibition or dislike of certain kinds of images – has been widespread and continues to be so: for instance, visual representations of 'explicit' sexuality are still a greater cause for concern than the literary. So to return to the production of intellectual work, we cannot assume that the critic's eye is more disengaged at the unconscious level than that of the ordinary consumer of ads. His or hers (ours) is as full of ambivalence, of lust, greed and guilt, as anyone else's. What the analytical gaze offers – the gaze of cultural studies – is permission to look and make judgements. It legitimises the voyeur's scopic investigation (Denzin 1995). It authorises the pleasures of looking while at the same time granting the satisfaction of repudiating and yet containing the culturally transgressive. In this way, by fixing advertising and attributing to it the injuries of our dependence on commodity capitalism, advertising texts are intellectually framed.

NOTES

1 Lee refers specifically to Clarke (1991) but see also McGuigan (1992), Frith and Savage (1993) and Lee's book (1993). See also the colloquy between Garnham (1995) and Grossberg (1995) drawn to my attention after completing this article.

2 Cultural studies and feminist analyses of consumption have frequently focused on the conceptualisation and experience of consumers/readers/spectators and on how texts are understood; see e.g. Winship (1981); Carter (1984); Radway (1986); McRobbie (1991); Nava (1992); Stacey (1994).

3 McGuigan includes among his targets Nava and Nava (1990).

4 In fact this kind of textual analysis fluctuates uneasily between proposing 'correct readings' and 'infinitely open readings'. But that is the substance of another argument.

5 This is not the place to unravel the interrelationship of postmodernism and post-structuralism. See Huyssen's argument for keeping them apart (1988).

6 For references, see note 2.

7 See Mica Nava (1988) 'Targeting the Young: What do the Marketeers Think?', an unpublished report of a two-day conference on 'The New Wave Young' organised for advertising agencies and their clients in April 1988; the points made in this section are also based on interviews and informal conversations with advertising professionals. Most important among the academic sources confirming this position are Schudson (1986) and Leiss, Kline and Jhally (1990). See also Adam Lury (a director of Howell Henry Chaldecott Lury) (1994).

8 A notable exception, which has just been brought to my attention, is Miller and Rose in *Theory, Culture and Society* (1996).

9 Apart from the patent inconsistencies in its own arguments, the report was also remarkably weak in its prediction of trends since today, eight years later, it appears that 70% to 80% of those same young people live with their sexual partners either without being married or before marriage.

10 McGuigan, in keeping with the logic of his political economy position, argues that it is part of the ideological stance of advertisers to trivialise the significance of their work (McGuigan 1992: 121).

11 A good example of ads which confound conceptual boundaries are those in the 1995 campaign against the proposed resumption of nuclear tests in the South Pacific by the French government.

12 Though see O'Donohoe and Schrøder in this volume.

13 One of the best sections of the book is on the promotional university and the 'professorial CV' as literary construct; academics cannot fail to squirm at the itemisation of tactics used to enhance professional status. However, the first part of book falls into many of the same traps as Goldman in its projection of meanings, though is less moralistic and conspiratorial.

14 For the specificities of this debate, see the helpful accounts of e.g. Huyssen (1988); Boyne and Rattansi (1990); Hutcheon (1993).

15 Schudson (1993) has also posed this question, and explained it, in the Afterword of the revised edition of his book, in terms of the North American philosophical and political tradition.

16 The critical neglect of consumption is addressed in Nava (1996).

REFERENCES

Adorno, Theodor and Horkheimer, Max (1973) *Dialectics of Enlightenment*, London: Allen Lane.

Althusser, Louis (1971) 'Ideology and Ideological State Apparatus' in *Lenin and Philosophy and Other Essays*, London: New Left Books.

Ang, Ien (1992) 'Living-Room Wars: New Technologies, Audience Measurement and the Tactics of Television Consumption' in R. Silverstone and E. Hirsch (eds) *Consuming Technologies: Media and Information in Domestic Spaces*, London: Routledge.

Boyne, Roy and Rattansi, Ali (eds) (1990) *Postmodernism and Society*, London: Macmillan.

Brewer, John and Porter, Roy (eds) (1994) *Consumption and the World of Goods*, London: Routledge.

Brignull, Tony (1992) 'The Adman's Lament', *Media Guardian*, 21 September.

Carter, Erica (1984) 'Alice in Consumer Wonderland' in A. McRobbie and M. Nava (eds) *Gender and Generation*, London: Macmillan.

Clarke, John (1991) *New Times and Old Enemies*, London: HarperCollins.

Denzin, Norman (1995) *The Cinematic Society: The Voyeur's Gaze*, London: Sage.

Fretten, Howard (1992) *They Consume Advertising Too: Advertising in Theory and Everyday Life*, dissertation for MA in cultural studies, Thames Valley University.

Frith, Simon and Savage, Jon (1993) 'Pearls and Swine: The Intellectuals and the Mass Media', *New Left Review* 198.

Garnham, Nicholas (1995) 'Political Economy and Cultural Studies: Reconciliation or Divorce?', colloquy in *Critical Studies and Mass Communication*, March.

Goldman, Robert (1992) *Reading Ads Socially*, London: Routledge.

Grossberg, Lawrence (1995) 'Cultural Studies vs. Political Economy: Is Anybody Else Bored with this Debate?', Colloquy in *Critical Studies and Mass Communication*, March.

Hutcheon, Linda (1993) *The Politics of Postmodernism*, London: Routledge.

Huyssen, Andreas (1988) *After the Great Divide*, London: Macmillan.

Jameson, Frederic (1993) *Postmodernism, or, The Cultural Logic of Late Capitalism*, London: Verso.

Jenks, Chris (1995) 'The Centrality of the Eye in Western Culture' in C. Jenks (ed.) *Visual Culture*, London: Routledge.

Lash, Scott and Urry, John (1994) *Economies of Signs and Space*, London: Sage.

Lee, Martyn (1993) *Consumer Culture Reborn*, London: Routledge.

Lee, Martyn (1994) 'Flights of Fancy: Academics and Consumer Culture', *Media, Culture and Society*, 16(3).

Leiss, William, Kline, Stephen and Jhally, Sut (1990) *Social Communication in Advertising: Persons, Products and Images of Well-being*, London: Routledge.

Lury, Adam (1994) 'Advertising: Moving Beyond the Stereotypes' in R. Keat, N. Whiteley and N. Abercrombie (eds) *The Authority of the Consumer*, London: Routledge.

Lury, Celia and Warde, Alan (1996) 'Investments in the Imaginary Consumer: Conjectures Regarding Power, Knowledge and Advertising' in this volume.

McGuigan, Jim (1992) *Cultural Populism*, London: Routledge.

McRobbie, Angela (1991) *Feminism and Youth Culture: From* Jackie *to* Just Seventeen, London: Macmillan.

Marcuse, Herbert (1964) *One-Dimensional Man: Studies in the Ideology of Advanced Industrial Societies*, London: Sphere.

Mattelart, Armand (1991) *Advertising International*, London: Routledge.

Miller, Peter and Rose, Nikolas (1996) 'Mobilising the Consumer: Assembling the Subject of Consumption', *Theory, Culture and Society*.

Nava, Mica (1988) 'Targeting the Young: What Do the Marketers Think?', report for The Gulbenkian Enquiry into Arts and Cultural Provision for Young People.

Nava, Mica (1992) *Changing Cultures: Feminism, Youth and Consumerism*, London: Sage.

Nava, Mica (1996) 'Modernity Disavowed: Women, the City and the Department Store' in M. Nava and A. O'Shea (eds) *Modern Times: Reflections on a Century of English Modernity*, London: Routledge.

Nava, Mica and Nava, Orson (1990) 'Discriminating or Duped? Young People as Consumers of Advertising/Art', *Magazine of Cultural Studies* 1 (reprinted in Nava 1992).

O'Donohoe, Stephanie (1996) 'Leaky Boundaries: Intertextuality and Young Adult Experiences of Advertising' in this volume.

Packard, Vance (1981) *The Hidden Persuaders*, Harmondsworth: Penguin (first published in 1957).

Radway, Janice (1986) *Reading the Romance*, London: Verso.

Richards, Thomas (1991) *The Commodity Culture of Victorian England: Advertising and Spectacle 1851–1914*, London: Verso.

Schrøder, Kim Christian (1996) 'Cynicism and Ambiguity: British Corporate Responsibility Advertisements and their Readers in the 1990s' in this volume.

Schudson, Michael (1993) *Advertising: The Uneasy Persuasion*, London: Routledge (first published in 1986).

Silverstone, Roger (1994) *Television and Everyday Life*, London: Routledge.

Stacey, Jackie (1994) *Star Gazing: Hollywood Cinema and Female Spectatorship*, London: Routledge.

Wernick, Andrew (1991) *Promotional Culture: Advertising, Ideology and Symbolic Expression*, London: Sage.

Williamson, Judith (1978) *Decoding Advertisements: Ideology and Meaning in Advertising*, London: Marion Boyars.

Winship, Janice (1981) *Woman Becomes an 'Individual': Femininity and Consumption in Women's Magazines 1954–69*, CCCS University of Birmingham Occasional Paper.

3

CONSUMER CULTURE AND THE POLITICS OF NEED

Don Slater

I

In his preface to *Consumer Culture and Postmodernism*, Mike Feather-stone remarks that 'despite the populist turn in analyses of consumer culture some of the questions raised by the critical theorists such as "how to discriminate between cultural values", "how to make aesthetic judgements", and their relation to the practical questions of "how we should live", it can be argued have not actually been superseded but have merely been put aside' (Featherstone 1991: viii). I think this argument is true and in this article I want to think through both why this might be a problem and how we might be able to get such questions back on the agenda. These questions are the kind that arise in carrying out a critique: they are questions about how, on what principled basis, one can *judge* consumer culture, how one can come to conclusions about its wrongness or rightness, about its potential for developing or thwarting the kind of life one might want to live.

The 'populist turn' that Featherstone refers to has involved a swing away from manipulationist models of the consumer: we are increasingly directed to attend to the productivity, creativity, autonomy, rebelliousness and even to the 'authority' of the consumer. This shift arises partly from a largely correct attention to the ways in which consumers mediate material and cultural commodities in the process of bringing them into their life-world. However, this populism has a more problematic basis as well: namely a refusal, common to both postmodernism and neo-liberalism, to pronounce value judgements upon the choices of consumers, upon their needs or wants – *de gustibus non est disputandum*. In effect, needs and wants as experienced by people are unchallengeable: they may be described or explained or understood, but they cannot be subjected to any external critical yardsticks in relation to which they can be found false, or wrong, or irrational or regressive. Ironically they can be determined or produced, but they cannot be 'untrue'. More specifically, and in a way which closely recapitulates key premises of liberalism, postmodernism accepts that needs and wants

51

cannot be rationally debated – there are no good or bad reasons for advocating or pursuing particular needs. Needs are reduced to preferences, and are therefore effectively arbitrary. The contrast here is with critical theorists who claim to assess actual preferences against a baseline of supposedly real and objective needs, those which can be rationally reconstructed in relation to a vision of a properly human life, and who can use these to critique wants as they are structured by contemporary social relations.

In this respect, postmodern thinking on consumer culture has closely mirrored both liberalism and the logic of the consumer society it seeks to analyse. Liberalism reserves the idea of rationality purely for the way in which social actors pursue 'self-interest', that is needs and wants which are themselves inaccessible to rational scrutiny. The formal rationality of market behaviour is built on the total non-rationality of the desires which motivate it. The liberal concept of 'preferences' – unlike most definitions of 'needs' – points to purely empirical data: we can observe and count them, as in market research, but that is about all. Indeed, for liberalism, the formal rationality of economic and political life breaks down if substantive rationality enters the equation. It is and must be irrelevant to market rationality whether we 'prefer' opera or opium, and it is fundamental to 'consumer sovereignty' that *no one* has the moral or social authority to tell us which one we *need*. We might term this approach to needs, 'economic amoralism' (for a fuller discussion of this, and other aspects of this section, see Slater 1997). Any non-evaluative approach to consumer culture is therefore wonderfully in tune with a market society.

On the other hand, neither liberalism nor neo-liberalism was ever really value neutral – they have consistently recognised values which stand above the empirically expressed preferences of individuals and which subordinate them to a higher rationality. First, the market – and to a lesser extent democracy – is so highly prized precisely because it is seen as a mechanism which automatically secures the *substantive* values of liberty, progress and justice. Second, as in the Weberian analysis, formally rational 'means' such as efficiency and calculability have become substantive ends as modernity has developed into technocracy. Third, early liberalism expected the market to realise the rationality inherent in all men (*sic*) by allowing them to define and pursue their interests in freedom from the irrationality of tradition, arbitrary authority and superstition. The optimism of Enlightenment thought fully expected this freedom to produce an agreement on common truths. Hence, individual preferences – emancipated into truth – would take the form of 'real needs'. This is what allowed Adam Smith to preface the formal rationality of *The Wealth of Nations* (1776) with the substantive value optimism of the *Theory of Moral Sentiments* (1759). It was only as the morally corrosive effects of market relations became apparent during the nineteenth century that economic

liberalism and social conservatism forged their unholy and unstable alliance. Reagan and Thatcher represented a late version of this attempt to hold together a neo-liberalism which abjured all value judgements (bar the formally rational values of the enterprising individual) with a neo-conservatism which supplied values conducive to social solidarity – values of family and nation largely. This fell apart again, dramatically, under Bush and Major.

Postmodernism has fallen into a similar conundrum. The relation between liberalism and social conservatism is mirrored in the relation between postmodernism and a range of residual left-wing, socialist, progressive values: in each case the pairs are logically incompatible but recognise common interests. On the one hand, postmodernism like neo-liberalism is a populism which refuses all value standards as elitist or totalitarian and which disallows the imposition of objective agendas of needs onto individuals, whose preferences are treated as incontestable. And yet, like liberalism, contemporary accounts of consumer culture do not appear particularly non-evaluative. If one takes figures such as John Fiske, the project is distinctly a *re*valuation of consumer culture, not a refusal of normativity. They are looking for and at only that consumption which can somehow be interpreted as progressive because it is indeed active, and shows the consumer as productive, creative, autonomous, rebellious and so on. Hence the unedifying spectacle of middle-aged male cultural studies lecturers wandering through the contemporary marketplace to find out just what makes Madonna so empowering, so pleasurable to young teenage girls. A similar problem arises in the use by Foucauldians, amongst others, of terms such as 'freedom' and 'resistance' in clearly normative senses while refusing to engage in a reasoned debate over what – if anything – grounds their value-commitments, or to put forward values in relation to which 'empowerment' might be a good thing.

The central issue is whether needs can be treated entirely as subjective preferences which are arbitrary with respect to rationally debatable values; or whether needs are things for which good reasons can be given and whose reasonableness can be translated into legitimately rather than merely empirically binding norms; or whether subjective preferences can be assessed from the point of view of needs which have a validity with respect to achieving visions of a good life – of 'how we should live' – and with respect to the socially available means for achieving such a life. This is the terrain of critical theory, which ultimately relied on a dichotomy between real and false needs, between grounded objective needs and arbitrary subjective wants, between desires proper to the individual and those which can be ascribed to forces outside them. Let's make no bones about this: the idea of real needs is essential to critique. It is only through the positing of real needs that we can put forward an independent standard or criterion in terms of which a social system can be judged and found

wanting. However, concepts of needs are claims as to what is essential to properly human life and therefore lead us down the dangerous path of deciding exactly what does constitute a proper human life – that is to say, statements about needs lead us directly to claims as to the nature of the good life and to statements of value. The burden of any critical theory – which to its credit it has generally taken up – is to provide plausible grounds for these value decisions.

The paradox of critique, however, is that it simultaneously opens up a political sphere in which the contemporary status quo is criticised on the basis of a substantive rationality, and at the same moment cuts down that politics at its root by putting forward ultimate foundations which claim to settle questions of human value. Moreover, it partakes of that disciplinary modernism of grand narratives which naturalises culture-specific values and needs – the politics of a particular place or people – through universal reason or human essence or scientific truth. In this particular context, critique closes down politics through the notion of real needs by criticising social arrangements in terms of their non-correspondence to a model of the real human being. In the case of Marxism, the 'real human being' was the non-alienated producer, realising 'man's species-being' through creative transformation of nature. Shoved down Eastern European throats in the form of the 'Stakhanovite worker', Marx's powerful critical vision was rather less appealing as a definition of 'real needs' or 'the good life'. Postmodernism and liberalism have both converged on the terroristic and totalitarian potential of *any* statement of needs which grounds meta-narratives in a transcendental truth of the human, in the name of which actual humans can be legitimately coerced into conforming to regimes of truth.

We seem then to be left in an incapacitating contradiction: either the reification of values in the form of objective needs, or the reduction of all values to irrational and arbitrary preferences. Adorno, who was in many ways the first postmodernist, summed the situation up with his adage: 'Universal history must be construed and denied' (cited in Rose 1978: 51). Transhistorical narratives of human development are logically essential to critical consciousness and practice, yet *belief* in their truth – and the social enforcement of their 'truth' through modern bureaucratic power – merely constructs a new prison-house of certainty, a dangerous space of truth that hovers above politics, immune to discursive interrogation or practical opposition.

II

The problem is that strategies of objective need and subjective preferences both foreclose political debate. A good formulation of the problem, and some good strategies for dealing with this impasse, can be based on

Kate Soper's (1981, 1990) extremely lucid and important work, on which I have drawn extensively for the following discussion. Anything worthy of the name politics must comprise, first, consideration of what constitutes the good life in society, how we should live, the values in terms of which social action and institutions are oriented. Second, it must comprise consideration of how social resources of material and power are to be organised in relation to those values, to achieving the good life. The concept of need is central to the way in which we carry on political discourses, because it is through this concept that we articulate visions of the good life in terms of individual motivation and action at the level of everyday life and that we can assess whether social resources are being distributed in accordance with such visions and values – whether our needs are being met. Put more simply, to say that 'one needs something' is to say that some social resources are necessary *in order to* produce or reproduce a form of life which embodies particular values. In stating a 'need', we are making a claim to a way of life. We can debate such statements of need both in terms of the rightness of the form of life they lay claim to and the extent to which resources are allocated to producing it. (See also Doyal and Gough (1991) for a review of definitions of need.)

From this perspective, debate about needs constitutes the very stuff of political life. As Soper (1981: 2) puts it, it is only through posing questions of need that we recognise our political nature at all. Political questions cannot be *solved* by appeal to human needs. On the contrary, questions are only properly political when they are posed in the form of a *question* about human needs. What this entails is a commitment to a political sphere in which all participants are able to articulate – through plural and competing statements of need – their various and differing senses of how social life should best be lived, and in which this discourse on needs has real practical consequences for the way social resources are given specific social form and distribution. That is to say, the fundamental criterion of social critique should not be the society's capacity for need-satisfaction *per se* (because definitions of need are part of the debate and cannot be assumed), but rather a society's realisation of its potential to maintain an open, reflexive, rational, democratic and consequential discourse on needs. Theories of objective and subjective needs alike work against this potential by treating as a presupposition of politics what should be its outcome: they both *start* with definitions of need which place needs beyond the sphere of rational discussion, beyond politics, either by grounding them in a human essence or by reducing them to irrational individual preference. This prevents from the start a political process in which people can collectively evolve and negotiate between their various, generally contradictory and conflicting, visions of the good life, visions which they can then interpret at the level of individual motivation and

everyday life in the form of needs. In short, a society or a consumer culture should be judged not by its ability to 'deliver the goods', but by the political, economic and personal democracy with which it debates and decides about just *what* is good.

The premise of this vision of the political realm, however, is one which is only gradually gaining acceptance. This is the idea that simply because values are undecidable in any final sense they are not therefore either arbitrary or merely empirical, they are neither matters of incontestable preference nor commitments decided solely by the *realpolitik* of power, force and strategic action. The ultimately 'ungrounded' nature of needs does not compromise a commitment to reason. First, we are capable of producing reasons for our needs (in the form of values orienting us towards a vision of how life should be lived). Second, we can (and often do) argue endlessly over needs and in the process give reasons to each other for counting particular needs or values as good or bad in terms of desired forms of life. This is – just as critical theory would have it – precisely how we are able to produce critiques of life as it is lived now, how we can escape the 'one-dimensional' world of complete personal identification with society. Third, in a move which further redeems the impulse to critique, we are able to carry out such arguments – which are or should be the stuff of politics – in relation to two interrelated kinds of 'learning process'. On the one hand, there is 'social knowledge': it is precisely through such arguments that we can further our knowledge of the social conditions under which particular needs are formed and met, largely by putting forward alternative visions of society in which other needs might obtain. Through this reflexive process, which is tied to social knowledge, we can both transform our own needs and perceive as transformable the conditions under which we form needs and satisfy them. On the other hand, arguments over needs – when carried out in the rational form of giving good reasons – can involve a hermeneutic learning process. Discourse involves challenging the validity of the assumptions (the values and the knowledges) underlying any statements of need, and being met with reasons which must be assessed. In so far as we enter into discourse, we must try to understand opposing value systems in ways which reflexively transform our own value systems, through the process Gadamer referred to as the 'fusion of horizons' (cited in Bernstein 1985).

These points are obviously not meant to argue that in the current real world we generally deal with our needs by democratically reasoning about them together. Rather, they are meant to argue – in accordance with the style and much of the content of Habermas' work – that there is a real, socially grounded possibility of such communicative rationality, and that we can detect actual social processes and events which already demonstrate it and whose potential can be developed.

III

The idea of 'needs' as opposed to 'preferences', the idea of *real* needs', is both true and false, necessary and impossible. In other words, the concept has to be redefined: 'real needs' are not statements spoken by authorities – scientific, religious, ideological – who claim to stand outside the political sphere, outside and above the interests of particular real people, and who claim to legitimately limit politics and define people's interests because they know the 'truth' about their selves, their bodies, their natures – their 'needs'. 'Real needs' are rather the way in which particular real people and communities formulate their values, identities, commitments in terms of what they 'need' in order to live a kind of life they deem good. 'Needs' are not absolutes, then. But neither are they mere individual whims and preferences: they are very serious political statements which are not made on the wing in a shopping mall or in a mad consumerist moment of impulse buying, but rather arise from core values of historically and collectively evolving ways of life, are tied to consequential issues about how social resources are allocated between different social groups and to debates between social groups about values, priorities and power.

We can approach this definition of need by looking at another argument that often surfaces with considerable political and emotive force. Crudely, the argument is that a 'culturalist' notion of 'needs' can only arise in a rather privileged community – like the consumerist West – where certain 'basic needs' have already been taken care of, which has already achieved (at everyone else's expense) that measure of wealth which actually allows people to worry about 'ways of life' rather than 'staying alive'. Such notions of need are positively obscene when much of the world is starving, dying of diseases which minimal nutrition and clean water would prevent, deprived of life and basic security by war and violence. Set against the basic needs which must be satisfied in order to live at all, defining need in terms of culturally specific 'ways of life' is insulting and inhumane. In a related but far more complex argument, Doyal and Gough (1991), and figures like Amartya Sen, claim that we need an objective definition of those basic needs which have to be met *in order for* individuals to be able to participate in a cultural 'way of life', and – beyond that – to participate in democratically changing and directing their way of life. You *need* to be alive, healthy and possessed of sound mind in the first place in order to be part of any culture.

The problem with these arguments is twofold. First, even if we agreed that, in the abstract, mental and physical health are 'basic needs', universal preconditions of being members of *any* human community, we still know that in practice we can only identify and define such needs by the form they take in *particular* human communities: indeed, the kind of health

required for participation is defined *by* communities, not outside them. For example, we need only look at debates about 'disability' to know that the threshold of health required to be a full member of the community is set by particular societies: a bit more wheelchair access, some changed attitudes, and there is more participation, not by filling a need (giving everyone a 'normal' body) but by refusing to make social participation contingent on having a 'normal' body.

There is a second problem though: when we talk about the 'basic needs' that must be met as a precondition of culture, we also tend to talk as if culture were secondary, superficial or superfluous, a kind of luxury about which the wealthy West should be embarrassed in the face of the impoverished rest. Yet we do not treat culture as a luxury when talking about *our own* lives: our minimum expectation is not simply a right to live, but the right to a *meaningful life* – one we can understand in terms of values, identities, social relations and so on, and one which should conform ever closer to the values we evolve. Our consumption is a process of cultural reproduction, not of keeping a physical body alive.

To define 'basic needs' as preconditions of culture is to treat people's right to a meaningful life, as opposed to mere living, as secondary. It is generally also to treat other people as mere bodies to keep alive rather than fellow humans who, like us, are 'selves'. It is the mentality of aid and charity rather than a politics of need. It gives quantities of nutrients to keep bodies alive rather than the full material means required to reproduce a culture. Moreover, as we know from examples like the 'Green Revolution', if we address 'basic needs' technically and 'neutrally' rather than culturally, then the process of meeting needs tends not to be a precondition of culture but a means of destroying it or subordinating it to Western technocracy.

Ultimately, it is rare, perhaps impossible, for people to be entirely reduced to pre-cultural 'basic needs', to a point of starvation, for example, where any food will do because the cultural person has been reduced to a pure body. It is only at the most horrific extremes of inhumanity – economic catastrophe, war – when social and cultural life has broken down, when – as we say in these circumstances – 'people have been reduced to animals', that 'basic needs' might emerge. Even then, it is brutally but often heroically obvious how catastrophic things must be before 'trivial' and 'superfluous' culture entirely gives way to 'basic need': people even starve to death in their own culturally specific ways (for example, refusing culturally prohibited or even distasteful foods, sacrificing themselves because they put social solidarity above physical survival). Indeed, this is what we call human dignity. And even if the breaking point comes and 'basic need' emerges, this is no basis for defining human need, for what we observe in these conditions is not the 'truth' of need but the extremes of social failure. The *minimum* political demand,

it would seem, is not the satisfaction of basic needs but rather a society materially and politically capable of sustaining a particular and meaningful cultural life.

IV

Needs, then, can only be understood in relation to concepts of culture: we 'need' things in order to live a certain kind of life. But there are problems here, too, for if the idea of culture is not related to a commitment to rational discourses about needs and wants, it too can pose political dangers which are very similar to those posed by objective and subjective need theories. Cultural theories of need also have a dangerous capacity for stifling political discourse by removing questions of need from the realm of reason into the realm of either the arbitrary or the absolute.

The largely correct supposition of most cultural approaches is that needs cannot be specified at the level of the individual or the universal at all, but only in terms of the intersubjective meanings and institutionalised norms of groups – the meaningful patterning of social life within which alone needs can be defined and made sense of. It is pointless to put forward lists of 'basic' or 'essential' needs – for example, food, clothing and shelter – because they can only be identified, let alone empirically exist, in the specific socio-cultural forms they take. On the other hand, it is pointless to focus on individual preferences, because these may only be formulated within the collective forms of life in which individuals can have identities and are able to access the symbolic and material resources through which they can formulate their needs. That is to say, if needs are always meaningful then they are always cultural; and if they are cultural then they can never be understood in terms of the isolated individual.

Sociologically, these points are uncontentious: needs cannot be defined independently of culture. Conversely, the reproduction of culture requires the meeting of particular needs in particular ways. It requires culturally specific consumption resources. The question of need then resolves into a question of cultural reproduction – needs and values are entirely immanent or internal to specific cultural forms. These sociological truisms can form the basis of several distinct kinds of politics. The most obvious are liberal-pluralism, which turns to slogans such as self-determination, liberty and sovereignty, and postmodernism, which turns to notions such as 'respect for difference'. Both are recognitions that, in so far as values are internal to cultures, cultures must be free to apply their own values and free from judgement by or imposition of the values of others. In other words, the cultural immanence of needs entails a recognition of the cultural relativism of values. In the case of postmodernism – which is considerably more radical than liberalism – it must also involve a rejection of any values (such as liberty, self-determination, sovereignty) which

mediate *between* cultural systems. That is to say, postmodernism tends towards a complete relativism, a very different kind of beast from the liberal's pluralism. It is this relativism which makes the postmodern use of terms such as 'respect for difference' appear inconsistent, a borrowing from Enlightenment traditions whose underpinnings have been rejected.

Of the many problems and incoherences within relativism, the one that concerns me – politically – is that cultural relativism is internally wedded to cultural absolutism. In so far as we argue that cultures can only be judged by their own values, we treat them as internally cohesive and undivided, as hermetically sealed and as not open to the rational political debate advocated above. We also embrace a notion of 'culture' which (as Raymond Williams long ago argued) emerges from Western traditions which are profoundly conservative, often reactionary, generally romantic. The concept of culture arose from eighteenth-century opponents of rationalism, market choice and individualism, the cash nexus and political pluralism. Figures like Bolingbroke at the beginning of that century and Burke at its end were fighting the disintegrative effects of rationality claims and money transactions on the *ancien régime* by locating the truth and legitimacy of the old society purely in its organic historicity – its immanent evolution of durable values over time and through 'community'. The old order was good not because its values could be backed up by good arguments but because they had been elaborated through the organic process of 'culture'. From Rousseau onwards, this strain of thought melded with romantic notions of ethnicity, nation and race into far scarier versions of cultural absolutism which were again implacably opposed to the pluralism and rationalism of modernity. Thus the Nazi equation of culture with race shows the terroristic potential of *ir*rationalism in the realm of culture. Paul Gilroy's (1987) analysis of the move from scientific racism to the notion of irreconcilable ethnic difference – an essentialist notion of culture – similarly shows the compatibility of cultural relativism with cultural absolutism. Finally, the recent vogue for 'communitarianism' in America and Britain often finds centrist social democrats and *very* far right social conservatives agreeing that what modern society lacks are cohesive communities whose solidarity arises from bed-rock cultural values (usually familial ones).

This conservative or reactionary tradition of culture is crucially based on denying the rational potentials involved in relations *between* cultures, and between subcultures within a larger society: it is based on denying the possibility of reasoned discussion between alternative value systems, visions of the good life and hence different 'real needs'. The counterargument here parallels the general argument about the potential for rational discourse on needs. First, far from values being unchallengeable and internal to a particular culture, cultural members constantly do, and certainly *can*, give challengeable reasons both to each other and to

members of other cultures for holding particular values and for believing their way of life to conform to those values. Second, cultures are never internally coherent or undivided, never themselves based on value consensus; and cultures are never hermetically sealed from other cultures. These facts are increasingly evident in modern conditions where we may simultaneously inhabit different value spheres such that dialogue between cultural values is simply an inescapable fact of life. We live – as a matter of social necessity – in a *pluralistic* world, not a relativist one, a world in which dialogue is inescapable, where the only 'choice' is whether it takes the form of violent conflict between absolutist cultures or democratic communication between open ones. Third, cultural absolutism and relativism are both founded on the untenable idea of incommensurability between meaning systems – the argument that value relativism is underpinned by the incapacity for communication between cultures and therefore the impossibility of agreement which renders each culture sovereign within its own borders. The idea that different cultures live in different worlds needs to be contested not by universal standards of rationality or universal 'real needs' (which reduces their 'apparent' diversity to 'real' uniformity) but rather by the very real process of hermeneutic understanding which can ground communication, the sense that all communication involves the gradual mutual *rapprochement* of different conceptual universes. Fourth, cultures and their values change, and partly through hermeneutic processes. Cultural identities are no more essentialist identities than they are mere arbitrary preferences, but can represent products or by-products of processes amenable to reason.

V

The argument in this article has been intended as a kind of clearing of the ground, an attempt to argue that critique – specifically a critique of consumer culture – is still possible and still necessary. I have been looking for principled grounds upon which one can *judge* consumer culture. Consumer culture is a historically particular arrangement for producing and mediating needs, one that arose on the basis of modern commercial and industrial capitalism and various modern ideologies concerning individual choice, domestic privacy and private property. How does it measure up as a way of doing things, as a way of defining, mediating and producing for needs? This begs a prior question, the one we have been dealing with throughout this article: what should it measure up *to*? My own answer, which comes largely out of Habermas, by way of Kate Soper's work, is that consumer culture – like any other social arrangement, past or future – should be judged by its ability to 'meet needs', but that because 'needs' are themselves defined by people within particular social arrangements we have to go further back in our critique. We need to think about how

free people are, under various arrangements, to define their needs, how empowered they are to get them satisfied, how democratically, openly and peacefully they are able to negotiate with others in a world of competing 'needs' – competing notions of 'how life should be lived', different priorities about who should have what and how much. To put this in utterly Habermasian jargon: a critical theory of consumer culture should be committed to developing socially available potentials for communicative rationality; these can be identified in terms of expanding the scope for a politics of need consisting of undistorted discourse and unforced agreement, concerning desired forms of life, the needs they give rise to and the social resources necessary to achieve them. The aim towards which those potentials point us is not cultural uniformity or unanimity over needs but a more democratic sphere of difference.

The next step is to apply this critical standard. Probably the most urgent issue in a critique of consumer culture is also the most obvious: consumer culture is essentially the culture of a market society, one in which needs are mediated by the exchange of commodities. A critical theory should be able to assess the compatibility of a market system with the kind of politics of need I have outlined. That is to say, what potentials and what barriers does market society manifest in relation to the furtherance of communicative rationality, to rational and democratic discourse about forms of life, values and needs? I can only suggest a few examples of the kinds of points I would want to make on the basis of such an analysis. First, the reduction of need to unreasoned preferences, to 'choice', is the social accomplishment of market relations: in a process we have seen intensified over the past neo-liberal decades, the sphere of politics has been eroded by a pluralism consisting of mere competition between alternative value systems, mediated by the impersonal steering mechanism of money, rather than by democratic and rational engagement between peoples' ideas of how life could be lived. This is an extension of what Habermas would call the colonisation of the life-world. Second, I would want to return to an expanded version of classical themes in the critique of market systems: markets pose enormous barriers to undistorted and equal social communication. They do this through the structurally unequal distribution of symbolic and material resources; through a structural split between self-interested actions and their social consequences such that it is difficult to hold individuals and institutions responsible and accountable for the social costs of their choices; and through a division of labour which allows the vast majority of the population no consequential role in determining the direction of social production. Third, returning to the most classic theme of all, market systems which are structurally oriented to profit necessarily mediate needs according to an instrumental and formal logic: as Marx put it, people's needs become a means to the end of profit rather than ends in themselves.

On the other hand, as a true critical theory of consumer culture, we would also have to look for potentials for expanded rationality which have been developed within the body of the beast. This might well return us to the populist themes of postmodernism and the concern to identify active, creative and rebellious consumption in everyday life under capitalism. However, this exploration of potentials would be carried on within an explicit critical commitment which could identify and assess them in relation to the expansion of a properly political sphere. As Benjamin intimated, the commodity dreams we dream as consumers contain utopian moments, but only if we know what they mean when we are awake.

By way of conclusion, the questions of 'what do we need?' and of 'does consumer culture meet our needs?' are inextricably tied to the question of 'how we should live'. These questions cannot be put aside, nor can they be resolved and therefore superseded. Our inability to ditch such questions is also our inability to eradicate politics, for these questions are the stuff of politics and seem necessarily to make us political animals. All that can – and does – happen is for such questions to be suppressed by removing them from rational debate, a suppression operated by power, by ideology, by unconducive structures and institutions. On this basis, the critique of consumer culture involves considering the extent to which the market mediation of needs by commodities promotes or suppresses a political sphere in which we can discursively debate visions of the good life and the needs which derive from our attempts to live that life; and in which we can identify the structural constraints which prevent us from articulating those visions and obtaining the social resources necessary for achieving them. The populist turn in contemporary theory is certainly correct in arguing that in a consumer culture we must look for politics and for political potentials in new and original places, people and practices. However, without some overarching framework in which we can identify both potentials and barriers to political life it is hard to see how much further this populism can go.

REFERENCES

Bernstein, R.J. (1983) *Beyond Objectivism and Relativism: Science, Hermeneutics and Praxis*, Oxford: Basil Blackwell.
Doyal, L. and Gough, I. (1991) *A Theory of Human Needs*, London: Macmillan.
Featherstone, M. (1991) *Consumer Culture and Postmodernism*, London: Sage.
Gilroy, P. (1987) *There Ain't no Black in the Union Jack*, London: Hutchinson.
Rose, G. (1978) *The Melancholy Science: An Introduction to the Thought of Theodor W. Adorno*, London: Macmillan.
Slater, D.R. (1997) *Consumer Culture and Modernity*, Cambridge: Polity Press.
Soper, K. (1981) *On Human Needs: Open and Closed Theories in a Marxist Perspective*, Sussex: Harvester Press.
Soper, K. (1990) *Troubled Pleasures: Writings on Politics, Gender and Hedonism*, London: Verso.

4

THE BENETTON-TOSCANI EFFECT

Testing the limits of conventional advertising

Pasi Falk

I want to discuss in the following pages whether there has been a significant change in the conventional code of advertising. In order to address this issue it needs first to be contextualised within the broader history of modern advertising over the last hundred years. This will be done only in outline (for a more detailed account see Falk 1994, Chapter 6) in order to give a sense of what I mean by the conventionality of modern advertising and how the code defining its boundaries has evolved during this century up to the emergence of what I call 'the Benetton-Toscani effect' in the late 1980s. This is the moment when Luciano Benetton and his art director Oliviero Toscani made their first transgressive moves in the field of advertising.

Toscani joined the Benetton company in 1984 and the following year Benetton launched an advertising campaign with a new line of representations linked to the slogan 'United Colors of Benetton'. The first of these were not particularly transgressive in their *mode* of representation, though they did nonetheless extend the normal aesthetics of adverts to include more spectacular imagery. The symptoms of transgression were to be found mainly in the *themes* of these representations, which ranged from differently coloured people – to be united by Benetton according to its 'ecumenical' mission (Shapiro 1994) – to iconoclastic though iconic comments on religious institutions (Jesus Jeans) etc. In this way Benetton adverts began to deal with the 'real world' and with problems which concerned people and made people concerned. The adverts contributed towards blurring the distinction between the 'politics of representation' and the 'representation of politics' (Giroux 1994: 7) or, in other words, towards breaking the (for most part unwritten) rules of modern advertising by bringing in the 'reality' of politics.

However, although the distinctiveness of Benetton adverts, as part of mass media publicity, was already taken note of in the late 1980s, the

actual breakthrough – and the breaking of rules – took place in 1991 with the launching of a series of catastrophe adverts recycling photographic material which the big media audience was more used to encountering in the reportages of TV news and newspapers: Albanian refugees on an over-crowded ship on the Italian coast, a burning car on a street, a man shot down on some other street, the death of an AIDS victim, and so forth. The topic of AIDS acted as a kind of bridge from the apocalyptic imagery of 'planetary danger' (Shapiro 1994), through the birth/life/death inter-lude (newborn baby/newly deceased man) to the more focused anti-AIDS and safe-sex campaign launched in 1992 which still continues, though now less prominently.

Before embarking on a more detailed analysis of the Benetton-Toscani effect I will make the promised detour into the history of modern adver-tising in order to trace the contours of this transgressive turn and to evaluate the nature of the transgressivity.

A BRIEF HISTORY OF MODERN ADVERTISING

The simplest way to define modern advertising – the beginnings of which took place in the second half of the nineteenth century – is to say that it is an *active* strategy of selling and marketing. This allows us to draw a line between the pre- and early modern announcements informing poten-tial clients and customers of the existence and availability of a certain product. The active character of the strategy implies an intentionality which is about more than selling goods: the idea is first and foremost to stimulate demand and thereby to sell as much as possible.

The preconditions of the birth of modern advertising as an active marketing strategy can be summarised by the prefix 'mass' as a common denominator: mass production, mass markets for consumer goods and mass media. Mass production expanded markets beyond local boundaries into the national and international sphere, and as a consequence replaced the identity of products as the personal extensions of small-scale producers and local shopkeepers with anonymous mass-produced goods which, for this very reason, had to be given a name and a voice of their own.

Naming is the first step in the construction of an identity which, on the one hand, distinguishes a product from other more or less identical competing products and, on the other, enables the commodity to intro-duce itself in the imaginary face-to-face encounter with the consumer. This is made possible by the dualistic sender/receiver logic of mass communi-cation: the message is sent out equally to the whole body of recipients, but is received individually by each of them.[1] So, messages are received by *individual* consumers who make choices (to buy or not to buy, to buy this or that) even though they are sent out to 'all of you', that is to say, to consumers as an *aggregate entity* standing for (potential) demand

on the consumer goods market.[2] This is also the dualistic basis of the consumer category which distinguishes it from the customer or client categories: the latter presupposes an actual one-to-one relationship with the other party and not merely an imaginary one. The consumer – both as an individual agent and as part of the 'mass' – is merely a potential client (or buyer) and the realisation of this potentiality in a transaction constitutes a relationship which is distinct from the imaginary one-to-one encounter with the speaking commodity.

The consumer/customer distinction should be understood primarily in a historical sense, as a means of distinguishing 'customers' of local shops, before the emergence of the consumer society, from 'consumers' under conditions of mass consumption. However, the conceptual distinction is valid even in contemporary 'promotional culture' (Wernick 1991) in which there is a tendency to expand the application of marketing strategies beyond the realm of economic exchange. This also involves symptoms of (escalating) commodification (Wernick argues) in, for example, the promotional strategies of universities as part of their competition for funds and students. Nevertheless, promotional culture cannot be reduced merely to an effect of commodification and thus to the mode of production. It is essentially based on the parallel 'mode of information' (Poster 1990) which creates a need for public-image building, not only for commercial institutions but for all socially significant bodies with public mass-mediated visibility.

Public-image building primarily addresses public opinion – the big audience – through the mass media, and looks for a more diffuse positive response than does commodity advertising. As a rule, the promotional strategies of public institutions do not include an individualising dimension. The exception is political promotion (Wernick 1991) in which parties sell their product (party/candidate) to the voter/consumer. In this sense contemporary promotional culture has made it more difficult to see the difference between consumers and customers (or clients) – in so far as they are all located within the 'audience' framework.

The second step in the construction of product identity is when the commodity, after announcing its name, proceeds to speak for itself, in an appeal to the consumer's needs or desires. This involves telling the public about the positive characteristics of the product. In effect the commodity voice says: 'I am what you need and desire and what you are lacking'. All the rhetoric of advertising is built on this fundamental message whatever its line of argumentation. By the creation of promises, assurances, allusions and associations, the commodity voice announces the good things it will bring and warns of the bad things that will happen if it is rejected.

Naming the product and offering it a voice with which to speak to the consumer is the process by which the product is transformed into a *representation* – and this is what modern advertising is basically about. In a paradoxical way the representation is both something added to the product

(the voice and what it says, verbally or by iconic means) and its replacement. The imaginary one-to-one communicative relationship is established between the consumer and the product *qua* representation, thus rendering to the relationship an additional imaginary dimension. Nevertheless, consuming merely the representation is not enough – the commodity marriage is not consummated until the act of exchange or intercourse has taken place. This is why the end effect of the representation (advert) should be positive, that is, the consumption of the representation should be followed by the consummation of the commodity marriage (purchase). In this sense the representation necessarily re-presents or is a representative of the product, otherwise it would not be an advert for the named product.[3]

However, the advert's pursuit of a positive end effect does not imply that the representation must operate only in a positive register. Negative elements can be incorporated into the representation in ways which are consistent with the ultimate aim, which is to emphasise the positive value of the product and ensure purchase. This is presumably the advertisers' view of the use of the negative register.

The negative dimension was already in use in nineteenth-century adverts for patent medicines – to be regarded as forerunners of modern advertising (Falk 1994) – in which the ailments the medicines promised to cure were listed, described or metaphorically depicted. The stress on the negative in this particular case was obviously linked to the specific product category and the negative condition of illness, but this is not a sufficient explanation. The argumentation and representation in late nineteenth-century patent medicine advertising demonstrates an increasing shift towards the positive register, towards identifying the good things of life the advertised product will bring to its users and alluding to 'a better tomorrow' (a slogan used in a Hadacol advert, Falk 1994).

Another use of the negative register – already widespread in the early twentieth century (Pope 1983) – was to promote a product by labelling the competitor's product in negative terms: 'their product (B) is no good compared to ours (A) which is good', or, in a less pejorative way: 'our product (A) is better than theirs (B)'.[4] However, this strategy of negative naming involved, from the marketing point of view, a problem which was already of concern in the early days of modern advertising: even the negative naming of a competitor's product could help to make it known and remembered. If the name of the product survived its negative characterisation in the minds of consumers – as some results in marketing research seemed to suggest – the advert for product (A) would in due course also promote the sales of the competing product (B). Perhaps for this reason, such use of the negative register has been marginalised as a tool of marketing strategy in modern advertising.[5] Today this strategy is more likely to be found in the realm of politics than in the world of goods.[6]

A third way of using the negative register – widely applied in the 1920s and 1930s, especially in the USA (Leiss et al. 1986) – is the stigmatising advert which is close to the first type described above. Here the aim is both to locate the positive/negative distinction in an individualised setting and link the positive to the transforming power of the product. However, while the first one focuses on the product's efficiency in transforming bad to good (the classic before-and-after scenario) and later shifts the emphasis from the bad-to-be-expelled to the good-to-be-gained, the representation of the stigmatising advert focuses on the social scene of the product's use and especially on the negative consequences of its *non-use* from which it claims the potential consumer is bound to suffer: bad breath ruins a man's career, a dirty kitchen ruins a housewife's reputation. So verbally and iconically the representation builds on the *absence* of a product. This is the reason for its strong anxiety-evoking negativity.

The stigmatising advert representing the non-use of a product was a conscious strategy of the marketing professionals and was probably first devised by Roy Johnson in 1911: 'we suggest the comfort or profit which results from the use of the product, or the dissatisfaction, embarrassment, or loss which follows from its absence' (*Printers Ink* 75; cited in Lears 1984: 382). However, this kind of negative representation is little used in advertising today, though the strategy is still sometimes employed in campaigns against drug abuse and AIDS. It seems the only way stigmatising themes of this kind can be allowed to enter the positivised world of advertising is by turning them into a parody of old-style advertising – which can also be interpreted as a sign of the heightened self-reflexivity of the contemporary advertising apparatus.

This basic pattern has remained unchanged throughout the history of modern advertising, though there have been some changes in the modes and methods of creating representations of what counts as 'good'. These can be roughly categorised as follows:

1 There has been a shift from product-centred argumentation and representation to the thematisation of the product–user relationship and the depiction of scenes of consumption which emphasise its *experiential* aspect.
2 There has also been a shift from an emphatically rational mode of argumentation supported by essentially falsifiable 'evidence' of product utility towards representations of the satisfaction that comes with using the product – again emphasising the experiential aspect of consumption.
3 Communication has changed from the verbal and literary to the audio-visual as a consequence of developments in communication technology: pictures were introduced to print advertising in the 1880s, photographs in the 1890s, while the twentieth century offered the new powerful media of cinema, radio and TV.

These trends in development lead towards a form of representation which is increasingly independent in relation to its point of reference – the product – and which increasingly operates in the positive register. In other words, the language and argumentation of advertising is moving towards depictions of the pure 'good', the truly positive experience. These interrelated shifts characterise not only the history of modern advertising but more generally the formation of the modern world of consumption, particularly in their emphasis on the experiential nature of consumption.

Modern advertising was born with one foot in the world of goods and the other in mass culture. The precondition for its birth was the expansion of the market for consumer goods as well as the formation of a specific mode of information, in which entertainment, and more generally, the spectacular was to assume an important role. At the beginning of the century the consumption of mass culture and consumer goods skyrocketed: included were films, magazines, department stores, and the advertising that links them all together. Mass culture transformed experiences into marketable products and advertising turned marketable products into representations, images and over time, into experiences once more. In other words, the consumption of experience and the experience of consumption have been interlinked from the very outset (Eckert 1978: 1–21; Lears 1984: 351; Mayne 1988: 69), and indeed it can be argued that the experiential aspect has become even more important over the last few decades.

However, an advert still has to sell the product. It has to produce the positive end effect of transforming the potential consumer into an actual consumer of the promoted item and has to ensure that the whole cycle, from representation to purchase and actual use, is repeated. In order to achieve this, conventional advertising still primarily uses the positive register of representation.

The dominance of the positive is aptly illustrated by comparing Coca-Cola and Aspirin ads. Since 1900 when it abandoned its patent medicine past, Coca-Cola has been associated with representations of pleasure and happiness, whereas Aspirin has continued to make use of the negative register, depicting the pain it promises to kill. However, recent Aspirin ads represent the joy the medicine brings in a style which could have been used for Coca-Cola (with smiling faces etc.).

But this is no longer the mode of much contemporary advertising. The latest Coca-Cola adverts have left behind the smiling faces on sunny beaches and adopted other genres of representation. They use visual effects to revive older trademark versions, structure graphic sequences in time with the latest jingle, 'Always Coca-Cola', and set up surreal scenes, not on sunny beaches, but at the North Pole where virtual polar bears watch the northern lights and drink Coke. Contemporary pain-killer ads may still allow negative elements (pain) to be represented provided that

they are subordinate to the positive experiential effect created by comic, spectacular dramatic and aesthetic means – thus, again, affirming the dominance of the positive register.

The aestheticisation and spectacularization of recent advertising widens the range of representation beyond the conventional (narrowly defined) positive register – while still keeping in mind the positive end effect – and thus makes space for the creation of something 'new'. After all, novelty is needed to make the advert more visible in the continuous flow of mass-mediated speech, text and images. Greater visibility should ensure that it leaves a positively charged memory trace with potential consumers which includes the brand (rather than the stigma) of the advertised product.

However, as has been noted above, the danger of losing the link between the representation and the product is a constant worry for the marketing people, and for a good reason: the pursuit of positive effects by spectacular and dramatic means is part of the autonomisation of adverts into entertaining experiential goods which are remembered (what a story/joke!) better than the products they are supposed to sell. And even if the brand is remembered – thus fulfilling the visibility function of advertising – it may still be consumed as a self-contained experience (Nava and Nava 1992) or product sponsored by the brand or company, just like any other sponsored spectacle (sports, music, etc.). Then again, contemporary marketing includes a whole range of parallel strategies from product advertising (using both product and experience-centred modes) to company image building which combine to make the company and products known and aim to make a positive impact on potential consumers.

THE BENETTON AFFAIR

So at this point we return to Benetton only to realise that what has been said above is not enough to solve the mystery of the representational strategies in the catastrophe adverts. It is true that the campaign has made the name Benetton very famous, but to interpret this as proof of a deliberate marketing strategy is not particularly convincing.[7] On the other hand, these catastrophe ads certainly take spectacular representation to the extreme. They are not softened into a consumable form through the use of comic or aesthetic filters. They operate primarily through non-sublimated shock effects (though not completely, as will be discussed below).

Thus we have to pose the question anew: what might be at stake in a shift from the positive to the negative register in which, say, a happy scene of a newlywed is replaced by a tragic picture of a newlydead AIDS victim and his family (Figure 4.1)? Or, more generally: how should we interpret the Benetton documentary genre of photographic posters and prints which is indistinguishable from the catastrophe imagery so characteristic of contemporary network news? As is by now well known, the AIDS picture

70

was originally printed in *Life* magazine, so there is not merely a recycling of documentary themes but also a reuse of actual pictures.

In order to pursue the argument further we have to establish a broader perspective which links together some of the points developed above. These are as follows:

1 The autonomisation of advert representation and the inclusion of the aesthetic and spectacular.
2 The structural characteristics of the contemporary mediascape in which the imagery of one genre is appropriated by another.
3 The contextualisation of commodity advertising in the larger frame of multiple marketing strategies which – especially in the case of Benetton – transgress the (narrowly defined) boundaries of the commercial realm.

The pursuit of more powerful effects in advertising is partly about the need to speak more loudly and clearly than competitors; however the battle for recognition actually takes place in the mediascape at large, in relationship to mass-mediated discourses and spectacles – including the documentary genre. So, the struggle is not only about persuading (potential) consumers to buy this or that advertised item but is also about being recognised within the much wider range of experiential media products which are there to be consumed (like films, music videos, radio programmes, etc.) of which adverts constitute only one category.

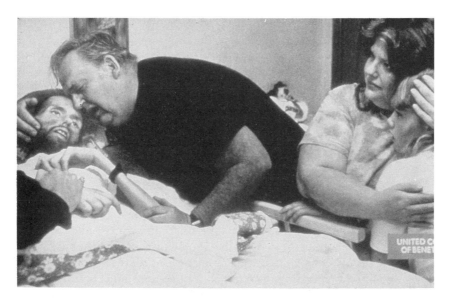

Figure 4.1 Benetton advertisement: dying AIDS victim, 1992.
Source: Benetton 1992

71

The autonomisation of advert representation and the struggle for the amplification of effect is therefore part of a wider struggle across the various categories within the mediascape for the attention of the audience. These include not only action movies (with their special effects) but also the documentary genre of news, in print form and particularly on TV. Over the last two decades there has been a clear move towards the spectacular in the documentary genre, exemplified especially by the being-there-when-it-all-really-happens reportages which take the spectator to the primal scene of the act(ion) in a way not unlike the evidential effects of hard-core pornography (Falk 1994: 213). In the former there is more violence than sex while in the latter it is (mostly) the other way around. Benetton's catastrophe ads recycle the former genre while also using the sexual dimension, though not in actual hard-core mode. Nevertheless, the evidential effect is the same whether its object is an explicit sexual act (to fuck is to fuck) or the death scene of an AIDS victim, captured – or better, shot – just three minutes after the act of death, which according to Toscani is 'the real thing' and affirms the simple truth that 'to die is to die' (Sischy 1992: 69).

The boundaries between different categories within the mediascape are increasingly permeable, facilitating the movement of themes, styles of representation and even actual images from one to the other. Catastrophe aesthetics already existed in the news before being transferred to the realm of advertising. Nevertheless, this does not explain Benetton's transgressive move away from conventional ad language. Although Oliviero Toscani's innovative advertising can be regarded as evidence of the autonomisation of advert representation – the separation of the advert from the product – it nevertheless still must include a reference to Benetton; it must include the slogan 'United Colors of Benetton'. Toscani may be very honest when he says, in line with the conventions of the other mass media professions, that 'nobody ever told me that my job is to sell anything, but just to communicate' (Sischy 1992: 69). However, he is only able to proceed with his autonomous venture as long as it conforms to the Benetton promotional system.

Thus we have to move to the third point presented above and take a closer look at the multiple promotional strategy of Benetton in which the name refers simultaneously to the person, the company (composed of both the production and retail networks) and the products. Here we are dealing with the circulation of the name which, however, is closely connected to the circulation of representations. In fact the very combination of these two circulatory systems adds up to a configuration in which the distinction between the 'politics of representation' and the 'representation of politics' – or the politics of aestheticisation and the aestheticisation of politics – tends to be dissolved.

The circulation of the name, in the present context, is not merely about the different routes the name may take, from the producer (person) to the product (e.g. from Henry J. Heinz to Heinz Ketchup) or from the product to the company (e.g. Coca-Cola Corporation). Certainly such a classical pattern of name circulation has not excluded the possibility of the named person appearing on the political scene. However, this scene would inevitably be understood as a *different* scene, no matter how closely intertwined the realms of economy and politics might be. The situation is quite different in the case of Benetton precisely because of the merging of the two circuits. The promotion of Benetton operates at all three levels at once – person, company and product. It disregards the boundaries between different realms of the mediascape yet is still part of a promotional strategy structured according to the specific character of these media circuits.

Benetton's multiple strategy is not structured according to the principle of market segmentation (in which products are represented differently to different consumer categories) but is based rather on the idea of *media* segmentation and on the ability to enter different domains of public discourse and representation. However, as a promotional strategy it cannot rely merely on the medium-is-the-message principle or simply pursue maximal visibility on behalf of the name. The task also requires a programme through which it can enter the other domains of public discourse on a scale which corresponds to its aim for global markets. And this is where Benetton's 'ecumenical fantasy' (Shapiro 1994) comes in – aiming at the 'union' of all (colours of) people and at a share of the global market for Benetton. The point here is that both these aims are pursued at the same time and without any contradiction. This is explicitly expressed in Benetton's advertising campaign literature from 1992:

> Among the various means available to achieve the brand recognition that every company must have, we at Benetton believe our strategy for communication to be *more effective for the company and more useful to society* than would be yet another series of ads showing pretty girls wearing pretty clothes.
>
> (cited in Giroux 1994: 14; emphasis added)

However, this is not the whole story. The fact is that Benetton marketing does also use pretty girls (and boys) wearing pretty Benetton clothes, but this more conventional advertising is presented in posters and catalogues (Figure 4.2) and is distributed mainly in Benetton retail outlets. Benetton's extensive retail network is actually an important precondition for the company's multiple promotional strategy with all its transgressive characteristics, because the (relative) independence of its outlets gives it greater freedom to run its political promotion without fear of retail boycotts (an increasingly common occurrence in the sector).[8]

Figure 4.2 Benetton advertisement: a more conventional image from a
Benetton catalogue, 1994.
Source: Benetton 1994

Benetton ecumenicism is marketed through other channels, those with
a wide media coverage and with an inclination to spill over to other realms
of public discourse and representation. However, ecumenicism is not in
itself an innovation as a marketing strategy. It was used by the Coca-Cola
Corporation in their early 1970s campaign in which hundreds of young
people of all colours, dressed in the national costume of thirty countries,
sang, 'in perfect harmony' and with a Coca-Cola in their hands: 'I'd like
to buy the world a home, and furnish it with love...' and so on until line
eight when the brand was named: 'I'd like to buy the world a Coke . . .'.[9]
Coca-Cola's ecumenicism – though youth-oriented (make love, not war)
– operated exclusively in a positive register: global peace and harmony were
to recognise and reconcile national, racial and ethnic difference; hope was
expressed for a better tomorrow for the whole of humanity. And in fact sim-
ilar kinds of positive aspirations characterised the first phase of Benetton's
ecumenical mission in the second half of the 1980s. The aesthetic style was
certainly different, involving a more spectacular and daring play of contrasts
and thus clearly articulating difference. Whereas the Coca-Cola harmony

advert reconciles difference by putting the uniting factor, the Coca-Cola bottle, in the hands of the representatives of the global community, Benetton limits its presence in its ads to the slogan 'United Colors of Benetton', thus allowing the photographic representation a much wider freedom of speech and so communicating not only with potential to-be-united consumers but also with others participating in public discourse.

Consumer response to the campaign was noted in sales figures; however, it could not be attributed to the advertising campaign alone. The larger impact of the secondary circulation of the ads in the media also has to be taken into account. The Benetton ads first entered public discourse in the second half of the 1980s, provoking discussion and criticism from various social-interest groups and institutions. Some black feminists were offended by a picture of a black woman breast-feeding a white baby, while the Catholic Church opposed (among others) the Jesus Jeans poster in which a female behind in blue jeans is accompanied by the text, 'the one

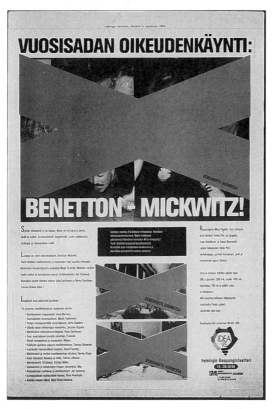

Figure 4.3 Advertisement promoting a conference of Finnish marketing professionals, 1994. The text reads 'The Trial of the Century: Benetton versus Mickwitz'.
Source: Helsingin Sanomat 4 September, 1994

who loves me will follow me'. From a conventional advertising point of view this would be regarded as bad publicity which could hardly be compensated for by the greater notoriety of the Benetton name. However, the public discursive sphere in which the Benetton name and representations circulate is more complex and heterogeneous. It is composed of comments both for and against the Benetton mode of promotion, and includes the responses of Benetton's own spokespeople as well, so the circulation of the name is maintained as 'communication' – and Benetton continues to promote its ecumenicism.

The catastrophe ad series introduced in the early 1990s takes the Benetton strategy one step further, and its effect is amplified by the secondary circulation. This is illustrated by the full-page (secondary) advert (Figure 4.3) promoting the annual conference of Finnish marketing professionals published in the leading Finnish newspaper (*Helsingin Sanomat*). The text translates: 'The Trial of the Century: Benetton versus Mickwitz'. This refers to the banning of two Benetton ads by the state office of consumer affairs (represented by Mickwitz). So, the Benetton ads reach their audience even when banned.

In fact this kind of secondary circulation has such a central role in Benetton's promotional strategy that it would perhaps be more accurate to call it primary. After all, the secondary circulation in this case encompasses not only the public debates about the acceptability of Benetton ads but also the themes they present – especially AIDS. Benetton was visibly present at the anti-AIDS action which took place in Paris in December 1993 and has continued the campaign in its own *Colors* magazine (no. 7), which is full of AIDS and safe-sex education presented in genuine Toscani style and brings together all the central elements of Benetton representations: 'Let's talk about fashion – let's talk about sex – let's talk about death – let's really talk about Aids', reads the cover text.

The secondary circulation also includes the exhibitions of Toscani's Benetton ads in art galleries around the world and even Senator Luciano Benetton's 'circulation' in the Italian Parliament to which he was elected recently. In fact the chapter you are now reading and all other analyses of the Benetton case are part of the same merry-go-round. (However, Benetton Formula One cars which circulate alongside other sponsored cars do not fall into this category even though they generate publicity.)

The stimulation of the secondary circulation of Benetton ads cannot be the only reason for introducing the catastrophe ad series. In fact the firm has pursued a multi-strategic principle and has continued to use the 'politics of difference' themes (Giroux 1994: 15–20) alongside and after the catastrophe series. A recent example of a 'politics of difference' ad was inspired by the changes in South Africa and depicts a relay baton being passed from a white hand to a black hand. However, even though

these representations articulate both the recognition and the reconcilia-
tion of difference (between different skin colour and socio-cultural
difference) the emphasis is clearly on the former, that is, on the equal
right to be different and recognised as such. Reconciliation is expressed
in gestures of friendship and love, but these representations lack a strong
argument for global unification despite being dressed in the united colours
of Benetton.

This is precisely the empty space the catastrophe ads are supposed
to fill – not in a Coca-Cola ecumenical manner dreaming of 'perfect
harmony', but in an inverted form which shifts the emphasis from shared
hope to shared fear. In spite of the inversion both versions have much in
common: both operate on a global scale, both grow from the imagery of
today's world and both are future-oriented. Coca-Cola preaches a gospel
of a better tomorrow while Benetton's 'world watch' wants to show how
bad today's world looks, implying a similar future-oriented vision along
with the meta-message: we care about the world, our world, your world
and about you and you and you – regardless of how different you are.
This is how things appear at the level of the meta-message of these ads.
However, the situation looks different when the message is related to the
media in which the ads circulate – including the secondary ones – and
when the mode of representation in the catastrophe ads is scrutinised
more closely.

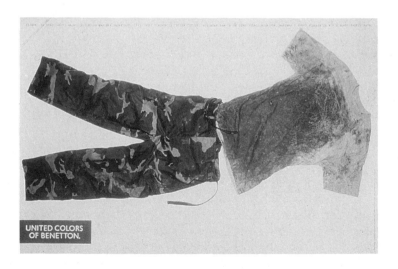

Figure 4.4 Benetton advertisement: the blood-stained clothes of a
Bosnian soldier, 1994.

Source: Benetton 1994

Notwithstanding Benetton's noble(?) aim of showing people 'the real thing', and waking them up with shocking pictures of today's reality, the circulation and reception of these representations is still based on the media spectacle/audience split which is characteristic of the consumption of media imagery and cultural goods in general. In this configuration the spectators facing the flow of representations still remain safe – they are not actually there; it is not happening to them. It is of course highly unlikely that you would come across the Benetton poster of the Bosnian soldier's blood-stained clothes (Figure 4.4) in the war zone itself, where the event might really have happened. In other words, the targeted audience is always elsewhere, at a sufficient cultural distance even if in (relative) geographical proximity.[10] Thus the evidential presence and realness is turned into just another – albeit more powerful – effect of representation, possibly evoking not only anxiety but also empathy and compassion: feeding with feelings – the staple food served in the movies.

It is therefore not surprising that these representations are served with a certain aesthetic touch absent from the original documentary genre that the catastrophe ads recycle. In newspapers such pictures are usually presented in black and white (though more recently in September 1995, in a new political aesthetic, *The Guardian* printed in colour on the front page a photograph of a young Bosnian woman who had hanged herself

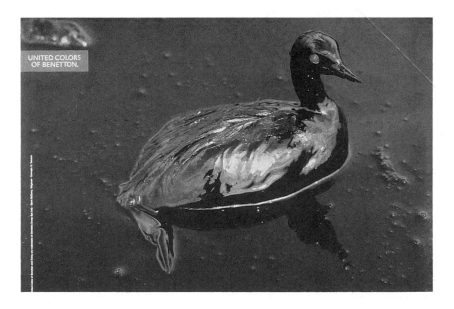

Figure 4.5 Benetton advertisement: oil-stained bird, 1992.
Source: Benetton 1992

in the woods outside her village home). TV news programmes routinely screen images in colour but they lack the aestheticisation of Benetton posters and prints. Benetton's catastrophic imagery – whether of blood-stained clothes, an oil-stained bird and environmental pollution (Figure 4.5), or a burning car depicting violence in the cities (Figure 4.6) – is constructed according to the rules of balanced composition with controlled colour grading and accurately framed close-ups.

My argument is not that these images evoke only pure aesthetic reflection; they certainly also evoke a variety of other emotions. However, the aesthetic and spectacular element remains an aspect of the effect which con-tributes to the reproduction of the basic split keeping the spectator-consumer safe. It also strengthens the regime of representation which goes far beyond the realm of advertising and moves towards a constellation reminiscent of Jean Baudrillard's extrapolated vision of 'hyperreality'(1983).

BACK TO BASICS?

In this wider perspective, Benetton's style of advertising can be interpreted as a symptom of a much more general tendency. However, a narrower focus on recent developments in advertising language provides good grounds for claiming that there is a 'Benetton-Toscani effect' in

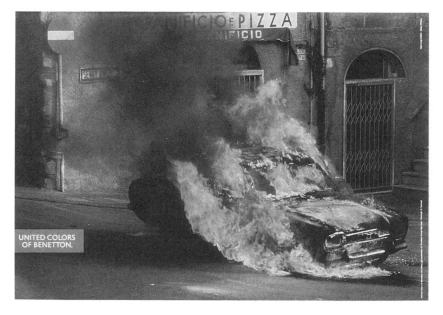

Figure 4.6 Benetton advertisement: burning car, 1992.
Source: Benetton 1992

contemporary advertising. The range of advert representation has become broader, incorporating additional levels of reflection, including self-irony, and new ways of utilising the negative register.

The recent Diesel campaign promoting casual wear to young people is an example of advertising which transgresses conventional codes in this way: the ads draw on counter-cultural images of drugs and violence etc. and present carnivalised scenes of middle-class adult life. Another example is the campaign for Death cigarettes which turns the obligatory warning printed on the package and ads into a name and a positive marketing argument, and backs this up with spectacular imagery (black box, death skull). The marketing of Death cigarettes certainly is new and transgressive. The novelty is not in the name but in the way it is linked to the product. People buy the perfume Poison because they know it is not really poisonous. But to buy and consume Death while being aware of the health risks of smoking is something else. Smoking a Death cigarette once may be a joke but to be a regular Death smoker is to register opposition to patronising health education and announce: 'I know what I'm doing and it's none of your business'. Thus we may conclude that the marketing for this product is highly targeted and focuses on a specific counter-cultural segment. In other words, the product is not even intended for the mass market, where it would have to compete with the established 'positive' brands. Although the target group of the Diesel advertising campaigns is

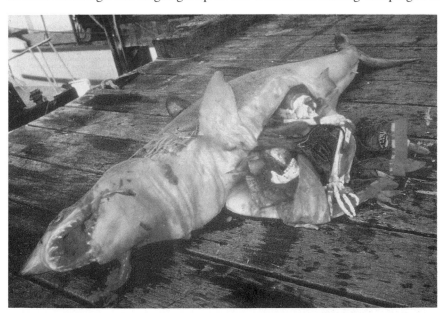

Figure 4.7 Kadu Clothing advertisement: cut-open shark with human skeleton, 1994.

Source: Time 4 July 1994

considerably larger than Death's, it is still quite narrow and, unlike Benetton, its strategy is not global.

So, are there any signs of the Benetton-Toscani effect in mass marketing? The only example I have found so far is an advertisement for Kadu Clothing (an Australian sports and leisure wear company – see Figure 4.7) which was published in *Time* magazine in July 1994, on its secondary circulation, as the Cannes prizewinning advertisement of the year. The elements of the representation are very much in line with the Benetton catastrophe ads: a real shark is cut open, there is real blood and a real (looking) human skeleton is emerging from the stomach – dressed, of course, in real brand-new looking Kadu clothes. Even though we may suspect that the scene has been set up and that it actually contains only one real death, that of the shark, the 'reality' effect is nevertheless there. But it is now subsumed into the conventional advert message: our products are good quality, they don't lose their colour, even in the gastric acids of a shark, and their double seams can endure its sharp teeth. So, the good old advert format has proved its ability to incorporate the transgressive elements of Benetton ads and use them for conventional purposes – provided the audience does not take seriously the meta-message that goods last and consumers don't. Or perhaps this is how the ultimate positive end effect is reached – the consumer lives for ever, not in but as Kadu clothes.

NOTES

1 The same individualising principle of mass communication is at work in the case of the TV-screen counterlook which addresses 'just you' and 'all of you' simultaneously. This applies also to the movie audience: the (rarely used) counterlook from the screen creates an illusion of eye-to-eye contact regardless of where you are sitting in the movie theatre.

2 Even though the 'market segmentation' strategy introduced in the mid 1950s (Pope 1983: 252) structures the aggregate consumer into certain subgroups (according to lifestyle typologies etc.) the basic dual configuration remains the same. Targeted marketing has not replaced the wide coverage (mass) marketing but rather supplements it.

3 Actually this basic rule of advertising has become problematic due to the recent tendency towards the autonomisation of advert language which tends to turn adverts into self-sufficient experiential products – TV-spots as mini-movies in the genre of music videos etc. – and thus to pieces of entertainment, or even art, sponsored by the brand name or company. In fact this is a frequently expressed worry of the clients of advertising agencies: the advert looks just fine but does it really make our product (name) visible and does it promote sales? The problem is linked to the broader structural change of the 'mode of information' (Poster 1990), which I deal with later in the context of the Benetton case.

4 This format is still in use today, mainly in a rational mode referring to objective comparisons and impartial tests understood to represent consumers' interests. On the other hand, one of the classic advert slogans, occasionally

used even today in the lower genre of advertising rhetorics, could be regarded as an indirect version of this line of argumentation: 'our product (A) is (simply) the best!', that is, better than all the rest, without mentioning any particular competing product. However, as an over-utilised argument it hardly has any credibility left and it is actually regarded as a tautological expression of the advert's will towards a positive end effect in general.

5 On the other hand, saying bad things about the other producer and product gives the advert a negative tone which does not promote a consumption-friendly atmosphere. It transmits a double message which urges consumers both to buy and not buy. After all, modern advertising has a historical mission to promote consumption in general, or, in the words of the American psychologist Ernest Dichter:

> In the promotion and advertising of many items, nothing is more important than to encourage this tendency to greater inner freedom and *to give moral permission* to enjoy life through the use of an item, whether it is good food, a speed boat, a radio set, or a sports jacket.
>
> (Dichter 1960: 189; emphasis added)

However, it is rather difficult to see how this obvious common interest of all producers and marketers can be articulated, formulated into rules and then turned into practice.

6 For a further discussion about this see Stephen Kline, this volume.

7 Nevertheless, this idea has some relevance in relation to Benetton's marketing principles. When I asked for permission to use Coca-Cola and Benetton ads in my latest book (Falk 1994) Coca-Cola was concerned that the name should not be associated with anything negative, and actually denied me permission to use the trademark, whereas Benetton was not in the least interested in the context in which the name would be used; their only concern was that it should appear, 'loud and clear'.

8 In fact in 1995 some of the German Benetton outlets were boycotted as a result of the ad campaign, and the franchise holders of the stores complained to Benetton because of their loss of income.

9 The advert and the song gained much positive attention and later a non-commercial version of the song (without the Coke line) was released as a record and quickly reached the top of the charts. The royalties were donated by Coca-Cola to the Institute of International Education and UNICEF. This was the aftermath of flower power and Coca-Cola soon returned to its more conventional smile-format.

10 Benetton's *Colors* magazine has a subtitle which reads, 'a magazine about the rest of the world'. Related to the present context this formulation invites a symptomatic reading.

REFERENCES

Baudrillard, Jean (1983) *Simulacra and Simulations*, New York: Semiotext(e).

Dichter, Ernest (1960) *The Strategy of Desire*, London: T.V. Boardman and Co.

Eckert, Charles (1978) 'The Carole Lombard in Macy's Window', *Quarterly Review of Film Studies* vol. 3 no. 1: 1–21.

Falk, Pasi (1994) *The Consuming Body*, London: Sage.

Giroux, Henry A. (1994) 'Consuming Social Change: The 'United Colors of Benetton'', *Critical Inquiry* no. 26: 5–32.

Lears, Jackson T.J. (1984) 'Some Versions of Fantasy. Toward a Cultural History of American Advertising, 1880–1930', in J. Salzman (ed.) *Prospects. The Annual of American Cultural Studies*, vol. 9, New York: Cambridge University Press.

Leiss, William, Kline Stephen, and Jhally, Sut (1986) *Social Communication in Advertising: Persons, Products and Images of Well-being*, Toronto: Methuen.

Mayne, Judith (1988) *Private Novels, Public Films*, Athens, Georgia: University of Georgia Press.

Nava, Mica and Nava, Orson (1992) 'Discriminating or Duped? Young People as Consumers of Advertising/Art', in M. Nava *Changing Cultures: Feminism, Youth and Consumerism*, London: Sage.

Pope, Daniel (1983) *The Making of Modern Advertising*, New York: Basic Books.

Poster, Mark (1990) 'Words without Things: The Mode of Information', *October* no. 53: 63–77.

Shapiro, Michael (1994) 'Images of Planetary Danger: Luciano Benetton's Ecumenical Fantasy', *Alternatives* 19 no. 4: 433–54.

Sischy, Ingrid (1992) 'Advertising Taboos: Talking to Luciano Benetton and Oliviero Toscani', *Interview* April.

Wernick, Andrew (1991) *Promotional Culture. Advertising, Ideology and Symbolic Expression*, London: Sage.

Part II

THE ADVERTISING INDUSTRY: TRANSITIONS, PROCESSES AND REFLEXIVITY

5

INVESTMENTS IN THE IMAGINARY CONSUMER
Conjectures regarding power, knowledge and advertising

Celia Lury and Alan Warde

INTRODUCTION: SOCIAL THEORY AND ADVERTISING

Many would accept that market research learned many of its analytic and diagnostic techniques from other social sciences. What is less widely recognised is the extent to which notions of consumer behaviour that have arisen in the marketing field have diffused into social theory. The self-reflexive consumer has become a central actor in sociological debate. Lifestyle has emerged as an important *mise-en-scène* for sociological interpretations of social life, and is a key motif in the accounts of social change advanced by sociologists such as Giddens, Bauman, Featherstone, Beck, et al. But at the same time, there is considerable disagreement, though often unrecognised, about what the terms lifestyle, consumer culture, reflexivity and the consumer mean. If we also take into account the different notions apparent in other social science disciplines, in economics and psychology especially (see Fine and Leopold 1993), then we might conclude that there is little useful consensus about how consumers behave and what would be appropriate ways to understand, or to predict, consumer behaviour. Yet social science has, in some instances, uncritically accepted the knowledge generated in the advertising and marketing industries, without recognising that parallel disagreements exist among commercial practitioners about how consumers behave, and how their behaviour should be analysed. In this context it seems important to consider the nature of the relationship between social scientific and advertising and marketing knowledges. An important question for us in this chapter is thus the nature of the rather complicated dialectic between commercial and academic knowledge about the consumer and consumer culture.

CELIA LURY AND ALAN WARDE

THE DIALECTIC OF COMMERCIAL AND ACADEMIC KNOWLEDGE: AN EXAMPLE

An article in *New Statesman and Society* (12 March 1993) reported the rapid expansion of a market research consultancy agency, Semiotic Solutions, that specialises in a research methodology explicitly derived from Barthes and Lévi-Strauss. Their prospectus lays out a set of procedures, called 'Myth Technology: Semiotics in the Marketplace', for investigating the cultural connotations of brands, products and product images. The agency handbook is a remarkable document: selling its services by hovering on the edges of an academic debate, it is, of course, an advert itself. It appeals to the myth of science and the science of myth:

> Within semiotics, myth has a precise meaning.
> Even more: there is a well-structured and now well-tried technology for *working* with myth:
> how to identify and define it properly
> how to evaluate and measure it
> how to dismantle it, update it
> ... *or even how to create an entirely new one*

The prospectus attributes a 'unique power' to culture (in the abstract), the power of 'a sleeping giant' which can be used to 'optimum marketing effect'. 'Cultural rules of social behaviour', not sociological, rational or psychological rules, are claimed as the motivation of consumption; culture is identified as the key driving force in all consumers, and is the foundation of our membership of 'cultural classes', 'symbolic communities' from which we derive 'our most powerful identity'.

This 'unique power' must be harnessed, but, since 'culture meanings are neither obvious nor transparent ... practitioners must use a methodology that can analyse the grammar of the signs and decode the symbolic languages of culture'. That methodology, we are told, 'is semiotics'. Semiotic Solutions lays this methodology out as a three-stage programme':

1 SemioScan: semiotic analysis
2 SemioQual: culture update
3 SemioPlan: strategic planning

The first stage involves an analysis of discourses, the residual, dominant and emergent codes and the myth of the brand, leading to a structure of hypotheses. In the second stage, these hypotheses are investigated through the use of qualitative research. The third stage involves the formulation of strategic recommendations for enhancing the brand in accordance with the consumers' cultural expectations.

At the end of the prospectus, the personnel are presented in terms of their academic training and qualifications: one is an ex-lecturer, another

has 'recently graduated from Wadham College, Oxford, with a first in English, having specialised in critical theory, under Terry Eagleton'.

Semiotic Solutions is thus a phenomenon of the interface of academic and market research. It employs cultural theory, presented in its more scientistic and instrumental mode, to legitimate its knowledge, makes use of 'soft' social science methodologies, and employs personnel who use Terry Eagleton's name as a guarantor of the expertise they employ. That the prospectus is able to use such vocabulary is perhaps evidence of the extent to which people in the client companies have also been trained, presumably while at university, in a set of cultural analytic techniques, since otherwise the company's material would be highly mystifying. Alternatively, maybe the pseudo-novelty of its approach is a way of selling services.

Whichever of these interpretations is right, we want to ask what is the significance of this commercial success for the academic knowledge upon which it draws? Is this the intellectualisation of commercial life or the bowdlerisation of academic practice? Or, alternatively, is there some mutual benefit and advantage to be gained for both academic theorists and advertising practitioners? As the *New Statesman and Society* feature notes, Semiotic Solutions has taken 'structuralist methods from the lecture-room to the board-room' and in the process quintupled its turnover in two years. Is Semiotic Solutions successful because it has found a way to understand the consumer mind, such that it systematically and reliably increases the likelihood of an advertisement promoting a product? Or is the process one of propagating a scientific myth, with much the same effects as Barthes himself identifies? Let us follow up the last line of thought.

A CONJECTURE: ADVERTISING AND UNCERTAINTY

We shall adopt the sceptical premise that neither advertisers nor sociologists can, at present, accurately or meaningfully generalise about what consumers want, need or will buy: that we know nothing about consumers, that all our supposed knowledge about consumers is incorrect and that the rationale of consumer choice is indeterminate. On this presumption of total inability to understand how consumers behave, that consumers are unfathomable, how then would we explain the contents and the proliferation of advertisements? We advance six theses, which amount to a hypothetical explanation, about modern advertising:

1 that advertising is a function of *producer anxiety* or uncertainty;
2 that the *power asymmetry* between clients and advertising companies requires legitimation strategies for the latter;
3 that these are primarily comprised of complex myths regarding the

89

market, and that these are, increasingly, understood in terms of consumer behaviour;

4 that in a scientific culture, these myths are constructed as *calculable and replicable operations* for divining the character of the consumer Will;

5 that these operations are granted recognition as a medium of specialised or *expert knowledge*, which confers some legitimacy on the practitioners;

6 that thus the practitioners of the special knowledges are able *to sell* their divinations to the worried producers.

Advertising as a function of producer anxiety

Most accounts of advertising by academics would see its primary function as helping the consumer to overcome uncertainty, limited knowledge and lack of imagination. It is primarily consumers who are held to be in need of guidance. We assert (as do advertisers themselves) the contrary hypothesis: namely: that it is the producers who are in need of guidance.

The influential work of Piore and Sabel (1984) revolves around the problem for mass producers of ensuring a market for their products, that is, of managing uncertainty. Production in large volume required stable, predictable and high levels of demand. Piore and Sabel chart a number of ways in which demand was stabilised from 1880 onwards, concentrating on one means, the creation of the large corporation. The problem that they identify is that of ensuring that there is a market for whatever products a manufacturer fashions. The manufacturer's problem, in other words, is finding sufficient consumers for the volume of goods produced. This is a permanent source of insecurity, uncertainty and anxiety for any producer: for they cannot *force* people to buy their products and can never even be sure that people who already do use them will continue to want to do so.

Marketing departments, and the special skills of marketing, emerge in response, and of course there are many different ways of trying to find consumers: the firm's representative may approach consumers or retailers and there are always special offers, promotions, etc. (see marketing's four Ps). Another way that producers of all kinds have adopted for securing a market for their product is the advertisement, although, oddly, Piore and Sabel say little about advertising in their account, despite the fact that it is an obvious, important and complementary way of attempting to find and stabilise demand. We suggest that advertising should be seen as a form of guidance to producers, helping them (not consumers) overcome uncertainty, limited knowledge and lack of imagination.

90

Piore and Sabel make the important point that the social organisation of markets has changed. They suggest, as do many others, that in contemporary society, competitive advantage now lies with those firms organised for flexible specialisation, because this is the most appropriate response to a situation where there is an increased demand for non-standard items, and where market demand is unstable or uncertain. We suggest that, as advertising is a function of producer anxiety, so it will change in a complex relation to changes in the organisation of the market and the ensuing anxiety that this provokes in the producer. How, then, is this anxiety allayed?

Power asymmetry between clients and advertising companies

It is widely recognised that clients enjoy an organisational and contractual asymmetry of power with respect to agencies. In the making of contracts for a sales promotion campaign, the client or producer has a wide range of options, including direct selling, developing a campaign through its own marketing department, even not advertising at all. Often the client will be a much larger and more powerful organisation than the advertising agencies seeking a contract. There is much competition between agencies; they are constantly required to pitch for new contracts and the renewal of existing ones; and clients may require agencies to drop other clients as a condition of acceptance.

However, the history of relations between clients and agencies is almost entirely absent in many academic studies of advertising, and there is very little consideration of the significance of the asymmetry of power between clients and agencies for the development of advertising campaigns. We believe that there exist important, but as yet unexplored, negotiations about the content of ads between the client and the agency. An analysis of the differentiation in ad formats between products would, we believe, provide a more complex view of the development of models of the consumer and advertising images. A preliminary investigation of ads for food products in weekly and monthly magazines (Warde 1994) indicates that the ad format identified by Leiss et al. (1986) as typical of contemporary advertising – with the emphasis on lifestyle – did not account for the content of food advertising in the British press. Most ads for food products are highly conservative in terms of the aesthetics of advertising; they make few imagistic associations, rarely feature pictures of people and only occasionally use lifestyle formats. We believe that while this conservatism may in part be explained by the nature of the product, it is largely due to the oligopolistic structure and mass-production techniques of food manufacturers.

What this example serves to show, we believe, is that there is significant negotiation between clients and agencies; the agencies are not free

to do what they please aesthetically but are often powerfully constrained by the clients' notion of what is a proper way to advertise particular products. We hypothesise that agencies respond to this comparatively weak position through their claims to expert knowledge and judgement about consumers. In short, agencies bolster their position relative to producers by claiming expertise in various fields, including understandings of the consumer.

Myths regarding the market

We suggest that advertising industries have come to assuage the anxieties of the producers (cf. Bauman 1988) by promoting themselves as experts in guiding, controlling, influencing and predicting what consumers will be prepared to buy; that is, they are in the business of what Ien Ang calls 'desperately seeking the audience' (1991). Put crudely, advertising agencies sell themselves to producers who hope to reduce uncertainties about what consumers might do. In this context, it makes sense that advertising professionals will need to present knowledge claims about the structure and processes whereby different sorts of people come to want and desire different categories of goods and services. This is, we suggest, increasingly a matter of developing expert and specialised knowledges that offer some insight into how consumers make choices.

Recent histories of the advertising industry have identified significant changes in the advertising industry in the last twenty-five years, many of which are directly associated with the development of new constructs of the consumer and with claims that understandings of the consumer are central to the success of advertising campaigns. Increasingly, quantitative methods of measuring the consumer have been replaced by qualitative methods – a shift which was directly linked, in an interview one of us carried out with a senior figure in the advertising industry, with the increased employment of people trained in social science. This challenge was institutionalised with the emergence of account planning as a specialised function within agencies in the late 1960s and 1970s, and was recently adopted as the basis of claims of competitive advantage by some 'third wave' agencies. ('Third wave' is a descriptive term adopted within the advertising industry to mark successive 'waves' of agency formation. Each wave is said to be characterised by a distinctive philosophy.) Demographic and occupational grade measures for categorising consumers are now routinely supplemented by focus-group discussions, psychographics and by techniques such as VALS, which claim to isolate value and attitude clusters amongst consumers.

Thus there has been a shift in the basis of knowledge claims made by advertisers, from knowledges deriving from the academic disciplines of economics and sociology, through psychology, to, more recently, cultural

studies. How are we to understand this shift? And what are its implications for the academic disciplines which provide the resources for such knowledge claims?

We hypothesise that with the spread of flexible specialisation, at least in some sectors of the economy, the movements of the market are increasingly recognised, not in terms of features of the product, but in terms of the individual motivation or will of the consumer. As a consequence, the disciplines of psychology and cultural studies are drawn upon as sources of expert knowledge, as means of counteracting the weak position of advertising agencies *vis-à-vis* their clients. Indeed, it can be seen as a way of making their services relatively more significant in the overall production process. For example, if the current emphasis on lifestyle as an explanatory catgeory and the strategic claim that consumers have become increasingly oriented towards 'identity-value' are accepted by producers, the development of an effective brand image becomes at least as, if not more, important in commercial practice than, say, product innovation.

Myths as calculable and replicable operations

Given the desire of producers to manage uncertainty, to predict, anticipate or even incite market demand, we assert that advertisers will tend to present the knowledges such disciplines offer as 'certain' or 'definite', and to adopt a scientistic mode of presentation. In this process, key concepts are reified through the adoption of scientistic modes of measurement and evaluation. This, we think, is an under-explored consequence of the relationship between the social sciences and advertising.

A recent example of the scientisation of the concept of 'culture' is the study of product and country images, a specialism which has been described as 'an important subfield of consumer behaviour and marketing management'. Some recent publicity for a book in this field (Papadopoulus and Heslop 1993) claims:

> Thousands of companies use country identifiers as part of their international marketing strategy, and hundreds of researchers have studied the ways these identifiers influence behavior. As markets become more international, the more prominently the origin of products will figure in sellers' and buyers' decisions. The time is ripe for practitioners and academicians to delve into the insights offered in this seminal volume so as to better prepare for meeting the competitive challenges of the global marketplace.

Chapters include: 'Countries as Corporate Entities in International Markets', 'The Image of Countries as Locations for Investment', 'Images and Events: China Before and After Tiananmen Square' and 'Global Promotion of Country Image: Do the Olympics Count?'.

One approach within this field has developed surveys to measure public perceptions of 'trust' in products according to their 'country of origin'. It appears to be motivated by the wish on the part of producers to identify calculable factors which influence public perceptions of 'risk' associated with products identified in relation to their country of origin. These factors, once identified and measured, are held to be open to influence through the association of product brands with selected dimensions of national identity. This is an explicit concern of the manufacturers of Swatch, the Swiss Corporation for Microelectronics and Watchmaking (SMH). Nicolas Hayek, a senior executive, claims in an interview (with William Taylor 1993: 103) that the Swiss production location of Swatch offsets its cost disadvantage. The buyers of Swatch are said to be 'sympathetic' to the Swiss: 'We're nice people from a small country. We have nice mountains and clear water'. He attributes the company's success to the fact that he

> understood that we were not just selling a consumer product, or even a branded product. We were selling an emotional product. You wear a watch on your wrist, right against your skin. You have it there for 12 hours a day, maybe 24 hours a day. It can be an important part of your self-image. It doesn't have to be a commodity. It shouldn't be a commodity. I knew that if we could add genuine emotion to the product, and attack the low end with a strong message, we could succeed . . .
>
> We are not just offering people a style. We are offering them a message. . . . Emotional products are about message – a strong, exciting, distinct, authentic message that tells people who you are and why you do what you do. There are many elements that make up the Swatch message. High quality. Low cost. Provocative. Joy of life. But the most important element of the Swatch message is the hardest for others to copy. Ultimately, we are not just offering watches. We are offering our personal culture.
>
> *You mean people can look at a watch from Hong Kong and then look at a Swatch and sense a different culture?*
>
> It's not just the mechanics of the product. It's also the environment around the product. One thing we forget when we analyze global competition is that most products are sold to people who share our culture. Europeans and Americans are the biggest groups in the world buying products from Asia. So if you can surround your product with your own culture – without ever denigrating other cultures or being racist in any way – it can be a powerful advantage. . . .
>
> The people who buy Swatches are proud of us. They root for us. They want us to win. Europeans and Americans are damn happy if

you can show that their societies are not decadent – that every Japanese and Taiwanese worker is not ten times more productive or more intelligent than they are.

'Country of origin' surveys seek to measure perceptions of 'risk' associated with the cultural dimensions of national identity, allowing the national identity of specific countries to be mobilised as economic resources. Not surprisingly, such surveys have found that perceptions of a product in terms of its country of origin are related to some rather disturbing 'cultural' expectations, those which are euphemistically termed 'patriotism' or 'ethnocentrism'. These scientistic measurements of cultural expectations may then be used to legitimate 'domestic sourcing' as a means of 'gaining additional advantage in the marketplace'. This is an example of the reification of not only the cultures of specific countries but of the term 'culture' itself in the interests of an attempt by market research agencies to assuage the anxieties of clients as markets are increasingly internationalised. While it is presented as scientific, it does not consider the assumptions built into its research procedures, nor question the tacit understandings of national identity, culture and 'race' which are embodied in such research methods. Its scientific character is highly dubious. Nevertheless, it acquires an aura of legitimacy through its self-presentation in terms of the social scientific techniques of the survey and interview.

The largely spurious process of 'scientification' has also been explored in relation to the market segmentation strategies discussed in Lien's (1993) case study of *Norwegian Monitor*. Associated with the process of developing brands, and with the desire to target advertising at particular audiences, a codified set of procedures to establish statistical associations between individuals' values, attitudes and previous consumer decisions was developed. The measures of statistical association employed in this process, however, were extremely difficult to interpret and even harder to communicate to clients. Consequently, different images or metaphors describing types of consumer were invented – in the case reported by Lien, these included 'myself first', 'live for the present', 'moderate', 'conformist' (ibid.: 159). At each stage, the constructs of the consumer become more reified and more concrete, despite the rather flimsy practical and pragmatic origin of the information being processed. As Lien points out, such schemes may be useful for certain limited marketing purposes, but the intellectual basis of the edifice of procedures is of uncertain quality.

Expert knowledge, and the legitimation of practitioners

There now exists a large battery of techniques and specialised knowledges about the consumption process, of which consumer segmentation procedures

comprise just one. There are many different segmentation techniques, working with different sorts of information and data bases, and drawing implicitly upon different basic assumptions about what operations will most effectively and parsimoniously identify target groups. Thus techniques associated with measuring urban segregation are used to identify small areas in cities where an advertising campaign might be targeted; audience surveys, based upon reported exposure to particular media, are conducted; qualitative techniques are used to anticipate how an audience will read a particular image or message; focus-group discussions are pulled apart using discourse-analytic techniques.

Consequently, the different forms of information collection and processing become themselves items at the centre of commercial competition. Some of the smaller agencies, for example, sell their services on the basis that they have developed expertise in qualitative market research methodology that will give superior insight into the minds and purposes of consumers, whose attention will be captured or behaviour influenced more effectively than if their dispositions were measured using older quantitative techniques. Thus, actors in the marketplace trade in informational techniques, and their own success and their legitimacy become bound up with the special knowledges at their disposal. From the point of view of clients, it is precisely the fact that the advertising agencies have this special and effective means of insight into the consumer that justifies offering them a contract for a campaign.

Advertising as the modern witch doctor

Thus the practitioners of the special knowledges are able to sell their divinations to the worried producers. However, if the sceptical premiss put forward at the beginning of this chapter – that no one actually knows how consumer behaviour works – is accepted, the various and competing techniques are mere speculations, ways of telling a story about the unknowable and the incomprehensible. They are thus myths, accounts that attribute meaning to events and actions, referring to known experience and giving people comfort, but ultimately unverifiable. Advertisers are, then, a kind of modern witch doctor, diagnosing and analysing signs and significations in order to calm the worried spirits of the producers of potentially unwanted commodities.

But, we might add, which doctors are the witch doctors? The growing symmetry between the accounts of social theory and other social scientific disciplines and the self-understandings of marketing experts should make us pause a while before once again identifying the advertising industry as solely culpable in its responses to the search for certainty so characteristic of our society. How should the symbiosis between commercial and academic knowledges be understood?

TELLING TALES ABOUT ADVERTISING ON THE BASIS OF OUR CONJECTURE

We will now recount a number of stories about the development of the advertising industry, assuming throughout that ours is an accurate and incisive account of the logic of the process. We will tell four such stories.

The first story: managing uncertainty as a lucrative vocation

If the world were as we have just constructed it, it might seem that many changes in the nature of advertising are a consequence of a profession alisation project of a group of cultural intermediaries. Professionalisation is an *occupational group strategy*, a way of achieving collective upward social mobility, as Parry and Parry (1976) describe it. If successful, all workers in a particular occupation improve their social and material positions. The strategy has been attempted by many groups. Key elements of the strategy in the past have included setting up an association, getting universities to provide courses which all practitioners must attend and pass, and establishing a set of tasks unique to the occupational group and from which all other workers are excluded by law.

A number of factors determine the success of professionalisation strategies and there are good reasons for thinking that the advertisers are not likely to be hugely successful. The origins and characteristics of the personnel of occupational groups are important. One reason why the older professions were invested with considerable exclusive powers (like the BMA monopoly) was because they were originally recruited from among the sons of the upper and upper-middle class. Such men were considered reliable and could be given state-guaranteed powers. This is generally not the case in advertising: its recruits are primarily business, humanities and social science graduates of comparatively humble origin. Second, professions usually require that the state grants a monopoly to practise, which is difficult to conceive in the field of advertising. Third, professionalisation strategies are likely to meet with resistance from potential customers. Generally speaking, professional occupational control is against the interests of the purchasers of services. Where there are few potential customers, or where the customers are organised, professionalisation is difficult to secure. The chances of advertisers becoming a respected traditional profession are thus very limited. However, they do have one asset that tends to enhance occupational power, and that is access to their special knowledge.

It has often been pointed out that professions try to prevent the general public gaining access to their expert knowledge by making it impenetrable to an outsider. But such arcane knowledge is undeniably part of professional strategies of exclusivity; that knowledge must also be necessary for successfully carrying out the job: where there is no need for the flexible

use of expert knowledge in the course of doing the job, workers are unlikely to be able to maintain high levels of occupational control. It is the mixture of expert, abstract knowledge and practical experience, which can neither be rationalised nor quickly acquired, that protects the privileges of 'educated workers'.

The body of knowledge upon which a profession is based tends to have several distinct characteristics. It must generally be considered true. It must be capable of being applied successfully to practical problems and be useful to some substantial section of the community. It must not be too narrow nor be too easily expressed as practical rules for application. But perhaps the key feature of professional knowledge is that

> it allows the professional to exercise his or her judgement in applying abstract knowledge to the client's particular case. The services of the higher professionals usually take the form of giving advice to clients in a situation of *uncertainty*, where the professional's knowledge and experience gives his or her judgement an authority which can scarcely be challenged by the client. Judgement in circumstances of uncertainty cannot be routinised or expressed as rules, thus providing an exclusive knowledge-base for the professional's control in work. Occupational control is extended by preserving space for informed judgement.
>
> (Abercrombie and Warde 1994: 86 [emphasis added])

This last condition does appear to hold in our scenario, and it is the basis upon which the advertising agency, and its technical workers, are able to command both respect and significant fees from clients. The character of the knowledge – its imprecision, the need for experience in applying statistical or qualitative techniques – is such that the advertisers are able to redress a balance of power that inherently favours the client. In this view we should not expect the techniques of market research to become more transparent or more rule-like; rather they need to retain an appropriate aura of the arcane and the opaque.

Maintaining the appropriate degree of opacity is, however, fraught with problems. First, it is necessary that the client believes that the knowledge is efficacious, which requires both a sense of its inherent plausibility and its success in predicting or inducing market demand. Second, there is the impetus to competition between agencies, which in part plays on the development of new techniques for divining the consumer will which, by and large, are likely to denigrate existing alternatives. The pressures of commercial competition probably exert a fissiparous effect on potential occupational solidarity: the nature of disputes within, for instance, an established academic discipline, which operates as an effective mode of occupational control in universities, are not exposed to anything like the same degree of commercial logic as exists in the advertising industries.

This might lead to speculation about the relationship between specialised knowledges that compensate for uncertainty in market-driven situations and the level of financial return. If market research work is lucrative, is that because of the very rapid turnover in new techniques, such that inventing new techniques is the most effective way of getting an above rate of return on knowledge-rents?

The second story: managing uncertainty as a way of managing the public

Our conjecture has located advertisers and marketers as one of the growing number of professions who are concerned with managing uncertainty, calculating probability and minimising risk. This project has a long history in Euro-American societies where a discourse of risk, together with an acknowledgement of an uncertain future, emerged in the nineteenth century. This discourse was motivated by a chaotic vision, or fear, of the future: the new study of 'chance' embodied in the sciences of probability and statistics revealed the order in the chaos, and offered the possibility of managing risk in the aid of profit and an ordered society. In the nineteenth and twentieth centuries, there has been a notable increase in the accumulation of statistics (and bureaucracies for their collection) dealing with all aspects of social life. Such techniques are represented as a means of enabling rational planning of social life in the interests of society as a whole. However, it should be remembered that categories and groups produced by these techniques did not exist independently of them – they had to be invented along with probability and statistics. In a sense, these techniques for the classification, measurement and management of the population produce 'society' and a sense of the 'social'.

The techniques identified here, the consequence of advertisers' attempts to assuage the anxieties of producers in the face of uncertainty, can be located in this tradition of managing populations. They are part of the commercial, as opposed to a state or professional, construction of risk and uncertainty. Their effectiveness, however, is bolstered by the dialectical process of legitimation between commercial and academic knowledge. Increasingly, it is these commercially based expert knowledges that are informing government policy and the provision of public services, and are diffused among the population at large, as public opinion and as common sense. As such, they can also be seen to be producing society as a 'consumer culture', in the sense that culture is at the root of individual motivations and is the basis of the collective allegiances. From this point of view, advertising is the latest phase of Foucault's bio-politics – a bio-cultural politics – and advertising and the social sciences are competitive partners in the management and regulation of a consumerised society.

The third story: the interrupted logic of the advertising industry

We have supposed that advertisers develop their knowledge claims in response to the anxieties of producers. However, it is possible that these knowledge claims are being taken up in ways which advertisers did not foresee, and in ways that may yet undermine the advertisers' own project. We have suggested that the industry needed to map out its own specialised field of expertise – knowledge of the consumer and consumer decision-making – in response to producer uncertainty, but in mapping the field, it may have infinitely extended the domain of uncertainty. Indeed, it has been argued that we live in a society in which people are beset by the impossibility of avoiding making choices and that this has resulted in a widespread anxiety about the workings of the will in modern society, visible in the proliferation of the contradictory injunctions to 'Just Do It' *and* 'Just Say No'.

This is the thesis put forward by writers such as Eve Kosofsky Sedgwick (1994), who argues that we are seeing the emergence of what she calls 'maladies' or 'pathologies of the will', manifest in the current tendency to describe almost any behaviour in terms of addiction. If she is right, this suggests that the advertising industry is caught in a contradiction, in part of its own making. If the advertising industry's representation of the consumer as infinitely complex and inherently unstable becomes widely accepted, then consumers themselves will undermine the credibility of the advertisers' claims to understanding, since the arbitrariness of their behaviour will become merely chaotic. In this case, exacerbated by the context of the competition between agencies, even the reified definition of culture being proposed in some quarters of the advertising industry may not be accepted by producers and the advertisers' claims to expertise will be rejected. Perhaps the science of myth will undermine the myth of science.

The fourth story: social theory's debt to the advertising industry

As we know, many theses have been promulgated in recent years to the effect that, rather than the media of mass communication reflecting the social world, the world is instead itself being (re-)created in the light of its media image. An example particularly relevant to advertising might be Wernick's notion of promotional culture (1991). Apparently, manufacturers increasingly see new products less as an engineering problem and more of a marketing one: the specification of the product is heavily prejudiced by the anticipated campaign for its advertisement or promotion. But this practice has been exported to other fields where, prima facie, it is much less fitted. So used have we become to the way in which commodities are promoted through advertisement that individuals and institutions have allowed their concerns with the representation of self to others to

displace or distort the purposes for which they exist in the first place. Wernick's example of the way that universities have come to see themselves as competing in a marketplace, and have thus adopted practices that are directed towards that end even though the objectives of the organisation are thereby hampered, is a pertinent instance.

Another example might be the symbiosis of academic and commercial knowledge about consumers referred to in our introduction. Pursuing the notion that interests are embodied in even the most abstract of theories, we see a symbiosis between practitioners of advertising and hermeneutic social theories. Activities are legitimated through the shared techniques for uncovering human meaning and motivation. For the practitioners, this is a source of commercial and personal advancement. But it is not only the activities of the advertisers that are legitimated through the shared techniques. For social theorists, the exercise is the art of getting the practical world onto the side of their theory, of theory achieving its own realisation and confirmation in the world of (commercial) practice.

For a century or more critics of scientific (or 'automatic') marxism have pointed to the apparent absurdity of seeking theoretical guarantees of social futures. The notion of the unity of theory and practice was the philosophical underpinning of a politics in which the working class became the bearer of inevitable historical progress. Political action was sustained in the theoretical guarantee of the inevitability of progress, and political strategy was designed in the light of the same theory. In this intellectual gambit, theoreticians allocated the logic of History to the side of the proletariat, and pronounced that the Future would extrude in the fashion prescribed in theory. No one believes this any more. But something rather similar is apparent in contemporary theories of the consumer. Social theorists in particular are adopting a view of general social practice that reflects the models of the consumer current in advertising practice. Consumer behaviour has become one of the most prevalent templates for individual action, as decision-making is conceived as following the logic of the shopper rather than of moral agent, citizen, associate, or whoever. The overarching place attributed by recent theory to the pursuit of lifestyle puts consumer behaviour at the very centre of the organisation of everyday life. Thereby, theory seems to be reappropriating models of behaviour that were the consequence of the practical application for marketing purposes of techniques that social science originally exported.

The abandonment by market research of socio-demographic and psychographic techniques that depended upon statistical reasoning impels social theory to elaborate a hermeneutical, rather than a positivistic, approach to social analysis. Culture, and the interpretation of the consumer culture, become central objects of abstract theoretical attention. The social world is reconstructed in the image and language of the lifestyle ad. The world is deemed to reflect its own media image. Thus we see the

vital contemporary historical process of theoretical irredentism at work. Irredentism is the project of redeeming territory from 'foreign' rule on the grounds of language. The hermeneutic approaches of the contemporary academy can be seen as yet another attempt, by theorists, to get the world on their side. If images and signs, codes and discourses, or language, are the exclusive components of the knowable universe, then privileged access to the operation of languages is an asset conferring considerable power. Thus arises the imperative to get language on the side of the theory and for theory to justify the primacy of language. This is, we presume, what political correctness is about: words speak louder than actions (as somebody must have said). The academy has redeemed language from its foreign location in the hands of the advertisers. The sovereignty of theory is restored as the world – the world of language, that is – is returned to the safe keeping of theory.

REFERENCES

Abercrombie, N., Warde, A., Soothill, K., Urry, J. and Walby, S. (1994) *Contemporary British Society* (second edition), Cambridge: Polity.

Ang, I. (1991) *Desperately Seeking the Audience*, London and New York: Routledge.

Bauman, Z. (1988) *Freedom*, Milton Keynes: Open University Press.

Fine, B. and Leopold, E. (1993) *The World of Goods*, London: Routledge.

Leiss, W., Klein, S. and Jhally, S. (1986) *Social Communication in Advertising: Persons, Products and Images of Well-Being*, London: Routledge.

Lien, M. (1993) 'From deprived to frustrated: consumer segmentation in food and nutrition' in U. Kjaernes et al. (eds) *Regulating Markets, Regulating People: On Food and Nutrition Policy*, Oslo: Novus Forlag, 153–70.

Papadopoulus, N. and Heslop, L.A. (1993) *Product-Country Images: Impact and Role in International Marketing*, New York: Haworth Press.

Parry, N. and Parry, J. (1976) *The Rise of the Medical Profession*, London: Croom Helm.

Piore, M. and Sabel, C. (1984) *The Second Industrial Divide*, New York: Basic Books.

Sedgwick, E. Kosofsky (1994) *Tendencies*, London: Routledge.

Taylor, W. (1993) 'Message and muscle: an interview with Swatch titan Nicolas Hayek', *Harvard Business Review*, March–April, 98–110.

Warde, A. (1994) 'Consumers, identity and belonging: reflections on some theses of Zygmunt Bauman' in R. Keat, N. Whiteley and N. Abercrombie (eds) *The Authority of the Consumer*, London: Routledge.

Wernick, A. (1991) *Promotional Culture: Advertising, Ideology and Symbolic Expression*, London: Sage.

6

ADVERTISING EXECUTIVES AS MODERN MEN

Masculinity and the UK advertising industry in the 1980s

Sean Nixon

16 May 1994 marked the fifth anniversary of the acquisition by the UK-owned advertising and marketing-services group WPP of the US-owned Ogilvy Group, the world's fifth largest advertising agency and one of the jewels in the Madison Avenue crown of the US advertising industry. The acquisition of the Ogilvy Group enabled WPP to top the world rankings of advertising agencies by the end of 1989 and, as such, marked the culmination of a strategy of acquisition embarked on by WPP's Chief Executive (and former Financial Director of Saatchi and Saatchi) Martin Sorrell. This had begun in 1985 with Sorrell and his partner Preston Rabi purchasing a controlling stake in Wire and Plastic Products – a small shopping trolley manufacturer based in Kent – with the intention of using the company as a vehicle for acquisition. The transformation wrought by Sorrell's acquisition programme on WPP was by any standards phenomenal. Even prior to the acquisition of the Ogilvy Group and, a year earlier, the equally spectacular acquisition of another giant of the US advertising industry, J. Walter Thompson, Sorrell had acquired for WPP a plethora of companies specialising in below-the-line advertising, together with design companies and media-production facilities. This had transformed the portfolio of WPP and helped drive up its share price from a value of 35p at the time of Sorrell's first involvement to 700p by the beginning of 1987.[1] It was fitting that the rise of WPP to the top of the world rankings of advertising agencies should have catapulted it ahead of Sorrell's former employers, Saatchi and Saatchi; Saatchi and Saatchi had dominated the UK rankings of advertising agencies through the 1980s to become a leading global agency, breaking for the first time since the 1950s the pre-eminence of US-owned agencies and their UK subsidiaries over the business of UK advertising. By going to the top of the world rankings by acquiring two of the dominant US agencies of the postwar period, WPP reinforced this historic break.

The moment of WPP's ascendancy and its underlining of London's pivotal position in the international advertising and marketing services industry, however, coincided with the first signs of the unravelling of the boom in advertising expenditure in the UK and the years of uninterrupted growth for the industry. This boom had seen year-on-year increases of 11.4 per cent in 1986, 9.9 per cent in 1987, 15 per cent in 1988 and 13 per cent in 1989, with advertising expenditure rising from 1.1 per cent of GDP in 1980 to 1.6 per cent in 1988.[2] The fifth anniversary of the Ogilvy Group acquisition reminds us of how difficult the intervening years have been for WPP and for the UK industry more generally. The years of acquisition and expansion, built on both the expanding advertising revenue and a sympathetic attitude towards the agencies sector from City institutions, were replaced by a period of recession and rationalisation with advertising expenditure dropping to 1.32 per cent of GDP in 1993 and the industry shedding 5,000 jobs.[3] The particularly acute difficulties of WPP through these five years, however, should not be allowed to obscure the fact that it has continued to articulate a coherent strategy in response to some deep-seated and ongoing shifts within the fields of advertising and marketing services; shifts which have their roots not in the recession of the early 1990s, but in the boom years of the UK industry.[4] Drawing on a strategy of organisational development most associated with Saatchi and Saatchi, WPP's aggregation of a global network of advertising and marketing services and the construction of its portfolio around a diverse range of advertising, marketing and media services (particularly in below-the-line services) remains exemplary of one influential type of response to the shifts in the nature of the advertising business.[5]

Beginning with this commentary on the anniversary of the Ogilvy Group acquisition by WPP dramatises well the fact that the situation of UK advertising agencies at the time of writing, despite the difficult five years of contraction and recession, continues to be dominated in large part by processes which began to cohere in the expansive phase of the industry. The mid to late 1980s, then, represent a formative period for the situation of UK advertising in the mid-1990s. It is for this reason that I return to this important conjuncture in this chapter. My ambition, however, is not to detail the strategic and organisational processes at work within the industry, but rather to focus on a different set of concerns: namely, the regime of masculinity at work within the advertising industry during this critical period. I want to reflect on two dimensions of this regime of masculinity. First, I consider the gendered languages through which the business of advertising was conducted and disinter the representations of masculinity which these privileged. As we will see, it is in relation to this dimension of the regime of masculinity associated with UK advertising in the 1980s that the WPP/Ogilvy Group saga will return to my account with some force. Second, I explore the way distinctive work-based

104

masculinities were signified through the codes of dress and individual consumption by groups of advertising men. At root, then, I want to begin to unpack – in a necessarily provisional way – the specificities of the regime of masculinity integral to this creative service industry.

In reflecting on this regime of masculinity the chapter has been brought up against the priorities and conventions of two fields of intellectual enquiry. On the one hand, it makes explicit a dimension of analysis typically the best-kept secret of mainstream business analysis and business history – namely, the way that, as Michael Roper has succinctly put it, 'the conduct of business and how it is represented as a social category' is strongly interwoven with representations of masculinity (Roper 1994: 19). On the other hand, breaking open the professional culture of the industry has also meant – in contradistinction to much contemporary cultural analysis – insisting on the importance of engaging with the operation of cultural representation in relation to the world of work and the domain of business. This insistence is part of a broader disagreement with a strong tendency within recent cultural analysis to privilege – in a largely rhetorical sense – consumer resistance as the linchpin to accounts of the sphere of consumption. This is done at the expense of an adequate account of the consumer institutions and their cultural practitioners which dominate this area of cultural circulation.

THE PLEASURES OF MASCULINITY

For work he dresses with great care and elegance. He buys his suits at Barnes, the advertising man's tailor, in the rue Victor Hugo in Paris. 'They're the right sort of clothiers for people who make it in advertising – English cloth. Prince of Wales checks with a touch of luxury. Not the sort of thing civil servants could wear, and bank managers couldn't get away with either. In banking you need a plain shirt; banking isn't showy, whereas in advertising, people put every penny they earn into clothiers ... When someone new comes to the agency, we size them up at a glance ...'

Michael R., a 30 year old advertising executive working in a Paris agency, interviewed in 1974 (Bourdieu 1979: 299).

In beginning to reflect on the regime of masculinity associated with UK advertising in the mid to late 1980s, it is perhaps appropriate to signal my own investment in these formations of masculinity, an investment which has in part driven this account. The quote drawn from the interview with Michael R., above, for me condenses some of the key elements of the appeal of the masculinity of advertising men which has emerged in the course of research conducted over recent years. To the son of a civil servant, the flamboyance of more contemporary versions of men like

Michael R. was compelling. In contrast to the attributes of the dominant version of masculinity associated with the civil service – the workaday suit, the administrative competencies, the investment in an incremental career structure, the clear separation of work and leisure – attributes which my father, to do no disservice to him, embodied during his working career, the public image of groups of advertising men offered a stylish and more contemporary version of masculinity. This was one in which the opening up of new pleasures of masculine consumption – particularly associated with dress codes – was evident. The appeal to me of the stylised masculinities of groups of advertising men, however, was not unequivocal. If sharp practices did not necessarily go with sharp suits, then other attributes and characteristics associated with these masculinities – like the excessive culture of self-promotion and the celebration of aggressive forms of individual success – raised my critical heckles rather than prompted my identification.

The quote from Michael R. is telling in other ways, however. First, the testimony is taken from a French source from 1974. Although my interest is with more recent versions of masculinity in the UK, it is clear that the modernity of advertising men – their representation as thoroughly modern men – has a longer history. Second, the metropolitanness of Michael R. – his position as an executive working for a Paris-based agency – is key. It is clear, in relation to UK agencies, that the location of their offices at the heart of metropolitan life – with a strong clustering of some of the high-profile agencies in London's Soho – was also important to the regimes of masculinity associated with the industry in the 1980s. Third, as a young executive, Michael R. represented one sort of advertising man. In reflecting on the formations of masculinity within the UK advertising, it is important to be alert to the differentiation between the masculinities of groups of men working in advertising. The masculinity of senior executives who joined the industry in the 1950s with a university education in classics are likely to be distinct from the masculinity of young art directors trained at art school during the 1970s, for example. It is important to be alert to the range of masculinities likely to be produced by factors such as generation, education and training as well as by organisational function within the industry.

It is with these general observations in mind, then, and with a sense of the personal motivations which frame my interest in advertising men, that I turn to the regimes of masculinity associated with the languages of business in UK advertising in the mid to late 1980s.

MANAGEMENT REGIMES AND THE LANGUAGE OF BUSINESS

In putting together an account of the languages of business associated with the UK advertising industry in the 1980s it is impossible not to

consider the broader shifts in the languages through which business was represented during this period; shifts which impacted strongly on the languages of business deployed in and around the advertising industry. The development of a new wave of management literature played an important role in fostering these new ways of representing the process of business, in particular helping to centre-stage the vocabulary of enterprise to these business languages. The decade saw something of a boom in this new wave management theory. Exemplified by the writings of Peters and Waterman and Rosabeth Moss Kanter, this work offered a vision of a new settlement in manager/employee relations based upon the forging of new modes and styles of conduct at all levels of organisations.

A central tenet within this management theory – and its central injunction to senior managers – was to harness rather than restrict the individual creativity of employees at all levels of the organisation. Putting in place systems within the organisation which enabled the 'extraordinary' capacities of 'ordinary' people to flower loomed large in the pronouncements of Peters and Waterman. Flatter management structures, the establishment of spaces for innovation and creativity at work, a focusing of the organisation around a mission statement rather than around formalised bureaucratic systems and the development of an 'end-user' culture were some of the key principles for the making of – in the terminology of Peters and Waterman – 'excellent' organisations.[6] As Paul Du Gay (1991) has argued, much of the distinctiveness of this new management literature stemmed from the way that its vision of 'liberated' employees was articulated through the language of enterprise – it conceived of releasing the creativity of employees by giving full rein to their enterprising capacities and encouraging them to represent themselves as enterprising individuals. In this way, the ambition of writers like Peters and Waterman was to reintroduce the values of enterprise into all organisations – whether they were large manufacturing-based corporations or small service sector companies, multinational businesses or public sector bureaucracies. They aimed to produce organisations of self-regulating enterprising individuals.

What was striking about the language of enterprise integral to the management regimes promoted by the advocates of new management theory was the way that it was, in many instances, articulated with a set of cultural representations of masculinity within business discourse. What this produced was a particular gendering of this management discourse and the privileging of certain images of masculinity in the coding of business narratives. Michael Roper, in his book *Masculinity and the British Organisation Man since 1945* (1994)[7] has usefully unpacked the ways in which these business narratives interlinked with representations of masculinity. As he notes, one dimension of this was written into an account of the UK's economic decline in which the fortunes of the UK economy at the turn of the 1970s and 1980s was rendered through lurid images of

107

emasculation and impotency. The most celebrated example of this decline history was found in Martin Weiner's influential book *English Culture and the Decline of the Industrial Spirit* (1981). Roper quotes the military historian and business commentator Corelli Barnett's sympathetic review of Weiner's book. What was so striking about Barnett's review, Roper suggests, was the way that he amplified the gendered metaphors of Weiner's decline history. For Barnett, like Weiner, the UK's economic crisis stemmed from the way that the education system – especially in its elite institutions of Oxbridge – had drained the virility of England's middle-class men and in consequence shorn its industry of the necessary levels of 'industrial spirit'. Roper quotes Barnett invoking the castration scenario of UK industry: 'Here amid the silent eloquence of grey Gothic walls and green sward, the sons of engineers, merchants, and manufacturers were emasculated into gentlemen' (Barnett, quoted in Roper 1994: 24).

For Barnett, then, instead of reproducing the aggressive desire for profit and the spirit of enterprise of their fathers, the education system had turned the sons of the great British entrepreneurs into men disdainful of industry and more interested in pursuing the genteel and cultured lifestyle of the aristocracy. In a prescription which echoed that of the new wave management theory, the solution for Barnett, as for Weiner, was the reinstalling of enterprise in the making of 'aggressive and acquisitive capitalists' (Roper 1994: 25) .

A slightly different gloss to this decline history was given by the political advocates of what was increasingly confidently referred to as 'enterprise culture' within the Thatcher governments of this period. Rather than single out the education system as the source of the crisis in the UK economy, the advocates of 'enterprise culture' focused their spleen on the welfare state. Its bureaucratic and overweening structures were charged with producing a 'culture of dependency' that was antithetical to enterprise. Conservative politicians like Lord Young (1992) invoked highly gendered images of economic revitalisation. Warming to his theme in a speech delivered to the British Institute of Management in 1987, Lord Young – the man whose self-proclaimed reason for entering politics was to see enterprise regained within UK industry – pressed on about tough competition, ruthlessness and the steely individual pursuit of profit as central to turning around the UK's economic fortunes.

Alongside the images of masculinity coded within the discourses on enterprise culture, there was the promotion and celebration of new business heroes. As if called by destiny (or by the same dark desires which gripped the soul of Lord Young) to fulfil their roles as figureheads of the enterprise culture, men like Lord Weinstock of GEC rose to prominence in the pages of the business press. For Michael Roper, two discrete versions of the enterprising man emerged. On the one hand, within the manufacturing sector, the ruthless financial manager appeared (men like

Weinstock), prepared to apply root and branch cost-cutting surgery to companies. On the other hand, within services industries like retailing, a more flamboyant manager appeared: men like Sir Ralph Halpern of the Burton Group or George Davies of Next, who were both aggressively enterprising but also in tune in their own self-presentation with the increasing importance of styling and design in marketing-led forms of service and goods production. In Roper's own study, these new masculine heroes of business contrasted strongly with the subjects of his story: career managers in the manufacturing sector who had begun their careers in the 1950s and whose masculinity was shaped around a celebration of a different cult of masculine toughness based upon hands-on experience, the pleasures of technical know-how and the formative generational experience of national service. It was these managers – and their versions of masculinity – which were challenged in a very direct sense by the ascendancy of the enterprising men. As the economic significance of the sector in which they worked declined, a strong theme of Roper's account is the way these career managers – formed by an earlier business culture – felt themselves under pressure and often literally cast aside as 'yesterday's men'; villains of the enterprise culture piece, charged with letting UK business become the most uncompetitive in Europe.

The gendering of business narratives and the way that sectoral and generational variations helped to differentiate the particular masculinities associated with them in the 1980s – themes which emerge from Roper's account – are highly pertinent to my argument about the regime of masculinity associated with the advertising industry in the mid to late-1980s. The short narration that I began this chapter with – WPP's acquisition of the Ogilvy Group – is a rich source of these masculine languages of business. The reporting of the acquisition revealed a celebration of entrepreneurial manliness written through with the symbols of virility. The apparently insatiable appetite of Sorrell and his colleagues for the acquisition of more and more companies, and the effect of this acquisition programme in transmogrifying a shopping-trolley manufacturer into the world's largest marketing services group in under five years, drew upon narratives of heroic masculine sexual prowess, casting acquisition as the sign of corporate virility. The deployment of this masculine language of business was very clear in the advertising trade press and *Campaign*, the leading trade journal, high on the heady thrills of acquisitions and economic growth in the industry during this period, thrilled to 'dynamos' like Sorrell (see, especially, *Campaign*, 16 February 1987: 28)

More significantly, WPP's acquisition of the Ogilvy Group also threw up other competing images of masculinity. In the reporting of the takeover, the business transaction was presented in highly personalised terms: it was Martin Sorrell's company taking over David Ogilvy's company, rather than a business transaction guided by commercial calculations. In some reports

Ogilvy drew on an older language of family capitalism in attempting to gain the moral high ground from Sorrell in the acrimonious public exchanges. He cast the Ogilvy Group as his child under threat from Sorrell, the hard-headed and soulless financial operator who lacked an understanding of the emotional and familial ties of business. The fact that these were, in Ogilvy's case, largely imagined was beside the point. It was, though, the contrasting images of the two men which was so striking about the whole takeover saga. Ogilvy, the English advertising man who had established Oglivy and Mather in Madison Avenue in 1945 and made it into a key player in postwar advertising both in the States and the UK, embodied the masculine qualities and expertise of the US advertising executive in its classic 1950s and 1960s mould. One of the most respected copywriters and advertising strategists of this period, Ogilvy represented the image of an industry dominated by – if not quite gentlemen amateurs – then clever university graduates with high levels of written and verbal acumen and a fascination with the process of selling. In particular, it was the deployment of the craft of copywriting skills to the solution of a marketing problem which was at the heart of the professional life of men like Ogilvy. On top of this, Ogilvy was not shy in using his skills at marketing and advertising for his own ends. His writings are full of self-glorification as well as his crafting of a testy and belligerent masculinity. Taking on the advocates of 'creative advertising' in one of his books, his tone was typical:

> What is a good advertisement? An advert which pleases you because of its style, or an advert which sells the most. They are seldom the same. Go through a magazine and pick out the adverts you like best. You'll probably pick those with beautiful illustrations or clever copy. You forget to ask yourself whether your adverts would make you buy the product.
>
> (Ogilvy 1983: 24)

It was these qualities which certainly came to the fore in the reported exchanges with Sorrell in the period prior to the takeover of the Ogilvy Group by WPP. Damning Sorrell as 'an odious little jerk' and a 'megalomaniac' – in the expurgated versions of his comments – Ogilvy played the role of the grand old man affronted by the impertinence of the philistine upstart. Sorrell's public image was altogether more interesting. His short, fleshy, bespectacled figure displayed counterpoising characteristics to what the *Financial Times* called the 'volcano' of Ogilvy; calm, not easily irritated, unfailingly polite and self-deprecating, Sorrell represented the cool-headed financial strategist who – with clinical precision and calculated risk-taking – had effectively bought Ogilvy out of his own company. Educated at Cambridge University and Harvard Graduate School of Business Administration through the 1960s, Sorrell was a chief executive

trained in professional administration rather than a creative director like Ogilvy and many other leading advertising figures. As such he was, during the years of acquisition at least, something of the darling of City investors where financial acumen counted for much. In addition, Sorrell also presented himself as a family man, reportedly flying home in the middle of deals to spend the weekend with his wife and sons (*Campaign*, 26 May 1989: 12). The effect of these reports was to enhance the professional qualities of financial expertise and sound (though not conservative) judgement which he possessed with the image of a man who had his feet firmly on the ground and was without the vanities and maverick individualism of an Ogilvy.

The ascendancy of Sorrell over Ogilvy in the takeover battle marked, then, not only the ascendancy of one company over another but also – in the press commentaries at least – the ascendancy of Sorrell's type of advertising man over Ogilvy's. Sorrell's success chimed with the ambitions of the new management theorists and the advocates of enterprise culture to free up enterprise and centre-stage the single-minded pursuit of profit as the only criteria of business. His was not the only image of the new enterprising masculinity produced within the business narratives of the industry in this period, however; a more flamboyant image of this masculinity was associated with the key players within agencies formed on the cusp of the 1970s and 1980s. The founding statements of many of these so-called 'second wave' agencies – agencies like Abbot Mead Vickers SMS, Gold Greenlees Trott, Wight Collins Rutherford Scott (WCRS), Leagas Delaney and Bartle Bogle Hegarty (BBH) – were quite explicit in their articulation of this new business language.[8] The central business strategy of all the agencies was to offer the services of the agencies' founding partners (and what the agencies saw as their key assets) directly to clients. Being close to the client in this sense was about – in the words of Robin Wight of WCRS – 'eliminat[ing] the non-productive middle men in the client agency relationship ... [and] investing in fewer but higher calibre people' (*Campaign*, 11 December 1987: 47). John Hegarty of BBH similarly emphasised the ambition to involve the agency's principals in the day-to-day running of the agency and – unlike WCRS – BBH put in place management structures which allowed the agency's founders to continue to work directly with clients as it grew on the back of account gains through the 1980s.

Building the service of the agency – at least in principle – around a 'close to the client' philosophy formed a key strand in the so-called 'small shop' ethos proposed by the 'second wave' agencies. This vision of how an agency ought to be organised as a business was explicitly set against the organisational structures of the large agencies – typically US-owned – which dominated the industry in the 1970s. It was also distinct from the new organisational vision of the 'global one stop shop' being pursued

during the 1980s by Saatchi and Saatchi and in the latter part of the decade by WPP. The way the 'second wave' agencies represented the differences between themselves and these other types of agencies was significant. A gendered and generational language of enterprise loomed large, with the 'second wave' agencies casting themselves as small 'hungry' shops free of the organisational sclerosis of large agencies and setting out to aggressively take clients from them. In the founding statement of Leagas Delaney these aggressive overtures were made explicit. As the statement put it, '[we aim] to rip large pieces out of agencies that have grown fat.' (*Campaign*, 11 December 1987: 47).

Representing themselves as lean and predatory businesses sat alongside a strong emphasis on creativity as a distinctive feature of the service offered by 'second wave' agencies. The importance of this privileging of creativity for my argument here is that it again connotated the dynamism and boldness of the 'second wave' agencies. Producing innovative and provocative work – work that, in the words of Gold Greenlees Trott's policy statement from June 1980, would get noticed and talked about – was central to the signification of both a new approach to business and the youthful energy of these agencies and, by inference, their founding partners.

In the commentaries on the pronouncements by 'second wave' agencies, then, another version of enterprising masculinity was produced through the languages of business. It was not, however, only within these languages that the discourse on enterprise signified in relation to advertising men during this period. The signification of new work-based identities amongst groups of advertising men within other cultural representations also appropriated the notion of enterprising masculinity. It is to this second dimension of the representation of enterprising masculinity and its impact on the formation of advertising masculinities that I want to now turn.

'AN IMAGE OF SUCCESS': DRESS CODES, INDIVIDUAL CONSUMPTION AND ADVERTISING MEN

As the quote from Michael R. earlier testified, the formation of specific work-based identities amongst groups of advertising men has long involved a certain stylistic self-consciousness and investment in the signs of conspicuous consumption at work. This was certainly the case during the 1980s for groups of advertising men. Significant changes in the sphere of individual consumption for men impacted on the versions of stylised masculinity available to these men. At the root of these developments were innovations in three key markets: menswear, grooming and toiletries products and consumer magazines. In each of these markets, new products were produced or the marketing of existing products was reworked

to appeal to what the producers and service providers identified as shifts in the values and lifestyles of groups of men. New designs in menswear across the three key menswear retail markets – new ranges of fragrances, toiletries and grooming products, the growth of style magazines and the formation of a sector of men's general-interest magazines – were the most tangible signs of these commercial rethinks. Advertising practitioners played a key role in the marketing of these goods and services to what – by 1986 – was confidently referred to as the 'new man'. As such they were deeply implicated in the deployment of new representations of masculinity associated with the selling of these goods and services. In two of the most celebrated marketing campaigns from the mid to late 1980s linked to the new male markets – those of Levi's 501 jeans and 'Brylcreem' hair-care products – it was advertising practitioners who forged the new masculine imagery which marked out the distinctiveness of these campaigns.

As I have suggested, however, the relationship between advertising practitioners and the coding of new highly stylised versions of masculinity did not only operate in one direction – with advertising folk implicated in the production of the new range of masculine imagery. For groups of advertising men the relationship was more intimate: their masculinities were clearly shaped by an investment in these new versions of masculinity. One place where this was evidenced was within the representations of masculinity produced within popular culture where advertising men appeared as exemplars of the new stylised forms of masculinity. This phenomenon was most clear in the pages of those men's magazines which were launched in the mid to late 1980s. I want to use the magazines as a shorthand to reflect on the relationship between the 'new man' masculinities, coded in relation to menswear and new forms of individual consumption for men, and the representation of the masculinity of selected advertising men. Exploring this relationship underpins my assertion that it is difficult to understand the regime of masculinity associated with the UK advertising industry in the 1980s without getting to grips with its relationship to the wider contiguous shifts in forms of masculine consumption.

Advertising men were most likely to appear on the pages of *GQ* (Conde Nast's general-interest men's magazine launched in the UK in 1988) as subjects of interviews or features. These men – advertising executives – were clearly chosen by the magazine because they fitted into the image of the 'new man' *GQ* was concerned to articulate. This conservative version of the 'new man' was different from the more 'avant-garde' version represented in the pages of *Arena*, Wagadon's men's magazine launched two years before *GQ* and the publication responsible for breaking open this magazine market. *GQ*'s representation of a new masculinity was most clearly articulated through its particular version of style, and it was in relation to this version of style that advertising men figured.

113

GQ did much to signify the cultural space within which its language of style operated through its regular sections, 'Body and Soul' and 'Agenda', which strongly coded a version of metropolitan sophistication. A central element of this version of metropolitanism in *GQ* was a play on the notion of the gentleman. For Paul Keers, the UK *GQ*'s first editor, reclaiming the notion of the gentleman was a spin-off from the centrality of success that the magazine promoted. 'Body and Soul' and 'Agenda' were central to the coding of these gentlemanly competencies.[9] They framed the representation of commodities around a traditional notion of the 'gentleman's toilette' and refined, but unfussy consumption. The coding of the objects invited a leisurely, connoisseur's appreciation. An article on port, for example, made much of the drink in terms of financial investment. It suggested that 'with port rapidly becoming an investors' market, this is the ideal opportunity to buy in at your own level' (*GQ* 7, 1989: 25). A short feature on wristwatches, 'Time is Money', emphasised the importance of investing in quality watches because '(although) luxury watches depreciate in value as soon as you walk out the shop ... fine craftsmanship ensures they stay looking good' (*GQ* 7, 1989: 116).

The representation of masculine consumption which *GQ* articulated drew on older notions of deluxe consumption for men. In its representation of the 'new man', then, *GQ* coded a distinctive formation of taste, lifestyle and consumption. This amounted to a subtly updated version of luxury consumption for men in which a set of elaborated competencies in relation to style, grooming and individual consumption loomed large. The magazine did much to underline the cultural connotations of this formation of taste, lifestyle and consumption – and the type of men it wished to speak to – with its first cover star, Michael Heseltine. Heseltine was important to *GQ* because he both represented a conservative version of style and – importantly – the centrality of success and the making of money to its version of masculinity. The editorial which prefaced the extended feature on Heseltine underlined this combination. It stated:

> Success with style – that's the ethos around which *GQ* has been created for British men ... *GQ* will be featuring men such as Michael Heseltine and Terence Stamp who embody both taste and achievement ... and covering menswear, from the influence of top designers, to suits and accessories appropriate for the professional. From aspirations to relaxations, from work to weekends, *GQ* is a manual for those who want to enjoy success with style.
>
> (*GQ* 1, 1988: 120–1)

Looming large in this celebration of 'success with style' was a cultural hero we have already come across in the course of this chapter: the enterprising young executive. In an important article from its second issue

entitled 'Farewell to the Company Man', *GQ* compared the attitudes of executives under 45 years old to those of an older generation. What emerged was a picture of clear differences of approach to work between the two groups. Gone for the young executive were notions of company loyalty (let alone public service) and steady advancement through a company. In their place was an emphasis on individual success and a representation of themselves as enterprising men. 'The modern young executive', the article concluded, 'is fleet of foot and hard of heart. One has to conclude that the corporate man is a dying breed' (*GQ* 2, 1989: 154).

In another feature article, the magazine set out more clearly who these new 'hotshots' were. Tempering a little the more aggressive entrepreneurial rhetoric expounded in 'Farewell to the Company Man', 'Hotshots for the 1990s' brought together ten men under 35 years of age in order to define – as it put it – the nature of success and masculine achievement. The fields of work from which the men were chosen was significant. Alongside a writer (Kazuo Ishiguro), a record industry executive (Nick Gatfield) and an athlete (Steve Backley), the men chosen were a mixture of professionals from the high-profile sectors of the economy of the late 1980s: retailing, the City, insurance and computing and – significantly for my argument – advertising. The advertising 'hotshot' chosen was Rupert Howell, a partner in the agency Howell Henry Chaldecott Lury, and formerly the youngest ever board director at the US-owned agency Young and Rubicam (Howell was 27 at the time) (*GQ* 7, 1990: 124). With a passion for red Ferraris and elegant suits and a reputation as one of the best new business directors in the industry, Howell embodied the precocious and flamboyant enterprising masculinity of the young advertising executive.

Another advertising executive figured in one of *GQ*'s regular 'Style and Substance' sections. This was Robin Wight of WCRS. The feature detailed Wight's wardrobe, reflecting on favourite shoes, jackets and accessories as well as passing comment on Wight's career and leisure interests. Looming large in the feature was a discussion of Wight's trademark bow-ties and waistcoats, together with reflections by Wight on his preferences in suits and the ritual of dressing:

> [Each morning] I hang up my suit, my shirt, a waistcoat, and then go through some ties to see how it all goes together. My wife says it never goes together properly and that I'm probably colour blind. But I think that if things don't fit properly together, they have a bit more energy ... I only have suits made ... because I can find a fabric I really like. ... Once to find to find a fabric I liked, I had to go to ten shops on Savile Row ... I hate putting on a suit in the morning that just isn't interesting.
>
> (*GQ* 2, 1989: 58).

The feature also gave a tantalising glimpse of the extravagance of Wight's lifestyle and his capacity for spending money. Talking about one of his favourite waistcoats, he explained that it was designed for a 'Black and White' party he had thrown. The centre-piece of the party, held at Wight's home in Casewick, was the staging of Donizetti's opera *Don Pasquale* by the Pavilion Opera whom Wight had hired for the event.

CONCLUSION

Where has this account taken us? I have ended by drawing attention to the way the masculinity of advertising executives was represented within popular magazines for men in the 1980s. I suggested that there was a correspondence between the public representation of these advertising men and the new versions of masculine consumption. This underpinned my argument that a flamboyant version of masculinity figured amongst groups of men within advertising during the mid to late 1980s in relation to the codes of style; a version of masculinity quite different from that which dominated in other fields of professionalised work during this same period, such as the public services. As such, then, these findings offer some suggestive pointers to the particularity of the work-based identities of these advertising executives. Clearly, however, in order to present a fuller picture of their work-based identities, it would be important to explore more fully than I can here the living out of these masculinities by advertising executives. Such a study might throw up – as Michael Roper's interviews with the career managers in the manufacturing sector certainly did in *Masculinity and the British Organisation Man* – some of the contradictions and fractures, as well as the competing investments, of the masculinity of these advertising men. In addition, it is important to remember that I have only reflected on a narrow range of advertising men: young or youngish executives.

A point I made earlier in the chapter is worth repeating: there are clear differentiations between groups of advertising men. Quite clearly not all of them participated in the new masculine dress codes associated with the 'new man'. The celebration of a very unstyled approach to clothes was revealed by men like Robert Bean, account manager at Doyle Dane Bernbach, who prided himself on presenting a new business pitch to clients in jeans (and we are not talking about jeans worn as stylish casual wear in this case).[10] The relationship to stylised dress codes, however, was but one index of the differences between different advertising men's masculinities. Generation, social and educational background and organisational function formed the significant variables that cut across and pluralised this distinction.

The centrality of the discourse of enterprise has emerged as a key theme throughout this chapter. In relation to advertising men's self-representation through dress codes, presenting yourself in ways which signified that

you meant business – quite literally – were important. Styling the self at work for these men formed part of their self-representation as enterprising men. It was in relation to the languages of business, as I have argued, however, that the vocabulary of enterprise was most key. Its articulation through a set of highly gendered metaphors privileged certain images of masculinity in the representation of the conduct of business. The hard-headed entrepreneur driven by the pursuit of the profit formed the hero of these languages, constituting an image of virility upon which the success of the economy as seen to depend. Financial strategists like Martin Sorrell – committed to advertising as a vehicle for commercial acquisition – and the partners of 'second wave' agencies – motivated by the image of their agencies as small, highly competitive shops which aimed to take on the lumbering dinosaurs of postwar advertising – represented the two dominant versions of this cultural hero within the business discourses of UK advertising.

What are we to make, then, of these elements of the regime of masculinity associated with the advertising industry in the UK in the 1980s which have emerged in the course of my account? How do we read them, for example, in relation to wider formations of gender and sexual culture? In one sense, of course, they can be read as exemplifying a dominant formation of masculinity produced during this historical moment in which the axis of political, economic, cultural and gender relations of power intersected: a Thatcherite version of the 'new man'. To properly make claims about the significance of these masculinities in relation to the formations of gender and sexual culture, however, would require further work. Specifically, it would require exploring the relationship between these men's masculinities and those of other men working in the industry, as well as – more importantly – the relationship between these masculinities and the femininities of the women working with them. Only by doing this – by reinserting these masculinities within the contiguous formations of gender and sexual culture – would we be able to make more elaborated judgements about their place in the field of gender/power relations. Without this kind of work it is too easy to see only the negative connotations of the languages of enterprising masculinity which I have considered. Implicit in my argument, then, is a plea to defer judgements of this sort about these highly stylised conservative masculinities until more detailed work is done.

I want to end on a positive note, however, by insisting on the importance of exploring the culture of creative services industries like advertising. Given the increasingly important role played over the last ten to fifteen years by advertising practitioners in the 'culturalisation' of goods and services, it is of paramount importance that we understand these key cultural intermediaries. In particular, we need to understand their intellectual and cultural formation – including the way that this is gendered –

precisely because it impacts on their role in cultural circulation. If, as cultural critics, we want to influence this process of cultural circulation, we need to understand the key players in this process. In that way, the basis of a realistic dialogue between cultural critics and advertising practitioners might be developed; a dialogue in which the elevated status of the rhetoric of 'consumer resistance' within strands of cultural analysis would be put into proper perspective.

NOTES

1 For details of WPP's growth see, 'A Crisply Laundered Takeover Victor', *Financial Times*, 30 May 1989; 31; 'Ogilvy Acquisition Helps WPP Soar 86% to £75m', *Financial Times*, 9 March 1990; 24; 'Sorrell: Just Another Day', *Campaign*, 26 May 1989; 16; 'Split Personality Which Made JWT Vulnerable', *Campaign*, 3 July 1987; 18–19; 'How David Ogilvy Ate His Words', *Financial Times*, 17 May 1989; 24.

2 These figures are taken from *Britain's Advertising Industry*, Jordans, Bristol, 1989; *Financial Times*, 17 October 1989; 32; *The Independent on Sunday*, 12 August 1990; 6.

3 Figures taken from *Advertising Statistics Yearbook 1994*, the Advertising Association, NTC Publications Ltd, Henley-on-Thames: 1994.

4 They key shifts in the nature of the advertising business which I have in mind here were, *inter alia*, the increasing globalisation of production and the concomitant construction of new goal markets; the pluralisation of advertising media and an associated segmentation of advertising audiences by media; the emergence of new sectors of advertising which dominated advertising expenditure in the late 1950s and 1970s.

5 For a more detailed account of Saatchi and Saatchi's model of expansion see Part Three, Chapter One, 'Acquisition, the Stockmarket, Diversification and Globalisation: Institutional Developments in UK Advertising' of my PhD thesis (Nixon 1996).

6 This account of new wave management theory owes much to Paul Du Gay's work. See, especially, 'Enterprise Culture and the Ideology of Excellence' (1991).

7 As will be clear my account of these gendered languages of business owes much to Roper's very fine book.

8 For a discussion of the theory of advertising waves see Nixon (1996) Part Three, Chapter One.

9 Interview conducted with Paul Keers, August 1989.

10 See 'The Quest for the Immaculate Crease', *Campaign*, 27 July 1994; 44–5.

REFERENCES

Bourdieu, P. (1979) *Distinction*, London: Routledge.

Du Gay, P. (1991) 'Enterprise culture and the ideology of excellence', *New Formations* 13: 45–61.

Nixon, S. (1996) *Hard Looks: Masculinities, the Visual and Practices of Consumption*, London: UCL Press.

Ogilvy, D. (1983) *Ogilvy on Advertising*, London: Pan.

Roper, M. (1994) *Masculinity and the British Organisation Man since 1945*, Oxford: Oxford University Press.

Weiner, M. (1981) *English Culture and the Decline of the Industrial Spirit*, Cambridge: Cambridge University Press.

Young, Lord (1992) 'Enterprise regained', in Paul Heelas and Paul Morris (eds) *The Values of the Enterprise Culture*, London: Routledge.

7

CAPITAL'S CULTURAL STUDY

Marketing popular ethnography of US Latino culture

Roberta J. Astroff

Contemporary capitalism explores differences with an eye to rationalising them within its own logic. For the most part, researchers in cultural studies have explored difference first through the discourses and practices of 'Othering', and then as a process of identity formation and the production of potentially resistant subject positions. The argument here, however, moves away from discussions of subjectivity toward the discursive economies of racial and ethnic meanings within social institutions. The institutions involved in constituting social identities are not the monolithic, monovocal, totally determining structures that earlier theories (or their parodies) have presented. Rather than some totality looming over 'spoken' subjects, these institutions are systems abounding in varied and at times conflicting sets of disciplines, discourses and values.

This is a study of racial and ethnic formation within the discursive economies of one such institution, marketing. In particular, it is a media study. That is, while later research will analyse statistical methods of market research and the racial and ethnic categories they create, this study focuses on the persuasive narratives about marketing to Latinos that appear in the business media, such as *Advertising Age* and *Business Week*. I analyse the production of a target market labelled 'US Latino' out of a set of ethnic, national and racial identities, and the distribution of knowledge about this product through marketing and media business publications. To do so, I borrow from the contemporary critique of ethnography to study these narrative representations of 'Others' (Marcus and Cushman 1982; Clifford and Marcus 1986; Handler 1986; Appadurai 1988; Clifford 1988; Richer 1988; Abu-Lughod 1991). I propose here that market research parallels ethnography as the way in which capital conducts its own explorations into category formations, subjectivities and everyday uses of cultural forms. Market research is 'capital's own cultural study' (Johnson 1986–7). Thus my focus here is the marketing industry's exploration/creation of 'new' cultures (of consumption, i.e. markets), the way

the media industry identifies, studies and distributes knowledge about a culture. In particular, how do these 'popular' marketing discourses legitimate their talk about 'other'? How do they produce what they set out to find? What is the nature of the 'culture' so produced? What are the relations between this marketing discourse on culture and broader social discourses on cultural identity?

In choosing to analyse the construction of cultures and difference through marketing practices specifically, I also begin to address the relationships between racial, ethnic and economic discourses. The engrossing literature on race and discourse refers in intriguing ways to these relationships but has not pursued the issue (Omi and Winant 1986; Chabram and Fregoso 1990; Goldberg 1990, among many others). Omi and Winant address the issue only in a footnote, stating 'we believe that all social relationships, including those of material production, are inherently structured politically and ideologically, as well as by 'market rationality' (a category which also has non-economic aspects) (Omi and Winant 1986: 152, n. 3). They go on to quote Laclau:[1]

> Today we see that the space which traditional Marxism designated 'the economy' is in fact the terrain of proliferation of discourses. We have discourse of authority, technical discourses, discourses of accountancy, discourses of information. Even categories such as profit can no longer be accepted as unequivocal. . . . The functioning of the economy itself is a political functioning, and cannot be understood in terms of a single logic. What we need today . . . is a non-economistic understanding of the economy, one which introduces the primary [sic] of politics at the level of the 'infrastructure' itself.
>
> (ibid.: 152)

Nevertheless, within most cultural studies of race and ethnicity, including Omi and Winant's, discussions of the economic focus exclusively on the intersections of class and race, and maintain economistic understandings of the economic. Within studies of race, ethnicity and media, definitions of the economic are limited to ownership and advertising dollar flows, and, as in the debates around *The Cosby Show*, representations of class identifications of racially marked characters. Van Dijk, in his introduction to *Communicating Racism*, urges researchers to correct 'the denial of the structural nature of racism in our societies', saying that much research

> ignores and thereby confirms and reproduces the fact that both blatant and very subtle racism permeates *all* social and personal levels of our societies: from the decisions, actions, and discourses of the government or the legislative bodies, through those of the various

121

institutions, such as education, research, the media, health, the police, the courts, and social agencies, all the way down to everyday inter- action, thought, and talk.

(Van Dijk 1987: 5)

Note, however, that the economic does not exist at either social or personal levels in this schema. In fact, Van Dijk explicitly omits what he refers to as the 'economic elite' from his list of 'elites ... in control of the decisions that directly affect the daily lives of ethnic minority groups and their members'. In his view, 'economic elites' are defined narrowly as 'corporation directors and managers', who 'have only indirect control over the reproduction mechanisms of ethnic attitudes'. This is in contrast to 'cultural elites':

> media workers, teachers, researchers, writers, and many others are engaged directly in the production of knowledge, beliefs, interpre- tive frameworks, fictional representations, and their persuasive effects. ... As the experts in matters of 'formulation,' they are the ones who produce the dominant discourse environment of a racist society.

(ibid.: 368)

In contrast to Van Dijk, the underlying premises of this article are that the market is constructed discursively, and that those who construct markets, as per Laclau and Mouffe, are also of course 'experts in matters of formulation'. Market discourse and the 'economic' are profoundly articulated with and shaped by discourses of identity and difference such as the 'problematically abstract categories' of class, race, sexuality and ethnic origin.[2]

MARKETING AND ETHNOGRAPHY

Discussions of the connections between economics and anthropology are not new but can benefit from some expansion. As has been noted else- where, anthropology has carefully hidden its market economics as part of its construction as an objective social science (Fox 1991). Funding and other conditions of the production of ethnographies are mentioned in acknowledgements but are absent from the ethnographic texts them- selves.[3] Critical writings on anthropology have revealed the exchange relationship of the ethnographers with informants, in which goods, money and status are exchanged for information. Other critiques reveal the economics of ethnography itself in the appropriation of knowledge and the exchange of that knowledge by the ethnographer for royalties, tenure and prestige (Clifford and Marcus 1986; Marcus and Fischer 1986). These latter critiques focus on the anthropological 'factory', its disciplinarity and

122

the symbolic field that enabled the development of the discipline (Richer 1988; Fox 1991; Trouillot 1991). Their argument is that the emphasis by the postmodern critique on the *writing* of the ethnography perpetuates the image of ethnographer as individual artisan instead of anthropology as industrial discipline. This approach emphasises the structures that discipline anthropology and analyses its 'points of production', workplaces and involvement in the circulation of academic capital (Fox 1991). It is this notion I wish to capture from within communication studies via 'discursive economies'.

However, the parallels between marketing and anthropology go beyond signalling anthropology's market economics. Both anthropology and marketing research can be seen as systems through which cultures are made knowable – that is, identified, defined and codified. Marketing, like anthropology, provides paradigms, theories, definitions, values and needs that are used to identify and produce cultures and markets. These processes in both anthropology and marketing make cultures into marketable goods according to their own disciplinary and economic structures. This does not deny the very real differences between ethnography and marketing, but points to the similarities in their effects.

In the following analysis I pursue the parallels between ethnography and marketing on the grounds raised by now well-known critiques of ethnography. The marketing para-ethnography examined here consists of a set of texts that attempt to define Latino culture and explain Latino values and behaviours. Articles promoting US Latinos as consumers with money to spend – and advice on how to get them to spend it – are published in business magazines such as *Business Week* and *Broadcasting*, the business sections of newspapers such as the *New York Times* and the *Los Angeles Times*, as well as in marketing journals, specialised marketing textbooks and annual special reports in *Advertising Age*. These articles are presented as providing marketing and advertising industry decision-makers with information.[4] They are also of course persuasive, intending to sell this market to advertisers. I label this para-ethnography as 'popular' to distinguish its context, style and production from market research that presents itself as science (as well as a product for sale, for example survey research and the information it produces). Particularly striking in this para-ethnography are the uses of a rhetoric of exploration and discovery, of native informants and cultural brokers, and the reification of what have been identified as cultural characteristics.

EXPLORATION AND THE NATIVE INFORMANT

Ethnographers and other post-colonial critics, in challenging models of exploration and discovery as well as the nature of ethnography, have replaced the notion of discovery with that of invention or creation.

The knowledge of the others brought back from voyages of exploration is produced in the context of existing disciplines, often before the voyage begins (Said 1978; Todorov 1984). The textual aspects of ethnographies are seen as complicit in constructing or maintaining the distance between so-called Selves and Others. This can be physical distance, often represented by tales of the anthropologists' travel hardships, as well as temporal distance, created as 'traditional' societies are represented as static, unchanging and originating from an earlier period in the evolutionary process than the anthropologists' society (Fabian 1983). Difference as distance is established as distinguishing characteristics of the culture are identified by the anthropologist in collaboration with informants, then reified, fixed and presented as an 'incarcerating mode of thought' (Appadurai 1988: 37).

A similar process can be seen in our marketing para-ethnography. The echoes of voyages of discovery and exploration resound in the advertising trade press as it touts the 'discovery of a new world' and 'Spanish gold' (Paredes 1979; McGuire 1982; Astroff 1989). These articles provide information gleaned from explanations from native informants, cultural brokers and reports from the field, encouraging advertisers to *pursue*, *reach*, *explore* and *discover*[5] these markets, which are presented as naturally existing resources.

In an analysis of the production of ethnographies through Marxist assumptions about the labour process, Richer argues that the ethnographic production process is one of a triple hermeneutic:

> We begin with the raw materials – a culture, or a set of socially meaningful practices. Much of this meaning, however, resides in what Giddens terms the real of 'practical consciousness' – the 'tacit stocks of knowledge which actors draw upon in the constitution of social activity'. A good part of the work of the anthropologists is to bring these elements to the plane of 'discursive' consciousness, i.e. knowledge which actors are able to express at the level of discourse. This essentially involves moving one's informant to the point of being able to be reflective about his/her taken-for-granted world. The culture is thus first mediated by its objectification on the part of the informant. It is simultaneously mediated, however, by what I have called the third culture, that set of meanings created and reproduced via mutual cultural accommodation of anthropologist and informant. Finally, it is again mediated when the anthropologist, typically away from the field, finalizes his or her interpretation in the form of an ethnography.[6]

(Richer 1988: 409)

The last stage in this process is the exchange of the ethnography for academic capital (publications, reputation and tenure) and for royalties.[7]

This describes the production of 'US Latino culture' in the popular business press as well. The authenticity and legitimacy of the narrative about Latino culture is provided in part by reference to Latinos who are advertising sales and creative staff members, owners of agencies and research firms, heads of divisions within larger agencies, all specialising in marketing to Latinos. These informants speak for and about Latinos as they objectify Latino culture.[8] Identified repeatedly as both Latinos and as participants in the advertising and marketing industries, they are a source of blanket explanations of Latino culture as it relates to buying practices, overtly operating as guides through an alien culture. As participants in the industries, they work then as 'cultural brokers', in traditional anthropological terms, or as cultural intermediaries, who 'have the capacity to ransack various traditions and cultures in order to produce new symbolic goods and in addition provide the necessary interpretations on their use' (Featherstone 1991).

Their ads for their services emphasise these capacities, and they also serve as sources and often author articles in the same 'Special Market' sections of *Advertising Age*. Lionel Sosa, president and creative director of Sosa and Associates, an advertising agency specialising in Latino marketing, and Bernadette Brusco, vice-president and director of marketing of the same firm, are marketed, respectively, as follows in their ad:

> Over 17 years' experience in advertising. 42 years' experience as Hispanic. His first-hand and wide-ranging involvement in the Hispanic market has led him to be regarded as one of its leading experts.
>
> A reformed academic with 15 years' experience in cultural anthropology and behavioral sciences. She is in the forefront of creating and implementing current Hispanic marketing theory. (Not bad for a partially bilingual Italian from South Philly.)
>
> (*Advertising Age*, 15 February 1982: M12, 13)

Thus their value lies in membership of multiple cultures. They present their professional experiences, ethnic backgrounds and linguistic abilities as credentials for their role as cultural brokers. Through their language use, heritage and skills they claim identity as expert members of *all* pertinent cultures. Brusco's academic credentials compensate for her non-Hispanic ethnic background and limited use of Spanish, while Sosa's advertising work is equated with his Hispanic identity. This equation of professional identity, language and ethnic identity is apparent throughout this discourse, with one agency claiming expertise and identity in Anglo culture, Hispanic culture and the industry by advertising itself as 'trilingual ... we also speak marketing'. Working within the paradigms,

theories and determinations of which marketing as a system is composed, these cultural brokers first objectify selections from various Latino institutions and practices as 'Latino culture'. Their constructions of Latino culture are certified in the trade press by virtue of their authorisation as members of Latin cultures, and, in Brusco's case, as social scientists. The knowledge so produced is then disseminated in these publications and reproduced as general knowledge.

This knowledge is not created for, nor, at this stage, transmitted to the communities being studied. That is, this study is not examining the advertisements aimed at the Latino populations in the United States, but rather the persuasive efforts aimed at those segments of the marketing and advertising industries that might then decide to market to Latinos. The production, circulation and exchange of knowledge and images examined here remains within the marketing industry. Thus, the Latino cultural broker's work is the site for the creation of what Richer calls the third culture: 'that set of meanings created and reproduced via mutual cultural accommodation' of marketing and Latino identity. The phrase 'mutual accommodation' should not be taken to indicate a denial of power relations. Nevertheless, all the participants in this accommodation have a stake in its smooth production. It is obviously to their economic advantage to work within 'the impression-management of ethnicity' (Briggs 1971: 53) to construct a marketable population of Latinos by maintaining a limited, controllable degree of difference.

That accommodation involves the interaction of marketing discourses with discourses of identity. As in classic liberal political theories of ethnicity, in which ethnic identity is structured 'on a particular notion of the marketplace and of politics as consumption' which works to 'tame' difference (Chock 1989: 177), the marketing industries reconstruct ethnic identity as 'yet another structure of commodity relations', as Dunn (1986: 50) said in a slightly different context, 'organiz[ing] the viewer's relationship to cultural meanings according to the dictates of the role of the consumer'. Thus, ethnic identity is reconstructed as a market segment. Specifically, this discursive economy of market economics draws on basic marketing talk – of consumer product use, product tie-ins, sales and conglomeration of specialty ad agencies, media use and sales, etc. – and on broader discourses of nationality, ethnicity and ethnic cultures. The elements drawn from these last discourses include origin stories, definitions and questions of assimilation and identity maintenance, and supposed explanations of cultural behaviours.

In the 15 February 1982 special section on marketing to Hispanics, for example, an article titled 'Beer Still Tops Wine, Spirits' intertwines descriptions of Latino culture with marketing techniques and goals:

126

Mr Maiken [in charge of the sales of Amaretto Di Saronno] readily admits, however, that the job is bigger than just convincing Hispanics to buy the product. Hispanics have traditionally never consumed much liqueur, so marketers of liqueurs must sell the entire concept and image of the beverage. . . .

Beer marketers in the US have never had to educate the tastes of Hispanic-Americans to their product. Beer has traditionally been important in private consumption and as a key ingredient in social gatherings. . . .

In most cases, the wine, spirits or beer marketers looking to score points in the Hispanic market have hired in-house Hispanic talent to handle the advertising and promotion or have contracted with specialists in advertising to Mexican-Cuban-American [sic] and Puerto Rican consumers.

Here a report from the field, describing action taken by marketers dealing with Latino culture, draws on elements from a sort of anthropology of 'Hispanic' culture, identifying elements of tradition, food, ritual, social gathering and, later in the article, the supposed special importance to Latinos of status and prestige. This information on 'Hispanic culture' is presented without attribution, and as general knowledge.

Marketing practices are then chosen in response to enter this culture, participate in and redefine supposed traditional activities. Thus, various community functions are sponsored: fundraisers, street festivals and 'even a low-rider auto program in Los Angeles'; and attempts are made to 'focus on Hispanic pride' by creating television commercials that 'show Hispanics saving the day – a baseball relief pitcher who strikes out an opponent to win the game, an auto mechanic fixing a car no one else could . . .' ('Beer Still Tops Wine, Spirits' 1982). At the same time in this active discursive economy the marketers' notions and practices often have to change in response to this 'knowledge' of Latino culture:

Coors commercials and print ads using 'The High Country' theme to connote the beer's clean, light taste and purity of its brewing water did not translate well for the Hispanic market. Mr Serber said studies proved many Hispanics were so unfamiliar with the concept of mountains, hiking, etc. that the theme's imagery evoked little response. So Coors premium beer instead developed the theme, 'Another cold one, another Coors.'

('Beer still tops wine, spirits' 1982)

Specialised 'knowledge' of Latino culture then is necessary to marketing successes. The solution is to turn to the specialists, to the cultural brokers, to act as guides.

THE USES OF CULTURE

The majority of the articles comprising such ethnography are of this type. They assign buying practices to a supposed Latino culture, present supposed traditions as explanations, adopt and present various odd elements of this constructed culture as general knowledge. They explain away unsuccessful advertising campaigns by reference to supposed Latino cultural traits, and, of course, recommend the hiring of specialists.

This use of culture reifies differences; that is, in marketing as well as in anthropology, only differences that are of value to the exploring disciplines, and those differences are taken to stand for an entire, essential whole (Appadurai 1988). Abu-Lughod notes that

> Culture is the essential tool for making other. As a professional discourse that elaborates on the meaning of culture in order to account for, explain, and understand cultural difference, anthropology also helps construct, produce, and maintain it. Anthropological discourse gives cultural difference (and the separation between groups it implies) the air of the self-evident.
>
> (Abu-Lughod 1991: 143)

The sources quoted in these articles, and the articles themselves, argue for the necessity of segmented advertising and advertising and marketing agencies that specialise in these 'different' markets. When some of the supposed cultural differences are challenged – and the most common challenge points out that US Latinos watch and read English-language media and their ads – other differences are produced. That is, the discourse of ethnic markets constructs, produces and maintains differences.

However, the constant use of unattributed cultural explanations signals a significant difference between anthropology's ethnographies and marketing's para-ethnographies. The former attempt to construct their representations of cultures, as Richer points out in the above quote from his article (see p. 124), out of informants' narratives of their culture and on observation, however structured by the history and politics of their discipline. In contrast, the article on the consumption of beer in Hispanic communities refers vaguely to unattributed 'studies' to support the highly dubious statement that Latinos are 'unfamiliar with the concept of mountains'. Such references thus become a fall-back to support the use of stereotypes, bolster dubious information and explain advertising campaign failures.

Market segmentation attempts to control or manage difference, assigning value to certain differences, making invisible those differences seen as of little value to the market, and reducing other (supposed) cultural differences to technical problems for advertising's media buyers. This control of difference, however valuable, is nevertheless more a desire

on the part of the industry (and applied social science) than a fact. Industry rhetoric is always speaking against other existing discourses of Latino identity. The market is not of course the only institutional site where such constructions of identity are being made. Latino politics, schools and the US census, among others, are all struggling to develop a definition of 'Latino' that could accommodate or contain a varied set of diverse populations within one category. Thus the marketing industry, as well as other disciplinary institutions, is constantly trying to corral a culture or sets of populations and cultures that keep escaping, untidily and unevenly, from their supposed boundaries, refusing to behave in line with what certain narratives have identified as the rules of their cultures.

At the same time, segments of the marketing industry worked for decades both through and against prevailing stereotypes to establish the value to the advertising market of certain US Latinos as people who consume media products and spend money. In the 1960s and 1970s, for example, the industry had to argue against a construction of Mexicans and Chicanos as itinerant farm workers with no money to spend. In addition, and continuing into the 1980s, they fashioned a Latino culture, in part out of existing stereotypes, in which the men were too macho to accept suggestions from commercial voice-overs and the women so submissive they would be frightened by a Mr Clean ad campaign (Dickstein 1975; Rosales and Rosales 1979; Diaz-Albertini 1981). Efforts were then made to provide instructions for navigating around these obstacles, establishing the value of the services of cultural brokers, who worked to translate supposed cultural handicaps into boons to marketers.[9] Arguing for the the value of this population, marketing discourse picked up rhetoric from other social institutions, and gradually incorporated the talk of the 1980s as the 'Decade of the Hispanic' (Ferre 1982). Some marketing texts eventually argued, against a wider social discourse about uncontrolled immigration, that undocumented workers were of value to the market as consumers and that Latinos could be 'Americanised' through consumption (Weiner 1978).

But the ability of the industry to *maintain* this necessary, profitable degree of difference is uncertain. Assimilation, seen in other discourses as a positive outcome of consumption, presents a problem for advertisers and marketers. If, despite marketing discourses, Latinos are not a single racial group, as census questions now point out; if not all are Spanish-speaking or if most are bilingual; if they watch English-language television; if they use coupons and buy 'all-American' products at American malls, where in fact, marketers ask, is the difference? Thus the industry takes refuge in culture, both ethnic and national, and in science.

While internal knowledge of Latino culture is a primary authorisation in this discursive economy, a discourse of social science is also valued in these popular business articles as a legitimiser, particularly as a possible

source of 'better information'. This discourse makes reference to statistics and research reports produced by firms with names like Market Segment Research and Strategy Research. It is also the basis for many articles and several legal battles over the years involving US Latinos and the US census, Arbitron and Nielsen Media Research. Credibility appears to be the most important product of this discourse. However, the language used in the popular business press to discuss this credibility, in the context of Nielsen's peoplemeter entry into Latino audience research, also reveals the discourse's fundamental contradiction:

> Mr Comber [Procter and Gamble's manager of target marketing] expects ad spending to increase because of increased confidence in the data. 'Once you have a set of numbers people believe in, they are more inclined to invest. It's a positive move, toward more of a science and less of an art,' he says.
>
> (Moncreiff Arrarte 1990: S6)

This science that requires and evokes belief, however, has in its own history shown the effects of its interaction with discourses of race, nationality and ethnicity. *Spanish USA* (1981) is a Yankelovich, Skelly and White, Inc. marketing research report intended to 'define the character of the US Hispanic population and examine its true value as a market'. Commissioned by the SIN Spanish Television Network (now Univision), the report claims in its introduction to be the first market study of its kind. But the discursive economy of market research and discourses of race, ethnicity and nationality is such that, despite claims to objective science, discourses of nationality and race shape the information produced.

The most significant evidence of this is graphic: out of twenty-eight tables on US Latino demographics and media use in the Yankelovich et al. study, all but two use national origin, not socio-economic status, as category headings. That is, instead of organising their data about consumer behaviour by family income, occupation, education, etc., as is usual in market research, all information is provided in categories labelled 'Puerto Rico', 'Mexico', 'Cuba', and 'Other'. Only in one table – 'Hours Spent With the Three Media' – is the same information organised comparatively: one table based on country of origin ('Hispanics by National Groups'), the other on family income ('Hispanics by Income Group').

This conflation of nationality with socio-economic status allows the marketers to segment the Latino market while maintaining a distinction between 'Anglos' and Latinos of similar class. That is, differences within national communities – between poor immigrants from Mexico versus middle-class Mexican-Americans who can trace their residence back to Spanish California; 'white' middle-class Cubans resident in the US since the 1960s versus the poor Afro-Cuban 'Marielitos' who arrived in the 1980s; wealthy Puerto Ricans breeding racehorses on the island versus

130

working-class Nuyoricans – disappear. Afro-Latinos disappear altogether. Contrasts in consumer practices are implicitly and explicitly made among 'Hispanic', Anglo or White (synonyms in these articles) and Black (Astroff 1989). Nationality equals race equals socio-economic status, arranged in a clear hierarchy with Cubans at the top. From the first article until the most recent, Cubans in the United States have been defined in advertising trade texts as white and affluent; and as such a valuable market to target ('Cuban invasion story . . .' 1966; Moncreiff Arrarte 1990).[10]

These uses of nationality and of 'culture' are evident in the following attempt to define Cuban-American cultures and consumers:

> Anays Robles and Roberto Suarez are like many successful married professionals in their 30s. They own their own home, drive new cars, and spend a significant portion of their annual $100,000 income on entertainment, clothing and popular consumer goods.
>
> *But unlike yuppies, the Suarezes are yucas – young upwardly mobile Cuban Americans. For marketers targeting this affluent niche, it is a crucial distinction.*
>
> 'This market segment has a great deal in common with yuppies,' says Gary Berman, president of Market Segment Research. But there are two important differences. One they hold on to their traditional values of family, religion and language. Two, and most important, they are bicultural and bilingual – they have options.
>
> The facility to participate in Cuban and Anglo cultures makes them both hard to find and hard to target. But their high incomes, unique dependence on the wealth of their families, and full participation in the accoutrements of the American dream make them especially alluring as an upscale target.
>
> (Moncreiff Arrarte 1990: S6 [emphasis mine])

Here, once again, the market discourses rely on an 'anthropological' reading of the lives, and consumption habits, of Cuban Americans. Their difference as yucas rather than yuppies is established through mention of their traditional values and a supposedly unique way of life – that is, through their culture. The young upwardly mobile Cuban-American Robles-Suarez family, despite their 'American' consumption, are different because of their cultural traits: a traditional emphasis on family, language and religion. But this difference is limited, controllable and valuable, since they are affluent consumers. Their difference is not a challenge to the American dream, since we are told later in the article that Mr Suarez wears a Rolex, dresses in Armani suits and drinks Absolut vodka. They simply present a challenge to marketing techniques and are dealt with in those terms: the question the article raises is where to advertise to reach this lucrative market.

131

Thus, marketing talk of affluent versus lower middle-class consumers, Armani buyers versus K-Mart shoppers becomes synonymous with the national categories of Cuban Americans or Mexican Americans, respectively. Puerto Ricans and the 'Others' – Colombians, Guatemalans, Dominicans, etc. – are generally placed at the bottom of the socio-economic hierarchy in marketing texts and thus are of less value. One exception, noted in an article on yucas, is the possible development of 'yunas': 'the children of Nicaraguan professionals who fled the Sandinista regime' (Moncreiff Arrarte 1990: S6). Thus there is also an obvious political as well as racial discourse, which we can see in the values ascribed to middle-class refugees from the leftist revolutions of Cuba and Nicaragua, and in the value they accrue when offered for sale in this ethnic market.

The industry's turn to culture as an explanation is doubly ironic. First, the portrait painted of Anays Robles and Roberto Suarez does *not* contain many of those supposedly 'traditional and unique' values of 'family, religion and language' used to define 'Hispanic culture'. Despite the supposed emphasis on family, the Robles-Suarez couple do not appear to have children nor do they apparently live with other family members. No mention is made by either of them (or by anyone else in the article) of religion. The 'traditional and unique' emphasis on family in this article is actually a reference to inherited wealth – 'their unique dependence on the wealth of their extended families'.

Thus the second irony: the cultural theories of both anthropology and marketing produce an image of cultures as bounded and discrete, as 'coherent cultural Others' (Abu-Lughod 1991: 146). In the above example the coherence of a cultural explanation is promoted even though the ideal family chosen for presentation contradicts the stereotype. In practice, however, marketing specialists must deal with the constant changes, contradictions and conflicts which exist in actual lived cultures and with their own perpetual surprise and frustration when these cultures do not live according to the so-called rules. It is at these moments of frustration that a call is made for better, scientific information. And it is in this same framework, I argue, that the efforts of the marketing industry to represent other cultures and to pin down the elusive, illusionary borders of cultures can be best understood as a discursive economy, one that would allow for 'the possibility of recognizing within a social group the play of multiple, shifting, and competing statements with practical effects', as Abu-Lughod (ibid.: 148) defines discourse.

The notion of a 'discursive economy' has an obvious double meaning in this analysis. By 'economy', I include notions of production, distribution and consumption of meaning (and of ethnic target markets), as well as a non-economistic understanding of the economy. The term 'economy' is used frequently now in non-economistic ways in writing on culture, as

in 'economies of truth', 'an economy of power', an 'economy of involvement', or 'the economy of meanings'.[11] Economy used in this way denotes a dynamic structure or ordering of elements and their interaction, a way of historicising and examining the interactions of discursive hierarchies. 'Economy' allows us not only to reference the dynamic action of exchange but also the notion of value.

As defined by the marketing textbooks, the discursive economy of the marketplace includes talk of information, products and networks. It also includes those discourses of rationality, technique, profit and value that Laclau lists. In addition, discourses of race and nationality are not incidental to, or simply added into, an already existing discursive economy of the market, but instead function as discourses that, among others, shape the market. They are intrinsic to the process of assigning value to differences.

San Juan (1992: 11) asserts that 'race as the mystifying logic of Otherness coincides with a programmed centralized system based on exchange value: the production, circulation, and consumption of commodified Others'. This present study functions as a sort of sympathetic critique of San Juan's 'programmed, centralized system'. This monolithic image is challenged by studying the discursive economy of market research on Others. While this is in fact a study of the 'production, circulation, and consumption of commodified Others' – in the form of the production of ethnic target markets – the various marketplace discourses on race and ethnicity and their variations, changes in their relative authority, their multiple (i.e. non-centralised) sites of origin and their interactions with broader social discourses argue against any view of the institutions involved in constituting social identities as monolithic, monovocal totalities.

NOTES

1 The citation is actually of Ernesto Laclau and Chantal Mouffe, 'Recasting Marxism: Hegemony and New Political Movements' *Socialist Review* 66.

2 I take these examples from Lila Abu-Lughod, 'Writing Against Culture' (1991) who also includes 'living situation (urban or rural), personal experience, age, mode of livelihood, and health' in this list.

3 An examination of any and all standard ethnographies would illustrate this point. In addition, the most frequently cited critique of ethnography focuses on its nature as text, emphasising therefore the nature and role of the author and narrative structures. The analyses of anthropology's connections to colonialism, and more recent studies of ethnography's 'industrial' context (Richer 1988; Fox 1991) begin to address anthropology's economics.

4 This study is based on an analysis of all articles on marketing to Latinos in these publications from 1966 to 1993. Only those articles from which I have drawn direct quotations are cited in the reference list.

5 These verbs are used throughout the thirty years of business articles on marketing to Latinos. For exemplary uses, see Guernica and Kasperuk 1982; 'Reaching Hispanic America' (Special report) 1984; Prus 1989.

6 Edward Bruner (1986) also argued for the co-authored nature of the ethnography: 'Our ethnographies are co-authored, not simply because informants contribute data to the text, but because . . . the ethnographer and informant come to share the same narratives. The anthropologist and the Indian are unwitting co-conspirators in a dialectic symbolic process.' (cited in Buckley 1987: 13). I am uncomfortable, however, with the phrase 'unwitting co-conspirators'. Buckley's article explores the ethnographic authority that can be obscured by a celebration of co-authorship.

7 Richer's article documents the efforts of various populations who were studied by ethnographers – i.e. who live the culture described in the ethnography – to share in its profits, the latter conceived not only as money but also as knowledge. Similarly, studies of the formation of Latino subjectivities would show the appropriations of the representations of Latino culture by advertising.

8 In an earlier study, I showed the tensions between those in the Latino advertising agencies and Latino media who were promoting the idea of a single unified 'US Latino' culture, and those who argued for recognition of different Latino cultures, all, however, commodified as markets. While the affluence of a very selectively constructed Cuban-American community makes them a more valuable segment of a larger Latino market, national marketing structures have created a preference for a national Latino market. See Astroff 1989.

9 These supposed cultural characteristics include larger families; a 'present' orientation rather than a future orientation, which is translated into meaning they spend their money instead of saving it; and the passionate nature of the women, who therefore shop emotionally rather than rationally. For more of these 'translations', see Astroff 1989.

10 These articles begin to appear in the marketing trade press in the late 1960s. While this is when Spanish-language radio and television began developing as commercial media in the United States, targeting Mexicans and Mexican Americans as their audience, the 1960s also marked the first major influx of refugees from the Cuban revolution. Such articles work at constructing Cuban immigrants and Cuban Americans as the most valuable part of the Latino market.

11 The sources of these phrases are, respectively, James Clifford (1988: 7) and papers presented in May 1993 to the International Communications Association annual conference by Lawrence Grossberg and Anne Balsamo. Grossberg contrasted an economy of power to a geography of power and a pragmatics of power.

REFERENCES

Abu-Lughod, L. (1991) 'Writing against culture', in R.G. Fox (ed.) *Recapturing Anthropology: Working in the Present*, Santa Fe, New Mexico: School of American Research Press (distributed by University of Washington Press).

Appadurai, A. (1988) 'Putting hierarchy in its place', *Cultural Anthropology* 3 (1), February, pp. 36–49.

Astroff, R.J. (1989) 'Spanish gold: stereotypes, ideology, and the construction of a US Latino Market', *Howard Journal of Communication* 1 (4), Spring, 155–73.

Astroff, R.J. and Kyste Nyberg, A. (1992) 'Discursive hierarchies and the construction of crisis in the news: a case study', *Discourse and Society*, 3 (1), pp. 5–23.

'Beer still tops wine, spirits' (1982), *Advertising Age* 15 February, pp. S1, S6.

Briggs, J. (1971) 'Strategies of perception: the management of ethnic identity', in R. Paine (ed.) *Patrons and Brokers in the East Arctic*, Newfoundland Social and

Economic Papers no. 2, Institute of Social and Economic Research, Memorial University of Newfoundland, pp. 53–73.

Buckley, T. (1987) 'Dialogue and shared authority: informants as critics', *Central Issues in Anthropology* 7 (1), pp. 13–23

Chabram, A. and Fregoso, R. (1990) 'Chicana/o representations', (special issue) *Cultural Studies* 4 (3).

Chock, P.P. (1989) 'The landscape of enchantment: redaction in a theory of ethnicity', *Cultural Anthropology* 4 (2), May, 163–81.

Clifford, J. (1988) *The Predicament of Culture: Twentieth-Century Ethnography, Literature, and Art*, Cambridge: Harvard University Press.

Clifford, J. and Marcus, G. (1986) *Writing Culture: The Poetics and Politics of Ethnography*, Berkeley CA: University of California Press.

'Cuban invasion story still being written' (1966) *Broadcasting*, 19 September.

Diaz-Albertini, L. (1981) 'Views from inside: Puerto Rican', *Advertising Age* 6 April, pp. 5, 8.

Dickstein, G. (1975) 'Growing Latin population strengthens its identity', *Television/Radio Age* 29 September, pp. A1–A4, A6, A8, A10, A12.

Dunn, R. (1986) 'Television, consumption and the commodity form', *Theory, Culture and Society* 3 (1) pp. 49–64.

Fabian, J. (1983) *Time and the Other: how Anthropology Makes Its object*, New York: Columbia University Press.

Featherstone, M. (1991) *Consumer Culture and Postmodernism*, London: Sage.

Ferre, M. (1982) 'Decade of the Hispanic', *Advertising Age*, 15 February, pp. M14, M16.

Fox, R.G. (1991) 'Introduction: working in the present', in R.G. Fox (ed.) *Recapturing Anthropology: Working in the Present*, Santa Fe, New Mexico: School of American Research Press (distributed by University of Washington Press).

Goldberg, D.T. (ed.) (1990) *Anatomy of Racism*, Minneapolis: University of Minnesota Press.

Guernica, A. and Kasperuk, I. (1982) *Reaching the Hispanic Market Effectively*, New York: McGraw-Hill.

Handler, R. (1986) 'Authenticity', *Anthropology Today* (London) 2 (1), February, pp. 2–4.

Johnson, R. (1986–7) 'What is cultural studies anyway', *Social Text* 6 (1), Winter.

McGuire, J. (1982) 'This SIN is legit', *Advertising Age* 15 February, pp. M34–35.

Marcus, G. and Cushman, D. (1982) 'Ethnographies as texts', *Annual Review of Anthropology* 11: 25–69.

Moncreiff Arrarte, Anne. (1990) 'Old money, new lifestyle', *Advertising Age* 12 February, pp. S1, S6.

Omi, M. and Winant, H. (1986) *Racial Formation in the United States: From the 1960s to the 1980s*, New York: Routledge.

Paredes, Richard J. (1979) 'Sophisticated plans fall flat if you don't know the barrio', *Advertising Age* 16 April, p. S20.

Prus, R. (1989) *Pursuing Customers: An Ethnography of Market Practices*, Newbury Park CA: Sage.

'Reaching Hispanic America' (1984) (special report), *Advertising Age* 9 March, pp. S1–S36.

Richer, S. (1988) 'Fieldwork and the commodification of culture: why the natives are restless', *Canadian Review of Sociology and Anthropology* 25 (3), pp. 406–20.

Rosales, M. and Rosales, S. (1979) 'If you don't sell Hispanics in Spanish, you don't sell', *Advertising Age* 16 April, pp. 2, 4.

Said, E. (1978) *Orientalism*, New York: Pantheon Press.

San Juan Jr., E. (1992) *Racial Formations/Critical Transformations: Articulations of Power in Ethnic and Racial Studies in the United States*, Atlantic Highlands NJ: Humanities Press.

Todorov, T. (1984) *The Conquest of America: The Question of the Other*, New York: Harper and Row.

Trouillot, M.-R. (1991) 'Anthropology and the savage slot: the poetics and politics of otherness', In R.G. Fox (ed.) *Recapturing Anthropology: Working in the Present*, Santa Fe, New Mexico: School of American Research Press (distributed by University of Washington Press).

Van Dijk, T.A. (1987) *Communicating Racism: Ethnic Prejudice in Thought and Talk*, Newbury Park, CA: Sage.

Weiner, R. (1978). 'Hispanic population's growth has big marketing implications', *Television/Radio Age* 23 October, pp. A3–A4, A6, A8, A10–13, A16.

Yankelovich, Skelly and White (1981) *Spanish USA: A Study of the Hispanic Market in the United States*, New York: Yankelovich, Inc.

Part III

CASE STUDIES: CAMPAIGNS AND PRODUCTS

8

IMAGE POLITICS:

Negative advertising strategies and the election audience

Stephen Kline

IMAGE POLITICS IN THE AGE OF TELEVISION

In the early 1970s film *The Rise and Rise of Michael Rimmer*, Peter Cook plays a manipulative character who ascends to political power as the consummate practitioner of image management. He starts his conquest of Britain by taking over an advertising agency, by falsifying election opinion-polling results and then subtly influencing the coverage of the opposition leader by subversive public relations. Proving that life sometimes imitates art, the emergence of real image politics is well documented in the election literature. Since Theodore White's (1961) revelations about the role of public relations personnel in the Kennedy election, there has been growing documentation that Rimmer's nefarious methods are the norm in contemporary democracies. Kathleen Jamieson (1988) notes that scripting and framing a candidate's television appearances is the central task of election campaign teams. The candidates are mobilised by a swarm of ex-journalists in suits who continue to spin doctor the coverage over drinks long after the cameras stop.

A journalist writing at the dawn of the television age once accused Eisenhower's advertising adviser Rosser Reeves of 'selling the president like a bar of soap'. And as most recent accounts of election campaigns indicate, the seasoned communication professionals are a growing presence in politics, especially those infamous back-room strategists who must orchestrate the campaign into a consistent and coherent communication process (Fox and White 1991; Diamond and Bates 1991). A long-standing flow of agency and public relations experts (notably Tony Schwartz and the Saatchis), transferring their experience and ideas from the promotional sector into the back rooms, are the primary indication of a bridge between the previously discrete spheres of consumer and political marketing – forging too a more synthetic political marketing paradigm (Sabato 1981). Wernick has pointed to a deeper transformation in the

way 'electoral politics has been made over in the light of the developing techniques and imperatives of mediatized promotion' (Wernick 1991: 123).

Guiding this army of advertising suits, PR hacks and ex-journalists who manage political campaigns is a carefully crafted campaign strategy. The strategy is itself divined from an expensive research effort which monitors shifts in public attitudes through polls, panels and focus groups (Mauser 1980; Fletcher 1990). Tempered by previous campaign experience, the election strategy provides the overarching scheme for campaign communication by defining the key phrases of the campaign, crafting the candidates' image through their appearances and the issues they will raise, and by suggesting ways of targeting particular segments such as women or undecided voters who can become more important as the campaign progresses.

No strategy of course is rigid. It is a broad framework for positioning the leaders, for timing their appearances and statements, and for generally organising and priming the many media opportunities into a crescendo of winning popular sentiment. The campaign's progress is monitored carefully by rolling polls, every modification is rehearsed and tested, and frequent adjustments to communication plans are made as things go off track, or the candidate responds to an event or statement made by an opponent.

The role that public relations plays in modern elections is neither hidden nor obscure. Jamieson found that marketing speak was not only used by campaign teams to frame the form and substance of election news coverage but increasingly infiltrated the content of the commentary provided by the journalists themselves, who discuss campaigns in terms of image management rather than issues (Jamieson 1992). In a review of the Canadian press coverage of elections, we found that the discussion of image politics and spin doctors plays an integral role in journalists' commentary on political processes, feeding anxieties that democratic choice is being subverted by manipulative communication practices (Kline et al. 1992). In fact, their impact on politics has now become so much a part of journalistic folklore that a war-game dynamic is created between the back-room boffins and the boys on the bus who don't like to be seen as their dupes and tools. In our review of the election news coverage of a provincial election for example, we found many occasions where reporters preferred hecklers or candid (off-guard) candidate scenes to set-piece photo opportunities crafted by the campaign team (Kiefer and Kline 1993).

The increasingly prominent role that opinion communications professionals play has most of all transformed political television (Kern 1989; Fletcher 1991). Given television's importance in contemporary America, it is understood that each campaign team must become adept in techniques of communication, and become familiar with both the full range

of media opportunities and the showmanship required to ensure that television appearances show candidates in the best light. Roderic Hart (1994) argues that ultimately television is responsible for transforming the US political discourse into a personalised spectacle in which political policies and ideologies no longer seem to matter: US voters blithely judge a leadership debate largely (71 per cent of cases) on the interpretations of the personal qualities of the candidates (Pfau and Kang 1991). Instead of the ideological grand narratives of egalitarianism, growth and progress mustered in reasoned arguments about political programmes and policies, election television has become a series of contrived glimpses at leadership persona, argues Hart. Personalities are interesting, he accedes, which is why the US electorate is content to watch their future president playing the saxophone on late-night talk shows. Yet when image politics is all that television offers, the results may be a deeper subversion of the public's experience of politics. By beguiling its viewers with information about politicians' personalities, televised politics ultimately undermines the rational foundation of political culture and distracts citizens from their traditional political involvements, because it changes 'the criteria they use to make judgements about how they should be governed' (Hart 1994: 152).

OF SOAP AND PRESIDENTS

Commenting on these changes in the US political practice, David Paletz (Boiney and Paletz 1992) compared the writing of political scientists and campaign strategists and found that the campaign practitioners worked with an operational model which ignored the political theorists' obsessions with party loyalty, issues, ideology and voter-decision processes. He found that campaigners employed a modified version of marketing's four Ps – positioning, polling, personality and promotion – which have become the central dogmas of campaign communication. Although the problem of selling soap and political leaders differs significantly, it can be argued that pragmatic political campaign managers must utilise the best marketing communication techniques to position their leader, because they communicate within the singular framework of commercialised media institutions and audience-marketing dynamics. With his eye less on television coverage than on the promotional infrastructure underscoring it, Wernick suggests that the significance of image politics resides in 'how promotional practices originally commercial in function and inspiration have made their strangely transformative appearance beyond the commercial zone', ultimately changing the way 'politics is politically defined and discussed' (Wernick 1991: 139). Indeed, marketing research techniques, consumer models of persuasion and advertising message formats are all familiar to political communicators, who share the common problem of persuasion

141

and who are willing to explore all available communication expertise in their attempts to win the election. As in the management of marketing communication, the political campaign managers have increasingly concentrated their resources on the television advertising effort. This allows them to address audiences directly and cost-effectively through media channels while avoiding the uncertain mediation of journalists (Kline et al. 1992), and affords the campaign teams maximal control over their message delivery. In the era of image politics, advertising campaigns have become primarily designed to promote candidates and their leadership ability, rather than to publicise the party platform, philosophy or the policies they will enact. In a study of 605 US political ad campaigns, Joslyn found that only 17 per cent of campaign ads actually mention policies and only 6 per cent contain arguments for a specific programme (Joslyn 1990).

Marketing seems to be the overarching framework for both the campaign strategy and the journalists' interpretation of democratic elections. In Wernick's view political campaigns exhibit many of the characteristics of marketing communication not only because, as a cultural product on television, 'liberal democratic politics is itself a form of entertainment' but, as he goes on to note, 'even the most serious kinds of politics . . . share the same discursive space' as advertising (Wernick 1991: 128). But, Wernick asks, can the ideals of democratic choice and rational debate survive when electioneering is reduced to 'a battle between rival advertising campaigns' (ibid.: 140)?

THE QUESTION OF RESPONSES

Clearly the enormous resources devoted to ad campaigns are based on the belief that they can influence attitudes and voting. Yet ultimately, the cultural impact of image politics depends on how audiences respond to these images and use the news reports and ads in forming their attitudes and deciding how to vote. Citing the growing evidence that the effects of advertising communication cannot be understood solely through central processing models (Petty and Caccioppo 1981; Batra and Ray 1986), numerous advertising researchers have focused on the way viewers' emotional readings of the style, message and source in ads contribute to judgements about the product. Given the reliance on television spots during campaigns, Thorson et al. (1992) wondered whether the broad similarities between televised product and political advertising meant audiences responded to them in the same way. Thorson reasoned that contrasting motivational sets, rooted in cultural attitudes to politics and the marketplace, might still orient viewers differently to political ads. Because politics is regarded as a more serious subject, they anticipated more reasoned judgement in assessing the claims of political

advertisements and less emotional and connotative processing. Employing the same semantic scaling techniques used to measure the 'peripheral processing' in product ads, this team tested whether the elicitation of emotional responses is as crucial to the communication effects of political advertisements as it is in consumer advertising. They were surprised to find that both political and product judgements are commonly influenced by the affective connotations and source dimensions of the ads. Indeed, these researchers found that viewers do not pay any closer attention to information in political ads than they do to the product attributes and utility claims in consumer advertising. Their study supports Kathleen Jamieson's more general observation that

> when skillfully used, television's multiple modes of communication and powerful ability to orient attention can invite strong unthinking negative responses in low involvement viewers. And by overloading our information-processing capacity with rapidly paced information, televised political ads can short circuit the normal defenses that more educated, more highly involved viewers ordinarily marshall against suspect claims.
>
> (Jamieson 1992: 50)

It is this potential to communicate and shape the audience's affective responses on a level 'deeper than our individual attitudes about political parties or social issues or citizen referenda' that leads Hart to worry about the changes being wrought in US political culture (Hart 1994: 134). He believes image politics make viewers feel informed and involved with political personalities while undermining an understanding of the forces that shape our lives. He goes on to claim that 'during the last fifty years, this structure of feeling has made the burdens of citizenship increasingly taxing for us, and it is, I believe, responsible for much of the alienation we now feel' (ibid.: 136).

THE RISE AND RISE OF NEGATIVITY

Verbal attacks on opponents and their policies are a very old election strategy. The broad acceptance of televised leader debates proves that facing down the opposition also makes good viewing. Similarly, one of the most significant innovations in political advertising has been the emergence of the controversial negative advertisements which permeate election television. Although in one sense these are merely a rather 'malicious strain of comparative advertising', they are a message strategy most product advertisers have shunned because the negative tone might sully their brand and corporate reputation and generally give advertising a bad name (James and Hensel 1991: 55). So while brand advertising is largely constrained to the promotion of positive feelings about the product,

143

negative political advertising is increasingly undertaken to focus voter attention on the limitations of a political opponent. There are good reasons why political strategists began to move beyond the image politics of feel-good brand advertising in their campaigns. Given the concentrated time-frame of election advertising, impression management and public relations must be more focused, more responsive to shifting opinion, and more unified than is typical of brand advertising campaigns. The 1994 US Congressional campaign was in fact generally considered to have mustered the most negative advertising yet (Fraser 1994).

As Surlin and Gordon (1977: 90) noted, negative advertising can be defined as attacks on 'the other candidate personally, the issues for which the other candidate stands, or the party of the opposing candidate'. They invoke, in James and Hensel's terms, an 'invidious comparison' between candidates (James and Hensel 1991: 56). Indeed, commentators have noted that what distinguishes the most recent attack strategies is the growing tone of viciousness and negativity which permeates the comparisons. David Taras uses pungent terms to characterise the intent of these campaigns

> to tarnish an opponent through ridicule or by a straightforward savaging of their character or record in office. The competencies, motives, intelligence and the integrity of opponents is brought into question. The object is to draw blood, to inflict irreparable damage.
>
> (Taras 1990: 53)

Diamond and Bates (1992) provide a detailed history of the development and testing of these attack spots, noting how negative ads began to move well beyond the *ad hominem* tactics of debates, under the tutelage of innovative advertising practitioners like Tony Schwartz. Schwartz, who also played a role in hard-hitting social and advocacy campaigns, found a way to make the figurative and metaphorical style of product advertising work for attacking strategies. These changes in design were in evidence in the late 1960s *Daisy* ad in which he juxtaposed the innocent charm of a girl picking daisies with the nuclear anxiety associated with a hawkish Goldwater simply through images. Some of the most inspired negative political campaigns work in a similar way, including Reagan's *Bear in the Woods* ad, which uses the image of a bear to refer ambiguously to the Soviet nuclear threat, and the notorious Willie Horton ad in which black and white images were used to imply that the Democrats were releasing black rapists from prison. The appearance of these highly tuned designs was itself probably dependent on the refinements in polling techniques and copy-testing methods that allowed campaign managers to gauge the responses of voters more accurately. Yet however they are designed, the reasons for the increase in negative emotional advertising tactics is simple: negative strategies have been shown to work because they are 'emotive'

(Roddy and Garramone 1988). Negative information has been demonstrated to weigh more heavily on voters' minds than positive information (Skowronski and Carlston 1987), especially in the evaluation of leadership (Mizerski 1982). Overall, negative advertising and invidious comparison appear to work most effectively when there is no third candidate or product that can benefit from a backlash (Merritt 1984; Roddy and Garramone 1988).

Although researchers broadly classify negative campaigns into image or issue formats (Johnson-Cartee and Copeland 1991), this scheme oversimplifies the variety of arguments, styles and strategies of attack advertising. Most commonly, negative campaigns invoke a dubious record; show the candidate out of touch; catch the candidate making contradictory statements; remind people of scandalous news headlines; imagine or portray a consequence of projected policy; or undertake an anticipatory counter-argument. Negativity, however, is not just an argument but an emotional tone. An ad must arouse anxiety, fear or other negative feelings in the viewer in order to undermine the opponent or to ground the invidious comparison. Innuendo and doubt have therefore become the crucial tools in the craft of politics, because negative advertising must work on an associative-affective level below (or beyond) reasoned judgement.

Indeed in launching an attack, it is not necessary to prove an accusation but merely to allude to the negative claim. Research has shown that despite viewers' awareness of the techniques employed, once a negative statement has been made, even when it is shown to be false, a shred of doubt usually remains in the minds of most viewers (Calder and Sternthal 1980; Calder and Tybout 1981). The craft of implied claims was in evidence during the 1992 Clinton vs. Bush battle. In his strategy of sullying Bill Clinton's already tarnished reputation, George Bush approved Floyd Brown, the consultant who produced the Willie Horton spot, to sponsor an election ad fundraiser which promised to reveal all about Clinton's alleged marital indiscretions, possible marijuana experimentation and draft dodging. Yet there is ample evidence that most US voters do not like negative advertisements (Garramone et al. 1991). Ads that are irritating or provoke disagreement lead many viewers to resist the attack with counterarguments (Biocca 1991) or incredulity, which can rebound by intensifying the negative evaluation of the source of the attack. Invidious comparisons may only work when supportive arguments outweigh counterarguments and source derogations. There is clear evidence of 'backsplash' when an attack ad is perceived as unfair or out of keeping with the standards, platform or character of the candidate who uses it (James and Hensel 1991). Garramone et al. (1991) have shown that independent ads are evaluated more positively than candidate-sponsored commercials. For this reason, in the United States, attack advertisements are often sponsored by supposedly independent sources to limit the possibility of backlash against the candidate.

145

James and Hensel argue that there are in fact two aspects to the resistive readings of a negative ad. The first concerns the comparison between two products, or candidates, on a scale of relative merit. The second aspect concerns an 'imputed inferiority' claim, which viewers can reject if they perceive the ad to be malicious or unfair in some way. It is this second process involving the transgression of cultural expectations and standards of fair play that seems to underwrite the backsplash phenomenon. As James and Hensel go on to say, these ads are often judged as

> violating preconceived standards of fair play in a malicious or vicious personal manner. It is this perception of maliciousness and perceived violation of fair play standards which, when combined with the perceived negative intent of the ad (impute inferiority, denigrate or destroy the competition's image), serves to differentiate negative comparative advertising from its milder cousin.
>
> (James and Hensel 1991: 55)

Yet the constant polling has also revealed that few current political leaders are respected and trusted by a majority of the voters. Unlike the market where consumers must decide between two brands they actually want, the contemporary voter usually must choose between the lesser of two evils. Pollsters have confirmed growing public mistrust and disillusionment with contemporary politics (Patterson 1990; Yankelovich 1991). As a US survey undertaken before the 1994 elections revealed, the electorate was

> boiling with resentments and anxieties: cynical toward government, hostile to immigrants, sharply divided along racial lines over the responsibility of government to help the needy, suspicious of the media, uncertain about the future and increasingly untethered to either of the two major parties.
>
> (*Los Angeles Times* 1994)

There seems to be a potential for political alienation and backsplash in postmodern political culture which has instilled a new wariness about the use of negative advertising. Campaign strategists have had to adjust their attacks to the cynicism and incredulity of voters. For this reason, negative campaigning is usually only launched when the party's candidate is lagging behind in the polls, or towards the end of the campaign when the opposition will have little time to rebut the attack (Biocca 1992). Some strategists prefer an anticipatory counterattack with a cleverly defensive ad, diffusing the attacker's claim by inoculating the public with counterarguments before the campaign (Iyengar and McQuire 1993). Others see the long run-up to the campaign as a crucial time to establish a candidate's resistance to attack. The important point is that negative advertising subsumes a panoply of communication

techniques whose use depends on the election context and includes public mood, response and press reaction to the candidate as major factors. Negative ad designs reveal the increasing psychological sophistication employed in these highly emotive and potent messages. Such ads can break through the election clutter and apathy and evoke the negative feelings of anxiety and distrust.

CANADA IN THE AGE OF NEGATIVE POLITICS

Should other Western democracies expect an inevitable drift towards a US style of aggressive political campaigns and growing public disenchantment with political leaders (Kaid and Holtz-Bacha 1995)? It is often claimed that the political culture in Canada, for instance, is different from that of the United States, in that Canadians are less accepting of the attacks typical of US negative campaigns, and that a three-part parliamentary system protects Canadians from descent into US-style dirty politics (Romanow et al. 1990). Although Canadians do not necessarily respect politicians any more than Americans do, a prime minister acts more as a team leader than a symbolic embodiment of the government. In addition, the existence of regionally based parties within the Canadian political culture means that policy differences remain significant because partisan identity goes beyond the personality of leaders to the constituencies the party has served.

Nonetheless, Canadians do have a tradition of negative politics which has increasingly been manifested in advertising during federal elections. In the provincial election we studied in British Columbia, only one television spot of the eleven used in the campaign did not have at least one negative element in it (image, issue or counterattack argument) and four of these showed pictures of the opponent. More recently, the Canadian public's distaste for personal attacks was demonstrated in the negative reaction to an ad used by the Tories in the 1993 elections which proved a huge public embarrassment. On its first showing the press condemned the Tories for engaging in desperate politics (Whyte 1994), which helped to elicit a public response and resulted in a ten-point decline in the party's standing in the opinion polls over the subsequent weekend. The ad was controversial because it showed an unbecoming photograph of the Liberal leader Mr Chretien's mouth (which sags noticeably because of an early childhood illness) over a statement of a purported 'streeter' interview that intoned, 'I would be embarrassed to have him as my Prime Minister'. Focus groups indicated that the backsplash following this ad's release arose from a dynamic created when the media's interpretation of the ad as an unfair attack on Mr Chretien's 'deformity' played itself into the public's willingness to judge some kinds of ad designs as inappropriate.

AFFECT, RESISTANCE AND JUDGEMENT IN THE INTERPRETATION OF CAMPAIGN COMMUNICATION: A STUDY

There are good reasons to believe, however, that the predisposition of viewers can influence how they respond to the ad, as well as the impression they form about a candidate (Garramone 1983). This study therefore was conducted during the provincial election campaign so that viewers' responses to the messages were grounded in real motivations, attitudes and judgements. Based on the assumption that the proportion of undecided voters has been growing (about 33 per cent in a US election) and that these individuals are often targeted by the campaigns, we recruited subjects who were still undecided about who they would vote for. Moreover, given the limitations of semantic differentials, this study attempted to triangulate data by utilising questionnaires, qualitative interviews and a multidimensional emotional measurement method (ICARUS) to track both the emotional and judgemental aspects of the experience of viewing, interpreting and responding to different aspects of election-time television campaigns.

Investigating the question of emotional response to political advertising in terms of the interpretations, judgements and retention of campaign materials, we asked subjects to complete a questionnaire concerning voting history, intentions and opinions about major issues that could influence their voting. In order to establish their political orientation, we also asked them to indicate what strengths and weaknesses they attributed to each of the major party's policies. We probed as well their monitoring of the campaign and the factors that might change their minds over the course of the election. Subjects rated the two major party leaders along six dimensions of leadership, and these were analysed in relation to their comments made after viewing the campaign material on video.

Individual viewers and focus-group participants were shown fifteen visual segments (of approximately twelve minutes) including eight political ads, three news clips and a portion of the televised debate in a video which also included three product ads. Because we were interested in the emotional involvement and interpretations that the personal and issue dimensions of campaign communication invoked, we noted both positive comments and resistance and counterarguments. While viewing the material, the subjects were specifically instructed to indicate (by pressing a button) when they felt most critical or disturbed. The discussions afterwards probed what they were thinking about on these occasions.

Results

The comments viewers made confirm the general claim that image politics is about personality and not issues. The results indicated that the

viewers' attitudes concerning the campaign issues were much more diverse and relatively less important to their political choices than their perceptions of what the leader represented. As the charts in Figure 8.1 indicate, subjects do make very fine-grain judgements about leadership. In the case of leadership contenders in this campaign (NDP, Mike Harcourt and Social Credit, Rita Johnson) competence and honesty were rated similarly. However, there were marked differences on the dimensions of friendliness and accessibility. These perceived differences in leader image were strongly predictive of the subject's ultimate vote.

From the interviews, however, we got the sense that these perceptual sets functioned as a cognitive filter rather than an orientation response to the leaders. It was very rare for subjects to report making up their mind based on the impression they formed from a single ad or news story. More typically, subjects reported having their previous impressions confirmed. Most subjects made reference to other candidate appearances (news, debate) in explaining their views and judgements. This suggests that throughout the campaign images of candidates are being built as perceptual sets which in turn determine what viewers look for when they watch election television.

Among the undecided voters there is a slightly stronger motive to follow the campaign closely, precisely because they are actively building and adjusting their perception of the leader as they decide about their vote.

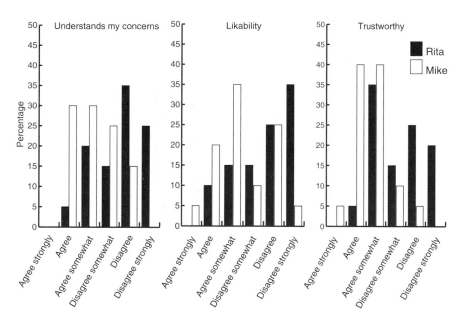

Figure 8.1 Salient dimensions of leadership

The statements of these viewers in the interviews strongly indicated that social dimensions of judgement were very important to the way they interpreted the ads. Very few of the subjects spontaneously judged or mentioned the political issues the ad raised (the future, taxes, scandal, economic mismanagement, etc.). Indeed, unprompted, very few subjects could recall any issue raised by the ad. Figure 8.2 shows the relatively free recall of the different material after viewing the whole series. The content of the debate and news clips and two negative ads using 'streeters' were recalled by more than 50 per cent of the subjects.

In probing these scenes we found that viewers tended to remember specific stimuli because of their emotional social content. For example, if they did not like the way Rita Johnson dealt with a female heckler in a news clip it was because 'as a woman she should have been more sympathetic'. Similarly Mike Harcourt's backing down from a confrontation over land use in the other news clip proved that 'he's just a wuss'. This particular campaign, which pitted a male against a female leader, was especially revealing because the discussions were underscored with gender-differentiated expectations. Rita's finger wagging meant she was a 'fish-wife', while Mike's refusal to engage in confrontation proved he was 'a wimp'.

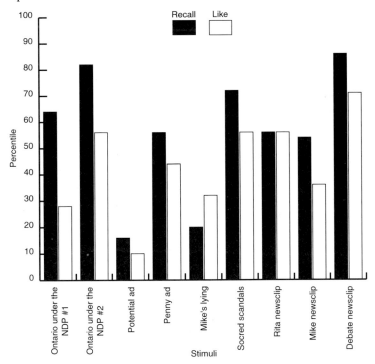

Figure 8.2 Remembering segments and spots key message

150

These interviews suggested that the similarity between the way viewers interpret political and commercial ads may well lie in the common use of the interpretive frame of 'social narrative' (as opposed to ideology or utility) to read the messages television offers them. In the product ads (included in the stimulus set) viewers based their impressions of the product on whether they liked the ad and the presenter and their interpretation of the story-line. In the political ads, viewers' responses were based on their impression of the ethos and credibility of candidates established by subtle readings of conduct and speech. In both cases, interpersonal attitudes, a sense of socially appropriate actions and social stereotypes played a powerful role in framing viewers' orientation to the televised messages. Political ads were rarely responded to in terms of their policy proposals.

Negative advertising formats were easily recognised as such by the audience. Personal attacks were more easily identified as muck-raking than issue-oriented accusations, visual metaphors and other negative advertising techniques. Subjects disliked some of these negative executions because they perceived them as being 'too nasty', 'uninformative' or just 'inappropriate' and would often comment that the whole campaign was descending into 'just a load of mudslinging'. Yet negative ads elicited more emotional responses and greater recall. In fact recall of ads was specifically connected to their socio-emotional interpretation by the subject. Subjects could recall emotional scenes in detail, whether they interpreted them negatively or positively. For example, in relation to the scene in which Rita Johnson was confronted, a minority of viewers expressed sympathy for Rita and felt that an unfair demand had been placed on her at a press conference: 'She has no control over the issues that concern this woman', 'I can't believe that this woman was coming up to the Premier to say "where's my daughter?" '. Yet many more subjects believed that Rita did not exhibit the qualities of warmth and understanding that they expected from a leader in such a situation: 'She wasn't successful at handling the conflict', 'Really phoney, phoney-looking concern on Rita Johnson and then sort of turning around and ignoring her', 'She puts on this fake public face when probably she is quite angry', 'She's play acting at being a nice benevolent mother type when in actuality she is a real shark'. Whether favourably or negatively, this scene was well remembered.

Predisposition was also a factor determining orientation to the ad, and its recall. The swing voters were much more likely to judge the ads as negative, dislike them more, and remember them better than were the partisan voters viewing ads from their preferred party. Although there is a general tendency to recall emotionally charged scenes, the ads least remembered by partisan voters were the negative ads from their own party. This suggests that because of the counterarguments it elicits, nega-

tive advertising is likely to have little effect on the voting intentions of a deeply partisan voter.

Whether for the party or against it, viewers revealed a deeply cynical response to all campaign communication: 'the election has become a circus' or 'just something they say to get elected'. Many viewers made reference to the strategies behind the communication: 'I know she's got a political adviser telling her to confront him'. Based on our research with these subjects, we speculated that voters became more actively engaged in the ads just because they divined the strategies behind them. Similarly, in relation to news and debate programmes, viewers spoke as though they were looking for the authentic person behind the leader's image, and actively watched for slips in the professional mask: 'Mike was just too evasive', 'Rita was ranting in anger'. Resistance and counterargument seemed to occur most, not when a claim or policy was presented, but when something felt not quite right about the presentation or performance. For example, when street interviews appeared too contrived, viewers saw the interviewees as 'angry actors'.

We noted that the critical reactions of viewers to an ad or news story were strongest when an idea or its execution was perceived as inappropriate, disturbing or provocative. The positive-image ads and set-piece scenes of promotional politics were neither liked nor remembered. Viewers were cynical about prepackaged formulations. Critical social judgements of leaders may be a central mediating factor in voter decisions. Cynicism, however, does not necessarily diminish the impact of the ads. Most viewers do not just accept or yield passively to the claims and messages in ads, but ignore, accept or resist aspects of the message. Indeed, as cynical readers, they can become more emotionally engaged by the news and by ads, because they must actively interpret and process the message in terms of motives, stylisation and impact of the campaign. Ultimately the election-as-a-strategy game may not only keep journalists very busy during elections, but many viewers as well. Indeed, journalists may well be feeding audience interest in the 'authentic moment' by focusing news coverage on the confrontational scenes of heckling and dynamic interchange which occur before and after the contrived public relations events (Schmuhl 1990).

The debate is perhaps the moment of highest social drama and confrontation, because viewers know that the leaders must project their leadership potential through personal performance and demonstrate control and competence. Swing voters especially seem to use the debate as a chance to validate and consolidate their judgements. Comments about the debate segment revealed how important the strategic confrontation between personalities was for the overall judgement of viewers. Subjects commented blithely, 'I found Rita really much too negative', 'I didn't think her interruptions were appropriate', 'Harcourt was too cautious', 'Rita was trying to be Miss Confrontational'.

Because social confrontation is at its peak, the televised debate is often regarded as the decisive moment or turning point of a campaign. Interestingly, we found that the debate, news clips and certain negative ads enjoyed the highest recall, and they were also the segments that seemed to be the most engaging to people. Although most subjects reported disliking the negativity of the campaign, especially the slagging-match ads, for the swing voters high recall was related to positive orientation. This might seem odd at first, but an analysis of how subjects read these ads makes the phenomenon more comprehensible. They liked the controversy if it helped them confirm affective or cognitive predispositions.

Discussion

It is sometimes suggested that low voter turnouts, the plummeting credibility of politicians, the growth in swing voting and the regularity of slur campaigns may indicate a reorientation of US political judgement and moves towards distrust, anxiety and doubt (Yankelovich 1991; Patterson 1991). Indeed, it has been argued that negative advertising campaigns have contributed to the degeneration of US political discourse and the cynicism of US political culture (Diamond and Bates 1992; Roddy and Garammone 1988). Most commentators view the growing negativity and cynicism of elections as a problem for democracy. Johnson-Cartee and Copeland (1991) suggest three potential social consequences of the rise of negative advertising in the United States: first a growing sense of alienation within the electorate, resulting in lower voter turnout; second the lack of pride that becomes associated with 'negative' campaigns, which degrades the whole political process, fuelling cynicism and alienation; and third the possibility that negative advertising lends itself to political demagoguery, resulting in a less reasoned and more emotive approach to political discourse. This drift in political discourse threatens to throw the moral authority of the Presidency and the credibility of the political process and politicians into question.

Johnson-Cartee and Copeland, however, raise one possible positive social implication stemming from the increase in negative advertising. This is the claim that more substantive information is actually discussed in such a campaign. They assert that although the negative advertising has a tendency toward personal attack, it raises the records and histories of candidates to the level of public debate, thereby focusing attention on actual policies, helping the electorate to evaluate candidates' positions on various topics of public concern. They also note that journalists pick up on these negative themes and investigate them, resulting in more attention for issues and controversy, and leading to a more substantive public debate. The problem with this assertion is that although leadership attributes are closely scrutinised in attack politics, the debates still tend

to focus on personality and image evaluation, and less emphasis is placed on discovering the underlying issues. Our study also suggests that the factors influencing leadership judgement formation are significantly affected by short, primarily visual scenes of emotive interpersonal interaction, and it is not clear how this serves to elevate public debate.

Most political communication models have not sufficiently understood the cumulative effects of mudslinging throughout a campaign. This study also suggests that negative advertising might help to generate a negative perceptual set based on personality categories applied to leadership judgement, and that many viewers will stay with and elaborate those categories as they watch performances on the news. Mud sticks because further communication in a campaign comes to rest on these early sets, and is reinforced by every confirming interpretation. Negative ads are a kind of lens through which the entire campaign can be viewed. They threaten democracy, not because they establish a negative tone of political incredulity, but because they shift the locus of our decision-making from a cognitive to a primarily affective plane through the focus on image management of leadership. The discussion here of the virulence and negativity which has permeated recent US political advertising campaigns leads to a speculation about the relationship between campaigns for presidents and campaigns for soap: are the negative tactics of political advertising souring the 'feel-good' world of consumer culture?

REFERENCES

Ajzen, I. and Fishbein, M. (1980) *Understanding Attitudes and Predicting Social Behaviour*, Englewood Cliffs, NJ: Prentice Hall.

Batra, R. and Ray, M. (1986) 'Response Mediating Acceptance of Advertising', *Journal of Communication Research*, 13(2), 234–39.

Beltrame, J. (1993) 'Poll Suggests Liberals Winning PC Contest', *Ottawa Citizen*, 4 June, A3.

Benze, J.G. and Declerq, E.R. (1985) 'Content of Television Political Spot Ads for Female Candidates', *Journalism Quarterly*, 62, 278–83.

Biocca, F. (ed.) (1991) *Television and Political Advertising*, vol. 1, *Psychological Processes*, Hillsdale NJ: L. Erlbaum Associates.

Boiney, J. and Paletz, D. (1991), in F. Biocca (ed.) *Television and Political Advertising*, vol. 1, *Psychological Processes*, Hillsdale NJ: L. Erlbaum Associates.

Calder, B.J. and Sternthal, B. (1980) 'Television Commercial Wearout: An Information Processing View', *Journal of Marketing Research*, May, 17(2), 173–86.

Calder, B.J. and Tybout, A.M. (1981) 'Using Information Processing Theory to Design Marketing Strategies', *Journal of Marketing Research*, February, 18(1), 73–79.

Diamond, E. and Bates, B. (1992) *The Spot: The Rise of Political Advertising on Television*, Boston: Massachusetts Institute of Technology.

Fletcher, F.J. (1990) 'Polling and Political Communication: The Canadian Case', presentation for the International Association for Mass Communication Research, Lake Bled, Yugoslavia, August.

Fletcher, F.J. (1991) 'Television in the 1988 Campaign: Did it Make a Difference?', in P. Fox and G. White (eds) (1991).

Fox, P. and White, G. (eds) (1991) *Politics: Canada*, 7th edition, Toronto: McGraw-Hill Ryerson.

Fraser, G. (1994) 'Down-and-Dirty US. Politics Gets Filthier', *Globe and Mail*, 4 November.

Garfield, B. (1992) 'Son of Willie Horton Maligns Only its Parent', *Advertising Age*, 13 July, 63(28), 38.

Garramone, G.M. (1983) 'Advertising: Clarifying Sponsor Effects', *Journalism Quarterly*, Winter, (61), 771–5.

Garramone, G.M., Steele, M. and Pinkleton, B. (1991) 'The role of cognitive schemata in determining candidate characteristic effects', in F. Biocca (ed.) *Television and Political Advertising*, vol. 1, *Psychological Processes*, Hillsdale NJ: L. Erlbaum Associates.

Hart, R.P. (1994) *Seducing America: How Television Charms the Modern Voter*, New York: Oxford University Press.

Iyengar, Shanto and McQuire, William (1993) *Explorations in Political Psychology*, Duke University Press.

James, K.E. and Hensel, P.J. (1991) 'Negative Advertising: The Malicious Strain of Comparative Advertising', *Journal of Advertising*, 20(2), 53–69.

Jamieson, K.H. (1988) *Eloquence in an Electronic Age: The Transformation of Political Speech-Making*, New York: Oxford University Press.

Jamieson, K.H. (1992) *Packaging the President: A History and Criticism of Presidential Campaign Advertising*, New York: Oxford University Press.

Johnson-Cartee, K.S. and Copeland, G.A. (1991) *Negative Political Advertising: Coming of Age*, Hillsdale NJ: L. Erlbaum Associates.

Joslyn, R. (1990) 'Election Campaigns as Occasions for Civic Education', in D. Swanson and D. Nimmo (eds) *New Directions in Political Communication: A Resource Book*, Newbury Park CA: Sage.

Kaid, L.L. and Boydston, J. (1987) 'An Experimental Study of the Effectiveness of Negative Political Advertisements', *Communication Quarterly*, Spring, 35, 193–201.

Kaid, L.L. and Holtz-Bacha, C. (1995) *Political Advertising in Western Democracies: Parties and Candidates on Television*, Thousand Oaks CA: Sage.

Kern, M. (1989) *30-Second Politics: Political Advertising in the Eighties*, New York: Praeger

Kiefer, T. and Kline, S. (1993) 'The Limits to Negativism: Audience Reception of Attacks During a Provincial Election Campaign', paper presented 4 June, at the Annual Meeting of the Canadian Communication Association Learned Societies Conference, Ottawa, Ontario.

Kline, S., Deodat, R., Schwetz, A. and Leiss, W. (1992) 'Political Broadcast Advertising in Canada', submission to the Royal Commission on Electoral Reform and Party Financing in Canada, Simon Fraser University, Burnaby, British Columbia.

Los Angeles Times (1994) 'Despairing Americans Say Curse on Both Parties', 5 November.

Maclean's (1992) 'Secrets from the Back Room', 19 October, 33–44.

Mauser, G. (1980) 'Positioning Political Candidates: Application of Concept Evaluation Techniques', *Journal of Market Research Society*, 22 July, 181–91.

Merritt, S. (1984) 'Negative Political Advertising: Some Empirical Findings', *Journal of Advertising*, 13(3), 27–37.

Mizerski, R. (1982) 'An Attribution Explanation of Disproportionate Influence of Unfavourable Information', *Journal of Consumer Research*, 9 December (3), 301–10.

Patterson, J. (1991) *The Day America Told the Truth: What People Really Believe About Everything that Matters*, New York: Prentice Hall.

Petty, R.E. and Cacioppo, J.T. (1981) *Attitudes and Persuasion: Classic and Contemporary Approaches*, Dubuque, IA: William C. Brown.

Petty, R.E. and Cacioppo, J.T. (1986) *Communication and Persuasion: Central and Peripheral Routes to Attitude Change*, New York: Springer-Verlag.

Pfau, M. and Kang, J.G. (1991) 'The Impact of Relational Messages on Candidate Influence in Televised Political Debates', *Communication Studies*, 42.

Roddy, B. and Garramone, G. (1988) 'Appeals and Strategies of Negative Political Advertising', *Journal of Broadcasting and Electronic Media*, 32(4), 415–27.

Romanow, W.I., Soderlund, W.C. and Price, R.G. (1990) 'Negative Political Advertising: An Analysis of Research Findings in Light of Canadian Practice', *A Report to the Royal Commission on Electoral Reform and Party Financing*, November, University of Windsor, Windsor, Ontario.

Sabato, L. (1981) *The Rise of Political Consultants*, New York: Basic Books.

Schmuhl, R. (1990) *Statecraft and Stagecraft: American Political Life in the Age of Personality*, Notre Dame: University of Notre Dame Press.

Shimp, T. (1981) 'Attitude Toward the Brand as a Mediator of Consumer Brand Choice', *Journal of Advertising*, 10(2) 9–15.

Skowronski, J. and Carlston, D.E. (1987) 'Social Judgement and Social Memory: The Role of Cue Diagnosticity in Negativity', *Social Personality*, 52(4), 689–99.

Soderlund, W., Surlin, S. and Gosselin, A. (1995) 'Attitudes Toward Negative Political Advertising: A Comparison of University Students in Ontario and Quebec', paper presented at the Canadian Political Science Association conference, 4 June.

Surlin, S. and Gordon, T. (1977) 'How Values Affect Attitudes Toward Direct Reference Political Advertising', *Journalism Quarterly*, 54 (Spring) 89–94.

Taras, D. (1990) *The Newsmakers: The Media's Influence on Canadian Politics*, Scarborough, Ontario: Nelson.

Thorson, E., Christ, W. and Caywood, C. (1991) 'Selling Candidates Like Tubes of Toothpaste: Is it Apt?', in F. Biocca (ed.) *Television and Political Advertising, vol. 1: Psychological Processes*. Hillsdale NJ: L. Erlbaum Associates.

Trent, J. S. and Friedenberg, R.V. (1983) *Political Campaign Communication: Principles and Practices*, New York: Praeger.

Wernick, A. (1991) *Promotional Culture: Advertising, Ideology and Symbolic Expression*, London: Sage.

White, T. (1961) *The Making of the President*, New York: Atheneum.

Whyte, K. (1994) 'The Face that Sank a Thousand Tories', *Saturday Night*, February, 14–18.

Winsor, H. (1993) *Globe and Mail*, 25 May, A1–2.

Yankelovich, D. (1991) *Coming to Public Judgement: Making Democracy Work in a Complex World*, Syracuse, New York: Syracuse University Press.

9

KEEPING MRS DAWSON BUSY

Safe sex, gender and pleasure in condom advertising since 1970

Paul Jobling

> We need to eroticize the condom, make it cool and trendy and perpetually fashionable to use
>
> (*Promoting Sexual Health* 1991)

This chapter takes its title from one of the most well-known and humorous of the Health Education Authority (HEA) 'Condom Normalisation' campaigns, launched initially in the cinema in December 1990 and subsequently shown on television. While extremely successful, the television screening was recalled by 74 per cent of people interviewed by HEA/BMRB (British Market Bureau) for the AIDS Strategic Monitor (HEA 1993: 14), the serious message relayed by Mrs Dawson's dialogue – she puts the increase in condom production down to AIDS and HIV – is subverted by the somewhat grotesque nature of the *mise-en-scène*, as Mrs Dawson is shown at work, hair tucked away in a surgical cap, rolling condoms on and off metal tubes. The dualism of the ad is, in turn, revealing of the coy and ambivalent way in which many of us regard the condom: a necessary evil which can only be rendered more acceptable as an object of gross parody or ridicule. In the closing shots even Mrs Dawson turns toward us and laughs self-consciously, as if to imply that she also finds the condom too comical for words.

As such, the Mrs Dawson campaign trades on familiar mythology; since the male sheath first came into wide circulation in the eighteenth century it has been the focus of awkward derision, often expressed in chauvinistic metaphors such as 'French Letter' in Britain, 'Capote Anglaise' ('English overcoat') in France and 'Pariser' ('Parisian') in Germany. More significantly, the promotion of the condom itself appears to occupy a paradoxical space within advertising at large. If, as Gillian Dyer insists, 'Advertising's central function is to create desires that did not previously exist' (Dyer 1982: 6), how is it possible to promote something which encourages us to curb *pre-existing*, fundamental desires and instincts? Condom advertising,

therefore, in common with tobacco advertising, runs counter to the promotion of most other products, exhorting us to think seriously about the implications of corporeal pleasure and confronting us with our own mortality. These are the issues which I want to explore in this essay by focusing on the rehabilitation and fetishisation of the condom as an object of desire in its own right. The discussion which follows has consequently been arranged into three separate but complementary sections – the first and second deal with the codification of the condom, gender and sexuality in terms of contraception and prophylaxis since roughly 1970; while the third evaluates the ostensible paradox between health and pleasure which the use of condoms appears to imply and the ways in which advertising attempts to resolve this disjuncture with reference to Freudian psychoanalytical theory.

CONDOM ADVERTISING BETWEEN 1970 AND 1985: CONTRACEPTION VERSUS PROPHYLAXIS

By the early 1960s condoms had begun to be advertised nationally in the British press. Some of the earliest advertisements could be found in quality Sundays such as the *Observer*, although best-selling dailies like the *Daily Mirror* did not print ads for contraception until 1970, following the 1967 National Health Service (Family Planning) Act which had included unmarried people in the provision of contraception for the first time.[1] From 1970 onwards, full-page campaigns for Durex also began to appear more frequently in magazines for women and the British Code of Advertising Practice (1974) consequently began to sanction the widespread publicity of contraceptives in the press provided that 'they did not contain anything deemed offensive to decency'.

The first phase of condom promotion between 1970 and 1985 was largely dominated by Durex, notwithstanding the fact that other brands such as Lam-Butt, Durateste and Parico were also being produced.[2] The decision of London Rubber Company (LRC) to run its first large-scale advertising campaign for various brands of Durex in the periodical press had been made in the wake not only of the more liberal legislation of the 1967 Family Planning Act but also a resolution by the Pharmacist Trade Association in 1969 to allow condoms to be sold openly from counter displays; it must be noted, however, that the largest pharmaceutical chain, Boots, did not follow suit until 1973 (Redford et al. 1974: 3). More significantly, a series of surveys into the sexual habits of the British public had revealed that attitudes towards contraception were becoming more tolerant. In 1963 two encouraging publications were issued by the Family Planning Association: the first appeared in its house journal *Family Planning* (October 1963, 13: 3) and tabled the results of a Gallup Poll in which 60 per cent of those consulted approved of birth control; the second,

a research document produced under the aegis of Professor François Lafitte of Birmingham University, demonstrated more particularly that the British public had an overwhelming preference for male methods of contraception (either the condom or withdrawal) and that the sheath was the most popular form of birth control among couples married between 1950 and 1960, irrespective of their social class (Lafitte 1963: 8–9).[3]

By the time the first wave of advertisements began to appear, however, the condom was suffering from an identity crisis and had been outstripped in popularity by oral contraception. In November 1963 *Which?* magazine tested twenty-seven different condom brands and concluded that not one of them, if used without a spermicidal jelly, was as foolproof a method of birth control as the pill, and that lubricated condoms, including the top Durex Gossamer brand, were particularly unreliable in terms of leaking. It is not surprising to find, therefore, that many early Durex advertisements initially appeared in periodicals for women such as *Women's Mirror, Loving* and *Brides and Setting Up Home.* In this way, London Rubber not only aimed to rehabilitate the condom as a harmless method of birth control which, unlike the pill, did not result in potential side-effects, but also recognised that purchase of the male sheath was no longer exclusively the province of men. The words and images of these early advertisements, therefore, codify the condom as a familiar and mutually beneficial form of contraception. The impact of the pill is acknowledged indirectly but played down in comparison to the availability, reliability and safety of the condom. We are a long way here from a sex-education manual written in 1937 admonishing men to take responsibility for the proper and effective use of contraception since, as the author put it,

> Many women are unreliable. The husband cannot be sure that his wife will carry out the requisite technique properly. . . . There are lots of careless women in the world. There are a lot of lazy women. There are a lot of women who are both careless and lazy.
>
> (Ryley-Scott 1937: 19–20)

The rhetoric of *Which Contraceptive Should We Choose?* (1970), for example, is reassuring in tone, with the text set out as a series of straightforward questions and answers which literally separates the image of a smiling husband in profile on the left and a similar one of his wife on the right. As such, the questions appear to be interpolated from one to the other and each partner is regarded as having equal freedom of choice in the type of contraception he/she should use. This message is somewhat compromised, however, by the different ways in which husband and wife have been posed: his arms are firmly crossed and he consequently appears to be more resolute than his wife, whose arms hang down by her side. In essence, the format of this advertisement with male and female divided by a central column of text is also rather old-fashioned and was based on

159

a prototype for the Family Planning Association, *The News that Must Be Welcome* ... , produced in 1961. The two advertisements are, however, distinguishable by what the text of each connotes. The FPA advertisement, although apparently anodyne and inoffensive in what it states, was subject to strict censorship – the middle paragraph which concerns the circumstances for exercising birth control was deemed to be too leading by Catholic clergy and doctors and had to be removed.[4] By comparison, the Durex advertisement, which discusses sensitivity and comfort, is much more directly informative and serves to demonstrate how far the discourse on contraception had advanced in the space of only eight years.

Another Durex advertisement from 1970, *How Much Should a Sweetheart Know?*, trades on a similar message but deploys a more intimate and romantic iconography. A young couple are represented in a park – the woman is sitting on a bench, the man looms over her with his foot on the seat. They do not look at each other but hold hands and appear pensive as if on the verge of making one of the most important decisions of their lives. At the outset, this is a rather ambiguous advertisement and we are drawn into a moral guessing game – both the photograph and the headline could lead us to believe, for instance, that the couple are planning pre-marital or extra-marital sex, or that the girl has just told her boyfriend that she is pregnant. As we read the small print, however, any suggestion of promiscuity soon evaporates and it becomes evident that the couple are newlyweds who are ruminating on the safest and most widely available form of contraception to use, namely the 'protective' or 'sheath', which is 'Britain's most popular method of contraception ... chosen by over 70 per cent of newly married couples'.[5]

Although the condom is made to appear appreciably more reliable and accessible in such advertisements, Durex campaigns of the 1960s and 1970s nonetheless tended to harp on normative stereotypes. They recognise neither the fluid sexual politics of the period nor the multicultural nature of British society, and the implicit message of these advertisements suggests that we should all conform to the same practices in terms of our contraceptive needs and sexual desires. As such, they disavow any real distinction between the needs and expectations of straights and gays on the one hand, or those from different class backgrounds and ethnic origins on the other. The couples portrayed, for example, are invariably white even though the ethnic population of Britain had greatly increased since the first mass immigration from the Commonwealth after the Second World War – the 1971 census had recorded an estimated ethnic population of 1,385,600, of which 35 per cent were aged 15 or under.[6]

And while London Rubber must be given some credit for promoting sex education in secondary schools between 1965 and 1966 with its film *London Image*, which was screened to over half a million pupils, paradoxically its advertising campaigns were much more reactionary in the

way that they dealt with youth culture and promiscuous attitudes towards sex. The partners in the advertisements always appear to be white-collar professionals and are represented as faithful and sexually inexperienced, notwithstanding the fact that British culture had been indelibly transformed by a sexual revolution amongst young people from all social classes. In 1965, Michael Schofield had corroborated the early impact of this revolution in a research paper for *Family Planning* (14, 2) entitled 'The sexual behaviour of young people' (afterwards augmented and published as a book bearing the same title by Pelican in 1968). His findings revealed a sharp increase in the number of young people between the ages of 17 and 19 who were indulging in pre-marital intercourse. Yet at the same time, only 43 per cent of his sample stated that they always relied on condoms, and the majority of teenage girls admitted that they either did not take any precautions themselves or that they did not expect their partners to do so.[7]

More alarming still was the failure of condom manufacturers during the 1960s and 1970s to address the impact of venereal disease on British youth culture (especially gay men), and their reluctance to promote condoms as a form of prophylaxis against sexually transmitted diseases (STDs) even after a bill had been passed to enable advertisers to deal with the transmission of venereal diseases.[8] This myopic stance persisted in promotions by British condom manufacturers until the mid-1980s, by which time the threat of contracting both genital herpes and AIDS/HIV had made safe sex a *sine qua non* for anyone sleeping with more than one partner. As late as 1985, for example, advertisements for Durex Elite such as *I Put The Cat Out . . .* with cartoons by Gray, although clearly more humorous than their antecedents, continued to promote condoms exclusively as a form of contraception. No mention whatsoever was made of STDs, and British condom campaigns consequently began to lag behind those from other countries such as America where advertisements for Trojan sheaths confronted the herpes epidemic both seriously and candidly.

CONDOM ADVERTISING SINCE 1986: THE CHALLENGE OF HIV/AIDS

Public awareness of HIV and AIDS since 1986 has given renewed emphasis to the prophylactic properties of the condom and invested it with a quasi life-saving role: in 1988 sales soared to about 140 million condoms and in 1993, 152 million were sold (Mead 1993). Not only are condoms easier to purchase through chemists, barbers' shops, vending machines and mail order but new channels of consumption such as supermarkets and service stations have also become prevalent.[9] While products by the London Rubber Group still dominate the market and London International Group condoms are sold in Germany, Spain, China and

France, the second phase of condom advertising has been much more pluralistic and diverse.[10] Many different brands have been frankly and extensively advertised in the periodical press since 1987, and to a lesser degree on television (guidelines for promoting condoms on television were drawn up by the IBA in April 1987 with the first advertisements for Durex and Mates appearing in August and November 1987 respectively). In addition, the efficacy of condoms in helping to promote safe sex has also been incorporated into the discourse of official campaigns by the HEA with advertisements like *Sex Feels Better When You're Using a Condom* (1992/3).

Since 1987 there have been several competitors to Durex's marketing and promotional hegemony. These include Lifestyles, manufactured by Warner Lambert Healthcare and targeted at couples aged 30 and over, and Jiffi, backed by Michael Conitzer of Stirling Cooper womenswear and targeted at a more youth cultural market of 13–25-year-olds. The latter have gained notoriety by deploying slogans and puns which trade, somewhat awkwardly, on a kind of schoolyard argot, for example 'Only Wankers Don't Use Condoms' and 'Real Men Come in a Jiffi'. But the most sustained challenge to Durex has been mounted by the Mates brand which was launched in November 1987 by the Virgin Healthcare Foundation.[11] Mates are targeted broadly at an 18–35-year-old heterosexual market and were originally sold at 12 pence each, thereby undercutting the cost of Durex by half. For a long time they were saddled with a reputation for being unreliable (in 1989, for example, Bloomsbury Health Authority withdrew them from circulation in their Family Planning clinics), but by 1993, Mates had garnered 30 per cent of the British market with profits from sales being donated to AIDS research (*Simplifyle* 1993: 372).

Like Durex, Mates were also promoted on television and six advertisements with subtitles for the hard of hearing were produced by Still Price Court Twivy D'Souza in 1987 at a cost of 10 million pounds.[12] The advertising agency aimed to attract sexual novices and women coming off the pill by playing on the awkwardness surrounding sex with reference to human emotions such as humour (symbolised by an embarrassed adolescent in a chemist's shop who is too tongue-tied to ask for a packet of condoms) and doubt (portrayed by a couple in post-coital slumber wondering how many previous partners they have each had). The latter theme was backed up by a press campaign with slogans such as 'Every Time You Sleep with a Girl (Boy) You Sleep with Her (His) Old Boyfriends (Girlfriends)' and 'Nobody Ever Thinks They're Promiscuous'. Moreover, if the discourse of the second phase of condom advertising has still not sufficiently recognised the disparate class and ethnic make-up of British society, it has been more ingenuous and realistic in espousing the prophylactic needs and desires of both women and gay men.

According to a General Household Survey sponsored by the government in 1979 the pill was still more popular than the condom with women aged 16–49, but with the advent of HIV and AIDS more women were gradually coming to rely on the condom for protection.[13] Research by Durex in 1992, for example, revealed that sales of condoms to women had increased by 108 per cent in the space of two years and that 16–25-year-olds in particular were not afraid to buy them or to be seen carrying them on their person. At the same time, manufacturers began to respond to the needs of young women on a more direct level and to gainsay the idea that only men purchased condoms. This sexual autonomy was manifest in the launching of brands specifically designated for women, like Durex Assure, and was underscored in brochures such as *Wise Up to Condoms* (Durex, April 1992). The front cover of the brochure was illustrated by a graffiti-covered wall depicting slogans like 'Condoms Are a Girl's Best Friend' while inside it contained personal testimony from young girls approving of condom usage on the grounds of hygiene: 'I like using condoms because I can't stand that messy feeling about sex'. The packaging for most condom brands aimed at a female market, however, still traded on stereotypical feminine colour preferences. Ultra 9 (launched by Warner Lambert in July 1987), for instance, retailed in shiny silver packets with typography in pink and baby blue, while Durex Fetherlite became available in pastel grey, pink and peach wallets.

In terms of advertising, the campaigns produced by Mates and the HEA have been the most adventurous in addressing the role of women as both producers and consumers. As already noted at the start of this chapter, Mrs Dawson had somewhat coyly publicised the role of women involved on the condom production line, but this campaign was preceded by more ingenuous promotions for Mates such as *One Condom Has to Satisfy Them All* and *I Expect to Get through 50 Gross in the Next Few Months*, which had appeared in *Chemist and Druggist* in 1987. Like Mrs Dawson, the women represented in these advertisements are seen wearing overalls and appear to be middle-aged, but unlike her they have make-up and hairstyles which make them look sexually alluring. Moreover, the use of provocative catchlines implies that for these women testing condoms does not stop in the workplace as it appeared to do for Mrs Dawson.

The positive role prescribed for women in these advertisements is taken to a more passionate and uncompromising pitch in HEA campaigns such as *And She's Too Embarrassed to Ask Him to Use a Condom?* and *How Far Will You Go Before You Mention Condoms?* (Figures 9.1 and 9.2) which were circulated in the youth press between July 1992 and March 1993. Clearly, the verbal and visual elements of these advertisements present us with a disquieting conflict concerning desire and freedom – a point to which I shall return in the discussion of pleasure below – but at the same time they attempt to empower women by representing them as

163

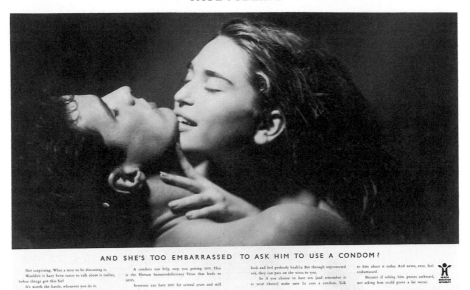

Figure 9.1 'And she's too embarrassed to ask him to use a condom?', 1992
Source: Courtesy of the HEA

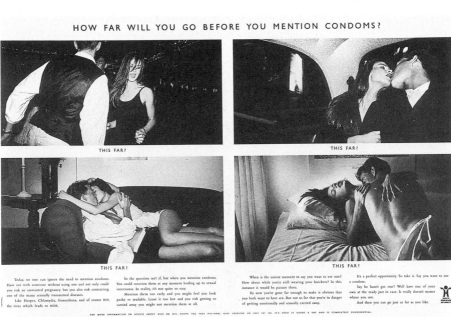

Figure 9.2 'How far will you go before you mention condoms?', 1992
Source: Courtesy of the HEA

co-equal partners in the sex act. In the iconography of these advertise-ments, the women are connoted as active and liberated sexual beings with minds of their own, and this message is further underscored in the slogans beneath the images. At this point, issues surrounding the 'right moment' as well as the 'right agency' are addressed and the myth that only men have the right to initiate sexual intercourse or that the decision to use condoms should be left exclusively to the male partner is torpedoed.

The position of gay men within condom culture has also become more visible since 1986. On the one hand, resistance by most well-known brands to associating their products with gay men and anal sex has led to specif-ically 'gay' products such as Red Stripe and Hot Rubber to take the initiative.[14] And on the other, campaigns have also been devised by var-ious political organisations such as Act Up, the San Francisco AIDS Foundation (Figure 9.3) and the HEA for both gay and bisexual men. The discourse of this type of advertising with regard to both text and image is often much more graphically disarming than that produced for a straight market. *For Safer Sex, Pinch this Tip* (Figure 9.4), for instance, actually depicts a condom about to be unrolled (something which is not allowed in press or television advertising codes for specific brands) with

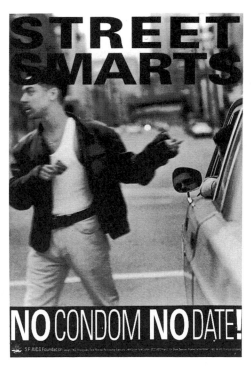

Figure 9.3 'Street smarts, no condom, no date!', 1993
Source: Courtesy of the San Francisco AIDS Foundation

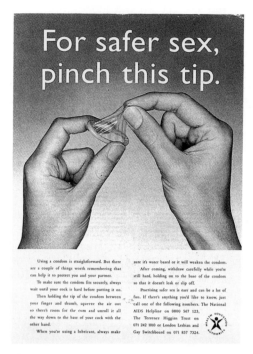

Figure 9.4 'For safer sex, pinch this tip', 1993
Source: Courtesy of the HEA

the advice, 'always wait until your cock is hard before putting it on' and 'squeeze the air out so there's room for the cum'. Similarly, *He's Into Safer Sex, So Why Not Give Him a Hand* (Figure 9.5), portrays two young gays fondling each other playfully and not only talks candidly about mutual masturbation, fingering and oral sex but, in its use of black role models, also raises the issue that the practice of safe sex is of as much relevance to ethnic groups as it is to whites.

In more general terms, the solicitous message of the HEA advertisements coincides with the popular belief that gay men have fostered a more responsible attitude towards HIV/AIDS and have reoriented their sex lives more willingly to safe sex. The HEA Gay Bar Surveys, which have been conducted since February 1986, reveal an acute awareness of advertising campaigns amongst the gay community (in 1990, 88 per cent of all respondents claimed to have seen at least one ad in the gay press, and in 1992, 79 per cent had seen at least one of the Testimonial television ads featuring gay men) as well as a clear trend towards safer-sex practice and a drop in unprotected penetrative anal sex from 59 per cent in 1986 to 19 per cent in 1990 (HEA 1993: 20–2).[15] Such statistics clearly serve to substantiate the assumption that gay men are well adjusted to safe sex

166

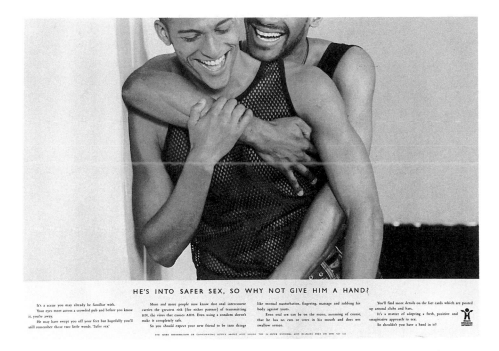

Figure 9.5 'He's into safer sex, so why not give him a hand?', 1990
Source: Courtesy of the HEA

and consequently do not need any encouragement to use condoms – a point which is also compounded by the paucity of condom ads to be found in the gay periodicals consulted in the course of preparing this chapter.[16] Yet this evidence also tends to simplify the actual sexual dynamics of gay men. The 1991 HEA Bar Survey, for example, also revealed that only 23 per cent of gay men thought that anal rimming was a high-risk activity, and in 1990 a survey by several doctors for *Genitourin Medicine* reported that 25 per cent of sexually active gay men never resorted to condoms, mostly on the grounds that they found them awkward to use or that they disrupted pleasure (Fitzpatrick et al. 1990: 346–50).[17]

The initial burst of advertising activity, therefore, may have helped to promote more condom sales – LRC statistics recorded wider use of condoms by 1991 (*The Times*, 12 August 1991) – but at the same time was undermined by reports of irresponsible attitudes towards safe sex and the unremitting increase in the incidence of HIV and AIDS cases. A NOP Survey of 18–34-year-olds in the *Independent* on 1 December 1991 revealed that 80 per cent of correspondents felt they did not need to change their sexual behaviour and the same report also stated that the World Health Organisation expected up to 40 million people to be infected

with HIV by the year 2000. Notwithstanding the HIV/AIDS epidemic, the condom appears to be suffering from a crisis of identity in terms of sex appeal and credibility and there is still strong resistance to a product which is generically regarded as being an impediment to passion.

THE ROLE OF PLEASURE IN CONDOM ADVERTISING

Allegations concerning the diminution of pleasure which can accompany use of the condom have been commonly expressed since sheaths made from sheep's intestines first became available in the late eighteenth century. Casanova, for instance, who praised the sheep-gut condom for affording him protection from venereal disease, ultimately described his abhorrence for such forms of prophylaxis in the following terms: 'I do not care to shut myself in a dead skin in order to prove that I am perfectly alive' (Himes 1971: 195). And more recently, in 1972 a survey amongst teenage males in America stated that 61 per cent of them had reported a loss of sensitivity when using condoms (Redford et al. 1974: 19, 115), while similar reservations were still being expressed by guinea-pigs involved in tests for the *Observer* in 1994 (*Observer Life*, 20 March 1994: 31). The antipathy that most men seem to have towards the condom is probably the most vexed issue that manufacturers and advertisers have to transcend. In 1971, for instance, *Playboy* refused to run advertisements for Julius Schmid condoms so as not to 'disturb the euphoria' of its readers. Attitudes such as this clearly reveal deep-seated anxieties concerning carnal pleasure and the intimacy of sexual feelings, which condom advertising confronts directly, bringing them into the open and transgressing the space between private and public spheres or emotions. Furthermore, in attempting to reconcile loss of sensitivity with the peace of mind which might result from the use of condoms, the discourse of much contraceptive/prophylactic advertising wages a form of psychological warfare that appears to borrow heavily from the ideas of Freud. By this, I do not wish to contend that condom promotions have an uncomplicated relationship to Freud's psychoanalytical theory, simply quoting his ideas directly or reflecting them back to us in order to give condoms some credibility. But rather more, as we shall see in the rhetoric of the advertisements discussed below, Freudian thinking operates on a subliminal level and is consequently deployed as a trope through which the meaning of pleasure and other fundamental human desires and fears can be framed and negotiated.

Freud himself had referred to condoms and contraception intermittently in several of his texts between 1895 and 1908.[18] Although at the outset he seemed to have opposed the use of all contraceptive devices, which he maintained impaired sexual enjoyment and 'hurt the fine susceptibilities

of both partners' (Strachey 1959, 9: 194), we must also bear in mind that Freud expressed such views with regard to the methods of prophylaxis and contraception which were available in his own time. It was these which he regarded as inadequate rather than contraception and family planning *per se* and, indeed, he appeared to look forward to the time when more reliable and convenient forms of contraception would be available, referring to them as 'one of the greatest triumphs of humanity, one of the most tangible liberations from the constraints of nature' (Strachey 1962, 3: 277). What is of more concern to us in this context, therefore, is Freud's emphasis on maintaining and maximising sexual enjoyment and pleasure, which he elaborated more consistently in his writing after 1910.

In the *Formulations of Two Principles of Mental Functioning* (1911), Freud had addressed the ego's quest for pleasure in terms which appear to borrow heavily from Graeco-Roman codes of ethical practice and moderation (Foucault 1985: part 1). Thus he argued that the individual's urge for fulfilment is continuously mediated by external events or 'the reality principle', which teaches the ego to delay gratification so as to attain pleasure more responsively and knowingly: 'the substitution of the reality principle for the pleasure principle implies no deposing of the pleasure principle, but only a safeguarding of it' (Strachey 1958, 12: 223). These ideas were expanded further in 'Beyond The Pleasure Principle', first published in 1920, where Freud describes the overwhelming tendency for the mind to filter out any unpleasurable feelings or experiences, which may be caused by either external or internal stimuli or repressions:

> The dominating tendency of mental life, and perhaps of nervous life in general, is the effort to reduce, to keep constant or to remove internal tension due to stimuli ... a tendency which finds expression in the pleasure principle ...
>
> The pleasure principle, then, is a tendency operating in the service of a function whose business it is to free the mental apparatus entirely from excitation or to keep the amount of excitation in it constant or to keep it as low as possible.
>
> (Freud 1991: 329, 336)

Moreover, for Freud, pleasure resided largely in the domain of sexual instincts and any form of sexual repression or anxiety about sex could seriously inhibit pleasure (ibid.: 288–91).

Clearly, advertisements for condoms have to confront a whole range of psychosexual anxieties concerning the possibility of unwanted pregnancy, the side-effects of the pill and the contraction of STDs, while trying to persuade us that the use of condoms is not necessarily antithetical to passion or disruptive of pleasure. What is usually maintained in these condom promotions, therefore, is that any reduction in sensitivity is

negligible or, at any rate, compensated for by good health and free-dom from possible side-effects. In a campaign for Durex entitled *Coming Off the Pill?*, published in the women's periodical press during 1980, these points were addressed through various rhetorical devices which not only presented the consumer with a moral and physical dilemma but which also sought to resolve it for both her and her partner. The advertisement features a portrait of a woman's face in a high-contrast, chiaroscuro style – the right-hand side of the image is bathed in darkness and is masked by text; the left-hand side stands out in sharp relief and clearly reveals her troubled expression. The woman's gaze is uncompromisingly direct and transfixes us, while the accompanying text reinforces the psycholog-ical moment of the image by establishing a discourse with the spectator which 'talks through' the pros and cons of various forms of contracep-tion. These tactics seem to imply that both the woman in the advertisement and the (female) spectator are active agents when it comes to making the final decision as to which form of birth control they desire; but in effect women are presented, somewhat paradoxically, with only one choice of contraception – the male sheath – and any doubts which they may have had in using it are dispelled by a dual form of exchange value which, as the ad puts it, promises to bring 'Safety for you and extra sensitivity for your husband'.

Consequently, the condom can be seen here to function in the interests of both women and men, maximising the pleasure principle by keeping anxiety at bay and heightening enjoyment for each of them. We find this dualism reinforced repeatedly in Durex campaigns during the 1970s and early 1980s. An advertisement for Durex Unison ribbed condoms in 1977, for example, carried the headline, 'It's Worn by Men. It Drives Women Wild. And We're Not Talking about Aftershave' and concluded, 'You'll hardly know you're wearing it. But she will. That's why we call Unison the male contraceptive for women.' In addition, several Durex advertisements aimed to convey the reliability and popularity of the condom diegetically, mobilising official figures from the Family Planning Survey of the Office of Population, Censuses and Surveys so as to make a direct appeal to the welfare of both partners. In 1973, *You Can't Choose Which. You Can Choose When* and *The Birds and the Bees Don't Know Everything*, for example, stated that the sheath was the preferred method of contraception with 39 per cent of married couples and the pill with 25 per cent.[19]

The discourse of condom advertising consequently appears to confront us with a fundamental paradox concerning our corporeal pleasure: on the one hand use of the male sheath seeks to augment such pleasure by removing the undesirable or worrying consequences of sexual intercourse, while on the other it implies the diminution or curtailment of such plea-sure through both an interruption in performance and a 'veiling' of the senses. But, the use of condoms also links issues of morality (is it justifi-

170

able to prevent conception through artificial means?) to issues of mortality ('if some form of protection is not used, might I not contract some deadly disease?'). Since the identification of HIV and AIDS and their impact on public consciousness during the mid-1980s, therefore, Durex and other manufacturers have been compelled to frame pleasure not just in the context of contraception but with reference to prophylaxis as well. Sometimes this was achieved through the use of humour: see, for example, the 1991 Durex poster campaigns for Family Planning clinics which featured cartoon sperm and slogans like 'Slip It On Before You Slip It In'. Yet more frequently, the rhetoric of Durex advertising has maintained a more serious or sober attitude in attempting to reconcile sexual pleasure with the epidemical threats which exist in the real world, and these concerns were imaginatively crystallised in the *mise-en-scène* of the first Durex television advertisement, *Together You're Safer with Durex*, produced in October 1987 by Dorland Advertising.

In the midst of a gold-tinted townscape we discern a latterday Romeo and Juliet divided by a chicken-wire fence. Through close-ups of their searching eyes, however, we can clearly see that they desire each other. Shots of the boy and girl progressing along either side of the fence are in turn intercut four times with images of fictitious newspaper headlines, each of them problematising the venturous or transitional nature of the sex act and symbolising the abyss into which the temptation of unprotected sex lures us. The first headline, 'Aids: Can Love Survive?', appears on the front page of a newspaper which has been trampled underfoot in a puddle; the second, 'Unwanted Pregnancies – The Statistics', appears with the girl's shadow projected onto it; the third, 'The Age of Romance Dead?', is represented through a car windscreen with the boy's face reflected in it; while the last baldly exclaims, 'Cervical Cancer Concern Continues'. Such impediments to pleasure are countered throughout the advertisement by the Frankie Goes To Hollywood soundtrack, 'The Power of Love' and are ultimately resolved in its climactic sequence, which states, 'Together You're Safer with Durex', and which represents the final front-page being carried off in the wind as the boy and girl are reunited in an amorous embrace.

The intertwining of health and desire which is connoted in this and other condom and HEA advertisements invokes yet another aspect of Freud's thinking on the pleasure principle, namely the polarity and interdependence he discerned between two forms of instincts. Taking his cue once more from the Greek code of sexual pleasure as well as from the earlier ideas of A. Weismann which had appeared in three key texts of the 1880s and 1890s, Freud propounded a theory of binary opposites based upon the 'ego instincts' and the sexual instincts.[20] Thus he spoke of the 'ego-instincts' in terms of the *soma* or body and the sexual instincts in terms of the reproductive 'germ-plasm': the former willing us towards

death through old age and infirmity and the latter biologically towards the prolongation of human life through birth. The use of condoms, however, and by extension their promotion in advertising, inverts the natural order of the sexual and 'ego-instincts' as described by Freud. In terms of contraception, the tendency of the sexual instinct to prolong life is denied, since the condom prevents procreation and thereby sets up a state of loss or death; whereas in terms of prophylaxis, sex triumphs over the ego and spares us from death since the condom inhibits the contraction of potentially lethal STDs. Consequently, the 'ego-instincts' and the sexual instincts are conflated in sex involving condoms, and in this way 'life' and 'death' can be seen to co-exist or 'come together', as it were. Freud himself had spoken of a similar type of correlation in his definition of Libido and though he did not affirm the transcendence of one form of instinct over the other, he nonetheless expressed the potential for a specific form of interaction between the two. Thus he emphasised that sexual instincts can be part of the ego in so far as they concern Libido (or the compulsion to fulfil desire), a psychosomatic condition which in turn he traced back to the evolution of narcissism during childhood:

> The ego now found its position among sexual objects and was at once given the foremost place among them. Libido which was in this way lodged in the ego was described as 'narcissistic'. . . . Thus the original opposition between ego-instincts and sexual instincts proved to be inadequate. A portion of the ego-instincts was seen to be libidinal; sexual instincts – probably alongside others – operated in the ego.
>
> (Freud 1991: 325)

Indeed, the very act of reaching sexual climax was viewed both by Freud and later by Roland Barthes[21] as having a fatally disruptive and dissipating character. This, for example, is how Freud himself put it: 'We have all experienced how the greatest pleasure attainable by us, that of the sexual act, is associated with a momentary extinction of a highly intensified excitation' (Freud 1991: 336–7). More expressly for Barthes, the type of climactic pleasure we are dealing with in such instances and which is, in turn, addressed in the discourse of condom advertising is *jouissance* or bliss:

> Text of bliss: the text that imposes a state of loss, the text that discomforts ... unsettles the reader's historical, cultural, psychological assumptions, the consistency of his tastes, values, memories, brings to a crisis his relation with language ... it granulates, it crackles, it caresses, it grates, it cuts, it comes: that is bliss.
>
> (Barthes 1990: 14, 67)

The ineluctable impulsion towards orgasm (or 'momentary extinction') that both authors refer to here and the ways in which condom advertising

admonishes us to temper such *coups de foudre* has already been discussed with reference to the symbolism of the 1987 Durex television campaign, *Together You're Safer with Durex*. Advertisements for brand names such as Durex, however, are produced within the parameters of restrictive legislation which allows STDs to be mentioned but which prohibits the use of suggestive language and the display of the product itself. This legislation is indicative of the ambiguous cultural status that the condom still has in contemporary society and militates against the codification of pleasure in more erotic and diverse ways. As Suzanne Moore, writing in the *New Statesman* on 19 February 1988, contends: 'As long as condoms are associated with cosiness, constraint and coupledom, men won't get into them and women won't make sure they do.'

In contrast, the HEA has enjoyed relative autonomy in the production of its advertisements and as a corollary many HEA campaigns have symbolised the relationship between safe sex and pleasure in a more egregious and provocative fashion. The narrative of Figure 9.2, for example, has been structured in a kind of picture-book format and the advertisement consists of a sequence of four interconnecting photographs, each of them sensuously portraying a particular step or moment in the mating game. We start at the top left with a couple dancing in a night-club, move to their kissing in a taxi on the way home, then to their petting

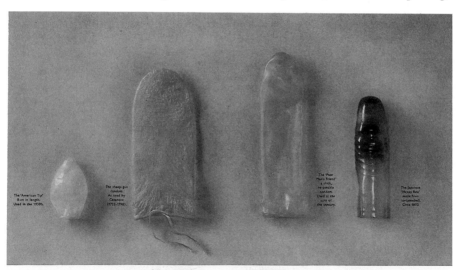

SEX HASN'T CHANGED MUCH OVER THE YEARS. FORTUNATELY CONDOMS HAVE.

Figure 9.6 'Sex hasn't changed much over the years. Fortunately condoms have.' 1993
Source: Courtesy of the HEA

in underwear on the sofa, and end at bottom right with a passionate scene of lovemaking in bed. Overarching the four frames is the caveat, 'How Far Will You Go Before You Mention Condoms?' and beneath each of them the same riposte, 'This Far?' The intertextuality of words and images here serves to emphasise the positive aspects of safe sex and departs from the more heavy-handed, eschatological discourse of the first government-sponsored HIV/AIDS campaign, *Don't Die of Ignorance* (1987), with its tombstones and wreaths. Rather than deterring passion, the HEA advertisements appear instead to encourage it, and condoms *per se*, whether visible or not within such contexts, become fetishised as an integral part of lovemaking. In common with advertisements for Durex any imputed loss of sensitivity is skilfully played down and compensated for either by general references to health and safety, or by way of specific historical comparisons with earlier, less sensual prototypes, as in the 1993 press campaign, *Sex Hasn't Changed Much Over the Years. Fortunately Condoms Have* (Figure 9.6) and the 1992 cinema/television ad, *If Mr Brewster Put Up with Geronimo You Can Use a Condom*, in which the eponymous character tells us: 'It was like having a bath with your socks on. But it never stopped me in no way.' More especially, lovemaking is represented as a more adventurous and versatile human activity because of, not in spite of, the need for safe sex and many HEA ads consequently highlight the pleasures of foreplay, stroking, masturbation and oral sex.

CONCLUSION

The role of condom advertising in Britain since 1970 affords us an interesting insight into the sexual politics of the period which touches on attitudes towards pleasure and promiscuity as well as issues of gender, race, class and generation. However, the temptation for us to believe that all condom promotion is essentially daring or risqué or ahead of its time by virtue of the sexual nature of the product in question is misleading. As I have suggested in this chapter, advertisements for contraception do not necessarily initiate any new social ideals or values; rather, more often they imitate an already nascent moral culture, and frequently they lag behind it. The advertisements that were produced before 1986, in common with the ideologies of most advertising, were oriented clearly toward a straight market and mostly one comprising young white married couples. No racial or class distinctions were manifest and no mention was ever made of pre-marital or extra-marital sex in the campaigns of the period. Likewise, there were no discrete promotions targeted at gay men, notwithstanding the fact that a rapid increase in the incidence of venereal disease amongst the gay community had already been detected at the end of the 1960s. Indeed, until the advent of HIV and AIDS, the condom was

prescribed almost exclusively as a method of birth control by both the establishment and advertisers alike and, although widely used, was scarcely regarded by most men and women as an item to relish.[22]

For most of its career, therefore, the condom has suffered from an identity crisis, impugned on both moral and aesthetic grounds, a seemingly unsexy and unerotic product which paradoxically found itself at the heart of the sex act. This is the very contradiction or stigma which the campaigns discussed in this essay appear both to subvert and to sublimate. Although the extent to which advertisements can actually encourage us to purchase any particular product is notoriously difficult to quantify, the iconography and symbolism deployed in the promotion of condoms since 1970 might at least persuade us that they could be fun and pleasurable to use. These representations are constant reminders, therefore, that the success not only of condom promotion but of the sex act itself resides in the tenuous balance between pleasure and pain.

NOTES

1 The first advertisement I could trace in the *Observer* appeared on 13 January 1963.
2 See *Which?*, 1963. Durex brands were first manufactured in 1932 and London Rubber became the chief supplier of condoms to British forces during the Second World War.
3 The research for the Lafitte report was conducted between March 1960 and July 1963; it involved twenty-one formal discussion sessions and the questioning of witnesses.
4 The advertisement had initially appeared in *Family Doctor* and *Getting Married* without any of the text being excised.
5 Cartwright (1970: 7), corroborates these figures by citing a survey which revealed that in 1970 condom users in Britain outnumbered users of the pill by 3:2.
6 The 1971 census was not totally accurate, giving no indication as to whether someone born in India but living in Britain was, for instance, of British or Indian nationality, and counting all those of mixed race as black. It recorded the following groupings – West Indian (258,000); Indian (252,000); Pakistani (124,000) and Africans (118,000). See Rees (1974: 7–9).
7 The numbers of recorded illegitimate births to under age girls accordingly had increased threefold to 1,486 by 1969 from 483 in 1959 (Wright 1971: 39).
8 In May 1970 the House of Lords passed an amendment to the Indecent Advertisement Act of 1889 to this effect. The *Evening Standard* (21 March 1969) stated that in 1967 119,545 men and 56,829 women had attended clinics for STDs, while the *Sunday Mirror* (15 June 1969) quoted similar figures for the rest of the Britain; and *Medical News* (17 January 1969) reported that 15 per cent of all new recorded cases of gonorrhoea were amongst gay men.
9 A report by Mintel in the *Guardian* (5 August 1992) revealed that in 1991 49 per cent of condoms were being sold by chemists, followed by vending machines (16 per cent), grocery stores and supermarkets (15 per cent) with mail order accounting for 2 per cent of sales. The *Sun* (16 November 1992) reported that Freemans fashion catalogue also intended to sell condoms from the spring of 1993.

10 In 1993 products by London Rubber Group still took 80 per cent of the market (see *Simplifyle* 1993: 372) and in 1988 LRC spent 800,000fr on ads in France (see Lever 1988: 50).

11 The original trustees of Virgin Healthcare were Richard Branson, Michael Grade, John Jackson and Anita Roddick. Patrons included: Peter Gabriel, Elton John, Phil Collins, Carey Labovitch, Sandie Shaw, Claire Raynor, Penny Junor, Dr Alan Maryon Davis and Rabbi Julia Neuberger. Mates are manufactured by Ansell, founded in 1905 in Melbourne and a subsidiary of Pacific Dunlop Ltd. who sold condoms in eighty different countries with sales figures for 1988/9 of c. £200 million. In 1988 the Mates brand name was finally sold to Pacific Dunlop.

12 Five agencies competed for the original account: Still Price Court Twivy D'Souza; Saatchi (whose caption was 'If It's Not On, It's Not On'); Ayer Barker; Davidson Pearce; and Geers Gross. Morgan (Bedell 1987: 56) states: 'The British consider themselves hung-up about sex – less than their parents perhaps, but much more than people on the continent.'

13 *OPCS General Household Survey 1989, 1991*, recorded that 15 per cent of women aged 16–49 were using condoms and 22 per cent the pill.

14 Red Stripe are sold under license from German and French condom manufacturers by Patrick Moylett and are approved for anal intercourse by the Terrence Higgins Trust; Hot Rubber are manufactured in Zürich and sold in various gay bars and clubs across Europe.

15 Since February 1986, the HEA Bar Survey has interviewed annually between 260 and 300 gay men of all ages.

16 The gay magazines I consulted during 1993/4 were: the *Pink Paper*, *Capital Gay*, *Gay Times*, *APN* and *Attitude*.

17 HEA (1993: 20–2) evidence was based on a sample of 520 active men as follows: London (228/45 per cent); Manchester (145/29 per cent); Oxford (65/13 per cent); Northampton (31/6 per cent). Their mean age was 31.6 years.

18 Namely, 'On the right to separate from neurasthenia a definite symptom-complex as "Anxiety Neurosis" ' (1895), see Strachey, vol. 3; 'Sexuality in the aetiology of neurosis' (1898), Strachey, vol. 3; and ' 'Civilised' sexual morality and modern nervousness' (1908), Strachey, vol. 9.

19 It must be noted, however, that sales of the contraceptive sheath fell by 25 per cent between 1973 and 1975. See Wellings (1986: 63).

20 Plato in the *Symposium* and Aristotle in *Ethics* speak of the conflation of death and immortality in sexual pleasure, contending that the sex act, on the one hand, appears to rob man of life-giving substances but, on the other, allows him to cheat death through procreation. The texts by Weismann to which Freud refers are *Uber die Dauer des Lebens*, 1882; *Uber Der Leben und Tod*, 1884; and *Das Keimplasma*, 1892.

21 Barthes (1990: 7), 'what pleasure wants is the site of a loss, the seam, the cut, the deflation, the dissolve which seizes the subject in the midst of bliss'. Barthes' *Le Plaisir du Texte* was first published in France in 1973.

22 *Which?* (1963) stated that 100 million condoms were being sold each year in Britain.

BIBLIOGRAPHY

'Aids Boosts Condom Sales', *The Times*, 12 August 1991.
Barthes, R. (1990) *The Pleasure of the Text*, Oxford: Basil Blackwell.
Bedell, G. (1987) 'Mates: shedding a social stigma', *Campaign*, 13 November, 56–7.

Cartwright, A. (1970) *Parents and Family Planning Services*, London: Routledge and Kegan Paul.

Curtis, H. (ed.) (1991) *Promoting Sexual Health, Proceedings of the Second International Workshop on Prevention of Sexual Transmission of HIV and other Sexually Transmitted Diseases*, London: HEA/BMA.

Dyer, G. (1982) *Advertising as Communication*, London: Methuen.

Fitzpatrick, R., McLean, J., Dawson, J., Boulton, M. and Hart, G. (1990) 'Factors influencing condom use in a sample of homosexually active men', *Genitourin Medicine*, 66, 5: 346

Foucault, M. (1985) *The History of Sexuality, vol. 2, The Use of Pleasure*, Harmondsworth UK: Penguin.

Freud, S. (1991) 'Beyond the pleasure principle', *On Metapsychology*, Harmondsworth UK: Penguin.

HEA (1993) *Health Education Authority, Mass Media Activity 1986–1993*, London: HEA.

Himes, N.E. (1971) *Medical History of Contraception*, New York: Schocken Books.

Lafitte, F. (1963) *Family Planning in the Sixties – Report of the FPA Working Party*, University of Birmingham.

Lever, R. (1988) 'The selling of safe sex', *Paris Passion*, November/December.

Lowry, H. (1994) 'Protection Racket', *The Observer Life*, 20 March, 31.

Mead, G. (1993) 'Aids directs attention to the condom market', *Financial Times*, 14 April.

Medanar, J. (1976) 'What did they think about birth control in 1959 and 1963?', *Family Planning*, April, 6–7.

Redford, M.H., Duncan, G.W. and Prager, D.J. (1974) *The Condom: Increasing Utilization in the U.S.*, San Francisco: San Francisco Press.

Rees, T. (1974) 'The coloured population of Great Britain', *Family Planning* 23, 1: 7–9, April.

Ryley-Scott, G. (1937) *Male Methods of Birth Control: Their Technique and Reliability – A Practical Handbook for Men*, London: T. Werner Laurie.

Schofield, M. (1965) 'The sexual behaviour of young people', *Family Planning* 14, 2, July.

Simplifyle (1993) 'Family planning – the learning curve', October.

Strachey, J. (ed.) (1953–74) *The Standard Edition of the Complete Psychological Works of Sigmund Freud*, vols. 3, 9 and 12, London: Hogarth Press.

Wellings, K. (1986) 'Trends in contraceptive usage since 1970', *British Journal of Family Planning*, 12:2.

Which? Supplement on Contraceptives, November 1963.

Wright, H. (1971) 'Schoolgirls and the FPA', *Family Planning*, July.

10

TRANSNATIONAL PUBLISHING

The case of *Elle Decoration*

Barbara Usherwood

This chapter examines recent changes in marketing strategies and consumer address within the home-interiors sector of the British magazine market. It looks in particular at the launch of *Elle Decoration* in 1989 and argues that this new magazine changed the boundaries of its genre in a number of ways; not only did it look different from other home-interiors titles, it also promoted new values in relation to home decoration and furnishing. These features are examined in relation to the innovative 'global-but-local' marketing strategies of the transnational publishing project of which *Elle Decoration* was part.

The study draws on material from the first sixteen issues of *Elle Decoration* as well as interviews with members of its production team. Other home-interiors magazines from the period (i.e. 1989–91) were used for comparative analysis. As a case history, it attempts to broaden the study of graphic design beyond aesthetic issues alone. It aims to demonstrate how the design of a magazine can be understood as part of a network of factors relating to the magazine's production, including its producers' assumptions about its readership.

PUBLISHING CONTEXT

When *Elle Decoration* was launched in Britain in the summer of 1989, it was one of a number of new consumer magazines concerned with home interiors. The three longest surviving titles in the field, *Ideal Homes*, *Homes and Gardens* and *House and Garden*, had been joined by five newcomers since 1980 and even more were to come.[1] This dramatic increase should be seen in relation to the startling rise in the number of all magazines during the 1980s and relates to the function of the magazine as a cultural form. Itself a commodity, a magazine is also one of the channels through which other commodities are displayed. It occupies a

pivotal position between the producers of goods and their publics, and has to attract both in sufficient numbers to survive.

And for a large part of the 1980s, the conditions for many kinds of advertising were good: the country was awash with consumer credit and finance for businesses, more people were eager to spend and willing to borrow, and manufacturing and service industries were anxious to attract their custom. It was within this context that a boom in home-ownership occurred (encouraged partly by government policies) and house prices increased: conditions which made financial investment in home furnishings and decoration attractive to producers and consumers alike. It's not surprising, therefore, that the gross readership of home-interiors magazines increased during this period, although it should be noted that this was unusual within the magazine industry. In most other sectors, the increase in titles reflected a fragmentation of an *existing* readership rather than an increase in the magazine-reading public (Braithwaite and Barrell 1988: 153). This splintering of magazine genres can be explained in relation to the move away from the vestiges of mass-marketing and towards more precise target-marketing techniques, involving the increasingly refined skills of market research companies (see Gunter and Furnham 1992).

So, not only were more people reading home-interiors magazines but, as with other types of magazine, the range of titles had become more varied as publishers sought new niche markets to target. Of the newcomers, *House Beautiful* was the cheapest and most broad-based in its appeal, whilst the others offered more specific perspectives on home decoration and furnishing: *The World of Interiors* sought to attract a wealthier section of the market, or those who liked looking at its opulently produced images of exclusive interiors and expensive artefacts; *Traditional Homes* addressed those interested in house renovation; and *Country Living* made an appeal to the reader whose 'heart is in the country', as did the rival *Country Homes and Interiors*.

Much was written about the advent of a new niche market in the late 1980s: a young, upwardly mobile social grouping of style-conscious city dwellers with money to spend. *Elle Decoration* aligned itself with aspects of this aspirational ideal by offering its advertisers a 'modern, stylish, urban market' interested in 'international style' (see Figure 10.1). The launch of *Elle Decoration* could therefore be seen as an attempt to seize and control a set of favourable conditions. On the one hand, there was an increased interest in home furnishing and decoration which had boosted the provision of goods and services for the home and given rise to a number of new home-interiors magazines. On the other, there appeared to be a potential readership of affluent young home-makers whose aspirations were not being addressed by these magazines. The task of this new magazine was to articulate a relationship between such people and the advertisers who wanted to reach them.

179

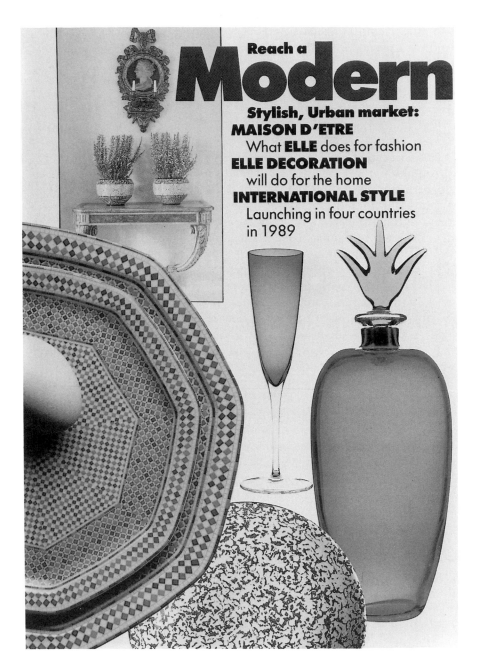

Figure 10.1 The cover of a pre-launch publicity leaflet for *Elle Decoration*, aimed at potential advertisers, summer 1989
Source: Courtesy of *Elle Decoration*

Elle Decoration was part of an innovative transnational publishing project which built on the success of the long-established French woman's weekly magazine, *Elle*, and which was organised by the magazine publishing arm of the French communications giant, Hachette. The original *Elle* magazine was launched in Paris in 1945 as a fashion and features weekly, but when its publisher decided to expand into other countries in the mid-1980s, it opted for the form of a fashion monthly. This venture took place at a time of general international expansion in the magazine industry, particularly by the large Continental publishers like Bauer and Grunher and Jahr. But whilst these big German companies were expanding on a unilateral basis, Hachette developed a partnership strategy: twelve of the fifteen foreign editions of *Elle* which had been launched by 1990 were joint ventures with local publishing companies. This gave Hachette two advantages: first it could use the local knowledge and experience of the partners to break into new markets relatively quickly and, second, it could prevent competition from these potential rivals in the process. In some cases the partnership remained intact, in others Hachette bought its partners out once the magazine was sufficiently well established, as in the case of the British edition of *Elle*, whose links with Rupert Murdoch's News International were dissolved in 1988 (Dourado 1991).

Whilst editions of *Elle* were springing up across the globe from São Paulo to Shanghai, Hachette launched *Elle Decoration* in France in 1987, followed by editions in some of the countries already colonised by *Elle*. This could be seen as part of a growing trend towards 'brand extension': a strategy which enables manufacturers to diversify their product range but minimise the risks involved by making use of well-established brand names.[2] The first foreign editions of *Elle Decoration* were launched in Britain, Spain, the United States, Greece and Brazil in 1989 and were joined by German, Italian, Dutch and Japanese editions by 1991. Publishing frequencies varied considerably, as did the circulation figures. The British edition was published bi-monthly and was credited with an average circulation of about 50,000 during 1991, reflecting its niche position in relation to the broader appeal of *Ideal Home* and *House Beautiful*, for instance, both with a monthly circulation average of over 230,000 in the same period and, indeed, in relation to the broader appeal of *Elle*, whose monthly average was over 200,000 (*Benn's Media Directory* 1990/1).

Hachette set up a global-but-local framework for all the foreign editions of both *Elle* and *Elle Decoration*, a framework which was intended to maximise the advantages of transnational publishing whilst being sensitive to the particular character of local (i.e. national) markets. In the case of both titles, Hachette's sensitivity to national differences resulted in a degree of autonomy for the team responsible for each edition,

although this was within a framework of centralised control over aspects of both editorial and advertising. Each edition of *Elle Decoration* used a common graphic format of a prescribed range of grids and typefaces and a common photo library of home interiors. Images in this photo library had been commissioned by the individual editions and paid for from their own budgets. These photographs were then made available to all other editions of *Elle Decoration* around the world, who paid the commissioning edition for any material it used. In the case of the British edition, the art editor explained that every issue contained between ten and twenty pages bought in this way, although she was keen to stress that the British design team would often redesign aspects of these pages to give their own 'sort of feel to it' (Hajek 1992). When each British edition was ready for printing, all layouts had to be sent to Hachette in Paris for final approval.

As for advertising, centralised control was invested in a branch of the company called Interdeco, which offered advertisers transnational marketing packages whereby they could advertise in one or both magazines in selected countries. In addition, point-of-sale promotions could be organised with chains of shops and 'advertorials' could be arranged within the magazines themselves. The use of advertorials, where costs are shared between magazine and advertiser, is a relatively new phenomenon and could be seen as a further step towards the erosion of boundaries between advertising and editorial. For, whilst direct advertising has been a feature of magazines almost since their inception, the indirect advertising of products and services by means of editorial coverage has been on the increase, particularly in the postwar period. Cynthia White reports that in the mid-1950s, editors were worried that 'the growing power of the advertiser would so far infiltrate editorial content as to render it no more than a manipulative device for influencing the spending habits of women, effectively destroying, or at best limiting, the social functions of the women's press' (White 1968: 156–7).

Significantly, a major social function of *Elle Decoration*, in common with many other contemporary consumer magazines, appeared to *be* to influence the spending habits of its readers through indirect advertising. As the editor explained, 'we act as a sort of upmarket yellow pages . . . half the magazine is merchandise' (Crawford 1992). One of her major concerns, however, was that some of the advertisers who wanted to use the magazine might not be sending the right kinds of messages to targeted readers; the identity of their own brands might not be compatible with the identity of the magazine:

> obviously in a recession you are much more accountable to advertisers than you are when times are good and money is plentiful . . .
> but you can shoot yourself in the foot if you try to please them too

much, because on the whole, the people who have lots of money to advertise are not necessarily going to be the ones that your readers want to hear about.

(ibid.)

MODES OF ADDRESS

Like other consumer magazines, *Elle Decoration* sought to create and maintain a 'brand identity' which would appeal to a sufficiently large group of people who would buy it regularly; people whose aspirations corresponded with the lifestyles and aesthetics depicted or who could find enough in the magazine to relate to. Such an identity derived its meanings partly in terms of its differential relationship with other home-interiors magazines, as well as the differences it implied between its readers and the rest of the public (notwithstanding the fact that readers of *Elle Decoration* might well read other home-interiors magazines).

Elle Decoration adopted an editorial mode of address which was distinctive within its genre, but was similar in some ways to the verbal and visual rhetoric of the fashion and style press, most notably its sister publication, *Elle*. Its tone was urgent by comparison to the more leisurely and descriptive mode of other interiors magazines. There were some discursive articles and passages of text, but sentences were mainly short and snappy (underscored by short line lengths) and the writing style was largely inspiring, hectoring and imperative. But given the image-based nature of the entire genre, perhaps the most obvious characteristic of *Elle Decoration* was its striking visual style, particularly its dramatic use of the photographic image. Extensive use was made of images which 'bled' off the edges of the page, whilst an imaginative use of colour, unusual camera angles and close-up shots injected a sense of surprise. A certain dynamism was achieved by the use of camera blur as well as cut-out images which were often large, placed at an angle or overlapped with other images. This is not to suggest that *Elle Decoration* was the only interiors magazine to use these techniques. It wasn't. But it did use such techniques more frequently and in a very assertive way and, taken together, they served to place an emphasis on the formal qualities of both individual images and page layouts.

In order to explain the significance of such formal emphasis, there is a need to consider the history of formalism within magazine design. Remington and Hodik (1989: 16) note that in the inter-war period, astute publishers such as Conde Nast recognised that the upmarket readers they wanted to attract were themselves attracted to the formal experiments of European artists and designers working in what we now call a modernist mode. The stylishness of the garments on the pages of magazines like *Vogue* and *Harper's Bazaar* was amplified by formalist techniques of presentation.

This link between formalism and upmarket tastes can be seen in the light of Pierre Bourdieu's theories about cultural capital. Bourdieu notes a class distinction between those people whose understanding of such things as paintings, music, food and photographs is based on their everyday experience and those who have learned to decode a system of secondary meanings which depend on a more cerebral approach. He calls the store of socially constructed competences and body of knowledge which enables people to understand secondary systems of meaning their 'cultural capital'. Bourdieu discovered in a mid-1960s survey that, for those without such knowledge, the value of photographs was measured by the information they contained, whereas 'cultivated spectators' with cultural capital were more likely to respond to the formal qualities of photographs (Bourdieu 1986). Yet to emphasise the formal qualities of their subject matter, fashion photographers have to find ways of minimising one of photography's most persistent features: its link with the world of lived experience. The association of accessibility or attainability with the photographic image is so deep-rooted as to seem almost 'natural'. As Susan Sontag puts it: 'A photograph is not only like its subject ... it is part of, an extension of that subject; and a potent means of acquiring it, of gaining control over it' (Sontag 1979: 155).

In their quest for formal emphasis, fashion photographers working for *Vogue* and *Harper's Bazaar* in the inter-war period used a variety of techniques to prevent a too-ready association of the photographic image with lived experience: bodies were fragmented and silhouetted; bodies, clothing and accessories were made to seem part of the same plane; similar shapes and/or colours were used to draw attention to relationships across the image; and the expressions on the faces of models were often passive and remote. Formal emphasis subsequently became a convention in upmarket fashion photography; a strategy of art direction with its roots in the aspirational emulation of an artistic elite which came to seem natural to the genre.

When asked to redesign the French *Elle* weekly in 1959, the new art director, Peter Knapp, sought to mix the formalism of upmarket magazine design with a more lively, approachable feel for the new postwar markets of modern French women. Writing about his work, a contemporary critic observed: 'the belief that the broad masses are accessible to a measure of formal beauty is now gathering strength' (McDonald 1961: 80). Fashion models were photographed in ways which stressed the interrelated shapes of their bodies and clothing, but which also drew the viewer into the narrative of the photograph (in which the printed page could be seen as one frozen frame). Settings were made less artificial than, for example, in *Vogue*, and models would often smile. Indeed, when *Elle* became a transnational fashion monthly in the mid-1980s, the approach to art direction was very similar. For example, Regis Pagniez, editor of

the American edition, said: 'a picture should be strong and graphic, but it must also tell a story'. He and his team engineered this by emphasising the formal qualities of models' bodies, their clothes and the settings, whilst trying to engage the viewer by making the models as lifelike as possible: 'she is not like a model. She is real; she breathes' (quoted in Konigsberg 1987: 8–9).

This oscillation between immediacy and distance which was one of the hallmarks of photographs in *Elle* magazine was also evident in the art direction of *Elle Decoration*. On the one hand, objects were lit and photographed so as to give a heightened sense of their textural qualities and to make them seem almost tangibly accessible: qualities which could be retained on the printed page, thanks to improvements in printing techniques and paper stock. On the other hand, the physical arrangement of objects and the cropping of images tended to emphasise formal qualities: shapes, patterns, colours and so on. Such images seem to mobilise a dialectic between the concepts of stylishness and attainability: concepts which both the editor and art editor were keen to stress. Ilse Crawford, the editor, said: 'it's about making ideas achievable, but not by going downmarket, which seems to be the usual philosophy' (Crawford 1992).

This approach to art direction was not typical within the home-interiors genre in the period under scrutiny. *The World of Interiors* was closest to *Elle Decoration* in terms of the breathtaking quality of its photographic images and printing, but made less use of innovative camera angles, close-ups and camera blur. During the whole of 1991, *Elle Decoration*'s nearest rival in terms of both art direction and content was the British edition of the award-winning American interiors monthly, *Metropolitan Home*, although this magazine only survived for eleven issues. Whilst formal emphasis does occasionally occur in other titles of the period, the vast majority of images give as much information about the rooms and products as possible.

Another major difference in visual style between *Elle Decoration* and other home-interiors magazines was its rigid adherence to a modernist-inspired design code. Again, this can be traced back to Peter Knapp's redesign of *Elle* in the late 1950s: a time when the brand identity of consumer magazines was high on the publishers' agenda. Designers were being given more recognition by publishers and were beginning to experiment with modernist-inspired ideas emanating from Switzerland about type, images and layouts. It soon became the norm to use an invisible 'grid' system to organise design elements in a consistent way throughout the pages of most magazines. The Swiss-trained Peter Knapp adhered very closely to modernist graphic principles by using such techniques as dramatic contrasts of size and weight of type or the size of photographic images; sans serif type; and the asymmetrical arrangement of type and image to achieve a dynamic sense of balance, with the use of 'white space'

(i.e. unprinted areas) as an active design element. These graphic conventions were retained by the transnational editions of both *Elle* and *Elle Decoration*, but have associations beyond the brand identity of the *Elle* project. For instance, the American design historian, Robert Craig, stresses the semiotic connotations of quality associated with the use of the grid: 'professionalism, concern with detail, carefulness, thoughtfulness, exactitude' (Craig 1990: 25). The ideological nature of the graphic code of simplicity, he argues, has its roots in the early twentieth century and gains its meanings in opposition to the 'complexity of Victorian design' (ibid.: 24). A similar connection between grids and 'design quality' can be found in a recent students' guide to graphic design, which actually uses *Elle* as an example of 'a leading international magazine which uses grids to maintain its design quality and enhance its position in the market' (Swann 1990: 95).

In short, it would seem that the design and art direction of *Elle Decoration* was intimately connected with both the historical legacy of the whole *Elle* project and the contemporary requirements of Hachette Magazines Ltd., who sought to build on the success of *Elle* and promote a coherent brand identity across all transnational editions. Moreover, the modernist features of this identity would seem to have had the advantage of signifying stylishness amongst the very groups which the magazine was trying to reach: a connotation which had its roots in the practices of European avant-garde designers of the 1920s and 1930s.

NEW VALUES FOR NEW HOME-MAKERS

In identifying a new niche in the home-interiors magazine market, *Elle Decoration* changed the contours of its genre in a number of ways. Not only did it look different from other home-interiors magazines, it promoted new values in relation to home-making. These values contrasted in a rather unsubtle way with those promoted elsewhere in the genre. Whilst assuming that its readers aspired to the condition of stylishness (defined by the *OED* as conforming to 'the fashionable standard of elegance') *Elle Decoration* implied that stylish home-making was associated with innovative rather than traditional aesthetics, with creative, 'artistic' people and with urban rather than country locations. In addition, it intimated that home-making was not necessarily a gender-specific activity. But perhaps the clearest point of implied difference was the shift from a national to an international perspective.

With occasional exceptions (most notably in *The World of Interiors*), ideas about home-making had been conflated with concepts of 'Britishness' in the home-interiors genre during the 1980s. Links with the land were stressed more consistently and forcefully by some titles than others, but for the most part Britishness was connoted by a furnishing

aesthetic derived from interiors presented as part of Britain's heritage: country cottages, stately homes and Victoriana in particular. *Elle Decoration* presented a less nationally orientated perspective in a number of ways. In the first place, over half of the homes featured during its first sixteen issues were outside the British Isles. As for British interiors, these tended to belong to people from other countries or to contain artefacts from other countries. Second, whilst all the merchandise on display in the magazine was available in Britain, much of it had foreign connections; goods were typically designed by a foreign team or inspired by some exotic style. Third, many of the people whose work was featured in articles were either from other countries or they had worked abroad.

On a symbolic level, the many links with fashion which were both shouted and whispered by the magazine may also have had global connotations for some readers, since the fashion industry is a transnational phenomenon and has been presented as such. Certainly, the connection between France and fashion is well established and *Elle Decoration*'s links with France are unmistakable, not least in its very title. In addition, the modernist design code used throughout the magazine, whilst linking *Elle Decoration* with *Elle* magazine and therefore fashion and Frenchness, may have had other global connotations for some readers. The modern movement which spawned this kind of graphic practice (as well as the modernist 'design classics' featured in its editorial) was originally connected with notions of an international style which traversed national boundaries. The utopian aims of modernist designers may not have been fulfilled in terms of popular tastes, but the styles they promoted have flourished in both the interior spaces and the publicity material of art galleries around the globe. Such places would presumably have been on the actual or aspirational agenda of many of the targeted readers, given the artistic bias of the magazine, and were echoed by the style of some of the interiors on show, with their white walls, hardwood flooring and a placing of household objects akin to the display of sculpture.

It was suggested earlier that the so-called traditional styles of furnishing and decoration promoted by other home-interiors magazines might have had the effect of conjuring up ideas about Britishness. The notion that styles of design may be used to suggest ideas about national identity is evident in the light of recent writing on this subject. Anthony D. Smith in *The Ethnic Origin of Nations* for instance, argues that concepts of nationhood are mobilised by means of links with a 'glorious past' in popular imagination (Smith 1986). John Corner and Sylvia Harvey's work would seem to support this view; they discuss the use of certain aspects of a British past in the formation of myths about national identity (Corner and Harvey 1990). Perhaps it is not too far-fetched, therefore, to suggest that concepts of *internationalism* may also be set in motion by links with a glorious past: the glorious utopian idealism of European modernism

enshrined in both the modernist type and layout of *Elle Decoration*, its highlighting of modernist-inspired interiors and articles about early modern designers.

The international perspective represented by *Elle Decoration* could be explained with reference to a number of different factors. There were certainly some obvious connections between the international bias of the magazine and the conditions of its production: for example, its visual links with other magazines within the *Elle* family were related to the publishing structure of Hachette Magazines, which in turn was organised transnationally with the aim of maximising profits in conditions of global uncertainty. In addition, further economic and political links between Britain and Continental Europe were very much on the business agenda in the late 1980s, and were to become increasingly topical in the British press.

However, to explain *Elle Decoration* solely in terms of such determinants is to ignore the fact that its form and content is carefully designed and selected to appeal to the range of presumed taste preferences of its targeted readers. A study of the magazine business by Braithwaite and Barrell emphasises that readers play a far from passive role here (Braithwaite and Barrell 1988). If the magazine's transnational links arose from the need for new, flexible strategies of business organisation in the precarious economic conditions of late capitalism, the active *promotion* of these links might well be attributed to the assumed aspirations of its targeted readership: people who might value the idea of an international perspective for its potential bolstering of their cultural capital.

Indeed, although there had long been a market segment of wealthy British customers who bought goods specifically for their foreign connotations, a broader spectrum of the postwar generation was attracted by foreign goods and styles. One case in point was the adoption of French and Italian cooking styles by fractions of the British middle classes in the 1960s: people whose dinner tables and cooking utensils might have been bought from Terence Conran's new retail company, Habitat (one of the most celebrated attempts to sell European furnishing styles to the British public). But whilst international cooking styles took off in a big way, Terence Conran's project to open the minds and wallets of the British public to international furnishing styles remained confined to a small section of the market.

The question for Hachette was: would the early 1990s *version* of the market segment who valued signifiers of internationalism be large enough to sustain a magazine like *Elle Decoration*? According to the editor, its presumed readership comprised working couples, aged 26–45; people who were open to a wide range of ideas, who had either travelled or wanted to travel, because, as she points out: 'you don't need to have done some-

thing to be interested in it' (Crawford 1992). Whilst acknowledging that a successful magazine has to be multifaceted enough to satisfy different people, she believes her readers to be united in their aspirations towards an international perspective:

> a number of people now travel the world who aren't the jet set . . . they just move around and, even though you might not be aiming at them specifically, there's a knock-on effect from that. There's a kind of shared culture and it's not now extraordinary for even a fairly average chap in his early thirties to have bits of Indonesian stuff he's picked up from somewhere, and bits from somewhere else, and to be aware of a French film and a German film. We are now, because of television, because of film, because of travel . . . more aware of what goes on in the world. So that's the premise of the magazine.

> (ibid.)

So, by stressing its transnational links, the producers of *Elle Decoration* provided a means by which readers could mentally align themselves with an imagined community of stylish, like-minded people. It could be said that these very aspirations had been created by the increase in the transnational marketing of goods and services during the postwar period: the internationalisation of capital as culture.

At the time of writing, *Elle Decoration* has managed to weather the recessionary storm in Britain using much the same methods and messages which characterised its first two years of publication.[3] During these initial two years, it has been suggested that *Elle Decoration* represented a shift in implied values in relation to home-making within the British home-interiors magazine genre, and that this shift was connected with both the transnational conditions of its production and the transnational aspirations of its targeted readership. It has been further suggested that innovative aspects of the design and art direction of this magazine played a role, sometimes pivotal, sometimes peripheral, in the articulation of these new values. The various design elements were not simply passive vehicles of communication, but active signifiers of meanings: meanings which themselves were historically specific and ideologically based.

This study has attempted to connect the graphic design of a magazine with its contexts of production, including its producers' assumptions about its readership. However, there is also a need to explore the relationship between the messages and methods of communication in magazines and the *actual* consumption practices of readers. The enormous amount of effort which goes into the production of a magazine and the carefully gauged assumptions about mutations in readers' tastes and aspirations is one thing, but as Ilse Crawford said: 'whether it works or not is another matter!'

NOTES

1 These newcomers were: *Interiors*, 1980 (later changed to *The World of Interiors*); *Country Living*, 1985; *Traditional Homes*, 1985; *Country Homes and Interiors*, 1986 and *House Beautiful*, 1989. These were joined after the launch of *Elle Decoration* by *Metropolitan Home* and *Period Living*, both in 1990. Only titles whose recorded circulation was around or over 50,000 have been examined.
2 Examples of brand extension from fashion to furniture include companies such as Laura Ashley, Next, Marks and Spencer and, on a much smaller scale, Mulberry and Jean Paul Gaultier.
3 Emap/Elan is Hachette's current publishing partner for the British edition and there are now ten issues per year, but the editorial team is largely unchanged.

REFERENCES

Benn's Media Directory (1990/91), Tonbridge, Kent: Benn Business Information Services Ltd.
Bourdieu, P. (1986) *Distinction: A Social Critique of the Judgement of Taste*, London: Routledge.
Braithwaite, J. and Barrell, J. (1988) *The Business of Women's Magazines*, London: Kogan Page.
Corner, J. and Harvey, S. (1990) 'Heritage in Britain: Designer History and the Popular Imagination', *Ten 8* no. 36 pp. 14–21.
Craig, R. (1990) 'Ideological Aspects of Publication Design', *Design Issues* vol. VI, no. 2, Spring: pp. 18–27.
Crawford, I. (1992), editor of *Elle Decoration*, interviewed by Barbara Usherwood.
Dourado, P. (1991) 'How to Unite Women of the World', *Independent on Sunday*, 24 March, p. 22.
Gunter, B. and Furnham, A. (1992) *Consumer Profiles: An Introduction to Psychographics*, London: Routledge.
Hajek, B. (1992), art editor of *Elle Decoration*, interviewed by Barbara Usherwood.
Konigsberg, D. (1987) '*Elle* Conquers with Style', *Graphis* 250, pp. 8–17.
McDonald, W. (1961) 'A New Trend in French Magazine Design', *Graphis* 93, pp. 36–41, 80.
Remington, R. and Hodik, B. (1989) *Nine Pioneers of American Graphic Design*, Massachusetts: MIT Press.
Smith, A.D. (1986) *The Ethnic Origin of Nations*, Oxford: Basil Blackwell.
Sontag, S. (1979) *On Photography*, Harmondsworth: Penguin.
Swann A. (1990) *The Grid*, London: Phaidon.
White, C. (1968) *Women's Magazines 1683–1968*, London: Michael Joseph.

11

ADDRESSING THE PUBLIC

Television, consumption and the family in Austria in the 1950s and 1960s[1]

Monika Bernold and Andrea Ellmeier

Early critiques of mass culture discussed the connection between television and consumption in the context of political economy and the Frankfurt School's more general critique of ideology, the media and the public sphere. This critical perspective on mass culture and mass consumption was based on implicitly gendered concepts of production/consumption, high/low culture, private/public spheres. As Adorno himself noted self-critically in 1969, the equation of culture industry with consumer consciousness had female consumers in mind (Adorno 1969: 65). The social identification of consumption and mass culture with the attributes and notions of femininity and the assignment of the sites and business of consumption to women on the one hand, and their status as objects within economic and symbolic exchange processes on the other, has made the question of the connections between television and the female consumer/audience a central issue for feminist theories of representation (Houston 1984; Doane 1987; Spigel and Mann 1992).

Our historical approach to the paradigmatic link between television and consumption as cultural and social forms (Morse 1990; Hansen 1990; Bernold and Ellmeier 1992) will focus on the contextual and relational qualities of its formation. We confront different dimensions and fields in the construction of Austrian consumer society with the implications of the gendered concepts of public and private spheres on which they are based (Davidoff 1993). This approach avoids the methodological pitfall of reproducing the dichotomies production/consumption, active/passive, supply/demand, and the hierarchisation that goes with them. In the following chapter we will instead consider selected features of the link between television and consumption in the Austria of the 1950s and 1960s, borrowing parts of the typology of modern consumer society developed by the historian John Brewer (1994). Brewer named three historical processes as key aspects of modern consumer society: first the development of highly elaborated communication systems; second the formation

of object domains such as the home and the body, where taste, fashion and style are created; and third the emergence of the category of 'the consumer'.

In the first section of this chapter we will shed light on the forms in which early television in Austria addressed its audience as citizens and as consumers in terms of institutional politics, creating a collective sense of belonging to a national broadcasting public. 'Belonging to' and 'participating in' were also the dominant meanings distributed in the early advertising campaigns for television sets, around which the normative idea of the object domain of the 'Austrian home' was constructed. The second section is concerned with what Brewer identified as the emergence of the category of the consumer. We will discuss the ways in which consumers and/as audiences became the object of research and of politics. Audiences and consumers were first examined and analysed in market research in the 1920s. In Austria this strong tradition of social research was interrupted by National Socialism and re-emerged only in the 1960s, when the commercial systems of the country started slowly to modernise and differentiate. On the other hand consumers had been organised and protected by co-operatives and consumer associations in Austria since the nineteenth century. But it was not until the 1950s and 1960s that 'the consumer' emerged as a political category which changed the status, position and perception of the consuming women, mainly in addressing the female consumer as citizen consumer.

PUBLIC BROADCASTING AND PRIVATE CONSUMPTION

'State' consumption

The Austrian economy of the late 1950s and 1960s can be described as a transitional phase from postwar scarcity to a gradually increasing standard of living (Sandgruber 1985). The preconditions for this development were the Marshall Plan of 1948 and its accompanying nationalisation laws, which affected the distribution of capital on the one hand and the formation of interest politics under the banner of 'social partnership' on the other. Alongside a massive process of urbanisation in the 1960s went the modernisation, rationalisation, and the changing organisation of work and the ratio of work to leisure time (with the introduction of the 45-hour week in 1959). These changes shaped the dominant living condititions for Austrian people during the 1950s and 1960s. Politically, the late 1950s and early 1960s in Austria must be viewed within the power triangle of the Cold War, political neutrality and economic and cultural orientation to the West (Wagenleitner 1991). Austria's domestic policy was carried by coalition governments from 1945 until 1966, when they were succeeded

by a majority Conservative Party government. In the field of social culture this was a phase characterised by central transformations of gender, class and generational relations (Schmid 1984; Saurer 1985; Luger 1991). The welfare state and market developments after 1955 – the crucial year of the departure of the Allies, the signing of the Austrian State Treaty and the start of Austrian Television – gave the development new contours but also created contradictions in the daily lives of broad segments of the population.

In the context of a system where all television is public – in Austria private or commercial television is a very recent phenomenon, accessible only via cable and satellite – watching television is tied to the acquisition of a receiver and the payment of fees to the Post Office. Unlike the cinema, where the anonymity and 'privacy' of cash are sufficient entrée for film consumers, participation in television reception means identifying oneself personally to the postal service, which represents the state. This identification was thus an essential element in the monopoly institution's power of representation. 'Audience as public/audience as market' is how Ien Ang has described the two controversial paradigms for constituting the audience in public and in commercial television (Ang 1991: 26). In the context of early television in Austria this dichotomy reveals itself as a complex intertwining of state and economic interests, whose power-political context achieves its specific national character through an increasingly organisationally differentiated form of 'social partnership', which structured all fields of political and economic power in the Second Republic.

Austrian television developed out of radio and after complicated negotiations with the Allies during the Second Republic, licences for transmission were turned over to Austrian administration and combined into a dual-medium public organisation (Venus 1985). In 1955, the year of the State Treaty, trial broadcasting was initiated with the transmission of 'König Ottokars Glück und Ende' from the reopened Burgtheater and Beethoven's opera *Fidelio* from the reopened Staatsoper. State television's 'cultural mission' thus manifested itself in its very first broadcast. In 1957 the Austrian Broadcasting Corporation was founded as 'a state company in private sector garb' (Stiefel 1980: 11) – a unique Austrian construction. The programming, production and organisation of early Austrian television were dominated by the political interests of the two leading parties (the Socialist Party and the Conservative Volkspartei) – 'Black wave and red screen' was a common satirical expression for the proportional political representation in Austrian radio and television.

It was only after the 1967 broadcasting reform, in fact, that Austrian television could provide a dominant model of an Austrian public linked to the idea of a superior 'we' beyond political and party interests. One of the preconditions for this development was the referendum in October 1964, which was initiated by representatives of the Austrian press

193

demanding a depoliticised television. With more than 800,000 signatures in favour of depoliticisation this referendum became one of the largest 'people's votes' in the history of the Second Republic. When a majority Conservative government came to power in 1966, broadcasting and programming were reorganised in the name of political 'independence'. The idea of an economically, and now politically, independent public broadcasting system thus became a powerful fictional fact in building an Austrian identity. The so-called 'New ORF' after the broadcasting reform of 1967 formed a scenario that made programming a pillar of nation state and workaday 'stability', assuming the role T. Elsaesser has referred to as 'the social bond that holds the fabric of the nation together' (Elsaesser 1992: 13).

Even before 1966, however, television's enterprise of information and education was tied to the notion of the rational consumer/audience; in constructing this model television distanced itself from the direct interests of capital. The prohibition on television presenters also appearing in advertising has been revoked only recently, provoking both earnest national debate and what amounted to a sort of public shock and anxiety at the abandoning of a particular aspect of Elsaesser's 'social bond' (Ellmeier and Ratzenböck 1993). The reaction is an expression of the new broadcasting system's success in establishing a paternalistic tradition in matters of commercial advertising, and shows the extent to which ORF has managed to establish in the collective consciousness the notion of a medium apparently free of economic interests. Television advertising was introduced into Austria in 1959, four years after the beginning of trial broadcasting. In the early years, advertising segments were presented as informational or cultural programmes rather than straightforward advertising. Lack of capital, political restrictions and public debates over how state broadcasting would be financed characterised the development of the state television monopoly and its restrictive advertising policy. The Broadcasting Law that took effect in 1967 limited advertising to twenty minutes a day, with Sundays and holidays being designated advertising-free in Catholic Austria.

Consumer advice, and with it consumer politics in Austrian television programmes, were on the other hand from the start explicit forms of address, positioning the audience as viewers and at the same time as 'rational' consumers. *Absolutely Housewives* was the name of one popular series introduced in 1957 that was addressed to an explictly female audience and supported by consumer protection organisations. The topics for the series in 1961 can be read as a guide to central issues of the beginning of mass consumption: the children's room; the fridge; the freezer; payment by instalment plan; the road to property; camping equipment, etc. The series represented the idea of a future characterised by the increasing importance of a commodity-linked childhood, by the

rationalisation of the household (including the setting-up of the inner-space of the nuclear family) and by social mobility. In the 1950s and 1960s series like *Weekend Market* (a consumer information programme controlled by the Socialist consumer association) and *A Look at the Country* (an agricultural product information programme guided by the Conservative federation of farmers) shared the task of advice and advertisement for women television consumers in the spirit of 'social partnership' (*Funk und Film* 1961: 4, 14).

In Austria, the specific contract of so-called 'social partners' rested on the idea of 'pacification' (Menasse 1992), which functioned largely by incorporating the notion of 'private consumption for all' into the state/ public sphere represented in television. To be sure, this social partnership contract was based upon a sexual contract on the economic and symbolic level, which until the 1975 reform of family law codified the subordination of women in the family by legislation. The basic code of this contract functioned in the first decades of Austrian television by addressing the audience as citizen-consumers, consumers as families, and families as 'women'. The use of this form of address made it possible to create a broad sense of participation in the emerging Austrian consumer and state public that crossed gender and class lines, beyond the very different gender or class-specific opportunities for participation.

'Home' consumption

Beyond the intentions of public broadcasting to address the audience as citizens and rational consumers of goods and images, in the 1960s television became one of the most important pillars of the system of communications that, with the help of technically reproducible systems of images and signs, equipped commodities with a complex network of circulating meanings. Television's direct influence on the audience's structures of perception and needs could only take effect after people had become accustomed to the new technology. Its influence was rather limited in the 1950s and into the late 1960s, a time when a large portion of the Austrian population had more expectations than actual experience of television.

In the early phase of the new technology, the economic and technical prerequisites for its broad dissemination, namely relatively well-off households on the one hand, and wide transmission on the other, were absent. At this period, advertising for the television set, and its placement in the social space of 'the home' and 'the family', still had the primary function of directing societal needs at the artefact (the set), the acquisition of which stood for 'social mobility', symbolising 'We're doing better'. Long before it became affordable for the mass of consumers, the television set appeared as a distant image in the most diverse frames: Hollywood films, advertising, shop windows (Bernold 1994). In 1955, the year of the introduction

of Austrian Television, Philips, the leading television manufacturer in Austria, advertised in several daily newspapers (*Kurier, Die Presse, Neues Österreich*). The ad, of a family watching television and an enlarged picture of the screen, shows the way in which the idea of the family and the idea of television were connected with the idea of participation in the national high culture represented by the opera. 'In the circle of the family – experience the historical event of the reopening of the opera' is the textual comment on the visual message. In this ad the television set is linked with the complex reference systems of the family and of the opera. The meaning, which the consumers are invited to give to the product, is deeply connected with the idea of belonging – belonging to a family, belonging to an audience that participates in high culture, belonging to the realm of individual and collective welfare that has to build up in the future.

Nevertheless, at this point 'family viewing' was not the dominant form of reception. Television was largely watched in collective situations into the 1960s. Watching television had the quality of special events and took place in pubs, coffeehouses, espresso bars, at the homes of friends and acquaintances, in political party meeting places. The emergence of the television set from public, communal spaces into the private household/family was accompanied by a complex ensemble of discourses which reveal the positioning of the television set within the family as the product of quite controversial debates about the limits of public and private.

In early 1958, just three years after the beginning of trial broadcasting, the industry reported 35,000 sets sold in Austria, and the Post Office recorded having issued 26,800 licences, with more than half of all registrations in Vienna; a study of the same year reported that 60 per cent of 2,000 households surveyed had already had the opportunity to view television programmes (*Funk und Film* 1958: 12, 21). Seven years later, in 1965, only 27 per cent of all households boasted a television set (*ORF-und Elektrofachhandel* 1965: 4–6). On the 1 January of that year the Post Office counted 584,549 registered sets, and the one million mark was not reached until 1969 (*ORF-Almanach* 1969: 76). Only the option, available from the early 1960s on, of buying on the instalment plan created the basic preconditions for a mass dissemination of the television set among Austrian households. The acquisition of consumer goods, especially television sets, was doubtless also of strategic significance for the nuclear-family economy, particularly as regards women's employment outside the home. Since the television set came to epitomise a family ideal tied up with social mobility for both women and men, it was possible, for example, to make a central social contradiction resulting from the gender-specific division of labour appear as an individual problem of women's double and triple burden, and thus to depoliticise it.

The difference between what one could not afford and what one could not afford not to have, as the pioneer thinker on television, consumption

and the family Günther Anders described it, thus only very gradually became a central motive for private mass consumption (Anders 1956/1986: 177). This transitional phase, in which the television set advanced from a luxury/public object to one of everyday use in private households, is functionally connected to the consolidation of an Austrian middle class whose ideological pillars included an ideal of the family that gained general currency, latent anti-Communism and the formation of a sense of 'Austrian' identity. In 1959, when empirical studies showed that 'home furnishings' were the number one consumer goal, a representative sample of Austrians questioned about the most significant world events of the past decade named the Austrian State Treaty of 1955 first, the Sputnik flight second and the Hungarian Uprising of 1956 third (*Pressedienst des Österreichischen Gallup-Instituts* 1959). The publication of this and other surveys, a phenomenon that increased markedly alongside the spread of television, was an important preparation, on the level of representation, for shaping society into a consumer public linked to the West (the 'world', 'outer space'). This shaping process assumed material form with the entry of the television set into the mass of Austrian households in the late 1960s, when programming from West Germany and the USA predominated over Austrian material (Rest 1988).

The emergence and standardisation of specific object domains, within and by means of which taste and buying decisions are established, is as Brewer (1994) says a central feature of the development of modern consumer culture. The central object domain of the 1950s and 1960s was the home. As an object, the television set became a dominant element of that space, towards and in which a large part of the postwar generation's consumer desires were concentrated and developed. Materially and spatially speaking, the ideal of the 'inner space of the family' was still unattainable for that large segment of the population in the 1960s who did not have their own homes. Automobiles and television sets, products associated with glamour and status, functioned for many people as windows on the distant world before their foundation and foothold, the world of the home, was even equipped with the material necessities. A 1965 report interviewed 400 young Viennese married couples, 40 per cent of whom did not own a flat; 24.6 per cent of this 40 per cent owned a television set, and 25.3 per cent a car ('Wohnverhältnisse und Wohnungswünsche junger Ehepaare in Wien', *Besser Wohnen* 1965). As catalysts of a new ideology of the private sphere, which it appeared would allow people to conquer the new public spheres through the consumption of distance and speed, televisions and automobiles generated the illusion that the interior space of the family was at once secluded from and attached to the spatial and temporal vastness of the world. The ideological linking of family, consumption and television fostered the postwar process of modernisation and functioned as a means of regulating the

accompanying shifts in class, gender and generational relations (Spigel 1992; Bernold 1994).

THE EMERGENCE OF THE CATEGORY OF 'THE CONSUMER'

Consumption and television in the history of the social sciences

The history of the production of knowledge about 'the consumer' is a constitutive element of modern consumer societies (Brewer 1994: 3). The scientific, statistical study of consumers and consumer behaviour on the one hand, and of the 'audience' of the audio-visual media on the other, are parallel histories of the applied social sciences in the twentieth century. The history of audience research is closely connected to that of market research and opinion polling, both in terms of personnel and structure. Market research, like the study of audiences, became a central agency of modern consumer society, which not only helped to create social needs but also had a major impact on society's notions of 'the consumer' and 'the audience'.

Interestingly, Vienna was a starting point for this parallel history. It was around the Centre for Research on Economic Psychology (Wirtschaftspsychologische Forschungsstelle), founded in 1931 (Fleck 1990), that the first attempts at both applied market research (Neurath 1986) and at audience study for Austrian Radio (RAVAG) were carried out (Mark 1996 [Lazarsfeld] 1932). The author of the latter, Paul Lazarsfeld, who emigrated to the USA in 1935, became director of research at the Office of Radio Research in Princeton, which was founded in 1937 and moved to Columbia University in 1940. He is considered one of the so-called 'fathers' of modern market and opinion research in the USA. However, unlike the USA, where television was commercial from the beginning, it was only very late – in 1968 – that Austrian public television instituted regular audience studies, in co-operation with the Austrian Fessl Institute and the German Infratest Institute (Bacherer 1985). From 1974 on, audience studies were carried out in Austria under the banner of 'social partnership', which meant in collaboration with Conservative and Socialist research institutes. In the late 1950s and early 1960s there had only been occasional surveys of the range or frequency of viewing, and it is striking how interested researchers were in women's television viewing habits (*Pressedienst des Österreichischen Gallup-instituts* 1953–62).

The parallel history of market and audience research is shaped by the international transfer of knowledge production. Its historical placement/displacement is one that must be viewed largely against the political backdrop of National Socialism and against the postwar developments in Europe under the signature of growing 'Americanisation'. Already successfully applied in the USA, the first opinion polls in Austria as well as in

Germany were introduced by the US authorities in late 1945. Austrian and German people were regularly asked for their attitudes towards democracy.

A crucial part of the production of this knowledge about audience/consumers is its gender-specific structure – though this can still be ignored in a recent survey which claims authority (Belk 1995). Women were not merely a central object of early market and audience research (in their role as 'housewives': Peck 1934; Grünwald 1955). They also represented a remarkably high percentage of researchers in the field (Nölle-Neumann 1940; Haselmayr-Scharde 1949; Ernst 1950), contributing significantly to the development of social scientific market and audience research. (Although not so often styled 'mothers' as Lazarsfeld is a 'father', the founders of both the largest German institutes – Elizabeth Nölle-Neumann (Alansbacher Institute for Audience Research) and Luise Haselmayr (Infratest, currently run by Renate and Wolfgang Ernst) – were women. As many nineteenth-century medical and pedagogical discourses assigned the notion of 'social affairs' to 'welfare' as a generally 'female sphere', thus defusing class conflict considerably (Davidoff 1993), so the social scientific study of consumers in the twentieth century functioned similarly as a part of the encoding of the notion of consumption as female. Within this process of signification the differences between women were channelled into a class-specific segmentation of objects and subjects of research, very similar to the class-specific segmentation of women into objects and subjects of social politics in the name of public welfare. The hierarchisation of the linguistic pairings of production/consumption and public/private was thus continued along gender-specific lines. The social scientific investigation of consumers and audiences was one that reacted to emergent publics, in the sense of controlling, managing and exploiting the increased demands of many people to participate in the centres of economic, political and also symbolic culture.

The entry of 'the consumer' into politics

The entry of 'the consumer' into politics can be discussed as a further significant level for the description of consumer culture in general, and for the 1950s especially. In the economic, cultural and political reconstruction of Austria after the Second World War 'the consumer' became one of the most significant terms expressing a political relationship to the free-market economy. On the one hand, 'the consumer' (usually meaning housewives as consumers) became the object of product information (consumer protection) and market research, and on the other, the intensification and loading of the meaning of (consumer) choice led to new forms of the modern constitution of the subject, the manufacture of the consumer-subject in politics.

Since the emergence of consumer culture, womens' organisations and co-operatives had made it their business to provide information for consumer choice (Ellmeier 1990, 1995). As late as 1950 consumer protection/education still meant mounting an exhibition organised by female members of the Socialist Party. It had occurred to them that no appropriate furnishings existed for the new public housing, and that working-class families were forcing overly large pieces into their small flats. Modernist design was to come to the rescue here: built-in furniture and kitchens and the idea of standardised furniture were propagated. It was out of these considerations that an exhibition of what is known in German as *Wohnkultur* (roughly 'home culture') was realised at the end of 1950, with the eloquent title 'Woman and Her Home'. The exhibition formed the basis of the first comprehensive consumer advice centre in Austria. It introduced Austrians to Scandinavian design: for Austrian Socialists in the early 1950s, Sweden was practically synonymous with the welfare state they hoped to establish. The advice the exhibition offered was all-encompassing: free counselling on home furnishings, fashion shows and cooking demonstrations, lectures on health and childrearing as well as infant care, with information on the 'smart buying' of electrical appliances as well as 'proper heating'.

In this respect the 1950s in Austria also saw the emergence of the housewife as a category mentioned intensively in the political as well as in the economic sphere – Erica Carter has explored parallel developments in West Germany, focusing on the relations between gendered consumer politics and power, in her recent thesis (Carter 1991: 187ff.). Acknowledging the political importance of consumption, political institutions started to establish permanent consumer advice centres: the Workers' Chamber in 1955 and the Trade Union Federation in 1956 (Ellmeier 1995). Thus, dealing with consumption issues became more visible in the public sphere and simultaneously the female notion of consumption became less evident. Finally in Austria the 'paternal' state, in the form of the so-called 'social partners' scheme, set itself up as the 'protector' of (female) consumers (the Association for Consumer Information was founded in 1961).

Interestingly, this was in parallel with the gradual professionalisation of consuming women (called 'housewives') into 'rational consumers' or *Konsumenten* – a professionalisation which was achieved using the masculine form in the German language; the grammatical gender of the actors changed. Alongside the process of increased public perception there is, to stress the point, a significant linguistic shift: the female connotation of 'the consumer' disappeared in the course of the consumer information/protection movement and the politicisation of consumer interests. Thus, with the entry into politics, the woman consumer (*die Konsumentin*) became male (*der Konsument*); 'the authority of the consumer' had been successfully denied to the woman consumer (Bowlby 1993; Russell, Whiteley and Abercrombie 1994).

But despite all these changes, consumption still carries a female connotation when it comes to reconciling the irreconcilable: if on the one hand women shoppers are forced to act rationally according to their means when shopping, they can be portrayed at the same time as seduced by advertising and products (Ellmeier 1990; Nava 1995). This enlistment of 'femininity' for the most various consumption issues must be understood as a fundamental political consensus that is still effective today. On another level, this process might be described as the shift from the woman consumer to the citizen consumer, indicating an expanding range of notions of 'the consumer' as a variable category to be applied in changing formations of public and private spheres.

NOTE

1 This chapter was translated by Pamela Selwyn and edited by Andrew Blake.

REFERENCES

Adorno, T.W. (1969) 'Freizeit', in *Stichworte. Kritische Modelle 2*, Frankfurt/Main: Suhrkamp.

Anders, G. (1956/1986) 'Die Welt als Phantom und Matrize. Philosophische Betrachtungen über Rundfunk und Fernsehen', in Anders, *Die Antiquiertheit des Menschen* , vol. 1, Munich: Beck.

Ang, I. (1991) *Desperately Seeking the Audience*, London: Methuen.

Bacherer, K. (1985) 'Geschichte, Organisation und Funktion von Infra-Test', unpublished PhD thesis, University of Salzburg.

Belk, R.W. (1995) 'Studies in the New Consumer Behaviour', in D. Miller (ed.) *Acknowledging Consumption. A Review of New Studies*, London: Routledge.

Bernold, M. (1994) 'Frühes Fernsehen in Österreich. Inszenierungen des Privaten in den 50er und 60er Jahren in Österreich', *Medien Journal* 10, 1, 19–26.

Bernold, M. and Ellmeier, A. (1992) 'Zur Politik des Versprechens. Wählerinnen-Zuschauerinnen-Konsumentinnen', *Aufrisse* 13, 4, 18–26.

Bernold, M., Ellmeier, A., Gehmacher, J., Hornung, E., Ratzenböck, G., and Wirthensohn, B. (1990) *Familie: Arbeitsplatz oder Ort des Glücks? Historische Schnitte ins Privat*, Vienna: Picus.

Bowlby, R. (1993) *Shopping with Freud*, London: Routledge.

Brewer, J.(1994) 'Studying Contemporary Consumption: What Can We Learn from the Early Modern Era', unpublished paper presented at the Symposium 'Konsumgeschichte als Gesellschaftsgeschichte. 18.-20. Jahrhundert im internationalen Vergleich', organised by the Arbeitsstelle für vergleichende Gesellschaftsgeschichte at the Free University of Berlin, Berlin, 2–4 June 1994.

Carter, E. (1991) 'How German Is She? National Reconstruction and the Consuming Woman in the Federal Republic of Germany and West Berlin 1945–1960', unpublished PhD thesis, University of Birmingham; revised version published under the same title by University of Michigan Press, Ann Arbor, Michigan, 1996.

Davidoff, L. (1993) 'Alte Hüte. Öffentlichkeit und Privatheit in der feministischen Geschichtsschreibung', *L'Homme. Zeitschrift für feministische Geschichtswissenschaft* 4, 2, 7–37.

Doane, M.A. (1987) *The Desire to Desire*, Bloomington, Indiana: Macmillan.

Ellmeier, A. (1990) 'Das gekaufte Glück. Konsumentinnen, Konsumarbeit und Familienglück', in M. Bernold, A. Ellmeier, J. Gehmacher, E. Hornung, G. Ratzenböck and B. Wirthensohn, *Familie: Arbeitsplatz oder Ort des Glücks? Historische Schnitte ins Privat*, Vienna: Picus: 165–201.

Ellmeier, A. (1995) 'Handel mit der Zukunft. Zur Geschlechterpolitik der Konsumgenossenschaften', *L'Homme. Zeitschrift für feministische Geschichtswissenschaft* 5, 1, 62–77.

Ellmeier, A. and Ratzenböck, V. (eds) (1993) *Kultur Medien – EC und Österreich*, Vienna: Österreichische Kulturdokumentation. Internationales Archive für Kulturanalysen.

Elsaesser, T. (1992) 'TV through the Looking Glass', *Quarterly Review of Film and Television* 14, 1–2, 5–27.

Ernst, L-R. (1950) *Rundfunkwirkungsforschung. Theorie und praktische Anwendung*, unpublished PhD thesis, University of Munich.

Fleck, C. (1990) 'Vor dem Urlaub. Zur intellektuellen Biographie der Wiener Jahre Paul F. Lazarsfelds', in W. Langenbucher (ed.) *Paul Lazarsfeld. Die Wiener Tradition der empirischen Sozial- und Kommunikationsforschung*, Munich: Ölschlager , 49–74.

Funk und Film (1958) 21: 12 (ed. Bilderzeitung), Vienna: Vorwärts.

Grünwald, R. (1955) 'Die Stellung der Markt- und Verbrauchsforschung in Österreich', in G. Bergler and W. Vershofen (eds) *Jahrbuch der Absatz- und Verbrauchsforschung*, Tiefenbach bei Oberstdorf: Gesellschaft für Konsumforschung, 117–122.

Hansen, M. (1990) 'Neue Freiheit – Alte Muster', in G.J. Lischka (ed.) *Feminismus und Medien*, Bern: Benteli.

Haselmayr, L., *nee* Scharde (1949) *Die Grundlagen der öffentlichen Meinung und deren Erforschung*, Munich: University of Munich.

Houston, B. (1984) 'Viewing Television: the Metapsychology of Endless Consumption', *Quarterly Review of Film Studies*, 9, 3, 183–195.

Jagschitz, G. and Mulley, K-D. (eds) (1985) *Die 'wilden' fünfziger Jahre. Gesellschaft, Formen und Gefühle eines Jahrzehnts in Österreich*, St Pölten/ Vienna: Niederösterreichisches Pressehaus.

Luger, K. (1991) *Die konsumierte Rebellion. Geschichte der Jugendkultur 1945–1990*, Vienna/St Johann im Pongau: Österreichischer Kunst- und Kulturverlag.

Mark, D. (ed.) (1996) *Paul Lazarsfeld's Wiener RAVAG-Studie 1932*, Vienna/ Mühlhelm an der Ruhr: Guthmann & Peterson.

Menasse, R. (1992) *Die sozialpartnerschaftliche ästhetik. Essays zum Österreichischen Geist*, Vienna: Sonderzahl.

Morse, M. (1990) 'An Ontology of Everyday Distraction. The Freeway, the Mall, and Television', in P. Mellencamp (ed.) *Logics of Television. Essays in Cultural Criticism*, Bloomington IA: Indiana University Press.

Nava, M. (1995) 'Modernity Tamed? Women Shoppers and the Rationalisation of Consumption in the Inter-war Period', *Australian Journal of Communication*, 22, 2.

Nava, M. (1996) 'Modernity Disavowed: Women, the City and the Department Store', in M. Nava and A. O'Shea (eds) *Modern Times: Reflections on a Century of English Modernity*, London: Routledge.

Neurath, P. *Paul F. Lazarsfeld (1901–1976) und die Entwicklung der empirischen Sozialforschung*, brochure, Department of Sociology of the University of Vienna.

Nölle-Neumann, E., *nee* Nölle (1940) 'Meinungs und Massenforschung in der USA', unpublished PhD thesis, University of Berlin.

ORF-Almanach (1969) Österreichisch Rundfunk G.m.b.H. (ed.), Vienna: Wimmer. *ÖRF-und Elektrofachhandel.*

Peck, L. (1934) 'Frau und Rundfunk', *Rufer und Hörer*, 2, 5, 65.

Pressedienst des österreichischen Gallup-Instituts.

Rest, F. (1988) 'Die Explosion der Bilder. Entwicklung der Programmstrukturen im Österreichischen Fernsehen', in H. Fabris and K. Luger (eds) *Medienkultur in Österreich*, Vienna/Cologne/Graz: Böhlau.

Russell, K., Whiteley, N. and Abercrombie, N. (eds) (1994) *The Authority of the Consumer*, London: Routledge.

Sandgruber, R. (1985) 'Vom Hunger zum Massenkonsum', in G. Jagschitz and K-D. Mulley (eds) (1985) *Die 'wilden' fünfziger Jahre. Gesellschaft, Formen und Gefühle eines Jahrzehnts in Österrich*, St Pölten/Vienna: Neiderösterreichisches Pressehaus.

Saurer, E. (1985) ' "Schweissblätter". Gedankenfetzten zur Frauengeschichte in den 50er Jahren' in G. Jagschitz and K-D. Mulley (eds) (1985) *Die 'wilden' funfziger Jahre. Gesellschaft, Formen und Gefühle eines Jahrzehnts in Österrich*, St Pölten/Vienna: Neiderösterreichisches Pressehaus.

Schmid, G. (1984) 'Die "Falschen" Fuffziger. Kulturpolitische Tendenzen der fünfziger Jahre', in F. Aspetsberger, N. Frei and H. Lengauer (eds) *Literatur der Nachkriegszeit und der fünfziger Jahre in Österreich*, Vienna: Bundesverlag.

Spigel, L. (1992) 'Installing the Television Set: Popular Discourses on Television and Domestic Space, 1948–1955', in L. Spigel and D. Mann (eds) (1992) *Private Screenings. Television and the Female Consumer*, Minneapolis: University of Minnesota Press.

Spigel, L. and Mann, D. (eds) (1992) *Private Screenings. Television, and the Female Consumer*, Minneapolis: University of Minnesota Press.

Stiefel, D. (1980) *Wirtschaftsgeschichte des Österreichischen Fernsehens*, Vienna: ORF.

Venus, T. (1985) 'Vor 30 Jahren: Die Fernsehlawine rollte nur langsam. Zur Frühgeschichte des Fernsehens in Österreich', *Medien Journal*, 10, 1–2, 37–52.

Wagenleitner, R. (1991) *Coca-Colonisation und Kalter Krieg. Die Kulturmission der USA in Österreich nach dem Zweiten Weltkrieg*, Vienna: Verlag für Gesellschaftskritik.

'Wohnverhältnisse und Wohnungswünsche junger Ehepaare in Wien. Eine Studie des Instituts für Empirische Sozialforschung' (1965) *Besser Wohnen*, 4, 3, 2ff.

Part IV
TEXTUAL STRATEGIES

12

RESORT TO NOSTALGIA
Mountains, memories and myths of time
Andrew Wernick

SEMIOTICS UNLIMITED

At the conference giving rise to this anthology, one of the papers occupied itself with analysing the promotional materials of a consultancy group called Semiotic Solutions.[1] The group had recently set itself up to facilitate communication between the advertising profession and academic specialists in contemporary cultural studies. The piquancy of the occasion was heightened by the fact that, unknown at first to the paper giver, the key players in SU (an Oxford history graduate and a new university PhD in media studies) were sitting in the audience. As they explained, they were at the conference touting for business. Of course, the application of a critical semiotic to their own advertising abashed them not one wit. It merely underlined – in a kind of impromptu live ad – one of their own promotional points. If there was a niche for their service this was because there was already a lively (if often unacknowledged) trade between structuralist and post-structuralist cultural theorising and the signifying practices of commercial popular culture. In the warm wash of amusing, seductive, persuasive and diverting messages by which we are surrounded, those who try to fashion and pass on conceptual tools for becoming more culturally alert will hardly demur. For we know that dissemination cannot be controlled and that, as witnessed by student career paths (and good luck to them), the protocols of hermeneutics and deconstruction, however nobly, politically or abstractly introduced, can readily be converted into a purely instrumental knowledge.

There is nothing uniquely scandalous about this complicity of high theory with low practice. The kind of critical semiology pioneered by such figures as Barthes and Eco merely joins an academic procession in which psychology (via Watsonian behaviourism), sociology (via survey research), psychoanalysis (via 'depth research') and communications studies (via content and effects analysis) have all at one time or another given methodological sustenance to Madison Avenue. Nor is there anything fortuitous about this latest juncture. For students in the human sciences, as for

advertisers themselves, the rise of linguistic, symbological and textualist self-consciousness has been provoked by a real development: the technologically enabled and economically driven proliferation of signs, the moment (crystallised in the long post-1945 boom) of what Debord (1977) called the spectacle, Boorstin (1961) 'the image' and Baudrillard (1981) the sign-commodity. Whether we are perturbed by it, amused by it, or practically engaged in it, semiosis (the conversion of things into signs) and, I would further suggest, promotion, have become structurally pervasive features of post-industrial society. Even where this does not provide the immediate object of reflections about contemporary culture it inescapably forms part of the medium through which any such reflection must speak. In that context, the mere possibility of a group like Semiotics Unlimited may serve to remind us of Umberto Eco's cautionary note issued thirty years ago against the autonomist pretensions of the oppositional cultural critic:

> The Apocalypse is a preoccupation of the dissenter, integration is the concrete reality of non-dissenters. The image of the Apocalypse is evoked in texts *on* mass culture, while the image of integration emerges in texts which *belong to* mass culture. But do these views not perhaps represent two aspects of the same problem? ... And is it not the case that apocalyptic texts constitute the most sophisticated product on offer for mass consumption?
>
> (Eco 1994: 18)

The problem for criticism is not just the power of capital to absorb and use its ideas. Just by being published even the most critical criticism of popular culture is continuous with the phenomenon it would distance itself from. On the site of reception itself, expressions of aesthetic or moral disgust can be taken as signs of positive fascination with the doubling mirror of the mass-mediated scene and the pleasures of its text. McLuhan, confronted with a similar dilemma (albeit from the side of a conservative Catholicism), prefaced his *Mechanical Bride* (1967) with a reference to Poe's story about the maelstrom and the sailor. The sailor's survival, McLuhan recalls, depended on the fascination he let himself succumb to – in that moment before certain death – with the precise motion of the water.

It is, at any rate, in a somewhat similar spirit that I would like to offer some reflections on a trivial and ephemeral instance of the image-world that pulses round us today. My speck of foam is an ad – a rather spectacular four-page glossy for a new four-season resort – which was enclosed in the business section of the *Globe and Mail*, in late July 1993. The ad is longer and more elaborate than most in print media. Nonetheless, it is disciplined, and tightly, by the same kind of rhetorical structure as may be found, and has long been typical, in myriads of visual (or indeed

audio-visual) promotions like it. That is, it attempts to effect a transfer of meaning from value-laden symbols onto the product such that the latter itself can be taken as a natural symbol for the values transferred. It also completes the circuit of meaning by drawing the reader/consumer into the picture through mechanisms of identification in which the subject of consumption is constructed on the very site of the subject called into being by the ad's mythic appeal.

But what leads me to suggest that there is something interesting, and revealing, about this ad is not so much the typicality, indeed the ultra-typicality, of its structure – not even the tone of knowing self-consciousness with which that structure is built up and displayed (I am thinking of the filmic mock-hype of such lines as 'coming soon to a location near you'), which would take us towards familiar characterisations of the postmodern. Through all the ad's self-referentiality and use of pastiche, what interests me more is the ideological content of its pitch. To promote its product, a total package leisure commodity, the ad mobilises and constructs a complex of values and symbols which harks back to the joys of the past and of returning to origins. Its appeal, using the term in its broadest sense, and in continuity with the current lexicon of consumption itself, is to 'nostalgia'. As such, and read a certain way – read that is as an index of the cultural history it refracts (and which materially, perhaps, consists of nothing but such refractions) – the ad can be construed as having an exemplary significance.

It is exemplary, I would suggest, in two senses. In the first place, and taken together with the increased salience over the past two decades of such trends as retro fashion, period movies, 'natural' foods and materials, resistance to modernist architecture, not to mention 'green' thinking, identity politics and preoccupation with cultural roots, it can stand as a historical marker for the whole sea-change in values – particularly since the heady early days of the postwar boom – represented by this list. Consider, by contrast, an ad which appeared in *Colliers* in 1950 (Figure 12.1). Suiting rhetoric to design, the Oldsmobile ad identifies the new era 1950s car with a space-rocket, on which the happy couple (hubby in front) rides off to a blissful and prosperous future. Phallic technology, futurist enthusiasm for progress, aspirations for social mobility and the baby-booming family blend together in this euphoric and, above all, future-oriented image of the car. When we turn to the resort ad three differences are starkly apparent. First, where the 1950 ad is marked by unabashed enthusiasm for the fruits of industrial civilisation, the 1994 example celebrates its antithesis under the sign of Nature. Second, where the first images career (via the business suit) as a striving for lift-off, and happiness as the outcome of an essentially moral economy, the second presents leisure as compensation for a lack; a lack moreover – of satisfaction and identity – which is partly engendered by the exigencies of the

209

work-world itself. Third, and most dramatically, where the car ad looked forward, the resort ad looks back. The Good identified as the essence of *its* product is located in the past, not in the future. It – Coke's 'real thing' – is something to be recovered rather than attained. The arrow of time has been reversed.

To be sure, it may be objected that the comparison is not well made since the products are different, and ads in any case are not required to be consistent among themselves. With the rise of target marketing we would even expect an incoherent plurality of appeals. However, perusal not only of post-1950s car ads (where rocketry and its connotations have long disappeared) but also of computer ads (where we might expect a similar fusion of techno and social enthusiasm) would show that the ideological difference exhibited by these ads does correspond (at least within the imaginary of consumption) to a wider historical shift. Progress myths in the old, and fuller, style are no longer in the common repertoire of

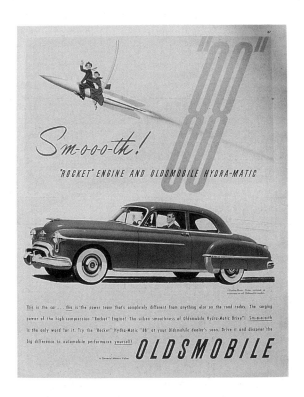

Figure 12.1 Oldsmobile advertisement, 1950, USA
Source: Colliers

contemporary promotion. The deep self has moved into view. The respective valuations of Nature and Technology have almost changed places. Students of early 1950s iconography will also recognise that then, but not now, Tradition was a timeless sign of status and quality; and that the themes of leisure/escape/nature etc., while often linked, were rarely linked with fondness for the past. In any case, if we fast forward we can see that the two ads are connected by a kind of narrative thread. The children of the couple taking off in the Oldsmobile Rocket have grown up to become the 'boomers' being enticed to the resort. They may have been brought up to *embody* the success-and-progress aspirations of their parents, but clearly not, from the ad's address, in a way they can be taken as *identifying* with, or reproducing in their turn.

All in all, and negatively put, the nexus of values appealed to in the resort ad testifies to a collapse of those celebrated in the car ad; above all to a belief in the future as a screen onto which to project desire. This collapse has its resonances in the contemporary intellectual field. Fukuyama (1992) has spoken of the 'end of History', Baudrillard of its death. Such phrases offer a hand-hold, though we should be cautious, since they condense a complex concatenation of many processes. For example, besides the slow logic of post-Enlightenment intellectual dissolution (the news from Hegel and Nietzsche has taken a long while to arrive) the ad's elevation of nature and emphasis on the self (as also its neutralisation of gender) are mildly counter-cultural. They bear a trace, that is, of the cultural upheavals of the 1960s and 1970s, particularly as tamed within the 'liberalised' mutation in hegemonic culture to which these upheavals led. Mixed in with that, the diminished hold of a progressivist sense of time has doubtless had something to do, as well, with the communications revolution, especially the rise in a 'high intensity market setting'[2] of multimedia and cybernetics. Welcome to the schizo world of postmodernity, and to that longing for the phantom original which the world of the simulacrum continually engenders and thwarts. At this level, the inverted horizon of the future is bound up with a veritable phase-shift in capitalist culture.

However, there is also something more historically contingent to be disengaged. The view forward has become bleak and not just blank. Even though the nuclear threat has apparently (for the moment) been lifted, this is not a time of great hope. Widespread disillusionment, both private and public, has attended the decline of Western economic expectations that followed the end of the long boom and the shocks provoked by globalisation and the 'restructuring of capital'. The mood has been fed by eco-pessimism, a sense of urban deterioration and tales of mad conflict everywhere. To this catalogue, though much more differentially received, we might add the historic defeat, in the 1960s and 1980s, of both the new and old left. Faith has been dented not only in the attainability and even

intrinsic worth of the consumerist (or American) Dream but also in our capacity to imagine anything else. The impulse, for those who can, is to cocoon.

Of course, there are many possible markers for the nostalgia complex which has arisen at the intersection of these multifarious trends. But, as with the Oldsmobile ad, what makes the resort promotion so useful to look at is the fullness of its ideological representation. A whole gamut of potential nostalgia elements – generational, existential, natural-romantic, pseudo-historical, communitarian – are combined within the same picture. This fullness allows us not only to use the ad as a summary reference point but also to throw light on the veritable assembling power of nostalgia as an ideological theme. Here, indeed, the ad has a further exemplary significance. For through that same fullness, the ad contains the seeds of a most instructive unravelling. The symbols selected to optimise our desire for the product risk resonating to excess. To which extent, I will suggest, the substitute gratifications which the ad and its product offer to satisfy the nostalgic ache it stimulates cannot conceal their irredeemable secondariness, and thus the fragility of the whole appeal.

I must immediately add that such a reading does not at all claim to be disinterested. The promotion intrigues me, in part, because of the way I am myself targeted by it. Leaving aside the class dimension (mere academics are just out of the product's price range), the cultural icon selected to provide the leading vector of reader interest – though doubtless having cross-generational appeal – targets with special force those who were young in the late 1960s. It connects with my own fond past. The analyst, then, is cathetically invested in the semiological object; while the analysis itself cannot avoid a messy encounter between residues of a 'real' generational experience and the tricks that memory can play, especially as mediated by history-turned-into-myth.

THE MAGIC MOUNTAIN

Like a book or album cover, the front page of a four-page fold-out has to be striking if the reader is to be drawn in (Figure 12.2). Here, indeed, an album cover is just what is offered. Evoking a tableau that must be one of the most familiar in pop cultural history, four figures in profile stride across a zebra crossing. But we are not in a stately street of St John's Wood, a stone's throw from the famous studio. The Abbey Road scene has undergone a startling series of substitutions. The road being crossed cuts through a forest of green pines. It winds towards a mountain whose dazzling, snow-flecked, mist-enshrouded summit towers majestically over the trees in the distance. Moreover, instead of the Fab Four, looking blank, dandified and parodic, the figures photographed in mid-stride – three male and one female – are a quartet of healthy looking, clean-cut

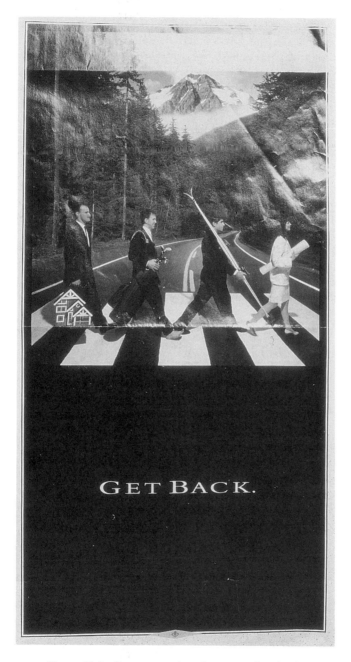

Figure 12.2 Intrawest advertisement: 'Get back'
Source: Globe and Mail, July 1993

213

young executive types. They are in straight business attire, though not without informal flourishes (like bare feet and a loosened neck-tie). Unlike the Beatles, they also wear a happy smile. But who are they? The mystery deepens as we notice their props and accessories. One carries skis, another golf clubs, a third what might be a doll's house and the fourth an architectural sketch. The solution will be revealed if only we turn the page.

But before doing so let us note a second substitution. Where the original album cover dispensed with words (the title would have been redundant given all the surrounding promotion), its altered version does carry a title. Though Beatles-related, however, it is not the one we might expect. It is that of a song actually released as a single shortly after *Abbey Road*, and included on their final album: *Get Back*. As we rapidly discover, getting back, in a multitude of senses, is precisely what the ad, and the symbolically saturated product it displays for sale, is all about. It is a thematic caption, governing the preferred meaning of the entire promotional text.

The remaining pages elucidate the enigma presented by all these substitutive moves (Figures 12.3 and 12.4) – on the one hand by revealing the identity of the commercial product (and its consumers) for which the mutated foursome are a metonym, on the other by weaving together the various ways in which that product can be construed as responding

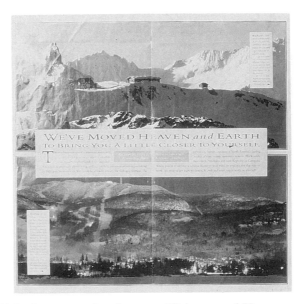

Figure 12.3 Intrawest advertisement: 'We've moved Heaven and Earth'
Source: Globe and Mail, July 1993

to the desire to 'get back'. Concerning the first, most of the direct infor-
mation is to be found on the back cover (after the front cover the page
most likely to catch the eye of the casual reader). The ad, besides being
a general corporate promo, is selling hotel space, condos (and perhaps
timeshares) in a new four-season luxury resort in Quebec which the devel-
oping consortium, Intrawest, has named Tremblant. Like the other three
resorts they have built, Tremblant will be open throughout the year, with
both a golf course and skiing facilities. Like the others, for reasons at once
practical, aesthetic and symbolic, it is set on the slopes of a mountain
surrounded by spectacular landscape.

The mountain motif has already been introduced on the cover page.
There, it is a subordinate, background element, albeit that the light
reflected from its just visible tip seems to shine like Akhenaton's sun[3]
over the whole scene. On the inside pages (printed as one) the mountain,
in fact two whole ranges of them, moves unambiguously to the centre of
the stage. The top picture shows the mountain setting of Blackcomb (at
Whistler, in British Columbia), the bottom one of Tremblant (in Quebec).
The former is shot by day, the latter in the dreamy pastels of night. The
buildings of the resort itself are not absent; but they are shown as blending
in, at Blackcomb as log cabins, at Tremblant as pinpoints of light reflecting

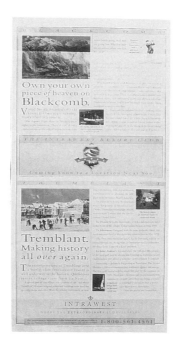

Figure 12.4 Intrawest advertisement: 'Own your own piece of Heaven'
Source: Globe and Mail, July 1993

the stars. It is the mountains themselves which are on display. The wide-angled lens has captured a vista beyond what even the human eye could see, a vision of mountains as immense, primordial, stunningly beautiful and (at least *behind* the Blackcomb chalets) unsullied by civilisation. These are not just lumps of rock, evidently. Through the camera's art we are brought into virtual co-presence with a romantic experience of Nature as sublime. The caption through the page – 'We've moved Heaven and Earth to bring you a little closer to yourself' – hyperbolically fixes its marvellousness within a loosely biblical frame. Biblical hermeneuts will note, though, that in these phrases the Creator-God merges pantheistically with Created Nature; while the corporation casts itself in the role of a Mediator which (combining the spiritual registers of East and West) can actively rejoin the participating subject to the real self within.

If we follow the verbal text beneath the picture we find an elaboration of this same double thought. Owning 'your own piece of Heaven', or just spending time there, not only gives you access to the mountain and thus a direct share in the sublimity of Nature and the archaic origins of the planet. It also brings you back in touch with yourself. In a box placed prominently at the centre of the layout the very word 'resort', we are told, means precisely that – at least in the pages of a dictionary (here, generic and simulated), and if meaning means returning a word to an etymological root. Thus: 'Re sort. 1. A return to self. 2. A meeting place. 3. A retreat, a refuge.' To resort, we might say, is to return to our authentic being, to go home, to get back to where we once belonged. And *a* resort – certainly this one – is where that occurs. The home-coming, then, is partly existential. Home is who you really are. Returning to Mother Nature brings each of us back to the authentic ground of our innermost being.

Doing so actively and recreatively is physically restorative as well. It is to appropriate Nature as Health – much as for visitors to a nineteenth-century European spa, bracing exposure to the unpolluted elements, combined with delight for the senses, was the prescribed soul tonic for the rich.[4] Of course, where the early version might have offered walking, boating and ballroom dancing, Tremblant, Blackcomb and the rest provide the more contemporary challenge and play of fairways, ski-slopes and discos. But this is not all. For Tremblant offers its patrons a kind of cultural home-coming too. To be sure, in its physical construction it is a totally designed, corporate product. But just as going there allows us to recover the unspoilt Nature that urban civilisation has paved, chimneyed and pyloned, so too we can leave that world behind in a quasi-historical sense as well. We can escape, as it were, from modernity itself – and not least in its frantic fragmentation and rootless denial of the continuity of time. Hence the resonant name of Tremblant (rising from the base of 'the historic Quebecois resort village'). Hence too, we learn from the blurb and pictures on page 4, the resort's emphatically retro design and look.

A special part of the Tremblant resort complex is 'a recreation of the old Mount Tremblant' featuring the original nineteenth-century renovated buildings now used for specialty shops and café. In a mistily traditionalist way these signs recall a more spacious and unhurried era of gracious living and *grandes soirées*, in whose architectural style the principal cluster of new condominiums (Le St Bernard, Le Deslauriers and Le Johannsen) have been built. The whole ensemble returns us to the vanished world of, if not the old Austrian or Alpine spa, with its little town accretion of cafés and hotels, then to its Northern New World facsimile, the fashionable colonial-era winter retreat. Hovering over this figure, besides its evocation of better days, is the suggestion that such a retreat, by 'Making History all over again', would bring us back, as well, to the warmth of traditional community: a home-coming, then, in every sense.

Altogether, then, there are five main symbolic motifs through which the ad identifies its product with all the good things promised by the notion of getting back. First, the mountain and related signifers for landscape as wilderness convey the sense of a return to the Big Origin of Nature. Second, the psycho-individual gloss placed on 'resort' conveys a sense of the bliss to be obtained by restoring contact with the originary self within. Third, the resort is a meeting place, a happy congregation of family and friends, a community in the good old sense, and thus a home away from home. Indeed, by virtue of all this restorative primary group intersubjectivity, more so than the mundane one from which we sally forth each day to work. Fourth, the highlighted design features of the complex conjure up a pre-industrial (yet lavish and not too distant) 'pastness', a pre-lapsarian time before our awful century, when leisure itself was less harried. Finally, but unlike the previous motifs, a fabrication solely of the ad itself (rather than of the sign-commodity on offer), we have the chain of associations released by the figure of the Beatles.

Here though there is a complication. The Beatles and related insignia are not just another sign to be exchanged with others for the resort. They frame the whole ad. Outside it, through various levels of identification, the Abbey Road reference seeks out an audience. Within, it provides a continuity through the text. (We may note that besides *Abbey Road* and *Get Back*, the ad also makes allusion at various points, to 'You Won't See Me', 'There's a Place', 'Revolution', and 'In My Life'.) But more than that, it is as if the pages following the 'album cover' are themselves sonic: the sides of the record to be heard within. Which is to make an equation not simply between the product and the Beatles as a cultural icon, but between the desire Tremblant promises to satisfy and whatever it is that the Beatles' *actual music* is about.

Within this multiple configuration the Beatles associations mobilised by the ad themselves branch off in several directions. Most obviously, the Beatles are displayed as a generational symbol. For current 40–50-year-

olds, they stir fading memories of youth. In part, such sentimentality is generic, a matter of mortality and generational succession. But this is also a particular youth, and there is a special wistfulness to the memories in play here. More than one 1960s reminiscer has recalled Wordsworth's paean about the 1790s: 'Ah, but to be young then was very heaven'. After the incandescent frenzy of activism, sex, barricades and Woodstock connoted by our own '1960s', moreover, there was a Big Chill. It is echoed in the break-up of the Beatles themselves. Their never-to-happen reunion is emblematic of this Paradise Lost; just as the Beatles together, at the crest of their wave, avatars of love and magic, are emblematic of the whole vanished carnival at its most benign.

In these various ways, the Beatles are invoked as the sign (and incarnation) of a home-in-time to which we might long to return. But this is not all. Through the hypertextual trigger of musical memories they, or rather their music, come to instantiate 'nostalgia' itself. Of course, to achieve this the referencing is selective. We are directed towards that particular part of the Beatles oeuvre which has nostalgia as its theme. Still, one memory can lead to another. So we might immediately wonder about what happens to the nostalgia constructed by the ad when the semiological mix is contaminated by the admission of other themes that were equally part of the Beatle's music – especially for memories formed by it at the time. What, for example, of their satirical playfulness (darkly edged in the *White Album*), or of their 'All you Need is ...' Gospel of Love? In any case, what about the nostalgia element itself? Is the force of even such obviously 'nostalgic' songs as 'Get back', 'Penny Lane' or the last fifteen minutes of *Abbey Road* itself consistent with the idea of 'getting back' which the ad's other signage constructs? To raise these questions is to broach the issue of the ad's self-undoing. But it also pushes us to consider more closely the constructed desire with which the ad itself seeks to lure the customer. What exactly is this 'getting back'? How and in what sense does the ad presume it to be salient among those to whom it would speak?

NOSTALGIA

I have been following current usage in employing 'nostalgia' to designate that to which the ad appeals. But I will now add that the word's conceptual aptness to do so only becomes clear, and clarifying, when we recognise the full ambiguity of its meaning. That is, when, without losing sight of what the word has drifted to mean, we rescue it from the dead metaphoricity into which it has more or less relapsed. If we consult the *Oxford English Dictionary* (this would be to follow the move simulated in the ad, but without its essentialist intent), we find that 'nostalgia' acquired its current sense of a hankering for the idealised past through a semantic slide that occurred roughly in the middle of the nineteenth

century. It had made its appearance a century before that as a medical term. Nostalgia – from *nostus*, homeland, and *algia*, pain – was a type of melancholia (a general term for mental disorder) which particularly afflicted sailors on long sea voyages. The symptom was immediately linked to its cause: the pain of being separated from one's homeland. Today we might understand such distress differently. Namely, as a combination of cognitive disorientation (discordances in mapping the immediate life-world) and separation anxiety, fear of being cut off from the primal unity of mother and child. The latter of course being understood not literally, but as transferred onto secondary but ontologically securing attachments to family, local community and motherland. We can imagine, perhaps, the special traumas of home-sickness when these levels were socially condensed, when travel was much more restricted, and when modal personality types, to use Durkheim's model, were more shaped by patterns of mechanical solidarity.[5]

By the end of the nineteenth century the word was being used to describe any kind of home-sickness, whether psychologically disabling or not. It was also being extended from place to time, as in nostalgia for youth, as if time and place were interchangeable, and time itself a succession of irrecoverable homes. From here, the meaning of 'nostalgia' moved increasingly towards the temporal pole: sharp regret at the passing of time, symptomatised by a sentimental over-valuation of the 'home time' lost. This home time might be individual, but it also might be collective and historical. Indeed, it might never have been present at all. Hence the term's further extension as a mildly contemptuous descriptor for golden age myths of all kinds.

Two things are to be noted in this change of meaning. First is the word's de-specialisation. Detaching itself from the professional power-knowledge of the Clinic (Foucault 1975), it became first laicised and then, through extension and analogy, generalised as the name for a widely shared experience. What gave currency to this extension was no doubt a real extension of displacement as a social condition. It indexed the deracination, with all its panic effects, experienced during capitalist modernisation, with trends to a geographically and occupationally mobile population, and to the destabilising of social patterns around fixed places of habitation. The second point to be noted is the metaphoric transfer itself. Again, it corresponds to a real process, to an intensification in fact of the one just mentioned. The growing disconnection between self, family, locale and country has attenuated the experience of home itself as a single nurturing and self-defining centre. At the limit, in a world of nomads, what home for the home-sick used to be becomes, on the one hand, a back-projection onto the screen of memory; on the other, a particularised construct of the individual's unique trajectory through space and time. But this move from space to time as the imaginary site of 'home' is not innocent, for it

links the problematic of the wounded narcissistic ego – exile and return
– to that presented by irreversibility and human finitude. Going forward
is towards death, going back moves you away from it. How comforting,
then, that going back should also be a movement towards the primal unity
of Mother herself, together with all her homy extensions.

The point of this excursus is not just to emphasise that there is a qual-
itative difference between the modern, and postmodern, nostalgia complex
and the disorder suffered by Cook's sailors. It is to insist above all on the
hybridity of the former. The thwarted yet imaginarily compensated longing
which 'nostalgia' has come to name, combines – as the word's history
suggests – both home loss and time worries. It is this, perhaps, which
accounts for nostalgia's power as a promotional attractor. It also allows
us to make some distinctions: for example, between a nostalgia thus consti-
tuted, which yet occludes historicity or the tragic dimension of time, and
so remains fantasmatic; and one which does articulate temporality as
another level of its anxiety and desire. A similar distinction might be
pursued with regard to contemporary counter-nostalgias: for example,
between Rose Braidotti's cheerful embrace of nomadicity (Braidotti 1994),
or Mark Taylor's ecstasy of Derridean errancy (Taylor 1984), and chrono-
typical positions which take cognisance of 'woman's time' (Kristeva 1986),
or which hew closer to the existential side of Marx, Nietzsche or
Heidegger.

It is not hard to see what our resort ad does in these terms. By its use
of both space and time signifiers for the return home promised by coming
to the resort, it shows how readily and 'naturally' these asymmetrical
dimensions can be co-ordinated within a single (third-order) sign. But this
co-ordination has a price. Time and space references can interchange
because their asymmetry is erased – on the one hand by hiding the tragic
dimension of time, as too its historicity, on the other by translating time
into the metaphorics of space. This is not surprising, since the main thing
for sale is rented space in a physical site. In any case, the interchange-
ability of space and time signs in the ad is the interchangeability precisely
of signs: colonial style architecture, Beatles-era music, the sublime moun-
tain. They are signs, moreover, fabricated to simulate what they purport
to make present. It is a double quality they all share, both among them-
selves and as condensed in the fantasy-object of the resort. What the ad
equates, in short, are simulacra, material examples of that techno-cultural
development which McLuhan (1962) was among the first to intuit as abol-
ishing both time and space.

The effect, unambiguously, is closure. In the ad, the 'nostalgia'
resonating in the historically determined ambiguity of that word, is both
reduced and naturalised. The desire it invokes is dehistoricised through
being inserted into a fixed (i.e. cosmic) and eternally human grid. The
terms of this operation we have already seen: home, self, nature, youth,

prc-industrialism, all identified with what is to be realised by getting back to the resort.

In Barthian terms, the nostalgic desire constructed by the ad as the basis of its product's appeal is mythified.[6] At the same time, the myth itself is presented in a sophisticated form. The ad's nostalgic desire is predicated (as again functionally it must be) on the irretrievable loss of home represented by the alienated and frantic secondary homes (house, job, etc.) of the ordinary workaday world. This is its moment of truth. However, as a token and realisation of this lost world, the ad projects a third home, a final and real one, represented by the resort. This is its untruth. Besides the hollowness of any such promise, the deeper home-comings organised on this site are themselves, even as displayed, vitiated or impossible. The history being 'made all over again', as too the resort's merry community, is manufactured. The mountain's credibility as a pure sign for sublime nature is ruined by the very presence of the resort. The self seeking its centre in the resort is simultaneously plunged there, as a paying customer, into another swirl of activity, competition and display. The *promesse de bonheur* is mission impossible. Psychoanalysts will tell us that the 'lost object' of infant desire splits the very self it orients, and can never be retrieved. The mendacity of the ad is not only in putting itself inside the charmed circle of this lost 'it' (in Lacanian terms, 'the real') but also in pretending that the tokens assembled for that persuasive task are not themselves failures as more than mere signs.

What, however, about the Beatles? In the nostalgic tunes the ad invites us to play in our head there is certainly loss and regret. But nowhere is there to be found this closed nostalgia, the illusion that it can be recovered via the possession of a token. 'Penny Lane' is remembered under blue suburban skies. Jojo's 'Get Back!' is a wake-up call from illusion. The melancholy of 'Golden Slumbers' is nostalgic only at the second degree: 'Once there was a way to get back home again . . .'. As for the Beatles' own anomie-provoking star-burst: it's a matter of getting on with it. Step on the gas and wipe that tear away. Iconographically, we might add, the *Abbey Road* cover's metonymic reference to the EMI studio where it was recorded places all such 'authentic' expressions always already within the order of the reproduced, within which there is indeed no way to get back home again. To be transported into this time sense is to be transported into a world of troubled nomadicity. Nomadic, because always on the move; troubled, because that same movement, for all its exhilaration, provokes an unquenchable desire to return, crossed with the realisation that it is impossible. This is the first disruption to the ad's construction of nostalgia which results from using the Beatles as just another sign for it. The sense and sensibility of even the music the ad means us immediately to recall bars any re-entry to Home via secondary substitutions, let alone via tertiary ones like a designer leisure complex.

221

But there is also a second disruptive strain in the Beatles' music which, if it lies outside the ambit of the particular songs harped on in the ad, and indeed in the industry's endless recycling, is nevertheless strongly associated with what that music overall expressed. This is its utopian moment, in which redemptive healing comes about not by going back in time but forward. That is, through the magic of non-possessive love, and the ruptural formation of a new, and carnivalesque, community. The disruption comes about when we hear in the anthems rippling out from the text of the ad (and especially from the songs it evokes about a trans-personal love) not a mere sign of 'the love generation', but a preserved trace of 'its' transformist consciousness, a decontextualised but still smouldering chip of what Benjamin (1969) called Messianic time. In such a context, the ad's appropriation – who is the Walrus? – will seem almost nihilistically banal, to be blown away in a breath of counter-cultural laughter. Altogether, the thematics of the later (post-1965) Beatles' music oscillates, and at its aesthetic best lives the tension, between the stances of 'no way home' and world-redemption. There is nothing in between. To live otherwise is to be a Nowhere Man. If we remove the psychedelic and political layers that get added on, this is easily comprehended as itself a residue of the Beat-influenced, bohemian and Sartre-reading late 1950s art school milieu in which so much of 1960s British rock culture was formed. In the ad, but only liminally, via the wider Beatles evocation which it tries to limit, it is this combination of historical residues, by turns existential, hedonistic and revolutionary, which presents the threat of a semiotic excess.

From that other vantage-point, the need to get back is imperative all right. But not in a way that can be satisfied by a symbolic substitute for Home. Nor, on the other hand, in a way which would placidly embrace the condition of nomadicity, together with a consumerist acceptance of the simulacrum as the only 'real' in such a world. It is just here, then, that the ad shakes. I do not mean to imply by this that the ad's operation fails for more than a minority of readers. Just that by invoking nostalgia for *this* nostalgia it touches on a hot memory. To the extent of its felt heat, the nostalgia it might make us nostalgic for is not the nostalgia we are invited to have for it. If we approach the lure of the resort from within the actual record album, its time-consciousness and its assemblage of desires would feed back and unravel everything. We would be reminded, in all its present inconceivability, of the delirium of an experienced possibility: that history can be open, and that even when recalling the fatal passage of dreams unfulfilled, history and all its might-have-beens, to cite Benjamin again, can be 'brushed against the grain'.

222

NOTES

1 See Lury and Warde, this volume.
2 The phrase was developed and popularised by W. Leiss. See Leiss et al. (1986).
3 Amenhotep IV, who renamed himself Akhenaton, briefly introduced sun-worship into the Egyptian Middle Kingdom, thereby displacing the official priestly cult of Amon-Ra. Period iconography (marvellous examples of which can be found in the British Museum) shows a many-fingered sun showering its life-giving beams on the blessed world of worshippers below.
4 And not only for the soul were TB sanatoria typically placed on mountains. Thomas Mann's *The Magic Mountain* (1924) shows the rich symbolic potential of such a site.
5 The distinction between mechanical solidarity (tribal and non individuated) and organic solidarity (arising from a harmonious division of labour) is central to Durkheim's analysis of the 'crisis' of industrial society examined in his *Division of Labour* (1893).
6 Myth, as defined in Barthes' *Mythologies* (1972), is 'second-order speech'. It describes a situation where a first-order sign functions as a second-order sign, as a naturalistic connoter of values. The photographic image is particularly well suited to such rhetorical usage.

REFERENCES

Barthes, R. (1972) *Mythologies*, New York: Hill and Wang.
Baudrillard, J. (1981) *Towards a Critique of the Political Economy of the Sign*, trans. C. Lewin, St Louis MO: Telos Press.
Benjamin, W. (1969) 'Theses on the Philosophy of History', *Illuminations*, New York: Schoeken Press.
Boorstin, D. (1961) *The Image: a Guide to Pseudo-Events in America*, New York: Atheneum.
Braidotti, R. (1994) *Nomadic Subjects: Embodiment and Difference in Contemporary Feminist Theory*, New York: Columbia University Press.
Debord, G. (1977) *The Society of the Spectacle*, Detroit: Black and Red.
Eco, R. (1994) *Apocalypse Postponed*, Bloomington and Indianapolis: Indiana University Press and British Film Institute.
Foucault, M. (1975) *The Rise of the Clinic: An Archaeology of Medical Perception*, New York: Vintage/Random House.
Fukuyama, F. (1992) *The End of History and the Last Man*, New York: Free Press.
Kristeva, J. (1986) 'On Woman's Time', in T. Moi (ed.) *The Kristeva Reader*, New York: Columbia University Press.
Leiss, W., Kline, S. and Jhally, S. (1986) *Social Communication in Advertising: Persons, Products and Images of Well-Being*, Toronto: Methuen.
McLuhan, M. (1962), introduction to H. Innis *The Bias of Communication*, Toronto: University of Toronto Press.
McLuhan, M. (1967) *The Mechanical Bride. Folklore of Industrial Men*, London: Routledge & Kegan Paul.
Taylor, M. (1984) *Erring: A Postmodern A/theology*, Chicago: Chicago University Press.

13

LISTEN TO BRITAIN
Music, advertising and postmodern culture

Andrew Blake

Early in 1996 the subject matter covered by this chaper entered the lime-
light in a very unfortunate way. After watching the pilot of *Hotel Babylon*,
a television programme made by an independent British production
company and targeted at the young throughout Europe, an executive from
the programme's sponsor, Heineken, wrote a fiercely critical memo. The
programme should, he insisted, show people drinking beer, not wine. The
audience should be more representative; in particular there should be
fewer 'extraordinary' people, and fewer 'negroes'. The presence of black
musicians elicited no comment: the massive black presence in popular
music is presumably taken for granted. Two of the stars of the first show
were in fact black performers, soul singer Seal and raggamuffin Shaggy;
the very name of the programme derives from Rastafarian culture.
But the sponsor's representative was concerned at the presence of black
people in the audience, reiterating among other prejudices the beliefs that
white viewers would find their presence offputting, and that black people
were not really consumers, too low in the economic order to buy even
such a routine commodity as canned lager. As soon as the fax was made
public, the company emphatically, even cringingly, apologised.[1]
 The Heineken outrage came just as British television advertising had
taken its first tentative steps to acknowledging that Britain really is a
multicultural society. Recent ads for British Telecom, Persil and Kellogs
had shown black people as ordinary individuals and families, not enter-
tainers or criminals; as routine consumers, in fact, just the type of people
advertisers want to attract. Heineken, too, have used black faces to sell
their product in Britain – if not in the same way as BT, as this chapter
will demonstrate. There's a quite peculiar mix of issues here beyond the
obvious and despicable racism: the transnational company trying to mar-
ket to different national markets, without an adequate sense of the nature
of those markets; the vexed question of 'sponsorship' and control of
programming; above all, though, the question of placing black people in
advertising, which has been an acute problem in British television for a
generation. The BT and Kellogs ads apart, blacks are too often *invisible*

in British advertising – but they are *audible*; this chapter will explore the paradox underlined by that Heineken fax.

The chapter briefly introduces, then, as an area in need of analytic work, the place of music in relation to contemporary visual culture, and discusses music in recent British television advertising. Through a reading of Paul Gilroy's text *The Black Atlantic* (1993), I argue that music is an important carrier of meaning, representing the invisible and unspeakable, capable of undercutting as well as underlining the visual content of any form of audio-visual representation. A consideration of music, therefore, aids our assessment of the radical shifts in a postwar British culture which, however reluctantly, has entered the condition of postmodernity.

For the purposes of this chapter, 'modernity' will be characterised as the period of growth, stabilisation and maturity of an economic and political system located within the cultural boundaries of Enlightenment thought and the geographical boundaries of the European and American nation state and its supporting imperial systems. 'Postmodernity' will be defined as the period of instability consequent from the collapse of Western imperial systems (including the Soviet Union and its empire), the globalisation of capital and the multiplication of assumed nationalities and other group and personal identities sometimes referred to as the 'localisation' of culture. I argue that Britain's postmodernity, its experience of contemporary life, is mediated by the historic relationship with the former colonies and with America; and I argue that we can *hear* these relationships through music. Even through what seems to be a global form, American popular music, we can identify a local, British inflection. Through the soundtrack of television advertising, we can listen to Britain.

THE PROBLEM OF SOUND AND IMAGE

There is, first, the problem of sound: of how, precisely, we attach meanings to the sounds we hear. For all the continuing presence of academic books on popular music within the general rubric of cultural studies, sound has proved resistant to theorisation: outside the autonomous realm of academic musicology, there is no accepted vocabulary with which to analyse music, as there is for literary texts and visual images. This has perpetuated a division, reproducing the elitist claims of European 'classical' music, in which this music is analysed with hardly a concession to its context either of production or reception, while popular musics are considered sociologically, historically and anthropologically, but seldom analysed as sound. The problem is currently being addressed in two ways: first through the attempt to encompass popular music within the hermeneutics of academic musicology and music analysis, which though still methodologically problematic (Middleton 1993) has produced interesting work (e.g. McClary 1991; Moore 1993; Walser 1993). Yet even this

welcome step may be too little, too late. Music as an abstract form – organised sound in and of itself – is only conceivable through the intellectual apparatus of modernity (Blake 1996a, 1997).

In the second theoretical approach, music is analysed through a belated application of psychoanalysis and psychosocial studies (Reynolds and Press 1995). But the growth of interest in sound and music among followers of these disciplines serves to undermine, rather than to underline, the autonomy of music. Music as a psychic phenomenon is of necessity related to the social and personal processes of the self; it can no longer have the independent existence assumed by musical analysis. Likewise, in the boundaryless culture of postmodernity, music itself as an autonomous entity is under threat, and in the entertainment business, sound increasingly exists primarily as an aspect of integrated products such as television programming, film and interactive video games.

There remains, therefore, the problem of interpreting a still under-theorised music within the arguably over-theorised study of the moving image. The *silence* of texts on film, video and television is often profound, even where the subject is laden with musical material (e.g. Silverman 1988). Academic work on television, for example, despite Raymond Williams' injunction that television is fundamentally a sound-based rather than a visual medium, has too often blithely ignored the sonic in its eagerness to deconstruct the visual, or the spoken. This is even the case where music is at the ostensible centre of the programming. One early and very influential treatment of MTV (the dedicated Music TeleVision channel which originated in America and is now available in localised forms in Europe and Asia), for example, relied almost entirely on the interpretation of visual rather than sonic images (Kaplan 1987) – though more recent treatment is more musically aware (Goodwin 1993).

The gap is most obvious, and in some ways most surprising, in film theory. It is often taken for granted that most of us do not actually hear film music at all, but experience it subliminally, or at least passively, while we more actively read the images on the screen, and less actively listen to the dialogue. It has been argued that the whole point of a soundtrack score is that it should be experienced and not heard; that if we can actively hear the music, it is not working (Gorbmann 1987: 1). This apparent paradox should, one would assume, attract the attention of those interested in the workings of the subconscious or unconscious minds. But no; despite the claimed subliminality of the best film music, and the current reliance by film theory on psychoanalysis, you have to look hard and long for more than a mention of the part music plays in either the making of the product or in our apprehension of it. Film theory takes very seriously the dubious proposition that Western culture is, and has been since the Renaissance, principally verbal, literary, and, in particular, specular; despite the beginnings referred to above, there is as yet no agreed

critical vocabulary for music, or for sound in general, to match that for, say, camera shots or lighting technique.

FILM, MUSIC AND ADVERTISING

But there *is* an important history here, which is available if you look hard enough (Altman 1980; Gorbmann 1987; Flinn 1992). Take the story of the dominant producers of the moving image, Hollywood. From the 1930s to the 1950s Hollywood film music was dominated by Europeans, most of them refugees from Nazism like Erich Korngold, Max Steiner and Miklos Rosza. Their musical vocabulary was drawn in the main from the European (especially German) romanticism in which they had been trained. In the 1950s and 1960s, American-born composers like Bernard Herrmann and Henry Mancini worked with a wider mix of styles, including the same romanticism, but also elements of modernist twentieth-century classical music (including electronics), jazz and popular musics of various kinds. In addition to dedicated scores, from the late 1950s Hollywood producers often demanded pop songs on soundtracks to help sell both films and the soundtrack albums, and though this sometimes meant a few songs placed at strategic points (or just the playout, as recently on *Batman Forever* (1995), which otherwise has an exemplary post-romantic orchestral score by Danny Elfmann), many films were made with rock or jazz/rock throughout the soundtrack. Then in the middle 1970s, with the success of John Williams' scoring for films like *Jaws* and the aptly named 'space opera' genre, the *Star Wars* series, the big orchestral sound made a comeback. But it was a different sound, led by the brass rather than the strings, and in which the orchestra now routinely incorporated synthesisers and other electronic instruments. In the 1980s and after, films have often used electronic scores which replicated the palette and gestures of the orchestra – Vangelis' work for *Blade Runner*, for example. In each case (rock, purely electronic and Williams-ish orchestral scores), a music is produced which is usually mixed for maximum dynamic impact and relayed in the cinema on increasingly impressive multichannel Dolby 'stereo' systems (now available in domestic versions). This technical change has arguably made music more important than ever in the cinematic affect: against a flat two-dimensional screen, the multichannel music and other sound effects give the experience space and depth – 'virtuality'. But the effect, it seems, remains subliminal.

A compressed outline of the history of Hollywood music was necessary for this chapter because this is the musical legacy which informs most British television (and indeed cinema) advertising. Of course there have been notable British film scores, as there have been a few notable British films: in the 1960s the James Bond series and the Beatles' films made important additions to the genre, and influenced Hollywood (Blake 1992).

227

However, most of the traffic in influence since the 1960s, as the British film industry collapsed, has been in the other direction. Film music and its conventions have been important in British advertising. Advertisements are short films. In most cases, in their rhetoric of techniques and generic references, they are far more cinematic than other television programming. It's a commonplace that directors working in Britain have little other opportunity to hone their cinematic talents: there is virtually no indigenous cinema – another reason why Hollywood's musical traditions are part of British television advertising, in the same way as all the other Hollywood traditions have become part of the language of British television advertising.

So is it true that film, or advertising, music can only be consumed through passive listening? Or do soundtracks matter as much as visual images? In many ways I think they do. To return to that assumption about the post-Renaissance, the verbal and the visual: without discussing the argument in detail two connected points could be made. First, that since the eighteenth century there has been a developing tradition of abstract music in Western society. The Western concert tradition embodies music which is not functional (in the sense of supporting religious or social or military occasions, or part of theatre, opera or music hall), but is there solely to be heard, and concentrated on as sound, not seen. The invention of mechanical sound reproduction devices such as the player piano and the gramophone a hundred years ago, then fetishised the invisibility of the audible, and for the first time people sat around listening to sounds coming from thin air without those sounds being actively made in their presence; the visual was then relegated or dissolved altogether (Eisenberg 1987; Chanan 1995). More recently the usual video/audio relationship has been reversed: with car stereo and the walkman you have the ability to make your own visual background to the sound you have chosen. In either case music, by itself, has a powerful presence in Western culture. Organised sound, as an entity in its own right, is an important aspect of post-Enlightenment rationality, despite, as mentioned above, the increasing threat posed by the proliferation of multimedia forms of which music is only one component.

Second, while much music has been and still is supportive of words, a great deal of music from this tradition is not; many people have suggested that non-verbal music has particular expressive capabilities which go beyond those of language. The role of music is of particular importance in the representation of the sublime – the otherwise inexpressible feelings of terror, at best perhaps 'pleasurable fear', theorised by Kant and Burke in the eighteenth century, and present as the obverse of the Enlightenment in Gothic fiction and aspects of romantic art, as well as in music from Beethoven's Fifth to *Bat out of Hell II* (Hebdige 1988b; Gilroy 1993; Walser 1993).

MUSIC AND DOUBLE CONSCIOUSNESS

Paul Gilroy's book *The Black Atlantic* reworks the connection between music and the sublime, in describing African-American music as expressive of the otherwise inexpressible condition, including the horrors, of the black experience of modernity. Gilroy refers to the 'slave sublime', and he claims that music has a particular importance to African-American and Caribbean people because of this expressive power, the power to go beyond the verbal. Gilroy's argument is signalled by his subtitle, 'modernity and double consciousness'. The legacy of slavery, and the continuing pervasiveness of racism, means that black consciousness cannot depend on one of the pillars of modernity, nationalism. Instead feelings of placed identity are both local and African, mediated by the Atlantic as both the historic site of the middle passage and the current site of cultural interchange between the Americas, the Caribbean and Europe. Music is one of the crucial registers of this double consciousness, and through this, Gilroy claims, we can 'challenge the primacy of language and writing as pre-eminent expressions of human consciousness' (Gilroy 1993: 74). The power of black music then derives from this need to express the unspeakable, *and the possibility of doing so through music*, with its continuing and immediate contact with the sublime.

I want to make three points in relation to Gilroy's very important arguments. One, the relative *invisibility* of the black presence in American and British culture has probably reinforced the importance of music as an invisible force binding together and expressing the continuities among black cultures. African-American music's commanding place in popular culture means that this form of expression is a continuous marker of the black presence, despite the relative absence of black faces from mainstream visual culture in film and television. This separateness was once reinforced by the racialised divisions of musical genres in America, often under explicit labels like 'Race music', now more usually hidden under terms like 'Urban Contemporary'. However, such barriers have had very little purchase since the triumph of rock 'n' roll in the late 1950s: the black presence in America was confirmed by the pervasiveness of these sounds even as it was denied by sight. This relative absence from the visual was reconfirmed in the early days of MTV in the early 1980s, when despite the continuing popularity of black music, its visual representation through video was denied by the channel, until the massive success of Michael Jackson's *Thriller* and its lengthy eponymous video forced a policy change (though the earlier policy was, perhaps, one of the reasons for Jackson's own colour change).

Two. On the other hand, this relative absence from everyday visual representation, together with the expressive power of the music, has underlined the difference, the alternative, even the subversive status of

black cultures in such a way as to attract many white people who wish to reject the dominant values of their societies, whether young white Americans who buy rap records or the young white Britons who were claimed by Dick Hebdige to have engaged in a 'phantom dialogue' with black American and Caribbean cultures (Hebdige 1979). The ethnographic work of Simon Jones, and the presence (and chart success) of cultural hybrids such as Apache Indian's Handsworth-originated ragga with Indian percussion, have indicated the availability of a black identity to young British whites and Asians, in the inner cities at least. This could perhaps be theorised as a different form of double consciousness (Jones 1989; Sharma and Sharma 1996).

Three. Hebdige's work on subcultures has been followed by his *Hiding in the Light* (1988a), in which a rather broader view is taken of the Anglo-American relationship. Cars and other products, films and film stars, the whole panoply of American culture is present in this later text – not just African-American culture. And so is their impact on Britain and British culture, in a positive assessment of the cultural pollution which was the object of hostility in that influential text of the founding of cultural studies, Richard Hoggart's *The Uses of Literacy* (1957). Gilroy argues that much cultural studies work is unreflectingly white-Anglocentric. In Hoggart's case this was not unreflecting, but a quite conscious assertion of the author's belief in the white working-class culture of his 1930s childhood, as against what he perceived as the dominance of imported American culture in the 1950s. Given the presence of Hollywood film and jazz-derived dance music in Britain throughout the twentieth century, the supposed purity of this remembered moment is no doubt a partial memory. Indeed, the American presence or influence was always welcome to many sections of the working class as an antidote to class-bound British culture (Worpole 1983; Hebdige 1988a; Morley 1995; O'Shea 1996; Schwarz 1996).

British culture is, and has been increasingly through the twentieth century, deeply imbricated with American products and values. What we have in contemporary British culture, it seems to me, is precisely a double consciousness. The split in this instance is not along the lines of space (as in Gilroy's model) but time. Modernity was, and postmodernity is, experienced through American or Americanised products, the future is imagined through them, and only tradition, the past, is seen as British, while European culture is irrelevant to all but the chattering classes: there is little or no autonomously British modernity (*Independent* 1995; Nava and O'Shea 1996). Where, exceptionally, a popular future is imagined and Europeanised, as with aspects of rave culture, it is feared and loathed by government – which has actively tried to repress it. There is, one could argue, a 'white Atlantic', through which both the present and the future are visualised and heard in Americanised terms. One of the strongest components of this relationship to America is black or black-derived

popular music (Blake 1996b). Of course this set of connections is not the same as Gilroy's black Atlantic, and of course white intellectuals have been so busy exploring implicitly white Englishness, or attempting to understand arcane French theory (in Baudrillard's case, a theory driven by a Hoggartian hatred of American culture), that there has been little appreciation and recognition, let alone analysis, of this Americanised British consciousness, and of the ways in which, through music in particular, black culture has become omnipresent in the consciousness of white as well as non-white Britons.

A 'WHITE ATLANTIC'?

I want to take one surprising example of the pervasiveness of American culture as expressive of the British experience, before moving on to the sound of Britain in advertising (the example is taken from Blake 1994). The summer 1994 issue of the quarterly *This England*, a *Country Life* for the Eurosceptic extreme right, commemorated the D-Day landings of 1944. The belief that the Second World War was won by the British, with the help of God, was repeated here, with the additional liturgy, in both articles and letters, that this victory will be worthless if Britain loses its sovereignty to a Europe demonised as bureaucratic and socialist. *This England* is the land of country cottages, of genteel whiteness evoked in Prime Minister John Major's 1993 vision of shadows on county cricket grounds, warm beer and old maids cycling to communion. The magazine tried to celebrate all this in music, offering its readers tapes and CDs. But these were not the usual musical signs of Englishness – not folksongs or Vaughan Williams' folksong-derived pastoral, or the ceremonial marches of Elgar, nor any other high-culture musical representation of Englishness. Instead, the magazine offered recordings of the dance bands and singers of that 1940s moment of battle, many of whom were not Little English but American (including the Ink Spots, the only black faces in the magazine); or Brits who tried to sound as if they were American. So even in this text of extreme nationalism, the accompanying musical soundtrack is black or black-influenced American music; the soundtrack therefore points accurately to the realities of the Allied victory of the Second World War, rather than the purely national success which is celebrated in the magazine's text.

Given this pervasiveness, structured into British culture well before the era of rock 'n' roll, it is unsurprising that American or American-derived music is often present in British television advertising. This is not to deny the presence of British or European music, pop and classical; or that this can sometimes be used in an explicitly or parodically nationalist mode. Consider a recent Carling Black Label campaign which parodies *The Dambusters*, a film celebrating the bouncing bombs which destroyed

two German dams in 1943. In the first of these, a German guard acting as a soccer goalkeeper heroically 'saves' the bombs from destroying the dam; the second portrays a telegenic Briton bouncing his towel along the water so as to reach the poolside deckchair before the Germans holidaying at the same Mediterranean locale. Commenting on these ads, Sean Brierley notes rather simplistically their consensual production of a metaphorical nation through jokey anti-Germanism (Brierley 1995: 147). Typically, he ignores the music, the *Dambusters* march, a score by Eric Coates which is the best-known sign of the film, and which adds to the inverted, and arguably as preferred reading self-parodic, creation of the lager-drinking subject. This is, then, a notable example of the presence of patriotic music – though the product advertised is a Canadian-derived lager. Ironic smiles all round at the agency, no doubt. But what of watching Little Englanders, or indeed Germans?

Why should well-known music from the 1950s be called on in advertising this decidedly recent product? Again it should be underlined that the use of music is a topic hardly touched on in research into advertising and consumption. One interesting attempt to decode the role of music in advertising (Cook 1993) examines classical or classical-derived music as the foundation of adverts for cars and insurance, and concludes that music of this sort, associated with notions of high culture and explicit excellence, can offer an assurance to the potential buyer that the product is quite simply better than the competition – thus making a bald claim in sound which would be illegal if spoken or written. The Carling ad, on the other hand, trying to impress in a market awash with similar, deeply anonymous lagers, addresses not the product but the consumer. The *Dambusters* march (an essay by a British light music composer, in a genre straddling the high/low culture borders), however playfully used, can be heard as part of a text which playfully denies authentic patriotism – but equally in a negotiated reading/hearing in which the text's real meaning is not seen but heard in a musical score which implies the patriotic superiority not of all Britons, but of those who drink the product advertised.

More often, though, the musical content is from American, or American-influenced, popular traditions which lack that elitist sense of value. Recent campaigns have featured, for example, the Velvet Underground's 'Venus in Furs' to advertise Pirelli tyres in possibly the most bizarre commercial of recent times, a feast of gay SM imagery only shown in full after the 9 pm censorship deadline; and a John Williams-type theme used to advertise the heroic nature of a washing powder. When American popular musics are used, the codes are less easy to analyse in terms of power and affect than in Cook's classical examples. I suggest that they signal a specifically British postmodern and post-colonial culture, deeply imbricated with that of America, but which is busily constructing its own, heavily mythologised, *version* of America, in order to represent,

subliminally, the widest possible British audience, and thereby to construct British citizens as subjects of an Americanised imagined present (and future) postmodern consumerism. The ads imply that their products will bestow the imagined freedoms and pleasures of America on the consumer.

To exemplify this tendency I concentrate now on two aspects of recent (1993–6) television campaigns which have explored the British relationship with American culture and with African-American music. First, there has been a remarkable series of advertisements set in the American South: taken together, they offer an America mythologised as rural or festively rather than problematically urban, and as the centre of black musical creativity. Once again lager, a drink whose rise to popularity in Britain occurred only in the 1970s, has been the ostensible object of much of this attention. Campaigns for Heineken and Budweiser beers have used black blues musicians, calling on the rhetoric of 'authentic' experience which is still attached to the blues, and particularly the *rural* blues as a musical form, a rhetoric which was, however, partly the creation of British musicians and fans.[2] The Heineken ad recreated a romantic myth of blues creativity, as a perfectly happy musician was unable to play the blues before drinking Heineken, after which his life became miserable, he began to sing once more with feeling and secured a lucrative recording contract. In Budweiser's case, one example showed a trans-continental train, a sign of America's size and of the potential it mythically offers to transform lives, in which a white man plays idly with a deck of cards, to the sound of black singer Howlin' Wolf's hobo anthem 'Smokestack Lightnin'. The text at the end of the ad proudly proclaims, 'The Genuine Article'. However, the genuineness is visibly compromised. Budweiser's authentic Americanness, already suspect since the product's brandname and label design are copied from a Czech beer, is undermined by the on-screen text, 'Brewed in the UK', which appears halfway through, in small print, like a health warning on a cigarette packet. The soundtrack here is a crucial part of the positive presentation of available Americanness counteracting the disappointing 'made in Britain' tag.

Some of this 'big country' imagery was then taken up in a campaign for the Peugeot 106 car, in which a miniature version of the female buddy road movie *Thelma and Louise* was enacted. The two heroines celebrate their freedom from the responsibilities of the everyday, and from patriarchal control, by driving around the open spaces of America in this ridiculously un-American little car, making dismissively witty remarks to the men they meet. In a follow-up campaign to launch a special edition of the Peugeot 106 called the Mardi Gras, the heroines were seen driving in New Orleans at carnival time; again a black blues musician is an important part of the scenario. A third campaign, shown early in 1995, effectively parodied the final scene of the movie. What is held in common here is a sense of that mythology of America as a spacious land of opportunity for

individual fulfilment, a version of the frontier thesis.[3] There is in the 'Thelma and Louise' ads a sense of the authentic America as the rural south, rather than the urban megalopolis of Los Angeles or New York. Also here is a sense of an indigenous British 'new frontier', the growing freedom of the twentysomething young woman, increasingly well qualified, independent and successful *vis-à-vis* her male counterparts, and therefore a crucial addressee for car adverts aimed at younger people (Wilkinson 1994; Mulgan and Wilkinson 1995). Continually present, symbolising these freedoms and opportunities, is the black music so popular among young British people. Country music may be routine shorthand for all this in America (including its gendered address), but not in Britain, where African-American musics are socially as well as ethnically pervasive, but country music is comparatively restricted in its appeal.

A second instance of this tendency is what could be called Potterism. The playwright Dennis Potter wrote a number of television series, such as *The Singing Detective*, *Pennies from Heaven*, and *Lipstick on your Collar*, in a genre related to the musical. In this distinctive Potter genre, actors in a serious drama every so often burst into song and dance, or rather burst into lipsynch and dance – the difference between Potter's efforts and the musical is that in the latter the songs are created specifically for the show, whereas Potter's characters 'sing' to the original recordings of songs the author liked. This led to the sight of, say, soberly dressed bankers interrupting their spoken dialogue in order to cavort through dance routines while singing 1940s pop songs; a sight many people, apparently, found attractive or amusing. At any rate this hybrid genre's effects on British television advertising has been strong, with campaigns for, for example, Direct Debit, the Access credit card and Allied Dunbar insurance using miniature versions. In each case these campaigns used dark-suited, middle-aged, white male actors lipsynching *to black music and/or black voices*. The Allied Dunbar advertisements featured the voice of Nat King Cole, singing 'Let's Face the Music and Dance'. Nat King Cole's voice then remained on British television, with a mini soap opera campaign run by the Meat Marketing Board, in which there is no lipsynching, but exclusively white actors playing out little romantic or family dramas, and cooking and eating a lot of meat, while Cole's voice sings 'Let There Be Love' (accompanied by the lush arrangement of white British musician George Shearing). Louis Armstrong's voice, like Cole's, has also been heard in a number of commercials, notably singing 'All the Time in the World' in a bizarre campaign for the Irish beer Guinness featuring the white actor Rutger Hauer.

Why are these sounds particularly important? Clearly because of the juxtaposition with the visuals: in the case of Potterised cross-racial lipsynch, music is not just the background, and it is not merely supportive of the advertising message. The music was the inspiration for Potter, and

of the advertisers who chose to copy him. Black music and/or the black voice, albeit as commodity, therefore underpins the continued place of Britain in global finance capitalism, and underpins the collective experience of postmodernity in Britain. In a television culture, and especially an advertising culture, which routinely denies adequate representation to the black British population, it is important that, through music, the black presence cannot be denied. The strength of the 'Black Atlantic' connection identified by Gilroy is continually signalled through music. Post-colonial Britain's black presence can be hidden from television's view, but not from its sound.

However, it is also important that this soundtrack is a part of the more general British relationship to postmodernity, the double consciousness of a British culture whose present is symbolised largely through American or American-derived cultural products. The black experience, in Britain as elsewhere, is unrepresentable without music; but modern Britain as a whole, white and black, is unimaginable without the constant presence of American culture, including music – and, as *This England*'s celebratory cassette illustrates, this Americanised imaginary is at least half a century old. There is a 'white Atlantic', but it is creolised and hybridised, changed irrevocably by the impact of black American culture.

Another recent example of this fantasy reworking of America may help to make the point. This television advertising campaign linked Hollywood film, the frontier, black American music and British suburbanism in a miniature version of another road movie, Stephen Spielberg's *Duel*. A car is driven along what seem to be Midwestern or Southern American roads by a white middle-class male, probably a sales rep. Its radio blares out classic soul and R&B. The car is followed closely by a huge truck, whose threat is only resolved when the car stops and the driver frantically tries to telephone for help. The truck screeches to a halt outside the phone booth and the white working class male truck driver descends from his cab to calmly ask 'What radio station are you listening to?' The station turns out to be JFM, which had been launched in 1989 as Jazz FM, and after the failure of its (very easy listening) jazz programming to attract an advertising base, was relaunched in 1992 as that specifically American form, an Urban Contemporary station (this title was not used by the station's owners). But whereas Urban Contemporary in America assumes a black audience, in London JFM's target audience is the advertiser-friendly 25–40-year-old ABC1 white male exemplified by the car-driving rep. The station currently broadcasts soul, gospel, R&B and related African-American music to the London area – a densely populated suburban conglomerate a long way, in all senses, from that particular mythologised America, the empty landscape seen in the advert. This miniature movie closes in fact with a piece of 'British' jazz, here (as usual) very much an Anglo-American hybrid – the JFM station ident, an acid

jazz reworking of the Miles Davis track 'So What' by the black British guitarist Ronny Jordan, from his 1992 Island records album *The Antidote*.[4]

Does all this mean that there is no British voice as such, no real sound of Britain? Far from it. The use of American cultural symbols does not mean simple Americanisation, in Britain or elsewhere (Kuisel 1993). Their meanings have been negotiated. The global is inflected by the local, and in working with American or indeed Caribbean symbols, overlaying and changing them, accepting aspects of their mythologies and fantasising others around them, different meanings are made as much by local cultural workers such as advertising agencies as by the interpreters of their messages. The American South which has been used to sell Dutch beer and French cars to the British is a mythologised, British American South, and the musical soundtrack for this vision of America is a British version of American music. Even in the voice of Nat King Cole, we can listen to contemporary Britain.

NOTES

1 The fax scandal became public just before the first broadcast of Hotel Babylon. It is entirely possible that the exercise was a publicity stunt. However, anecdotal evidence would suggest that racism of this sort is common. Two months later the Ford motor company equally cringingly apologised for replacing black faces with white ones in an old publicity shot about to be reused in an advertisement destined, they said, for Poland.
2 E.g. musicians such as Alexis Korner, John Mayall, Graham Bond, even the Rolling Stones (Melly 1970; Harker 1980; Heckstall-Smith 1989; Mackinnon 1993).
3 The 'frontier thesis' was the notion of the historian Frederick Jackson Turner, who asserted that the meaning of American history lay in its constant search for new frontiers to replace those of the West, which had been 'conquered' by the late nineteenth century. Turner recognised that the new frontier of the early twentieth century was the growth of large cities. President Kennedy then used the rhetoric of the frontier to describe the exploration of space; the metaphor was, of course, taken up by Gene Roddenberry in the opening voice-over of the influential science fiction television series *Star Trek*.
4 It is worth noting that one aspect of this campaign at least, the change of name, was a failure. The station's audience declined further, and in August 1995 returned to the old name Jazz FM - though the station's Urban Contemporary programming was not altered.

REFERENCES

Altman, R. (ed.) (1980) 'Soundtracks', special edition of *Yale French Studies* no. 60.

Blake, A. (1992) 'Bond and Beyond', in M. Barker and A. Beezer (eds) *Reading into Cultural Studies*, London: Routledge.

Blake, A. (1994) 'Village Green, Urban Jungle', *New Statesman and Society*, 12 August: 32.

Blake, A. (1996a) 'Re-Placing British Music', in M. Nava and A. O'Shea (eds) (1996) *Modern Times: Reflections on a Century of English Modernity*, London: Routledge.

Blake, A. (1966b) 'The Echoing Corridor: Music in the Postmodern East End', in T. Butler and M. Rustin (eds), *Rising in the East*, London: Lawrence and Wishart.

Blake, A. (1997) *The Land Without? Music in Twentieth-Century Britain*, Manchester: Manchester University Press.

Brierley, S. (1995) *The Advertising Handbook*, London: Routledge.

Chanan, M. (1995) *Repeated Takes*, London: Verso.

Cook, N. (1993) 'Music and Meaning in the Commercials', *Popular Music* 13, 1: 27–40.

Eisenberg, E. (1987) *The Recording Angel*, London: Picador.

Flinn, C. (1992) *Strains of Utopia: Gender, Nostalgia and Hollywood Film Music*, Princeton NJ: Princeton University Press.

Gilroy, P. (1993) *The Black Atlantic*, London: Verso.

Goodwin, A. (1993) *Dancing in the Distraction Factory*, London: Routledge.

Gorbmann, C. (1987) *Unheard Melodies: Narrative Film Music*, London: BFI.

Harker, D. (1980) *One for the Money*, London: Hutchinson.

Hebdige, D. (1979) *Subculture: The Meaning of Style*, London: Methuen.

Hebdige, D. (1988a) *Hiding in the Light*, London: Routledge/Commedia.

Hebdige, D. (1988b) 'The Impossible Object: Towards a Sociology of the Sublime', *New Formations* 47–76 (reprinted in E. Carter, J. Donald and J. Squires (eds) (1995) *Cultural Remix: Theories of Politics and the Popular*, London: Lawrence and Wishart).

Heckstall-Smith, D. (1989) *The Safest Place in the World: A Personal History of British R 'n' B*, London: Quartet.

Hoggart, R. (1957) *The Uses of Literacy*, Harmondsworth: Penguin.

Independent (1995) 'Yankee Doodle Dandy for Britain', 5 June.

Jones, S. (1989) *Black Culture, White Youth*, London: Macmillan.

Kaplan, E.A. (1987) *Rocking around the Clock: Music Television, Postmodernism and Consumer Culture*, London: Methuen.

Kuisel, R. (1993) *Seducing the French: The Dilemma of Americanization*, London: University of California Press.

McClary, S. (1991) *Feminine Endings*, Minneapolis: University of Minnesota Press.

Mackinnon, N. (1993) *The British Folk Scene*, Milton Keynes: Open University Press.

Melly, G. (1970) *Revolt into Style*, Harmondsworth: Allen Lane.

Middleton, R. (1993) 'Popular Music: Analysis and Musicology', *Popular Music*, 12, 2: 177–90.

Moore, A. (1993) *Rock: The Primary Text*, Milton Keynes: Open University Press.

Morley, D. (1995) 'Theories of Consumption in Media Studies', in D. Miller (ed.) *Acknowledging Consumption*, London: Routledge.

Mulgan, G. and Wilkinson, H. (1995) *Freedom's Children: Work, Relationships and Politics for 18–34-Year-Olds in Britain Today*, London: Demos.

Nava, M. and O'Shea, A. (eds) (1996) *Modern Times: Reflections on a Century of English Modernity*, London: Routledge.

O'Shea, A. (1996), 'What a Day for a Daydream. Cinema and the Experience of Modernity', in M. Nava and A. O'Shea (eds) (1996) *Modern Times: Reflections on a Century of English Modernity*, London: Routledge.

Reynolds, S. and Press, J. (1995) *The Sex Revolts: Gender, Rebellion and Rock 'n' Roll*, London: Serpent's Tail.

Schwarz, B. (1996) 'Black Metropolis, White England', in M. Nava and A. O'Shea (eds) (1996) *Modern Times: Reflections on a Century of English Modernity*, London: Routledge.

Sharma, A. and Sharma, S. (eds) (1996) *New Asian Dance Music*, London: Zed.

Silverman, K. (1988) *The Acoustic Mirror: The Female Voice in Psychoanalysis and the Cinema*, Bloomington IN: Indiana University Press.

Walser, R. (1993) *Running with the Devil: Power and Gender in Heavy Metal*, Hanover, New England: Wesleyan University Press.

Wilkinson, H. (1994) *No Turning Back: Generations and the Genderquake*, London: Demos.

Worpole, K. (1983) *Dockers and Detectives*, London: Verso.

14

ADVERTISING AND THE MODULATION OF NARCISSISM

The case of adultery

Iain MacRury

A number of recent car advertisements have made their appeal within a narrative that implies or depicts adulterous relationships. The advertisements share a complication in their stories, whereby, in the end, the adulterer is shown, one way or another, not to be culpable. The rule of the seventh commandment bends but is never actually broken.

It would be possible to examine these ads as documentary evidence for a claim that in the 1990s the institution of marriage has a value which is being defended and reasserted as part of a conservative political agenda. Advertising, in such a view, is seen as a conduit for the pervasion of 'family values' and of other conservative representations. Such a critique of advertising texts as oppressive representations of aspects of the social world and as politically motivated and suspect representations of social relations can be valuable. However, they do not provide the only interesting way to approach a cultural study of advertising.

This analysis attempts to examine the psychological and social contexts which inflect the particular textual organisation of advertisements. This depends upon a sense of advertisements as rhetorical interventions to be assessed and used by a readership rather than as closed or foreclosed (mis)representations of cultural contradictions coercing false assent. The term 'readership' here has two meanings. One is the traditional sense of the target audience thought of in terms of demographics (Kent 1994: 105). The second meaning depends upon a sense of reading seen as an activity with a style. In this sense the suffix '-ship' (as in craftsmanship) is to denote that in the practice of reading there are individuated and habituated capacities and dispositions asserted by readers in reading transactions.

The ads to be examined provide exemplary instances for the exposition of a model of advertising communications which concentrates upon the role of texts in the modulation of our emotional relations towards the

world of symbolic goods. The aim is to give some account of the role of advertisements in the provision of a textual environment efficacious for the performance of a composition of the consumer's relationship to the arrays of products in the 'projective system' of goods (Richards 1994: 93). In this conception consumer motivations are not thought of as necessarily rational, nor are they imagined to be hopelessly irrational. They are not simply the indulgence of a perpetual whimsicality, nor are they entirely determined by marketeers. Consumption need not be thought of simply as compliance with a false urge to satisfy false needs. It is possible instead to envisage a space in which, potentially, advertising and consumption make some contribution to various needs for social and unconscious self-expression.

It is a truism that advertisements must have an audience. What is interesting is the specificity of that audience. And what is most interesting of all is advertising's adaptation to and adoption of these specificities in the form of a creditable articulation of conscious and unconscious wishes and needs. By means of analyses of the rhetorical strategies involved in making adverts for specific audiences it is possible to see some of the ways in which advertising attempts to address different target markets. It is then possible to examine the relative distinctions between readerships in terms of the unconscious needs and wishes as they are expressed towards and within these different audiences.

READING DILEMMAS

The first adultery advertisement is for the Peugeot 306:

SCENE: *In the dark recesses of an underground car park stands a woman. A young executive is about to get into his car. From out of the shadows he hears the stranger's voice. 'Nice car, want to show me what it can do?' The tone is flirtatious.*
Background music – Marvin Gaye's 'Sexual Healing'.
SCENE: *The man is driving his black Peugeot on the open road. The woman, in her sexy black cocktail dress, is enjoying the journey. She is moving provocatively. He seems both a little nervous and rather excited.*
SCENE: *The couple are at the beach having sex against the car. We see the sea and the rocks and their passion and, of course, the car. He drops her back at the car park.*
SCENE: *The man returns to his idyllic home. We see children run through the garden gate to greet their father. This is the moment of drama. We instantly know that he is married. Who then was the mystery woman? What of his wife?*
SCENE: *The little daughters crowd around their daddy. 'Where's your mother?' he asks. The camera pans on to the mother/wife (with more*

children). 'Right here,' she says, and then, in a voice we have heard before, 'nice car'. The lover and the wife turn out to be one and the same woman. All's well that ends well. We are told, as the ad signs off, that Peugeot drives the imagination.

We are left to review the ad in the light of this recognition. Was this romantic adventure a memory? A fantasy? A game? Whatever we answer (if we do) as elsewhere in the drama, there is mystery and uncertainty. It is the skilled modulation of these ambiguities and tensions in the text which allows the appropriate readerships to tune in to the ad. This sense of what is being tuned in to can be set out more clearly when the detail of the ad text is examined. One important aspect is the suspenseful narrative structure. We can call this a narrative of adultery denied. The story is a kind of paradox, riddle or some other subspecies of joke. 'Did you hear about the man who committed adultery with his wife?' The narrative of this ad can be split in two and summed up as follows. On the one hand a man, with the assistance of his 'nice car', commits adultery. On the other hand a man, with the assistance of his 'nice car', does not commit adultery. The story of the exploits (and exploitations) of (and by) the protagonist driver is overlaid and revised by a reparative narrative of familial solidarity and trust. The ad sets up dilemmas which might strike chords.

As with most adulteries there are (at least) two stories and, also, two worlds. Hence the scenic organisation also offers juxtapositions, oppositions and contradictions which enhance drama and conflict. These oppositions in the imagery can be set out as follows:[1]

underground car park	driveway in sunny country home
darkness/shadow	light/sunshine
vulnerability	security
work	home
open rural	domestic rural
beach (edge)	garden (inside)
black dress	white cotton
adult world	children's garden
individual	family
adultery	marriage
woman	mother
man	father
'show me what it can do'	'daddy, daddy'
woman as body parts	woman as whole
disarray	composure
coming	coming home
sporty performance	family car
indulgence	asceticism
female desire (active)	female desire (covert)

241

Along with these narrative themes and imageries the role of the backing track is of central interest. As well as its role in evoking and isolating a readership's nostalgia it underpins the narrative. The notion of 'sexual healing' condenses two kinds of relationship to the woman in the ad. The woman is offered at once as a source of pleasure and a source of support; as someone to hold (appellation 'baby') and as someone to be held by – the healer/mother. The backing track subliminally predicts and echoes the peculiar dynamic of the ad's plot and the identity play in the relations between the characters.[2]

These concerns are textual. They can (with some licence) be located within the text. But there are also some intratextual considerations at work in this narrative of denial. Doubtless also there exist in the text a raft of significant intertextual allusions. Numerous beach bonks (especially *From Here to Eternity*) spring to mind. However, spotting intertextual moments in contemporary advertising is a little too much like looking for hay in a haystack. What is more important in the final twist away from the simple narrative of sexual conquest and fantasy is an (intratextual) assertion of distinction from the purported mass of other car ads in which man gets fantasy woman thanks to his hot rod. The Peugeot ad acknowledges and participates in this fantasy. However, it does so while simultaneously distancing itself from such a basic 'man gets car gets woman' narrative by the incorporation of a plot twist and by a partial redistribution of the sexual predator role which gives some weight to the woman's desire. This distancing, a kind of 'disavowal' (Bourdieu 1993: 74), contributes to the work the ad does in distinguishing itself and its product from more simple and 'vulgar' narratives and advertising idioms and from advertising idioms employed in other readerships.

THE READER'S DILEMMA

This advert, a very simple play of oppositional worlds, is not read, in any important sense, as a picture of the real world. But if it is not to be seen as a (warped) attempt to depict contemporary married life, to what does the advert refer? One way to answer this question is to insist that adverts such as this are indeed merely badly observed or delusional images of men and women. In such a view of advertising there is every reason to judge its shortcomings. But I think it is worth pursuing another answer, if only for the reason that advertisers cannot ever be expected to set out with the intention of making mini-documentaries.

The literary critic William Empson discusses at length the reading of ambiguous texts. Examining ambiguities in the responses to sexual imagery in poetry he makes some points that are relevant here:

242

some people who think this a beautiful poem are reading it in a very different way from others who would agree with them. And to find reasons for the fact that any particular person reads it in any particular way, that he [*sic*] allows any particular settlement between the two opposite modes of judgement, one would have to know a great deal about him. Indeed the way in which a person lives by these vaguely-conceived opposites is the most important thing about his make-up; the way in which opposites can be stated so as to satisfy a wide variety of people, for a great number of degrees of interpretation, is the most important thing about the communication of the arts.

(Empson 1984: 220–1)

One of the ways of thinking about what ads refer to is to think of their intended readerships. It is interesting to explore the idea that advertisers' presentations of ambiguous texts are addresses to and about the oppositions and conflictual relations to consumption present in the psyche of a readership. Advertisers know something about these ambivalent attitudes towards consumption from market research. There is a skill in speaking to these readerships. As well as using market research, advertising creativity also resides in the operation of a quasi-instinctual sense of what constitutes a felicitous intervention into the symbolic economy of the readership from campaign to campaign. This might be described as a successful assertion of 'cultural capital' (Bourdieu 1993: 24) in the field, a practice informed by a 'feel for the game' (Bourdieu and Waquant 1992: 98). A different vocabulary might call it a kind of 'empathy'.

But empathy with what? If we think of 'readership' as more than a function of media sales calculations, and if we think of consumption as more than just the rational pursuit of rational goals, we must come to a point where we have to consider some other version of the subjectivity and motivation of the consumer/reader. Empson discusses the subject who lives through 'vaguely-conceived opposites'. Later he speaks of 'a clear case of the Freudian use of opposites, where two things, thought of as incompatible . . . are spoken of simultaneously by words applying to both' (Empson 1984: 226). The connection between 'Freudian' ideas, ways of reading and a conception of the subject as constituted in conflict and of textual artefacts which contain such conflicts, towards which Empson hints, is one which can be elaborated here. One way of doing so is with reference to the work of a psychoanalyst whose thoughts seem particularly useful in exploring these aspects of advertising.

The psychoanalyst in question is Heinz Kohut. His work is especially relevant to thinking about advertising and consumption because of its close association with one concept. This concept is narcissism (Kohut

1971, 1987). 'Narcissistic' is the psychoanalytic epithet most commonly evoked in attempts to understand, describe and condemn contemporary consumer culture. Particularly associated with American society (Kohut practised in the US) narcissism is often equated with an unpleasant kind of greedy selfishness, insatiability and an incapacity to feel. Christopher Lasch's writings spell out this critique in detail (Lasch 1979; 1984).[3] Kohut's account of narcissism is of relevance here because it provides some useful terminologies. Before briefly setting out the key concepts needed for discussing the advertising text it is important to point out that for Kohut, in contrast to Lasch, narcissism is not, in and of itself, a pathology or a personality disorder. Whilst pathologies arise with the *disturbance* of ordinary narcissistic structures, these narcissistic structures are necessary for the maintenance of a sense of a self capable of enjoying consistently healthy self-esteem, assertiveness and a sense of sustaining ideals.

The important concept for the purposes of this discussion is that of the 'bi-polar self' (Kohut 1977: Chapter 4) or the 'firm self' (Kohut and Wolf 1978: 414). A brief description of the developmental dynamics operating in the formation of this self feeds suggestively into a sense of how readerships might relate to the kind of double narrative discussed above. As with other psychoanalytic accounts of subjectivity[4] the key lies in the earliest years of life. The bipolar self is made up of two aspects or modes of experience. Kohut calls these aspects the 'archaic grandiose self' and the 'archaic idealising self'. The grandiose exhibitionistic self is a function of an infant's feelings of omnipotence. The infant possesses feelings of being at the centre of his or her own and everybody's universe. He or she is the centre of his or her own and everybody's attention. This sense is corroborated (to whatever extent) by the evidence of a capacity successfully to demand and command a surrounding environment. The hungry baby satisfies his or her appetites. The performances of the child are mirrored in the appreciative gleaming eyes of those around and in what Kohut calls 'baby worship' (Kohut 1987: 62). The baby is enjoying the feeling 'this is me isn't it beautiful' (ibid.). In this dynamic the infant 'attempts to save the original all-embracing narcissism by concentrating perfection and power upon the self – here called the grandiose self' (Kohut 1971: 106). This pole is about *holding*; holding attention, objects, power.

Simultaneously, narcissistic libido is given over to objects outside the infant. This move brings about the 'archaic idealising self'. This aspect of the self comes from feelings of *being held*. The infant, given nourishment, care and protection takes pleasure in this security. The child finds solace against feelings of rage and helpless anguish. The child finds his or her own strength in, and out of, the strength and perfection of his or her parents/care givers (and other objects). Kohut describes the process in

these terms: 'the psyche saves part of the lost experience of global narcissistic perfection by assigning it to an archaic rudimentary (transitional) self-object' (Kohut 1971: 37).

Greenburg and Mitchell designate these aspects (grandiose and idealising) as follows. The former says, 'I am perfect and you admire me' and the latter, 'You are perfect, and I am part of you' (Greenburg and Mitchell 1983: 354). These represent the basic articulations of the child's primary narcissism. In the adult the bipolar self might simply be described as a configuration of the personality which demonstrates some relation to the residual developmental dynamics which exist between feelings of holding and being held and between having held and having been held. It can be described as some enactment, interplay and embodiment of formative experiences of activity and passivity, strength and dependence, centrality and isolation. These experiences need to be seen as functions of a sociocultural as well as a familial environment, especially when applying these terms in an account that is concerned with the reception of cultural forms such as advertising.

Maintenance and coherent disposition of the self come to be a function of the actions and interactions of and between these aspects of the self in relation to the world and to other objects. In their 'archaic' states the aspects of the bipolar self retain a distinct flavour of unreality. Manifestations of the archaic or primitive aspects of the self's early narcissistic formations in adult life tend to produce inappropriate, antisocial and unhealthy character traits. These are pathologies of narcissism. The watering down of these archaic aspects of early narcissism occurs within a process which Kohut calls 'transmuting internalisation' (Kohut 1971: 106). This is described as follows: 'Under the best circumstances there is a bit by bit transformation of self and object images from the more global and archaic to the more complex and resilient' (Greenburg and Mitchell 1983: 354). For the purposes of this discussion I want to argue that the consuming self is constituted in and by this developmental dynamic. This self contains complex and resilient unconscious formations of complementary and/or contradictory unconscious needs. One pole can be called the 'pole of ambition', the other, the 'pole of ideals' (Brooks Bousson 1989: 15). This formation makes for a tension. Kohut calls this the 'tension arc'. To summarise, the activities of the self can be described in the following terms:

> (1) one pole from which emanate the basic strivings for power and success; (2) another pole that harbours the basic idealised goals; and (3) an intermediate area of basic talents and skills that are activated by the tension-arc that establishes itself between ambitions and ideals.
>
> (Kohut, cited in Brooks Bousson 1989: 15)

245

NAUGHTY BUT NICE CAR

Holding this account of the psyche of the reader in mind it is possible to see how the textual analysis of the Peugeot 306 advert refers to the readership. The ad does not determine a response. Instead it incites fantasy around the sales proposition. In this case the basic proposition goes something like this: 'this is an excellent car for a man, perhaps with a young family who, while retaining a liking for a little sporty performance, is mature enough not to lose sight of his responsibilities (and your wife might like it too)'. As one commentator on reading has said, the skill and value of good pieces of writing is 'that for the author they can be called "Conclusions" and for the reader "Incitements" ' (Proust 1994: 30). Instead of simply stating a definitive product profile the text of an advertisement can incite fantasy, speaking to aspects of the self other than the rational workaday 'wide-awake' self in frequent, trivial, forgettable moments of dreamlike attenuation of consciousness (Schutz 1967: 213). As Barthes writes:

> all advertising says the product but tells something else; this is why we must classify it among those great aliments of psychic nutrition ... which for us include literature, performances, movies, sports, the press, fashion; by swathing the product in advertising language, mankind gives it meaning and thereby transforms its simple use into an experience of the mind.
>
> (Barthes 1988: 178)

But why these particular swathes of advertising for this car and for this readership? The key to understanding how the ad works is to see the structure and presentation of oppositions in the ad as playing in and modulating the fantasy life of the readership's bipolar narcissism. This can be set out so that it echoes the presentation of dichotomies in the ad:

archaic grandiosity	archaic idealising
holding	being held
performance	support
potency	vulnerability
'look at me, I am perfect'	'I am part of you'
ambition/appetite	ideals
aggression	restoration
excitement	security

The advertiser is attempting to present a text which offers an optimal relationship between residuals of idealising narcissistic fantasies and exhibitionistic/aggrandising fantasies. It is to be optimal in relation to the composition of the ambitions and ideals of the target audience. This process is less to do with any sense that a target audience is likely to have

certain wishes and fantasies in common. The specific contents of people's fantasies are profoundly idiosyncratic. What is important is the degree of tension evoked between the aspects of the bipolar self in relation to dominant and collective cultural values and ambitions, especially with reference to the idioms of advertising operant within the product field. The ad must use pictures, words and music to provoke and tune in to this tension. It must convey some sense of being on the audience's wavelength. This again is a question of empathy. Kohut writes of games in which mother plays with the child's alternating pleasures of independence and dependency, being held and holding attention, being there and being hidden (his example is peek a boo). Of special relevance here is the observation that at different stages of maturation different degrees of tension and discrepancy need to be evoked. Not tense enough the child is bored, too tense the child is unable to enjoy the conflict. Kohut observes that to play (peek-a-boo)[5] successfully

> an optimal, psychoeconomically decisive, specific level has to be reached. It is different at different stages of development. The important issue is the mother's empathy for gauging just the right moment when the separation from the object has set up enough anxiety to make it blissful to leap to a reunion. ... Art comes to be in the specificity of the point at which such a game must be played.
>
> (Kohut 1987: 49–50)

Advertising can be seen to play with the residual fantasies attaching to such early modes of pleasure. Thus the Peugeot ad may be interpreted as a play of separation and restoration, transliterated into fantasies attached to the appropriate poles of the bipolar self. This play is experienced (in the tension arc) as a minor conflict. The advert places idealising tones/moments and aggrandising or individualistic tones/moments into a satisfying arrangement of dissonance and harmony – perhaps never perfectly resolved.

The work of the advertising creative in transliterating the brief into the final ad involves the organisation and expression (in graphics and copy, film and sound) of competing and perhaps (formally) conflictual qualities and values. The execution of the brief will, ideally, present the reader with a felicitous incitement to re-experience (in the presence of the name of the product) some version of the marketing intention, some good image of the product and some attachment to the image of the product in the unconscious operation of the tension arc. This is to say simply that the ad situates the product in some relation to the (perhaps discrepant) ambitions and ideals of the readership. The ad depicts a transition between two fantasy worlds and two styles of fantasy. The ad attempts to situate the car as the object which can cope[6] with and ease this transition.

READERSHIPS

To attempt is not always to succeed. Whilst success in advertising need not result in any immediate purchase, failure to arouse any interest at all cannot be good (for the advertiser at least). What of all the people who find the ad boring, or crude, or banal? What of all those who don't even notice it? One way of thinking about this might be to propose that the ad, as it is pitched, can only be picked up meaningfully, can only offer pleasure, for a readership whose urges for aggrandisement and idealisation can attach to the imageries in the terms that are presented. Further, the specific tension/resolution dynamic offered by the dramatic text in its '*jeu de contrastes*' (Langholz-Leymore 1975: 78) needs to be appropriate to gain the readership's meaningful attention. To paraphrase Kohut's observation, 'ads come to be the specificity of the point at which such a game must be played' (Kohut 1987: 50). This is where the ambiguity in the term 'readership' becomes important. Advertisers, in trying to get the most relevant audiences for their ads, engage in a great deal of research into audiences and in a great deal of work called 'media planning'. Thus, as most people will have noticed, there are a lot of house-paint ads during sports programmes, and not many ads for children's sweets during the 10 O'clock News. Within the various scales of variables available to demographic analyses there remains a lot of latitude. Common readerships (for example, all people who watch the Cup Final) in the demographic sense may have far less in common with each other, and with the target consumer profile, than advertisers may wish. There is a danger, as it were, of playing peek-a-boo with an audience that finds such a game absurd. So in order to address the intended audience successfully the advertising message must do more than simply cross the relevant fields of vision as many times as possible with a bland appeal attempting to satisfy all sections of the audience. This is why what is called creativity in advertising increases in importance. For it is through the creative and the

Table 14.1 Basic product specification for the Peugeot 306, Renault Laguna and Volkswagen Passat

Car	Peugeot 306	Renault Laguna	Volkswagen Passat (Estate)
Lowest Price	£9,445	£10,570	£12,000
Size	small medium	medium	upper medium estate
Power	1.3l–1.8l	1.6l–2.0l	2.8l
Car Class	B/C	C	C/D (estate)

Source: Autocar magazine, 1994
Note: Only lowest price is shown; car class letter codes refer to the labels used by market analysts Mintel

aesthetic that the advert can speak best to its intended readership in the second important sense: namely, 'readership' as a set of dispositions, interpretative competencies and (sometimes unconscious) anxieties, needs and attitudes regarding consumption.

This can be illustrated by means of an analysis of two further advertisements both of which utilise the adultery theme, and which modulate the basic adultery narrative in a manner which speaks to slightly different readerships. Some basic preliminary product and market information is of use in order to put the analysis in context (see Table 14.1). The aim is to establish correspondences between product specification, likely target markets and the modulation of different kinds of narcissistic impulses in and by the advertising rhetoric. A brief description of the Laguna and Volkswagen adverts will assist analysis. First a look at the Laguna advert, set in and around Paris, and then the Volkswagen advert, which takes place in an indeterminate modern corporate environment.

Laguna

SCENE: *A husband is with his wife at the station. They are saying goodbye with a rushed and commonplace kiss as the clock ticks. He hurries to part. She's gone – we see an enigmatic smirk from the husband.*

SCENE: *He is then seen driving out of the dark station car park, alone, purposeful.*

SCENE: *He is meeting the New York flight. We see the airport, a plane is arriving. We see some prettily crossed legs. These herald the arrival of another young woman.*

SCENE: *He is embracing this other woman. A kiss? The moment is edited out. Is she his lover? Probably.*

SCENE: *They drive to a five-star (French) country hotel (conventional site for illicit affairs). They walk together into the hotel.*

SCENE: *Some time later he emerges. The other woman waves him an affectionate goodbye from a bedroom. All the evidence points to an affair.*

SCENE: *He meets his wife off her arriving train just in time. They exchange looks. She knows something is up. He drives her to the same hotel where he and the other woman had been together.*

SCENE: *The wife is happy, a surprise romantic trip. But he gently disentangles himself from her grateful clasp. Is the adultery to be revealed? Is this to be a showdown?*

SCENE: *The wife is delivered into a room full of excited women. Part party, part harem. All the secrecy was in the service of a surprise celebration for his wife. The women wave gratefully to the departing hero. He has brought them all great satisfaction, but of a kind more*

249

noble than first we thought. The great lover is proven to be, above all, the great husband.

SCENE: *But wait, his innocence once more is in doubt. A further woman waits to be met. Is this another guest or the partner in an ingenious assignation? Husband beyond reproach or master adulterer? We are left this ambivalence.*

The slogan is, 'It's all worked out beautifully'. Of what is this 'it' the pronoun? The linguistic and the narrative indeterminacies conceal ambiguity. We can play with the choices between either a kind surprise or a cunning scheme. 'It has' or 'It is' worked out beautifully. The party or the affair.

Only the man is in control of these answers. The specially composed background music enhances the suspense and the revelations of the action.

Volkswagen

SCENE: *An executive in a cartoon bright modern office is busy at work and is the centre of the attention of all the female staff.*

SCENE: *The Japanese[7] receptionists eye him. He passes them by.*

SCENE: *A young female executive (a colleague) attempts to seduce him. He doesn't fall for her charming ploys.*

SCENE: *Finally his female boss tries to win him over. He is able, easily, to refuse. He receives flirtatious offers from all around, throughout the hierarchies of the corporation. But, like Odysseus tied to his mast, he is able to deny all advances.*

SCENE: *Cut into the series of flirtations we see shots of the mysterious female driver of a Volkswagen Passat Estate negotiating the traffic.*

SCENE: *Now the young man has left work. We see he has bypassed the women in the office to be with the driver of the car. But the moment of drama comes when he turns to the back seat of the car to greet his two children. We see that he has not chosen one woman over the others; he has chosen the mother of his children and a family. In the background Frank Sinatra sings 'Your eyes are bluer but they're not truer, Sorry but I'm going to have to pass'.*

These ads, along with the Peugeot 306 ad which has been examined in more detail, share an interest in the idea of adultery. When looked at together their treatments of narratives of adultery differ from one another in significant ways. All the ads offer a kind of double narrative (and contrastive environments) working between committing adultery and commitment to marriage. But the degree of tension between these narratives in each ad is different.

The Peugeot ad offers the most violent resolution of the tension. The driver is, for a moment, definitely an adulterer who has explicitly and intensively transgressed. And then, suddenly, he is absolutely not an adulterer. The transgression of the marriage and then its reparation is explicit and almost definite. Though nothing is ever *utterly* certain. The two worlds of the drama and the two poles of the readership violently clash before equilibrium is reinstated.

In the Renault Laguna ad the driver seems to be an adulterer. At one moment this transgression appears to be more than likely, perhaps even beyond reasonable doubt. But we see nothing. All evidence is circumstantial When he is exculpated at the moment of the revelation of the party it is not our certainties that are challenged but our suspicions. Likewise his exculpation is not so entirely secured. As the ad ends with a new enigma some of the dichotomy and tension between great lover and good husband is re-evoked. However, the violence and the extent of revelation and resolution is never so intense as in the ad for the Peugeot 306.

In the Volkswagen ad the adulterous narrative is most muted. The protagonist is only ever momentarily implicated in world of the adulterous impulse. The other women offer the hint of a risk. However, the jeopardy is never strong. We are increasingly convinced that flirtation is the beginning and the end of these encounters. The man's serial denial of temptation is perhaps at first seen as ambitiously motivated – working up the office hierarchy. But the story pattern makes a different kind of crescendo. His final object choice transcends the work-bound realm of office romance and vulgar metropolitan flings. He escapes into the arms of his wife, the bosom of the family and the seats of a large estate. He relinquishes the power strivings of work and exchanges them for the familiar idyll of the nuclear family. This ad, more clearly than the others, offers an unambiguous celebration of security and a far less fraught renunciation of aggrandising pleasures.

This analysis should make clear that the car advert narratives which deny adultery and other aggressive impulses do so with different intensities. These varying inflections can, I hypothesise, be correlated to the differing readerships addressed by the advertisers and, relatedly, to the different product characteristics of each car (see Table 14.1). The Peugeot 306 offers the ad with the most manic drama and resolution in its text. This mode of appeal is suitable for a young readership with less integrated and more fraught tensions between ambitions and ideals. The transitions to full adulthood[8] are only just secured. There remains a flavour of adolescent anxiety and waywardness, as well as a hint of the adolescent's proneness to idealise. All in all, in this life-world, socially and culturally, things are more at odds, at once more certain and more uncertain than in a more mature milieu. To sell a car here requires an aesthetic which chimes with such a relatively turbulent inner world.

The Laguna on the other hand, being a little larger and more powerful, and being a little more expensive, is represented through a more subtle aesthetic. This world is calmer and less exciting. Tensions survive, but less assertively. The readership addressed here is more mature, more entrenched in a socio-cultural trajectory, more secure and managed. The aggressive urge survives, however it is more integrated with real opportunities for responsibility and control (hence the obsession with clocks in the ad described here, an echo of *carpe diem* but also, contrastively, a pleasure in orderedness) and a sense of the pleasures of security.

The Volkswagen is the largest and most expensive of the cars. This ad is for an estate version, which pushes it even more towards the settled side of things. The desire to embrace the family as the seat of all that is good (present in all the ads) is given its strongest assertion here. The realms of performative success, while still important, must take their place alongside a mature responsibility to family, fatherhood and security.

These ads speak to a fantasy life. As stated before they are little or nothing to do with depicting the real world. Instead they are rhetorical interventions designed to situate the cars within a system of relative distinction in the projective system of goods. Thus there is a dual dynamic at work in this address to readership. At the level of psyche and at the level of the social there is the assertion of relative styles of maturity and relative compositions of social, cultural and economic capital. This is achieved by the ads standing as different and differentiating compromise formations, articulating strategies for coping with competing unconscious desires for aggression and security. In another language it might sometimes be possible to talk about the adverts offering competing degrees of compromise between vulgar, conspicuous consumption and the sophisticated or pragmatic discernment of appropriately sublimated taste.

This mode of analysis probably raises more questions than it answers. However, it is part of the move away from direct textual analysis towards a text-based consideration of what different readerships make of advertising. These questions can be approached in other ways, notably ethnography and also market research (as demonstrated in other sections of this book). However, it is hoped that the analysis has demonstrated that the text/reader dichotomy need not entirely dictate approaches to research into advertising and that to consider either pole of the dichotomy in isolation misses opportunities to understand the operation of advertising more fully as cultural and social communications whose merits or demerits are contingent upon the specific social locations of readerships.

NOTES

1 For an interesting structuralist and anthropological analysis of textual oppositions in advertising, see *Hidden Myth* by Varda Langholz-Leymore, 1975. She refers to an advert for a ready-made curry as explicable in terms of an opposition or *'jeu de contrastes'* (Langholz-Leymore 1975: 78) between the sacred and the profane.

2 For a full discussion of the recent increases in use of popular music backing tracks see Blake, 'Listen to Britain', this volume.

3 See for instance Chapter 1 of *The Minimal Self* entitled 'Consumption, Narcissism and Mass Culture' (Lasch 1984: 21–59). See also Richard Sennett, *The Fall of Public Man*, especially Chapter 14 (Sennett 1993: 313–340).

4 For instance, Lacanian theory talks about the infant and the 'mirror stage' as central to the formation of a sense of social or cultural identity. This idea is fundamental to Williamson's argument in *Decoding Advertisements* (Williamson 1978: 60).

5 Peek-a-boo plays on separation anxieties. Kohut refers to other games enervated by other anxieties, such as disintegration anxieties. His example in this case is 'This little piggy' which ends, after some excitement, with the little piggy (like our driver) coming home from market. Kohut writes, 'The corresponding game in terms of self-cohesion and self-fragmentation is "this-little-piggy-went-to-market" ... if you play this game with an older child he thinks you are absurd. If you play it with a very small child, again you are absurd. ... But if you play it at the right time, and if you play it with the right kind of empathy for the child, then what do you do? You take him apart toe, by toe, "This little piggy, this little piggy, this little piggy" ' Finally when the child, with excitement and anxiety has been all taken apart, what comes then? The mother embraces the child and ... the child is put back together again, united with himself and with the idealized mother in a blissful experience of being a selfobject all in one.' (Kohut 1987: 50)

6 'Cope' is a suggestive and ambiguous word in this context. It can mean either to bridge two discrete objects, as a coping stone secures two bricks. It can also mean to cover up, 'to furnish with a cope' a cloak or a disguise.

7 Volkswagen advertising maintains a habit of making renunciations of things Japanese in their ads, most famously in their 1980 campaign for the Golf in which a Japanese car salesman admits the success of VW cars amongst the Japanese.

8 For two relevant and interesting discussions of the relations between driving, maturity and adolescence see published market research reports by Menzies Lyth (1989: 124) and by Dichter (1960: 303). Menzies Lyth writes, 'The driver's dilemma describes the psychological conflict that faces drivers. On the one hand driving offers a unique combination of pleasure and satisfaction, on the other hand these can be realized only by entering a situation fraught with dangers, real dangers that in turn arouse unconscious phantasy. ... To realize the positive opportunities in driving, the driver has to find ways of keeping his conscious sense of danger and anxiety at a tolerable level.' Dichter's report indicates that 'there is a relationship between car history and life history. A car owned in a certain life period reflects the psychological characteristics of that life phase. It is interesting, therefore, to study the characteristics of different life phases; in other words to find out how youth is psychologically different from maturity.'

REFERENCES

Barthes, R. (1988) *The Semiotic Challenge*, Oxford: Blackwell.

Bourdieu, P. (1993) *The Field of Cultural Production*, Oxford: Polity.

Bourdieu, P. and Waquant, L. (1992) *An Invitation to Reflexive Sociology*, Oxford: Polity.

Brooks Bousson, J. (1989) *The Empathic Reader: A Study of the Narcissistic Character and the Drama of the Self*, Amherst MA: University of Massachusetts Press.

Dichter, E. (1960) 'Appendix II: The Psychology of Car Buying', in E. Dichter, *The Strategy of Desire*, London: Boardman.

Empson, W. (1984) *Seven Types of Ambiguity*, London: Hogarth.

Greenburg, J. and Mitchell, S. (1983) *Object Relations in Psychoanalytic Theory*, Cambridge MA: Harvard.

Kent, R. (1994) *Measuring Media Audiences*, London: Routledge

Kohut, H. (1971) *The Analysis of the Self*, New York: International Universities Press.

Kohut, H. (1987) *The Kohut Seminars on Self-Psychology and Psychotherapy with Adolescents and Young Adults*, London: Norton.

Kohut, H. and Wolf, E. (1978) 'Disorders of the Self and Their Treatment', *International Journal of Psychoanalysis*, 59, 413–25.

Langholz-Leymore, V. (1975) *Hidden Myth: Structure and Symbol in Advertising*, London: Heinemann

Lasch, C. (1979) *The Culture of Narcissism: American Life in an Age of Diminishing Expectations*, London: Norton.

Lasch, C. (1984) *The Minimal Self: Psychic Survival in Troubled Times*, London: Norton.

Menzies Lyth, I. (1989) 'Safety on the Roads: Two Papers', in I. Menzies Lyth, *The Dynamics of the Social: Selected Essays*, London: Free Association.

Proust, M. (1994) *On Reading*, London: Penguin.

Richards, B. (1994) *Disciplines of Delight: The Psychoanalysis of Popular Culture*, London: Free Association.

Schutz, A. (1967) 'On Multiple Realities', in A. Schutz, *Collected Papers*, vol. 1, The Hague: Martinus Nijhoff.

Sennett, R. (1993) *The Fall of Public Man*, London: Faber.

Williamson, J. (1978) *Decoding Advertisements: Ideology and Meaning in Advertising*, London: Marion Boyars.

Part V

READERS AS PRODUCERS OF MEANING

15

LEAKY BOUNDARIES
Intertextuality and young adult experiences of advertising[1]

Stephanie O'Donohoe

Much discussion of advertising's intertextual nature has focused on ads themselves. This paper explores it from the perspective of young adults, based on a broader qualitative study of advertising experiences among Scottish 18–24-year-olds. It discusses how their descriptions and experiences of particular ads shaped and were shaped by their experiences of other texts. The implications of the blurred boundaries between advertising and other communication forms are then considered for perceptions of advertising's pervasiveness, the development of advertising literacy and the relationship between ad and brand consumption.

ADVERTISING INTERTEXTUALITY

The term 'text' is derived from a Latin word meaning 'to weave', suggesting that texts are created from the weaving of many threads (Graddol 1993a). The concept of intertextuality emphasises this interdependence of texts, both in terms of encoding and decoding. Thus, Berger (1991) defines it as the conscious or unconscious use in one text of material from others, while Cook (1992) discusses how meanings generated from one text are determined partly by meanings taken from others. This is consistent with postmodern theories of language, which focus on how meaning is generated 'ephemerally and precariously' from the interaction of texts, contexts and the social activities of individuals (Graddol 1993b). Similarly, for post-structuralists, meaning exists in the surface of an ever-changing web of signs, constructed from second-hand words and images. These derive meaning from the 'free-play of the signifiers', or the ways in which they shimmer against each other and their previous contexts (Scott 1992: 597).

According to Fiske (1989a, 1989b), popular culture is particularly intertextual: popular texts have 'leaky boundaries', flowing into each other and everyday life, and they cannot be understood without this context. This

seems especially true of advertising. As Wernick (1991) notes, the signs, conventions and values of ads are drawn from the common cultural pool existing in a society at particular points in time. These signs may be reworked by advertising and fed back into other cultural forms, a process facilitated by increasing institutional ties between advertising, commercial media and mass entertainment: as Jensen (1991) puts it, conglomeration breeds intertextuality. Indeed, according to Leiss et al.,

> The substance and images woven into advertising messages are appropriated and distilled from an unbounded range of cultural references. Advertising borrows its ideas, its language and its visual representations from literature and design, from other media content and forms, from history and the future, and from its own experience. ... The borrowed references are fused with products and returned to cultural discourse.
>
> (Leiss et al. 1990: 193)

The fusion of advertising and art discourses has received particular attention. Nava and Nava (1990) and Davidson (1992) discuss how advertising has appropriated and indeed developed forms, techniques, ideas and even personnel from other art forms such as photography, cinema, video, pop music, comic strips and radio or television programmes. Indeed, as Davidson observes, there is hardly an element of 'fine art' that advertising has not appropriated for itself. In this context, Caudle (1989) offers a detailed account of how ads appropriate forms and styles from paintings. According to Berger (1972), ads quote particular works of art to imply both wealth and spirituality, imbuing products with a sense of luxury and cultural value. Similarly, Williamson (1978) points out that while appearing to transcend social distinctions, recognised works of art provide a distinct set of easily understood social codes for audiences to use in interpreting ads.

Some might agree with Fink (1994) that advertising has become an art form in its own right, but others see the link between the two as problematic. Richards (1986) sees it as the 'noxious slug' of commerce crawling over the delicate 'flower of beauty', while Goldman focuses on the tensions surrounding the use of art in ads:

> When art invades advertising it opens a contested terrain, a space in which the hegemony of commodity discourse is momentarily disclosed and challenged. But art is also swallowed up by the commodity form – instrumentalized into another marketing ploy aimed at expanding the commodification of desire.
>
> (Goldman 1992: 166)

As Nava and Nava (1990) point out, works of art are fundamentally derivative; with advertising, however, the appropriation and reworking of ideas is overt and even celebrated. In this sense, Cook (1992) describes

258

advertising as a 'parasitic' discourse, almost to the extent that it has no separate identity. Rather than criticising it for this, he uses Lévi-Strauss' notion of 'bricolage' to explain the borrowing and interweaving of other discourse types in advertising. Denigrating this process, according to Cook, implies a misguided belief in 'the possibility and the virtue of original and autonomous discourse' (ibid.: 34). This echoes Barthes' (1971: 160) comment on the 'myth of filiation', in that 'the citations which go to make up a text are anonymous, untraceable, and yet already read: they are quotations without inverted commas'.

As advertising has become more pervasive, Wernick (1991) argues that it has become recognised as a point of cultural reference in its own right. In this context, Cook (1992) distinguishes between intra- and inter-discoursal allusion in advertising, noting how ads often assume knowledge of other ads or discourse types such as film. As ads draw on and make explicit reference to other ads, their meanings become interdependent among themselves. Thus, the process of communication becomes self-conscious and self-referencing, leading to a situation described by Goldman and Papson (1994) as 'intertextual inbreeding'. As a result of interdependence within advertising and between advertising and the media, Wernick (ibid.: 121) argues that 'to be caught up as a cultural consumer in the vortex of promotional signs ... is to be engulfed, semi-otically, in a swirling stream of signifiers whose only meaning in the end is the circulatory process which it anticipates, represents and impels'.

Nonetheless, individual consumers are still required to create some meaning from ads, however provisional it may be. There are several accounts of this process of meaning creation. Thus, Barthes (1964) distin-guished between the denotative or literal image, and the connotative or symbolic image. He pointed out that the range of possible connotative readings is due to individual differences in practical, national, cultural and aesthetic knowledge. As ads use external and socially situated codes, concepts and myths, they are bound up with and construct ideology. Similarly, Williamson (1978) discusses the 'overt' and 'latent' meaning in ads. She argues that for latent meaning to be generated, the significance of one object has to be transferred to another. This process of meaning transfer can only be accomplished by an ad's audience: it does not take place within the ad itself. Furthermore, one object has to be meaningful, to be part of the audience's reservoir of social and cultural knowledge (Leiss et al. 1990), if its significance is to be transferred to another object. Likewise, McCracken (1986) argues that ads juxtapose consumer goods with representations of the culturally constituted world, relying on audi-ences to make the connections, imbuing products with cultural meaning. He emphasises that in the process of meaning transfer, the audience is the final author, whose participation is essential. Mick and Politi (1989: 85) discuss 'the hell of connotation' involved in examining the range,

complexity, inconsistencies and idiosyncrasies of consumers' advertising interpretations. Nonetheless, Mick and Buhl (1992) present a meaning-based model of advertising experiences, and apply it to the interpretations given to selected ads by three brothers. They use this to demonstrate that consumers experience ads and construct meaning from them in ways which are intertwined with their personal life histories, life themes and life projects.

Overall then, advertising seems to be a rich and complex signifying system, drawing on many other texts and discourses. Furthermore, its meanings are activated by the participation of its audience, whose inter-pretations reflect their own experiences, social situation and concerns. This chapter seeks to explore these issues from the perspective of a young adult audience.

THE PRESENT STUDY

The discussion of advertising intertextuality which follows is derived from a broader qualitative study of the relationship between 18–24-year-olds and advertising. Not only do young adults represent a lucrative market for many advertisers (Mintel 1990) they also have a particularly sophisti-cated understanding of advertising (Gordon 1984; Nava and Nava 1990). Furthermore, much advertising deals in images of personal identity and social relationships, and these are issues of great concern to young adults. Therefore, we might expect young adults' relationships with advertising to be especially interesting, and perhaps of broader significance. Davis (1990), for example, argues that cultural changes originating with this age-group often find their way into mainstream adult culture.

This study set out to understand and offer a 'thick description' (Geertz 1973) of young adults' experiences of advertising. It was assumed that those experiences would be socially constructed and bound up with their everyday lives. Therefore, the study was conducted in the tradition of audi-ence ethnography (Moores 1993), seeking to explore the 'infinite, contradictory, dispersed and dynamic practices and experiences ... enacted by people in their everyday lives' (Ang 1991: 13). The research used a combination of small group discussions and individual interviews, with the tape-recorded part of the discussion generally lasting between one and a half to two hours. Doubts have been expressed about the extent to which such methods of audience research may be considered ethno-graphic (Radway 1988; Nightingale 1989). However, given the perva-siveness of advertising, the many media in which it is encountered and the often private nature of its immediate consumption, it was thought that these methods offered a practical way to begin exploring advertising expe-riences. Small groups (usually involving four participants) were used for the benefits of social interaction and idea stimulation, while still allowing

individual comments and interpretations to be pursued. Individual interviews were used to allow more detailed exploration of personal experiences and interpretations.

Following Glaser and Strauss (1967), an attempt was made to develop grounded theory, emerging from and illustrated by the data collected. This calls for the joint collection, coding and analysis of data in so far as is possible, and a constant comparative method of analysis. Given the emphasis on grounded theory, it would have been inappropriate to impose a set of ads for discussion. Instead, informants were encouraged to describe their experiences of advertising in their own words, in their own way and with their own examples. They were asked to describe ads which they liked, disliked or remembered for any reason, and from any time or medium. Subsequent discussion emerged from and built upon their own experiences and descriptions of ads. In keeping with the ethnographic tradition, the young adults were treated as 'informants' rather than 'respondents' (Spradley 1979), reflecting the attempt to ground the study in their language and culture, rather than those of the researcher.

In order to address a range of experiences, age, gender and occupational status, quotas were used. Given the difficulties of measuring young adults' occupational status (Francis 1982), informants were simply classified as unemployed, students or workers; among the older workers, with one exception in the pilot study, graduates and non-graduates formed separate groups. This provided some approximation of current buying power and future prospects, both of which may help to shape advertising experiences. The pilot study involved four small group discussions and two individual interviews. The main research, conducted in Edinburgh in 1991, involved fourteen groups and fourteen individual interviews, with informants located by a professional recruiter. In total, eighty-two young adults participated in the research.

INTERTEXTUAL EXPERIENCES OF ADVERTISING

The young adults taking part in this study were clearly 'advertising literate' (Meadows 1983: 413): they demonstrated a sophisticated understanding of advertising strategies, styles, conventions and imagery, and often discussed these using the industry's specialist terminology. They also approached advertising with a great deal of ambivalence. They saw it as something to be enjoyed and endured in almost equal measures, and they expressed both a sense of immunity and vulnerability with respect to its persuasive powers. Informants also treated advertising as a distinct entity, yet one which flowed easily into other communication forms. Thus, it was described as 'very entertaining in its own right', with its own history and cultural identity. In this context, someone regretted having missed a screening of television ads:

I believe down in London last summer – I missed it and I really wanted to see it – the National Film Theatre was showing seven and a half hours of the best adverts of all time, constantly. Maybe an hour, and then a quarter of an hour break ... I think that would have been brilliant. They had all the famous adverts of all time, all the early Hamlet ones, all the Guinness ones.

(male students 21–24)

The willingness of an institution such as the National Film Theatre to screen seven and a half hours of ads suggests an appreciation of advertising as a distinct cultural form. This is highlighted by the student's view of what the event would be like. There is a certain irony in the idea of taking a break from a screening of ads: such an arrangement must represent the ultimate accolade for material created for a commercial break. Furthermore, references to 'classics', 'famous adverts of all time' and 'the early Hamlet ones' suggest that advertising is seen as having more than a transient existence.

Many informants described ads in similar terms, and there was considerable discussion about ads and advertising styles from the past, and indeed from other cultures. Informants often distinguished between Scottish, English and American ads, for example, and had enjoyed watching programmes such as those presented by Clive James or Jasper Carrott that showed ads from other countries. At the same time, the young adults' experiences of ads were inherently intertextual. They described advertising in terms of other cultural forms, and discussed how their experience and expectations of particular ads were shaped by knowledge of the source material. They were also well aware of how advertising was recycled in other forms of popular culture. These issues are discussed in turn below.

Descriptions of ads in relation to other texts

Informants' descriptions of ads often drew on knowledge of the world beyond advertising. Their references to the inspiration for ads may be categorised using Cook's (1992) distinction between intra- and interdiscoursal allusions, as ads were thought to draw on other ads as well as films, television programmes and so on. When informants referred to ads evoking knowledge of other ads, they tended to mention imitations or parodies. For example, the Gordon's Gin ads featuring a plain green screen were 'trying to copy the cigarette adverts, this surrealist approach'. In keeping with the 'sign wars' described by Goldman and Papson, (1994: 40) they often discussed parodies of particular ads or advertising styles, such as Harp's 'rip-off' of the first Gold Blend ad featuring the 'yuppie couple', Hamlet's 'having a go at' the ads for Milk Tray chocolates, or

262

Irn-Bru's 'taking the mickey' out of the traditional cola approaches. As one informant put it, 'It's funny when you get an advert like that Gold Blend one, but then you get a spoof on it. Other adverts taking off other adverts . . .' (male workers, 21–24, mixed). There was even an example of Wernick's (1991) self-conscious and self-referencing intertextuality: an ad for the Royal Bank of Scotland was described as 'taking the mickey out of themselves', as it showed 'the actual advertisers trying to make up an advert'.

Other cultural forms were also recognised as sources of ideas for particular ads. For example, informants identified music 'taken' by ads and used to build an atmosphere or tell a story. 'That advert with the Strollers, the sweeties. That's from Black, and I love that record. I think it's good for the advert, it's really sort of exactly how the guy's walking, he's just sort of sauntering along, and that's what the record's like' (unemployed females 21–24) Consistent with Unwin's (1982) discussion of 'transferred style', informants also recognised films, television programmes and various genres as the source of ideas for ads. 'Big glossy productions' were thought to have 'a sort of filmy look'. Indeed, describing a lager ad with very complex imagery, someone commented, 'It's a very serious movie actually. Movie – what am I talking about? Advert!' (male worker 18–20). Others drew on knowledge of specific films in describing particular ads. Thus, there were many references to the use of the two characters from *The Blues Brothers* in ads for Tennent's Special. Similarly, a Marlboro magazine ad was compared to a scene in *Casablanca*, and one for Budweiser beer was described as invoking *King Kong*: 'It was King Kong, but instead of clinging to the Empire State Building, it was clinging to a bottle of Budweiser. It was really smart. It was exactly like the film . . .' (male workers 21–24, mixed).

Turning to television formats, the Gold Blend ads were compared to 'soap operas' or 'mini-series', while ads for Red Rock cider were 'done in a sort of detective spoof sort of way'. The Lurpak ads featured a claymation figure based on 'wee Morph that used to be on Tony Hart's *Take Hart*', a children's art programme. It was also suggested that Jeremy Beadle's candid-camera style television programmes had inspired Radion's 'home video' ads.

The world of art was also mentioned as a point of reference for ads. For example, a student referred to an ad as 'multiple repeated images, Andy Warhol style'. Similarly, a Persil poster looked like a painting 'in Gauguin style', and there was some discussion of a Guinness ad in which the actor Rutger Hauer was 'going through the Old Masters', taking bits from paintings by 'Van Gogh and all that'. Print formats and genres were also mentioned as a source of ideas for advertising. Thus, a Tetley tea ad was designed to look like a problem page in a magazine, and a Kit-Kat ad borrowed the Andy Capp cartoon character. There were even some

references to Shakespeare: someone liked an ad which featured 'the three witches from Macbeth', and another talked about a 'Hamlet character' kicking a skull about.

Experiences of ads influenced by knowledge of other texts

Experiences of particular ads often seemed coloured by knowledge of other texts. Thus, at what Cook (1992) would call the intra-discoursal level, experience of one ad sometimes enhanced or detracted from their appreciation of another: 'I used to think the Coke one was a brilliant advert. When you saw the Irn-Bru ones you saw the funny side of it' (unemployed females 21–24).

Such influence was not limited to parodies. Wernick (1991) and Goldman (1992) discuss how ads in a campaign may assume knowledge of earlier executions. In this context, particularly in relation to cigarette ads, there were several comments along the lines of 'if you didn't know what it was, you wouldn't know what it was'. A Guinness ad which deviated from the campaign's conventions was described in a similar way:

> He's sitting in a really loud bar and there's lots of colours going around and he's wearing a jazzy outfit with a huge cocktail, and he goes, 'Don't worry, it's just a nightmare'. And if you didn't know about the other adverts, you'd think, 'What is he talking about? What is he advertising here?'
>
> (male graduate worker 21–24)

Experience of texts beyond the world of advertising also influenced the young adults' experience of ads. Thus, a student described how the Hamlet World Cup ad was 'just so perfect', and 'really funny', as it interrupted the actual football matches which she found boring. Others had enjoyed seeing the Blues Brothers 'carrying on' in the Tennent's Special ads, although some did not like to see the film appropriated to give the beer 'a young image'. The effectiveness of Nick Kamen, the star of the Levi's 'Launderette' ad, was undermined for some informants by his appearances elsewhere: 'When you first saw him on the advert you think, "oh, he's really nice". And then when you saw his picture in the *Jackie* you thought he was a bit girly-looking' (female workers 21–24). Or 'Nick's thick [laughter]. He was on *The Tube* or something. They had answers written out ... they asked him question number five and he answered answer number four' (male graduate workers 21–24).

As Nava and Nava (1990) note, when experienced actors make ads, they not only draw on theatrical skills and conventions but also bring with them identities from other performances, which may enhance certain ad meanings. This was well understood by informants. They often categorised

ads featuring celebrities according to the degree of 'fit' between the endorser and the product or brand, based on a knowledge of what the celebrity represented beyond the world of advertising. For example, there was much discussion of how Rutger Hauer's film roles resonated with his portrayal of the Guinness man, in that he was 'cool', 'mysterious' and even 'clinical and chilling'. However, an unemployed informant had problems reconciling his Guinness persona with the 'bad man' he played in *The Hitcher* (1986). There was also much talk about 'comedy' ads featuring established comedians. A commonly made distinction was between ads where the comedians 'stick to their own style of comedy', and those where they did not. Thus, Russ Abbot was thought to remain in character for the Castella cigar ads, while Billy Connolly's endorsement of Kaliber low-alcohol lager was thought to present him in unusually subdued form. Indeed, a male student found this endorsement as credible as 'Mick Jagger saying "don't do drugs, kids" '.

The interdependence of music and ads was also discussed in some detail. A male student was greatly amused by the use of Handel's *Water Music* for the water privatisation campaign, and many others talked about enjoying ads which featured well-liked tracks. There was, however, no automatic link between recognising and liking the music and liking the ad which used it. One informant, for example, felt that Tina Turner's status as a 'rock legend' was undermined by her appearance in a Pepsi ad. Others expressed concern about a Clash track, 'Should I Stay or Should I Go?', featuring in a Levi's ad: 'To me that was a brilliant song. . . . But now it's just like, I suppose, a bit of a sell-out. The Clash is supposed to be this punk group that was standing against the establishment' (male graduate workers 21–24).

Ads feeding back into popular culture

Informants were very conscious of how ads fed back into other cultural forms. One way in which they saw this happening was through parody. Several people referred to television or radio programmes which 'ripped off' particular ads. For example, a comedy programme made fun of the ads in which attractive women had sensual encounters with Flake chocolate bars. The sketch featured a man and his 'really fat girlfriend': 'And he's taking pictures of her for a magazine. And he says "look seductive" and sticks a Flake in her mouth. And it goes everywhere!'(female workers 18–20).

Informants had also noticed 'so much media hype' around certain campaigns. There were various comments in this respect concerning the 'Gold Blend couple', where the news that they were about to kiss in the forthcoming ad had been 'splattered' in the papers, even making the front page of some tabloids. Less sensationally, several informants

commented that television programmes such as *Brookside* or *thirtysome-thing* featured characters working in ad agencies. As well as providing subject matter for other texts, advertising was thought to be capable of influencing them. Thus, some informants thought that the Guinness ads had enhanced Rutger's Hauer's film prospects. Many people commented on the success of re-released music when it featured in an ad for Levi's, to the extent that the company could 'dictate what's happening in the charts'.

Experience of ads sometimes appeared to influence informants' own experiences of other cultural forms, particularly in the case of music. For example, a male student commented, 'they put on Mozart, and you'll be going oh, cigars, coffee', and a female graduate worker observed that the classical music used in the Hovis ads 'is the Hovis song now'. Another informant had liked the Clash track prior to its use in the Levi's ad, but, 'I suppose every time I hear it I think of snooker now, and leaning across the table in tight jeans' [laughter] (female students 18–20).

Several people felt that when an ad 'took' music which they had liked, the music tended to get 'overplayed' and became popular with new audiences, which spoiled their enjoyment of it somewhat. This was particularly the case when 'teenyboppers' and 'all these wee kiddies' became interested in bands which informants liked to think they had discovered themselves. More positively, however, a student felt that the use of 'classic' tracks in ads gave them fresh meaning for her. She drew a parallel with the Righteous Brothers' music for the film *Ghost*. Before she had seen the film, 'I heard the song and I thought "I don't really like that, it does nothing for me". Then I went and saw the film and I sort of connected it with the tune. And I thought it was such a nice song after that' (female student 18–20). This last comment is a particularly good illustration of the leaky boundaries between advertising and other aspects of the young adults' lives. The comment addresses how the meaning of a song is changed by its placement in a commercial context, and illustrates this point with an experience taken from yet another cultural form.

Coping with leaky boundaries

As a result of the interdependence of commerce, the media and entertainment, Wernick (1991: 121) sees consumers as 'engulfed . . . in a swirling stream of signifiers' at the vortex of promotional signs. In this study, several comments indicated some confusion at the 'leaky boundaries' between advertising and other cultural forms. An unemployed informant mixed up a short film, *Creature Comforts*, on which the Heat Electric ads were based, with the ads themselves. He was not the only one to confuse ads and other material: a female worker, for example, mentioned reading what she thought was a genuine problem page in a magazine, only to find

that it was an ad for tea. Indeed, one informant was gripped with what might be seen as postmodern panic at the leaky boundaries between popular music and advertising: 'Is it the advert that's advertising the song, or the song that's meant to be advertising the advert, you know? Which way round is it supposed to be?' (male workers 21–24, mixed).

There were, however, many indications that the young adults could cope remarkably well with life at the vortex, working their way through various cross-references and levels of representation. Thus, a male student mentioned in passing that for some 'classic' music tracks, 'what's become the video of the song is the advert'. Someone else described an ad which he had seen on a Clive James programme about advertising:

> It was an American advert, I can't remember, it might have been a toy. And it started off a really boring, long type thing. And then this little duck walked across it. It was like he was invading other people's adverts and they were taking the piss out of sort of stereo-type adverts, and they were using that to promote their own product. I thought that was pretty impressive.
>
> (male graduate workers 21–24)

This informant had no difficulty talking about an ad which he understood to be a parody of other ads, and which he had seen on a television programme taking advertising as its subject matter. It is a pity he did not remember what the ad was for, as this might have really impressed him. It was for Ever Ready's Energizer battery, and the 'little duck' was in fact the battery-operated toy which featured in many of Duracell's ads. Thus, the ad poked fun at stereotyped ads with a character borrowed from its main competitor.

A final example of informants' ease with leaky boundaries is offered by their enjoyment of two ads for Castella cigars. The first ad showed a man fishing. Instead of using a fishing rod, he simply placed a Des O'Connor record on a turntable and lowered it into the water. The record somehow proceeded to play, apparently distressing the fish so much that they leaped out of the water to be gathered up smugly by the fisherman. This ad was recognised as drawing on several other texts. In the first place, informants identified the main character as the comedian Russ Abbot, and associated him with his television series. Furthermore, it was thought that his character in the ad was consistent with his television image, as 'that's the way he entertains'. Second, informants related this ad to others in the Castella campaign, describing how they generally showed the Russ Abbot character devising innovative schemes to make life easier for himself. Third, they recognised Des O'Connor, and appreciated that the ad was making fun of his singing. Thus, some comments tapped into the performer's almost mythic status as the butt of many British light enter-tainment jokes:

- The Russ Abbot ones, you see him fishing and he sticks in a Des O'Connor record and all the fish start jumping about.
- Poor Des, what'll he say about that? [laughter]

(female workers 21–24)

Another Castella ad features Des O'Connor poking fun at Russ Abbot in return, and many informants appreciated that this was a revenge match. One account of the second ad draws on knowledge of the two personalities and their monetary value, the Castella campaign in general, and an earlier ad in the campaign:

the ongoing saga of Russ Abbot slagging off Des O'Connor and his records. The last one, when he's shooting clay pigeons. He's – Russ Abbot takes out a big elephant gun and shoots the things. And you see over the divider, the guy slinging them out is Des O'Connor, with a Russ Abbot record. So they bring out the counter-attack. It must cost them a fortune to hire these celebrities.

(male worker 18–20)

An ability to cope with leaky boundaries does not equate with acceptance, however. One informant echoed the sentiments expressed by Richards (1986), although she spoke more in sadness than in anger:

I mean, sooner or later, even though an idea may be sort of virgin, maybe pure, someone is going to take it and use it to sell something. That's just a fact of life. . . . No matter how you try and keep things secret and sacred and lovely, it just doesn't happen.

(unemployed female 21–24)

ADVERTISING INTERTEXTUALITY, PERVASIVENESS AND LITERACY

The intertextual nature of the young adults' advertising experiences seemed related to their sense of advertising as omnipresent. Many informants referred to the pervasive presence of advertising in their lives. 'You read a magazine, you're bombarded. You read a newspaper, you get advertising. You watch the telly, you've got advertising. You drive your car, you get advertising chucked at you' (male graduate workers 21–24). Or:

- How can you actually stop someone from seeing adverts?
- Blindfold them, deafen them, tie their hands, I dunno.

(male workers 21–24, mixed)

This last comment is particularly telling. Blindfolding and deafening people may well prevent them from exposure to ads, although it is hardly a long-term solution. However, there was a belief that even that would not be enough, that advertising would somehow still seep through into

people's consciousness. The act of tying someone's hands to screen out advertising would achieve nothing, but the very ludicrousness of the idea underlines the futility of attempts to avoid it. This sense of being unable to escape advertising seemed heightened by its intertextual nature, as it could crop up in so many different forms and contexts.

Indeed, the issue of leaky boundaries was considered many times from personal experience as the first draft of this material was being written. In the space of three weeks in March 1993, advertising in one guise or another kept invading what was supposed to be leisure time. While these encounters were obviously noticed by someone sensitised to advertising, none was sought out. During this period, there was a television programme covering an advertising awards ceremony, while various newspaper articles discussed aspects of advertising campaigns by Benetton, Volkswagen and Renault respectively (Chaudhary 1993; Donegan 1993; Hall 1993). A novel bought to provide a break from work turned out to be partly set in an advertising agency (Maupin 1980), and even a visit to the hairdresser provided no escape: Radio One, the non-commercial station, was on in the salon, and a 'news bulletin' reported a trip to America by 'the Gold Blend woman'. An interview with David Bowie in the music press (Sutherland 1993) discussed a reference to Benetton's advertising in the title track of his album *Black Tie White Noise*. When the album was previewed in a Sunday newspaper supplement, the approach to be taken in advertising it was explained, and one track was described as 'not a return to the brass-tacks Sixties nostalgia of "Pin-ups", but a lush reworking influenced by Bobby McFerrin's Cadbury's adverts' (Thompson 1993: 24).

Here again, there is evidence of leaky boundaries: not only does it appear that music from an ad influenced a track in a rock album, but this is discussed in a newspaper article. Finally, a visit to a local card shop highlighted the ways that advertising seeps into everyday life and other texts. The shop stocked a series of cards detailing events which took place in particular years, and several of these contained reproductions of old ads. For example, the 1954 card included a Guinness ad featuring the toucan once synonymous with the brand (apparently that year marked the start of the association). Another card, from a different company, showed a worried couple watching their labrador puppy, which was sitting with its snout close to the television screen, and draped in pink toilet paper (see Figure 15.1). This card's humour relies on people recognising and enjoying the direct reference to the Andrex 'puppy' ads. Furthermore, cards are for sending, so anyone buying the card must also expect those receiving it to appreciate the joke.

The diversity of contexts and media in which advertising was encountered during those three weeks supports the young adults' perceptions of advertising as pervasive. It may also help to shed some light on the

phenomenon of advertising literacy. Goodyear (1991) suggests that it may be influenced by exposure to film and television, as these provide opportunities to learn many advertising conventions. Similarly, Nava and Nava (1990: 16) argue that young adults' critical skills are 'untutored': 'No other generation has been so imbued with the meanings produced by quick edits, long shots, zooms, by particular lighting codes and combinations of sound.'

Figure 15.1 Intertextuality at work: you'll only get the joke if you've seen the television ad.

The present study supports and extends this view of literacy sources. The young adults themselves suggested that much of their advertising knowledge had been acquired by osmosis. While some had touched upon advertising during their formal education – usually in art or English – they appeared to have learned a great deal from observing ads over time, and also from the mass media more generally. In addition to absorbing film and television conventions, they appeared to have learned about advertising from these media in more explicit ways. Indeed, in the encounters described above, there were references to the length and style of ads, the rationale for and history of various campaigns, and the social consequences of advertising. In many cases, specialist industry terms were also employed or explained.

The young adults referred to such learning experiences, with television programmes mentioned most frequently in this respect. Several informants remembered seeing documentaries examining 'how ad agencies work', or topics such as the use of animals or session singers in ads and AIDS advertising across Europe. These programmes had sometimes been noticed 'out of the corner of my eye', but on other occasions, people had actually 'sat and watched them':

> I watched a programme once . . . it was the making of the Volkswagen advert . . . they started off with the sort of phrase at the end of it, 'if only everything in life was a reliable as a Volkswagen' or something like that. And then they had lots of different ideas, you know . . . like unreliable things going on in their life, but they've still got their Volkswagen to drive away at the end of it.
>
> <div align="right">(unemployed male 18–20)</div>

In addition to documentaries, informants mentioned various other programmes as being informative. For example, it was suggested that *Brookside* had 'that advertising woman in it and it's just a mechanism to teach people about advertising . . . in *Brookside*, they have a policy of, they take issues . . .' (male students 21–24). In this context, a few informants referred to an episode of *Brookside* where the 'advertising woman' argued with a male colleague about the sexism of a proposed campaign for a floor mop. There were also many passing references to various magazine or newspaper articles about advertising. Over time, then, it appears that there is indeed scope for people to absorb a great deal of information and ideas about advertising in the course of their everyday actions and general media encounters.

CONCLUSIONS

This study paints a picture of young adults as active, sophisticated and ambivalent consumers of advertising. They communicated a sense of

enjoyment and ennui with respect to advertising, and appeared to feel both immune and vulnerable to its persuasive power. Furthermore, they appeared to see advertising as a distinct yet intertextual cultural form. Thus, they treated it as something which had its own identity and varied over time and across cultures. At the same time, however, the boundaries between advertising and other communication forms were very fluid for them, and their experience of each informed their reading of the others. While a detailed examination of differences in such experiences according to age, gender and occupational status is beyond the scope of this chapter, it is worth noting that all these groups emerged as sophisticated and ambivalent in their relations with advertising.

A sense of leaky boundaries was also evident across the whole sample. This appeared to contribute to the young adults' view of advertising as pervasive and omnipresent, seeping into the fabric of their everyday lives. Davidson (1992: 192) asks, 'what do you do with the fact that culture and commerce are now fully intertwined, that there no longer exists any point in culture safely outside the terms of commodity relations?' Thus, intertextuality may contribute to the young adults' feeling of vulnerability and insecurity with respect to advertising: they were well aware that they could not escape its presence, and this may have undermined their confidence in being able to bypass its influence. In this context, Davidson suggests that advertising's cultural appropriations have also led to its taking over the concept of value. He argues that this has happened intellectually as well as in the marketplace: value has become contingent, subjective and ideologically elusive. Furthermore, he suggests that the strength of the links between culture and commerce has made resistance to advertising seem particularly drab.

Underlining the ambivalence of the young adults' relations with advertising, however, this may not be the case. Nava and Nava (1990) have wondered whether the decoding skills which young people bring to bear on ads may be used to subvert, resist and contest the logic of consumer capitalism. This study suggests some ways in which this could occur. In the first place, by explicitly and implicitly contributing to the young adults' advertising literacy, other cultural forms may provide them with knowledge to use against advertising. Second, as we have seen, informants considered advertising as a cultural form in its own right. Treating ads as distinct entities, they often divorced the selling message from the art form. For example, 'I like the Scottish Amicable advert cos it's funny. But it doesn't make me want to join the Scottish Amicable. I just go "well done, Scottish Amicable, you made me laugh" ' (male student 18–20).

While such sentiments may contribute to the sense of immunity often expressed by this study's participants, it could be argued that such protestations are hollow. However, an examination of the uses and gratifications which the young adults found for ads (O'Donohoe 1994) indicates many

ways in which ads may indeed be consumed independently of the brands they promote. For example, the use of advertising for purposes of social interaction, play or ego enhancement seemed to have very little to do with traditional marketing transactions. This was particularly the case when 'horrendous' ads for products of no intrinsic interest to the young adults acquired cult status, in much the same way as 'B movies' do among film buffs. For example:

- I really love, it's so cheap, the [ad for] Balmore Double Glazing. It's so bad!
- I like the one for Martin's Plant Hire.
- No, oh please no, oh no!
- Oh, it's awful!
- It's quite a good advert. It's just so horrible, that's why I like it.

(female students 18–20)

Indeed, the range of uses and gratifications which the young adults had for advertising were very similar to those identified for the mass media in general (Severin and Tankard 1989; Lull 1990). Thus, the very intertextuality of advertising may enhance its potential to be consumed independently of the brands which it promotes. This form of resistance to advertising – if that is what it is – seems a far cry from the drabness envisaged by Davidson.

NOTE

1 The main fieldwork for this study was funded by the Nuffield Foundation's Social Sciences Small Grants Scheme, and the pilot study by the Faculty of Social Sciences at The University of Edinburgh. The author is also grateful for helpful comments from Robert Grafton Small and Caroline Tynan.

REFERENCES

Ang, I. (1985) *Watching 'Dallas': Soap Opera and the Melodramatic Imagination*, London: Methuen.
Barthes, R. [1964] (1977) 'Rhetoric of the image', in R. Barthes, *Image, Music, Text*, London: Fontana Press (S. Heath, translator), 32–51.
Barthes, R. [1971] (1977) 'From work to text', in R. Barthes, *Image, Music, Text*, London: Fontana Press (S. Heath, translator), 155–165.
Berger, A.A. (1991) *Media Analysis Techniques*, Newbury Park: Sage.
Berger, J. (1972) *Ways of Seeing*, London: BBC and Penguin Books.
Cook, G. (1992) *The Discourse of Advertising*, London: Routledge.
Caudle, F. (1989) 'Advertising art: cognitive mechanisms and research', in P. Cafferata and A.M. Tybout (eds) *Cognitive and Affective Response to Advertising*, Lexington, MA: Lexington Books, 161–218.
Chaudhary, V. (1993) 'Benetton 'black Queen' raises Palace heckles', *Guardian*, 27 March, 9.

Davidson, M. (1992) *The Consumerist Manifesto: Advertising in Postmodern Times*, London: Routledge.

Davis, J. (1990) *Youth and the Condition of Britain: Images of Adolescent Conflict*, London: Athlone Press.

Donegan, L. (1993) 'Still young at heart', *Guardian 2*, 26 March, 2–3.

Fink, G. (1994) 'Originality is essential to creating great advertising', *Campaign*, July 22, 25.

Fiske, J. (1989a) *Reading Popular Culture*, Boston: Unwin Hyman.

Fiske, J. (1989b) *Understanding Popular Culture*, Boston: Unwin Hyman.

Francis, L. (1982) *Youth in Transit: a Profile of 16–25-year-olds*, Aldershot: Gower.

Geertz, C. (1973) *The Interpretation of Culture*, New York: Basic Books.

Glaser, B. and Strauss, A. (1967) *The Discovery of Grounded Theory*, Chicago: Aldine.

Goldman, R. (1992) *Reading Ads Socially*, London: Routledge.

Goldman, R. and Papson, S. (1994) 'Advertising in the age of hypersignification', *Theory, Culture and Society*, 11(3): 23–53.

Goodyear, M. (1991) 'The five stages of advertising literacy', *Admap*, March, 19–21.

Gordon, W. (1984) 'The ads are better than the programmes – so say some of us', paper presented at *Admap* Conference, London, October.

Graddol, D. (1993a) 'What is a text?', in D. Graddol and O. Boyd-Barreti (eds) *Media Texts: Authors and Readers*, Clevedon: Multilingual Matters Ltd., 40–50.

Graddol, D. (1993b) 'Three models of language description', in D. Graddol and O. Boyd-Barrett (eds) *Media Texts: Authors and Readers*. Clevedon: Multilingual Matters Ltd., 1–21.

Hall, J. (1993). 'Forever England', *Guardian 2*, 30 March, 4–5.

Jensen, K.B. (1991) 'Humanistic scholarship as qualitative science: contributions to mass communications research', in K.B. Jensen and N.W. Jankowski (eds) *A Handbook of Qualitative Methodologies for Mass Communication Research*, London: Routledge.

Leiss W., Kline, S. and S. Jhally, (1990) *Social Communication in Advertising*, London: Methuen.

McCracken, G. (1986) 'Culture and consumption: a theoretical account of the structure and movement of the cultural meaning of consumer goods', *Journal of Consumer Research*, 13, June, 71–83.

Maupin, A. (1980) *Tales of the City*, London: Corgi.

Meadows, R. (1983) 'They consume advertising too', *Admap*, July-August, 408–413.

Mick, D.G. and Buhl, C. (1992) 'A meaning-based model of advertising experiences', *Journal of Consumer Research*, 19, December, 317–38.

Mick, D.G. and Politi, L. (1989) 'Consumers' interpretation of advertising imagery: a visit to the hell of connotation', in E.C. Hirschman (ed) *Interpretive Consumer Research*, Provo, UT: Association for Consumer Research, 85–95.

Mintel (1990) *Youth lifestyles*, London: Mintel.

Moores, S. (1993) *Interpreting Audiences: The Ethnography of Media Consumption*, London: Sage.

Nava, M. and Nava, O. (1990) 'Discriminating or duped? Young people as consumers of advertising/art', *Magazine of Cultural Studies*, reprinted in M. Nava (1992) *Changing Cultures: Feminism, Youth and Consumerism*, London: Sage.

Nightingale, V. (1989) 'What's ethnographic about ethnographic audience research?', *Australian Journal of Communication*, 16, December, 50–63.

O'Donohoe, S. (1994) 'Advertising uses and gratifications', *European Journal of Marketing*, 28, 8/9, 52–75.

Radway, J. (1988) 'Reception study: ethnography and the problems of dispersed audiences and nomadic subjects', *Cultural Studies*, 2, 3, 359–76.

Richards, B. (1986) 'Prometheus plagiarized', *The Times*, 19 July.

Scott, L.M. (1992) 'Playing with pictures: postmodernism, poststructuralism, and advertising visuals', in J.F. Sherry and B. Sternthal (eds) *Advances in Consumer Research*, 19, Provo, UT: Association for Consumer Research, 596–612.

Severin, W. and Tankard, J. (1988) *Communication Theories*, New York: Longman.

Spradley, J.P. (1979) *The Ethnographic Interview*, New York: Holt, Rinehart and Winston.

Sutherland, S. (1993) 'Alias Smiths and Jones', *New Musical Express*, 27 March, 12–23.

Thompson, B. (1993) 'Merry Easter, Mr Bowie, you're back on form', *Independent on Sunday*, 28 March, 22, 24.

Unwin, S. (1982) 'The style is the ad', *International Journal of Advertising*, 1, 157–67.

Wernick, A. (1991) *Promotional Culture. Advertising, Ideology and Symbolic Expression*, London: Sage.

Williamson, J. (1978) *Decoding Advertisements: Ideology and Meaning in Advertising*, London: Marion Boyars.

16

CYNICISM AND AMBIGUITY

British corporate responsibility advertisements and their readers in the 1990s[1]

Kim Christian Schrøder

THE RISE OF CORPORATE ADVERTISING

'The development of the corporate image became a phenomenon of the 1980s as business realised that it had to sell itself as well as its products.' While this is a statement from a study of media coverage of business (Tumber 1993: 358), similar observations have been made by commentators from other perspectives. White (1991: 181), reflecting on modern public relations, notes how 'business organizations are now expected to meet social and political objectives, as well as those of profit and employment'. Schumann et al. (1991), writing from an advertising perspective, foresee 'an expanded role for corporate advertising in the future', for three reasons: environmental concern, the rising importance for the general public of certain social issues (e.g. gender) and increasing global competition in the economic realm. Perhaps to this should be added the need for business to attempt to counteract what is perceived to be anti-business editorial coverage in the media.

There is thus widespread agreement that companies and organisations will have to demonstrate, not just in product development and marketing, but over the whole range of their communicative relations, internally as well as externally, that they are capable of dialogue with their publics; that they are willing to adapt and to be more sensitive, or 'accountable', to public concerns than they used to be.

One of the ways in which this accountability manifests itself is through different forms of advertising that have variously been called, among many others, social marketing, ethical advertising, advocacy advertising, image advertising, public relations advertising and issue advertising (Hunt and Grunig 1994: 327). Terminology is difficult here, because the various labels are not applied with any consistency to the different forms of non-product advertising: the labels may refer to very different types of advertisement,

from corporate environmental advertising, through the health-oriented advertising of government departments and non-governmental agencies, to the advertising through which companies or corporate associations try to intervene directly in issues on the political agenda, such as a ban on tobacco advertising or legislation about forest industries.

What is meant by 'corporate responsibility advertisements' in this chapter is advertisements that proclaim a social ethos as they inform about a company's commitment to environmental concerns, community relations, or the future of mankind, without any overt attempt to promote a specific product. For instance, the headline of a Volvo ad in Scandinavian Airlines' *Scanorama Magazine* (1990) echoes the words of the first man on the moon: 'A large step for our planet. A natural step for Volvo'. Although the picture shows the hazy shape of a Volvo lorry, the ad does not refer to specific Volvo products; rather it concentrates fully on introducing Volvo's 'Environmental Charter', drawing attention to the company's 'quality, safety, high ethics and showing care for people and the environment'.

THE PRESENT STUDY

The project from which this chapter stems explores contemporary corporate responsibility advertising in a holistic perspective. That is, it looks at

- business and advertising communicators, in order to illuminate the sender's intentions and conceptualisations of the role of business in society;
- the actual texts of corporate responsibility advertising, both in order to determine changes in the volume of this sort of advertising over time and to characterise the verbal and visual features of such ads, as compared with consumer advertising;
- the readers of such advertising, in order to find out how the general public experience the corporate responsibility advertisements that they come across in general-appeal newspapers and magazines.

The main emphasis of the study is cultural, in the sense that corporate responsibility advertising is seen as a social and cultural phenomenon, in the context of citizenship, democracy, political power and public opinion (for a more detailed project outline, see Schrøder 1993, 1994).

Content analysis: British corporate responsibility ads 1981–91

In order to explore the hypothesis that there has been an increase in corporate responsibility advertisements between 1981 and 1991, a content analysis of a number of publications was undertaken. The month of September was chosen for both years and all ads of two-fifths of a page

or more were counted. Ads were counted in three categories: consumer ads, corporate responsibility ads, and those 'in between' which promote a commodity as well as an image or corporate concern, most frequently of an environmental kind (called 'consumer responsibility advertising' in Table 16.1).

The analysis of nine major general-appeal publications shows a statistically significant increase in corporate responsibility advertising from 1981 to 1991 (Table 16.1). While the total volume of advertising increased, there was a relative growth in consumer responsibility ads and corporate responsibility ads, but a relative decline in ordinary consumer advertising. The accidental reader of the publications examined would encounter thirty-six more consumer responsibility (typically 'green') ads in September 1991 than in the same month in 1981, and sixty-eight more corporate responsibility ads.

Different sections of the British press have distinctively different profiles with respect to the amount of corporate responsibility advertising they carry. The overall increase comes mainly from Sunday quality newspapers and the financial newspapers, and surprisingly perhaps, from the tabloid papers.[2] All categories of publications showed substantial increases, even if they were not statistically significant (for example, the weekday qualities).

The readers' response to corporate responsibility advertising

Methodologies of audience research

Now what happens when this increased number of corporate responsibility ads meet their readers? Do readers notice them at all? Do they notice that they are not 'ordinary ads'? And what sense do they make of them – do they read them in the spirit in which the corporate communicators conceptualised them, or do they reject the claims made for corporate concern, invitations to dialogue, etc?

The question that receives exclusive attention in all of the audience studies on corporate advertising that I have come across is *effectiveness*. And most of them use surveys that test respondents' awareness/memory

Table 16.1 Corporate responsibility ads in British publications

	1981		1991	
	No.	*%*	*No.*	*%*
Total ads	1600	100	2012	100
Consumer ads	1496	94	1804	90
Consumer responsibility ads	13	1	49	2
Corporate responsibility ads	91	6	159	8

of, attitudes to, or confidence in the company. Schumann et al. (1991) present a list of forty-two studies, all but two of which use surveys. Also, most studies show that corporate advertising campaigns are successful, although Schumann et al. have their reservations about many of these results, where often 'it is difficult to determine the significance of the finding or to identify the influence of corporate advertising as the primary causal factor' (ibid.: 52). They conclude, therefore, that 'it is still unclear how, when, and why corporate advertising works' (ibid.: 53).

As regards audience perceptions of environmental advertising, Finkelstein, Zanot and Newhagen's review of the literature shows ambiguous results: on the one hand there are studies that suggest that 'the majority of the public doubts the veracity of environmental advertising claims', but other studies seem to indicate that people like these ads and 'say that they were positively influenced by them' (Finkelstein et al. 1994: 7).

The overall interest in 'effectiveness', however, runs the danger of falling into the 'hypodermic needle' trap of seeing communication effects as direct and immediate, instead of mediated and negotiated through the multiple face-to-face encounters and intertextualities of everyday life. These studies thus seem to be ignorant of the fact that it is a long time since communication theory introduced the concept of two-step – or more recently multi-step – flow as the sound way to conceptualise mass communication effects (Katz 1980). And it is surprising, in the light of new methodological orientations in the study of consumer behaviour and 'marketing and semiotics' (Mick 1986; Sherry 1987; Stern 1989; Mick and Buhl 1992), that Schumann et al. can only envisage an 'effectiveness' framework as a platform for further research on corporate advertising.

The project reported on in the following pages is based on the conviction that in order to answer fundamental questions about how the signs of corporate advertisements live in society it is necessary to adopt an ethno-semiotic approach: meaning cannot be taken for granted; it is not *in* the message, it is created in the reading encounter and depends on the cultural codes and verbal resources at the disposal of each individual reader (Jensen 1987; Schrøder 1987; Morley 1992; Katz and Liebes 1993).

British readers and corporate responsibility advertisements:
empirical design

The present study carried out two series of individual in-depth interviews with sixteen British informants in their homes. The informants were selected so as to equally represent gender, the age-groups 20–30 and 40–50, higher and lower educational levels and political orientation (Conservative vs. Labour/Liberal). On each occasion informants were given nine recent print advertisements including both consumer ads and corporate responsibility ads, and hybrid forms of the two, so as not to artificially focus their

attention on the corporate category (indeed allowing for the possibility that the category 'corporate responsibility advertising' might not be part of the informants' consciousness at all). A list of the nine ads used in the second interview can be found in Table 16.2.

It is not certain that all of these ads had the general public as their primary audience, in spite of the fact that they appeared in general-appeal newspapers and magazines. Some corporate advertisers may wish to reach a relatively small, well-defined group, say potential investors; but sometimes to target this group directly may be infelicitous, whereas the use of a public medium 'may prove a successful way of communicating since there is less of a feeling of being got at' (Bernstein 1984: 93). The point in the

Table 16.2 List of advertisements used in the second interview

Company	Description of advertisement
DishwashElectric	'Washing up needn't be a life sentence.' A straight colour consumer ad for a dishwasher which talks about the advantages of having a dishwasher. *Telegraph Magazine*, spring 1992.
Toshiba	'Not only do we help you clean up in the business world, we help clean up the world itself.' A colour product ad for a portable computer which mentions its technical potential, and adds a 'green' touch. *Financial Times*, 25 September 1991.
Total	'To some this oil field is virtually empty, to Total it is more than half full.' A black and white corporate ad which emphasises Total's leadership in oil extraction techniques. *Sunday Times*, 17 November 1991.
VW	'We put people in front of cars.' A colour product ad which mentions VW's safety and environmental concern as good reasons for buying a VW. *Observer Magazine*, 10 November 1991.
Nokia	'Before. — NOKIA.' A colour consumer ad for mobile phones. *Telegraph Magazine*, Spring 1992.
Zanussi	'Planets that are caring for your future.' An environmental colour ad which stresses the caring image in connection with the entire Zanussi product range. *The Green Magazine*, April 1992.
Vauxhall	'Drive the new Astra and help change the face of cycling.' A colour consumer ad with a 'green touch': the Astra is recyclable etc. *Sunday Mirror/News of the World*, 17 November 1991.
Midland Bank	'Midland's business banking charter.' A black and white customer-oriented ad which stresses the dialogic nature of Midland's communication. *Daily Mirror*, 23 October 1991.
BP	'Oil companies tend to invite criticism. At BP, we actively encourage it.' A black and white corporate ad which stresses both environmental concern and the desire for dialogue with interested publics. *Green Magazine*, December 1991.

context of this project is that by selecting a newspaper as its publication vehicle a corporate advertiser will always *also* reach a portion of the general public, affecting public opinion in some way. Moreover, since the cost of advertising in general news media is staggering, corporate advertisers will usually not incur this expense unless they want their message to reach the eyes of the general public. That this is indeed often the case is borne out by surveys of the primary goals of the corporate advertising of American companies: these goals include: improving consumer relations; presenting stands on public issues; improving stockholder/financial relations; improving trade relations; community relations, employee relations; and 'image' and reputation (Hunt and Grunig 1994: 328).

The informants were asked to put the nine ads in the order in which they wanted to talk about them, and, for each ad, to respond to the visual and verbal characteristics and to reflect on what it wanted them to do. Each interview lasted between 30 and 60 minutes, and was tape-recorded. Every effort was made to create an interview atmosphere that was as informal and symmetrical as possible: smalltalk was not avoided, and although the interviewer was the initiator of the occasion it was made clear to informants that the study was not 'after' anything in particular, except their personal experiences and impressions of the ads; the interviewer would also offer personal interpretations and comments.

The first of the two interviews is regarded purely as an encounter to establish an open dialogue between informant and interviewer, and is therefore not used as data in the corporate advertising study. It is assumed that, due to this design, the second interview gives access to relatively unfiltered meanings from the informants' life-world, although absolute authenticity is obviously a phantom.

British corporate responsibility advertisements: what the readers have to say

The analysis of the sixteen interviews explored two things: first, do ordinary people distinguish between different categories of advertisements, and second, how do they make sense of examples of contemporary corporate responsibility advertising? More specifically, do they read the corporate responsibility ads in the spirit in which the corporate communicators conceptualised them, or do they produce 'aberrant' readings, namely readings that would lead one to doubt the 'effectivity' of these ads?

According to Ivor Goudge, BP's manager of corporate advertising, 'corporate advertising is about reputation, about winning the benefit of the doubt' (quoted in Shepard 1993: 15). BP's 'For all our tomorrows' campaign aimed to 'highlight BP's involvement in environmental care, social responsibility and technical expertise' (ibid.: 16): to get across to the public that BP has objectives beyond those of profit and employment.

Sometimes the concern expressed in corporate ads for the environment or the community seems to point to a strand of ethics in corporate policy: as David Bernstein puts it, 'Social responsibility in the last twenty years has moved from the status of optional extra to a built in component' (Bernstein 1984: 51).

Another salient feature of much corporate advertising is the declared willingness to engage in a two-way communication process, as if realising that the more corporate communication comes to resemble everyday face-to-face interaction, the more will the company benefit from public inputs when it seeks to navigate through the troubled waters of the late twentieth century. Two of the ads used in the interviews stress the dialogic relation, Midland Bank calling itself 'The Listening Bank', with 'An eye to the future, an ear to the ground', and BP saying that 'Oil companies tend to invite criticism. At BP we actively encourage it.'

The diverse ways in which the informants respond to corporate responsibility ads can be grouped into three categories, according to their willingness to give the companies 'the benefit of the doubt' on the basis of these ads:

The Sympathetic Response: those statements which express trust in the corporate message of a particular ad; which accept that the company is really as concerned, responsible and accountable as it claims to be; which believe that the company is prepared not to simply maximise profits, but to let ethical considerations enter into the picture.

The Agnostic Response: those statements which express doubt about corporate motives and behaviours; which may grant that a few companies perhaps once in a while let ethical considerations prevail, but who believe that generally this is not the case; which find it difficult to know with any degree of certainty what business is really up to. Another possible label would be 'sceptical'.

The Cynical Response: those statements that reject out of hand all corporate claims about concern and responsibility; which believe that the professed ethics is nothing but empty rhetoric, and that corporate practice is completely unaffected by environmental or community considerations.

After generating these categories from the data it became clear that they correspond to another set of frequently used labels. Borrowing from recent audience theory one might also say that the sympathetic response is one that simply takes over the intended message of the ad, namely the sender's 'preferred meaning' of the ad; the agnostic response is one that struggles with, or 'negotiates', the intended meaning, ending up with a reading that is not totally antagonistic; whereas the cynical response performs an 'oppositional' reading of the ad in which the intended meaning is clearly decoded, but vigorously resisted (Hall 1980). In this article I shall continue

to use the new labels, as they are more directly related to the subject matter of the present study.

The interview data of this study has examples of all three types of reading. The first thing to be dealt with, however, is the question of whether people distinguish at all between different categories of advertisements. The answer is that they do, although not as a rule using the categories employed in academic research. The categories mentioned by informants should not, therefore, be regarded as belonging to a conscious, well-defined system, but rather as an informal ad-hoc resource that resides in what Giddens calls 'practical consciousness', namely a subconscious framework that is activated whenever an everyday situation requires it, and which may become the subject of discursive, conscious reflection if necessary:

> All human beings are knowledgeable agents. . . . Knowledgeability embedded in practical consciousness exhibits an extraordinary complexity . . . for the most part these faculties are geared to the flow of day-to-day conduct. The rationalization of conduct becomes the discursive offering of reasons only if individuals are asked by others why they acted as they did.
>
> (Giddens 1984: 281)

All informants have at least a vague notion of ads with 'a green element' (Informant 10) or 'pollution ads' (Informant 1) and most are able to at least declare an ethical ad to be 'a concerned advert' (Informant 4) or 'going for the caring image' (Informant 7). Half the informants use clear labels to refer to various types of adverts: one informant, for instance, has a system that includes 'propaganda ads', 'green ads' and 'buy-our-shares ads' in addition to ordinary product ads (Informant 6); another distinguishes between 'environment' and 'product' ads (Informant 9); a third distinguishes 'PR ads' from ordinary ads (Informant 3).

In spite of their possession of such labels, however, pure corporate ads sometimes pose problems for informants. Faced with a total non-product ad one informant exclaims 'What are they trying to do? Nothing!' As this ad doesn't describe a product or talk about investment, 'to me it's a page of nothing' (Informant 5). Another informant is similarly at a loss to understand the purpose of this ad: 'Didn't really know what to make of this one at all. . . . I can't see the point in that ad to be quite honest with you. I can't see what it is for' (Informant 1). For these informants an ad is something which asks you in one way or another to buy something; their puzzlement over ads that appear not to do that, but rather to ask for their respect and trust, may be related to their rejection of the idea that companies are genuinely becoming more socially responsible: they see nothing beyond a company's economic identity and interest, in its advertising or in its social behaviour.

Sympathetic responses to corporate responsibility advertising

Some informant statements are quite sympathetic to the corporate claims of responsibility. One female informant believes companies are prepared to listen to criticism: 'They are ready to listen rather than to get on with it. ... I think they have come round to thinking people are not happy with the way things are being run ... and they are prepared to listen' (Informant 15). Later in the interview she elaborates at some length:

> When it comes to the environment I think they are ... everyone is so aware of it now, I think the whole world is changing. ... But they don't just go ahead to make it for profit, well, obviously they do, but it is more important [inaudible] ...

Another informant expresses a similar view in connection with a VW ad about safety and care for the environment: 'they actually tell you in a way which makes you feel that it is credible, because they keep saying "we were the first to do this ..." ' (Informant 10). While she is critical of the green bandwagon effect, she is nevertheless sympathetic to the view that business is fundamentally changing: 'Well, I would like to think it is', although she acknowledges that there are limits to environmental concern in business, which 'wouldn't become responsible I'm sure if that meant that their profits were going to be cut dramatically' (Informant 10). In an inverse manner this informant is actually saying that 'green' does have some power *vis-à-vis* profit maximisation: business won't accept 'dramatic' cuts, but apparently will countenance moderate ones.

Agnostic responses to corporate responsibility advertising

Such sympathetic statements are few and far between; most informants can be readily categorised as agnostics or cynics. One female informant expresses a certain ambivalence about a BP ad. On the one hand she categorically denies the sincerity of the invitation to dialogue and the environmental concern: 'It is a propaganda thing, isn't it ... in the end they have got shareholders and they want to make money, don't they. ... I'm sure that they are still doing the same as they have always done' (Informant 9). But within the same argument she brings herself into a more open-minded stance: 'we as the public can change the system, by actually demanding, because if the demand is there, they will provide'. She sees the BP ad as a response to such pressures, concluding, 'I am not sure ... I don't know whether it is true. It is a jolly good PR job, isn't it'.

Another informant is critical of BP for skirting the issue of practice:

> I would have thought it might have been a bit better to say, 'We have listened to people and this is what we have come up with',

rather than clinging to the fact that they are still listening and inviting criticisms as if they are totally preoccupied with that.

But at the same time she does acknowledge the invitation to dialogue:

not only have they got something to sell to you or whatever, but it is a two-way thing. A conversation is going on between them and their customers or whatever. ... They are not trying to patronise you or tell you how they are trying to convince you of things, but they are really trying to treat you as sensible people with sensible things to say. ... I think that they are beginning to recognise that a lot more people *think* and perhaps they can't get one over you quite so easily.

(Informant 14)

Finally, a male informant is quite sympathetic to the environmental efforts of some companies: 'The motor industry can do a lot more about the environment ... but they are trying' (Informant 2). In the case of BP he thinks they 'could do a lot more', but he has 'always been reasonably impressed with what they do'. He is, however, sceptical about the tendency for some companies to jump on the green bandwagon: he sees a Toshiba laptop ad as 'offering to be environmentally friendly but it doesn't do very much at all ... I think it's just a clever trick' (Informant 2).

Cynical responses to corporate responsibility advertising

By far the majority of the informants are quite cynical about the ethical and dialogic claims of corporate responsibility advertisements. They simply don't trust the promises and declarations made by the companies, and seem to discern a gulf between corporate communication and corporate practice – 'to me it's all mouth and no do', as one informant expresses it (Informant 16). Another sees Midland Bank's invitation to dialogue as 'icing on a rotten cake' (Informant 1).

The BP ad triggers the cynicism of one female informant: it's fine to invite criticism, 'but part of me says, "well, they'll listen and then they'll go through and bulldoze exactly what they want anyway"' (Informant 10). Her preferred sort of accountability communication would talk not about promises for the future, but ethical accomplishments of the past: 'you know, the VW ad ... is actually giving examples of where they *have* listened and what happened as a result of that. I mean, I would be much more convinced by that than by saying that they listen' (Informant 10).

The BP ad is also singled out for scathing comment by another informant, seeing a discrepancy between words and action – 'They say that [laughs] they invite the local community to tell them what they think, but it doesn't say that BP actually take any notice whatsoever of what people say' –

and the assistance which they claim to offer environmental groups is insubstantial: 'I'm sure they don't give them any help at all' (Informant 12). Later on she observes that business responsibility is just a question of appearances, not substance: 'Well, businesses are having to be seen to be doing something about the environment and taking it into account in their products ... I'm sure that they don't really want to do it at all.'

Many informants see only falsehood and hypocrisy in corporate responsibility claims. Referring to the corporate lobbying at the Rio summit in the summer of 1992, one informant had this to say: 'All these companies probably stick to speaking with a forked tongue ... they're saying one thing to the public, trying to convince the public that they're friendly. At the same time they're doing their utmost to make sure they don't have to' (Informant 4).

The membership of the informants

It would be tempting simply to distribute the sixteen informants among the three types of discourse described in the previous sections, in order to get a clear picture of which discourse is dominant among this group of ordinary people in Britain in the early 1990s. Unfortunately this is not possible: the three types are to be regarded as *ideal types*, which need not in principle correspond to the meanings expressed by any individual informant. The modern world is complex enough, and the individual consciousness sufficiently polysemous, to allow an individual to hold ambivalent views on issues like corporate responsibility advertising. The present study has found this to be the case. About half the informants

Figure 16.1 Three types of response to corporate advertisements.

can be placed fairly unequivocally in only one category, as pure Agnostics or Cynics, but many informants have a foot in several camps at the same time: one respondent is thus predominantly Cynical, but comes out with a few isolated Sympathetic views; another is on the whole Sympathetic, but leans towards the Agnostic; a third expresses views from all three types.

As an experiment I have illustrated this by placing informants in three intersecting circles, on the basis of my overall interpretation of the views they express in the interview (Figure 16.1). It is important to stress that the figure has no mathematical accuracy, only interpretive value; the apparent reliability of the graphic representation is thus somewhat deceptive. The figure illustrates the remarkable fact that no informants fall into the 'pure Sympathetic' area, with most occupying the 'pure Cynic' circle. A few fall into the Sympathetic/Agnostic area, one the Sympathetic/Cynic category, and another in the area where all three circles overlap.

CONCLUSION AND PERSPECTIVES

The present study clearly shows that when we move beyond the narrow audience of business leaders and investors, and look at representatives of the general public, corporate responsibility advertisements are far from reaching the goal of 'winning the benefit of the doubt', as BP's Ivor Goudge put it. This discovery is in stark contrast to the findings of other research on the effectiveness of corporate advertising, which concludes that such campaigns are quite successful (Schumann et al. 1991).

The present study therefore also raises the question of research validity. Have the numerous previous studies (mostly of the survey type) actually managed to come to grips with the everyday meanings that people create about business as such, about the performance of individual companies and about the communication produced by corporate communicators? Or have they artificially isolated corporate ads from the everyday contexts in which the meanings of corporate and other ads are interwoven with media coverage of business affairs and with deep-rooted popular ideologies about business? Or are both types of investigation, quantitative and qualitative, beset by methodology effects that render our findings less valid than we would like to believe? If the present study is accepted at face value, however, it is fairly clear that corporate communication is facing serious legitimation problems with the general public, and that they will continue to be on the defensive against various pressure and activist groups.

In recent years there has been growing critical ferment among consumers. Smith has analysed the increasing consumer pressure for corporate accountability, which he describes as a kind of 'social control of business via the market' (Smith 1990: ix). Ethical purchase behaviour may take many forms. More and more people, whether vegetarians or

not, have decided not to buy meat for ethical reasons (causing the Association of British Meat Producers to launch a counter campaign in 1992). Many people prefer to buy domestically produced goods. And, most seriously for manufacturers, big and small consumer pressure groups may organise boycotts and other forms of radical protest against offensive business practices. For instance, in November 1991 the British Animal Liberation Front claimed to have contaminated millions of bottles of the drink Lucozade because the manufacturer used animals in laboratory tests of pharmaceuticals; within hours the stock-market value of the company dropped £133 million.[3]

This state of affairs looms large in the discourse of many informants in the present study. They believe that if business has become more responsible, this is fundamentally because of the pressure that customers and activist groups have put on them. Asked whether she thinks consumers will penalise companies which are not behaving responsibly one informant says,

> I do, I mean, personally ... I mean I do it. You look at things, and I think if it is showing that the company is not bothering, people are going to boycott it ... that is when ... going slightly different the animal rights people, they cause lots of trouble.
>
> (Informant 15)

Of course one should not exaggerate the activist potential of the general public, although the number of informants for whom activism comes to mind as a real possibility is quite surprising. Another informant holds a more moderate view on this issue, saying that one shouldn't assume that people 'care deeply about the environment. I don't know, most people would like to do their bit but not to ... have to go out of their way to be doing it' (Informant 12). Similar reservations are expressed by other respondents. One informant starts by offering disclaimers about the power of ordinary people to effect real change, but ends on a note of quiet resistance:

> And me and Mark were saying how does the everyday person in the street have any saying in what's going on? Really he hasn't. You can only do your own little bit. I mean you *can* get involved in these groups to try and put pressure on these companies to change. ... Honestly I wouldn't, you know – apart from not buying their products.
>
> (Informant 16)

She then describes her own protest against Johnson and Johnson when she stopped buying their products and wrote a a letter of complaint.

Four informants spontaneously develop quite sophisticated arguments about the inherent contradictions of environmentally concerned advertising. For one of them there is a fundamental contradiction

288

between the whole role of advertising and the ecological thing, because what we should be doing is *not* buying these products packaged the way they are. . . . What we really need is a society that is no longer a consumer society in the way it has been, so there's an irony there which you can never resolve really. I think people pick up.

(Informant 10)

Ultimately, she thinks, by creating more and more sophisticated messages, advertising is shooting itself in the foot: 'they are really training people to be sophisticated in the way they receive the ad, and in the end that works against advertising as a whole' (Informant 10).

The question, then, is how far consumer sovereignty may extend, and whether it has any real political potential. Nava believes that, in the future, consumer politics can 'mobilize and enfranchise a very broad spectrum of constituents', and moreover produce 'a kind of utopian collectivism lacking from other contemporary politics' (Nava 1991: 158). In this perspective, if corporate responsibility advertising is a strategy designed to anticipate the emergence of a popular consumer politics, and to provide a way for the individual company to immunise itself from the adverse effects of such a politics, the present study shows that it is doubtful whether it is accomplishing this goal. The study also shows – and popular support for Greenpeace's campaign against Shell dumping its Brent Spar oil rig in June 1995 further documents – that the future accomplishment of this goal depends on the corporate willingness to adapt not just its communication but also its practice to the expectations of important publics.

NOTES

1 I am grateful to James Grunig and Larisse Grunig, the School of Journalism, University of Maryland, and Stephen Kline, the School of Communication, Simon Fraser University, Vancouver, who all provided stimulating comments to an earlier version of this paper.

2 The increasing occurrence of corporate advertising in British tabloid newspapers is perhaps not so surprising when it is considered that in the 1980s, under the influence of Thatcherite policies, share-ownership spread into larger sections of the population. According to Tumber, 'as seven million people became shareholders and two-thirds of the population became home owners, the tabloid press also jumped on the personal finance bandwagon. Advertisers began to increase the proportion of their advertising expenditure on the tabloid press. In 1987 the *Sun*, claiming that one in five of its twelve million readers had bought shares . . . relaunched the personal finance column . . .' (Tumber 1993: 350).

3 According to a study reported by the *Daily Telegraph*, 50 per cent of shoppers operate product boycotts of one kind or another (Nava 1991: 168).

REFERENCES

Bernstein, David (1984), *Company Image and Reality. A Critique of Corporate Communications*, Eastbourne: Holt, Rinehart and Winston.

Finkelstein, Marni J., Zanot, Eric J. and Newhagen, John (1994), 'A longitudinal content analysis of environmentally related advertisements in consumer magazines from 1966 through 1991', unpublished paper, School of Journalism, University of Maryland.

Giddens, Anthony (1984), *The Constitution of Society. Outline of the Theory of Structuration*, Cambridge: Polity Press.

Hall, Stuart (1980), 'Encoding/decoding', in S. Hall et al. (eds), *Culture, Media, Language*, London: Hutchinson.

Hunt, Todd and Grunig, James E. (1994), *Public Relations Techniques*, Fort Worth TX.: Holt, Rinehart and Winston.

Jensen, Klaus B. (1987), 'Qualitative audience research: toward an integrative approach to reception', *Critical Studies in Mass Communication*, 7(2): 21-36.

Katz, Elihu (1980), 'On conceptualizing media effects', *Studies in Communication* 1: 119–41.

Katz, Elihu and Liebes, Tamar (1993), *The Export of Meaning: Cross-Cultural Readings of Dallas*, 2nd edn, Cambridge: Polity Press.

Mick, David (1986), 'Consumer research and semiotics: Exploring the morphology of signs, symbols, and significance', *Journal of Consumer Research*, 13.

Mick, David G. and Buhl, Claus (1992), 'A meaning-based model of advertising experiences', *Journal of Consumer Research*, 19: 317–38.

Morley, David (1992), *Television, Audiences and Cultural Studies*, London: Routledge.

Nava, Mica (1991), 'Consumerism reconsidered: buying and power', *Cultural Studies*, 5 (2).

Schrøder, Kim Christian (1987), 'Convergence of antagonistic traditions? The case of audience research', *European Journal of Communication*, 2(1): 7–31.

Schrøder, Kim Christian (1993), 'Corporate advertising from senders to receivers', *The Nordicom Review*, no. 1, Gothenburg.

Schrøder, Kim Christian (1994), 'Corporate advertising: ethics, dialogue and legitimation in corporate discourse in the 1990s', *Business Research Yearbook: Global Perspectives*, vol. 1, Lanham, MD: University Press of America.

Schumann, David W., Hathcote, J.M. and West., S. (1991), 'Corporate advertising in America: A review of published studies on use, measurement, and effectiveness,' *Journal of Advertising*, 20(3): 35–56.

Shepard, Valerie (1993), 'Does it pay to advertise?', *International Magazine of the BP Group*, Spring.

Sherry, John F. (1987), 'Advertising as a cultural system', in Jean Umiker-Sebeok (ed.), *Marketing and Semiotics. New Directions in the Study of Signs for Sale*, Berlin: Mouton de Gruyter.

Smith, N. Craig (1990), *Morality and the Market. Consumer Pressure for Corporate Accountability*, London: Routledge.

Stern, Barbara B. (1989), 'Literary criticism and consumer research: overview and illustrative analysis', *Journal of Consumer Research*, 16.

Tumber, Howard (1993), ' "Selling scandal": business and the media', *Media, Culture and Society*, 15: 345–61.

White, Jon (1991), *How to Understand and Manage Public Relations*, London: Business Books.

17

(AD)DRESSING THE DYKE
Lesbian looks and lesbians looking[1]

Reina Lewis and Katrina Rolley

INTRODUCTION

This chapter stemmed from our realisation that a lifetime's commitment to reading fashion magazines was neither a solitary nor an un-lesbian activity. Not only were lots of other lesbians doing it, but we all seemed to like the same spreads. A straw poll of who had cut out what to stick on or in which wall/desk/wallet revealed a commonality of visual pleasures. This led us to explore what it was about these particular images which attracted lesbian viewers. We should be clear from the start that this 'survey' is highly selective, based on our own readings and on opinions gathered from friends and responses to conference papers. The magazines we sampled were all mainstream high fashion magazines from the 1990s – *Vogue*, *Vogue Italia*, *Elle* and *Marie Claire* – since we were interested to analyse the possible lesbian visual pleasures offered by fashion imagery in a field of cultural production that is understood to be aimed at an exclusively female (and overtly heterosexual) audience. We have not, therefore, entered into the realm of the more avant-garde 'lifestyle' magazines, such as *The Face* and *iD*, since these address a mixed audience and are often deliberately provocative in content and imagery.

This chapter approaches the lesbian gaze from a variety of angles: the first section explores how the fashion magazine functions as a mainstream space in which a plurality of possibly deviant sexual positionings can be expressed/explored; the second addresses theories of narcissism and female visual pleasure; the third examines the specifically lesbian pleasures offered by a series of mainstream fashion images. Whilst the third section of this article was jointly authored, the first two parts were written by one or other of us, in the context of shared discussion.

THE QUEER SPACE OF THE FASHION MAGAZINE
(Katrina Rolley)

Before we analyse the apparently subversive readings available to the lesbian viewer of fashion magazines, I want to explore the forms of pleasure offered by fashion images to both heterosexual and lesbian women. During the course of this exploration I will suggest that fashion magazines function as a form of (homo)erotica for all women, making the lesbian's ostensibly seditious pleasures supplementary, rather than necessarily oppositional, to the predicated readings. This contradiction stems from the fact that due to its impeccable (heterosexual) credentials, the high fashion magazine offers a space within which rules can be broken: it is a fascination with precisely this normative and subversive duality that animates our analysis of this material.

Responses to the recent proliferation of erotic images aimed specifically at women (be it men's bodies in mainstream advertising or lesbian erotic magazines) tend to ignore the fact that a form of sexualised female pleasure already existed in the form of the fashion image. Indeed, prior to the recent emergence of the patently desirable male nude within mainstream cultural production, sexual desire and desirability were predominantly signalled in terms of the female nude: imagery that was understood to function for both men and women. Thus women have long been tutored in consuming other women's bodies, in assessing and responding to the desirability of other women. This process has often been understood as one of passively identifying with the woman who is the subject of the active male gaze/sexuality (as will be discussed in greater detail later). However, I would suggest that this process potentially involves far more complex forms of identification and desire and that it is difficult, if not impossible, fully to separate admiration from desiring to be and from desiring to have.

According to popular wisdom, women are generally understood to be more critical and perceptive with regard to dress and appearance – especially that of other women – than the majority of men: hence the plethora of jokes about men not noticing new hairstyles and dresses, etc. Indeed this 'fact' was brought home to me recently when attending an exhibition entitled *Chambre Close*, featuring Bettina Rheims' photographs of naked and semi-naked women. My male companion – despite being sophisticated, visually aware and very appearance conscious – perceived all the pictured women as professional models, whereas I was immediately intrigued by the fact that this clearly was not the case, since the women's faces and bodies, whilst attractive, just were not 'perfect' enough to fulfil current codes of model good looks.

The specificity of my visual response was hardly surprising given that from an early age women are encouraged to develop a potentially

obsessive concern with their own and other women's appearance. One of the primary, socially sanctioned – and indeed quintessentially feminine – mediums through which women develop this skill is the fashion magazine. These magazines are comparatively freely available regardless of income: they are passed around at school, are a staple of every waiting room and may be flicked through at any large station, supermarket or stationery shop. Girls and women consume fashion images in a way similar to the male consumption of 'hobby' magazines (bikes, sport, computers); this activity, together with group shopping trips and experimenting with hair, dress and make-up, plays a primary part in adolescent female bonding. Similarly as a group activity, the eroticised pleasures of reading fashion magazines correlate to the teen male consumption of porn.

The magazines thus consumed are *a priori* a 'world without men', and 'world' is often the word used to describe the milieu they invoke ('your *Cosmo* world', etc.). Both the producers and the consumers of these magazines are presumed female. If a contributor is male it is often integral to the purpose of the article; in general, it is only exceptional men – the subject of a 'star' profile, for example – who feature within their pages. Thus, within this matriarchal subculture the mainstream is turned upside down, leaving men, as opposed to women, in the role of the mysterious 'other' whose alien characteristics are obsessively catalogued, dissected, criticised and ridiculed.

Therefore fashion magazines are fundamental to a socially prescribed and formative feminine experience. Either individually, or as a group, the regular 'flicking through' of magazines in which women are the exclusive subject of almost every image effectively tutors women in actively consuming the female body and appearance. What is also undeniable is that sexuality is fundamental to the production, consumption and content of these magazines. Sex in one form or another pervades women's magazines and thus surrounds the fashion images, especially those in *Elle* and *Marie Claire*. In addition, whilst heterosexuality is still the norm within mainstream magazines, articles on homosexuality and/or lesbianism are now commonplace: the majority of magazines will reference lesbian and gay sex/sexual issues and lesbian and gay couples in their general articles on sexuality and relationships. Similarly, whilst the sexuality of the magazine's models, staff and readers is still predominantly predicated as heterosexual, the line between hetero- and homosexuality is often a fine one: a good example being Kate Puckrick's 'Confessions of a Female Skirt-Chaser' in *Elle* (Puckrick 1994: 17). Here, the author admits that '[w]hen I see a woman who's thrown down the gauntlet to conventional cuteness in order to celebrate her own unique sexiness, I can't contain myself. And there's no one kind of woman who'll make me want to scratch 'n' sniff': although Puckrick (re)assures the reader that 'seeing a fine foxy lady exploiting her potential just fills me with button-popping pride that I'm a woman, too'.

In addition to being a pervasive issue for the reader of a fashion maga-
zine, sexuality is also integral to the production of the fashion image.
Despite some notable exceptions, the majority of fashion photographers
are still male, and an element of sexual attraction between model and
photographer is generally understood to be an important part of many
photo shoots (remember the fashion shoot in the film *Blow Up*?). Thus
Jeanloup Sieff said, of the photographer Peter Lindbergh (*Independent
On Sunday*, 13 March 1994: 11), 'it is obvious in Peter Lindbergh's
photographs that he loves women who love him back'. This 'love affair'
between photographer and model means that the success of many fashion
images supposedly resides in the photographer's communication of the
model's sexual response to 'his' gaze. However, what does it mean when
this gaze is then replaced by that of the female viewer of the fashion
magazine? Does her perception of the model's sexual response (to the
now absent male photographer) trigger her own desires? In this context
it is also interesting to note the number of eminent (male) fashion photog-
raphers who also produce erotica/pornography (David Bailey, Norman
Parkinson, Helmut Newton, Stephen Meisel, etc.); the number of 'super-
models' who are now constructed as overtly sexual objects of desire and
who pose (semi)-naked for male magazines, posters, calendars, etc.;
and the way in which the 'quality' press use fashion spreads (especially
those featuring lingerie and swimwear) to titillate the (male or female?)
reader.

In *Women and Fashion: A New Look*, Caroline Evans and Minna
Thornton argue that

> Fashion imagery, like fashion in general, tends to be trivialized.
> ... Fashion takes its revenge against its trivialization: it gets away
> with murder. Extraordinary liberties are taken precisely because it
> is 'only' fashion. The 'evidence' lies in the photographs themselves.
> ... Here the outrageous, or the transgressive, particularly in relation
> to female sexuality, find covert expression.
>
> (Evans and Thornton 1989: 82)

Individual fashion spreads might occasionally become the focus of
concerned debate, but such attention is rarely seen as a serious problem
by the magazine in question and the more avant-garde magazines often
appear to court controversy. As 'LA' pointed out in the *Observer* (30 May
1993), it was only because Corinne Day's photographs of Kate Moss in
her underwear appeared in *Vogue*, the respectable bible of couture
fashion, that they became the subject of such widespread discussion. In
other words, the main problem was aesthetic. Day's representation of
'generation X' kids in their natural 'unglamourised' environment – already
commonplace within magazines such as *The Face* and *iD* – shocked
Vogue's very different readership.

However, Day's photographs do raise a number of interesting questions about the acceptable and unacceptable face of sexuality in fashion images. Whilst media debate focused on the apparent youth of Moss, and the images' potential appeal to (male) paedophiles, no one questioned the role of these supposedly overtly provocative images in a magazine aimed at women. What was the assumed response of the female readership to these images? Were they presumed immune to such seduction? And, of course, what these photographs also represent are potentially erotic images of a woman taken by another woman – in this case a friend of the model – for consumption by women. In other words, whilst the feminist and lesbian movements have made a self-conscious, and much vaunted, effort during the past decade to produce a woman-centred erotica, fashion photography has been offering this pleasure to women for the last fifty years, via the work of female photographers such as Louise Dahl Woolf (who began working in the 1930s and who also produced sensuous naked photographs of her fashion models whenever possible), Sarah Moon, Deborah Turbeville and Ellen von Unwerth (amongst others), all of whom have produced overtly sensual/erotic images of women for women.

Thus it appears that the fashion magazines' established place within the heterosexual mainstream – together with the fact that fashion itself is understood to be both inherently heterosexual and inherently trivial – allows both the creators and consumers of the fashion spread to explore potentially subversive and challenging representations of female sexuality. Therefore whilst the lesbian consumer might feel herself to be reading against the heterosexual grain in her response to certain fashion photographs, I would suggest that not only do many fashion spreads overtly and covertly play with provocative lesbian themes, but that to some extent the magazines themselves almost invite – indeed educate – the reader into something very close to a lesbian response to much of their imagery of women in general. Heterosexual women, or women constructed as heterosexual, do themselves desire the women in the magazines. They have been trained into it. So what is set up is what we might call a paradigmatically lesbian viewing position in which women are induced to exercise a gaze that desires the represented woman, not just one that identifies with them.

THE LESBIAN GAZE (Reina Lewis)

This raises the question of whether/how far one can distinguish an overtly lesbian gaze, which self-consciously desires the represented woman, from a narcissistic one that identifies with the represented woman as an object of a presumed-to-be-male desire? It is possible that for the heterosexual woman viewer the temporarily lesbian mode of viewing can be contained

if she remembers that the logic of the magazine positions the desired woman as ultimately the object of male desire. On the other hand, the self-consciously lesbian viewer can take what the codes of the magazine offer and add to that an extra-textual knowledge that presumes the existence of other lesbian readers. This shifts her to a position of desiring for herself the represented woman or/and desiring to be the woman who is desired by other lesbian readers. Thus the social context of reading that we have previously argued is fundamental to the establishment of the magazines' logic can also include a recognition of interpretive communities with reading habits that go against the grain of the magazines' heterosexist rationale.

Several writers (Brooks 1982; Myers 1982a, b; Evans and Thornton 1989) have commented that the peculiar situation of the female viewer looking at fashion images of women problematises the sexuality of the female gaze. Two main themes recur in these discussions: distanciation, understood as objectification, and narcissism. The first is concerned with the distancing effects of the (male) gaze that objectify (read dehumanise) women, and the second with an (over)identification between viewer and image – the opposite of distanciation. In both cases the possibility of a female visual pleasure based on a sometimes voyeuristic gaze at images of the female body raises the question of pornographic or eroticised pleasures that are difficult to accommodate within accounts which assume a solely heterosexual positioning.

What interests me is how lesbian responses to selected fashion images may be both objectifying and narcissistic (identificatory). Here, I am thinking of object and objectification in psychoanalytic terms, that is in relation to the processes of objectification that bring, or are imagined by the subject to bring, pleasure. A heterosexist analysis – in keeping with the generally trivialising attitude to the aspirational qualities of the fashion magazine – would assume that the female pleasure in fashion magazines was purely narcissistic, in that the female spectator wanted only to *be* the object. However, I am concerned with the double movement of a lesbian visual pleasure wherein the viewer wants both to be and to *have* the object.

In Freud's account, narcissism is not merely the desire for a reflection of oneself, but of what the self 'would like to be'. This explains the obvious pleasures of identification with the model and the entire world of high fashion imagery. Further, a narcissistic desire is not simply a desire for identification with the object of one's own desiring gaze, but also a desire to experience oneself being loved by others (Freud 1914). So although narcissism is sometimes understood to mean simply self-love, Freud makes it clear that narcissism is not an inability to objectify, to engage with an object outside of the self. It refers instead to a tendency to objectify that which reminds one of oneself or of the self as one would like to be/have been (for example, as the self was when your mother loved you).

Thus, it is not that pleasure is not gained via object love; object love exists, but it requires an object that has some fantasised relation/similarity to the self.

Thus the devices that would satisfy a narcissistic desire are those that enable the fantasy of identifying with an ideal self and/or those which enable the fantasy of being desired/being loved. In consuming the magazine, then, the female viewer can potentially enjoy a variety of narcissistic pleasures: the object of the woman's (desirous) gaze is both the female body and the glamour of the high fashion world that transforms a female gendered body into an ideal. Thus, the fashion context, like the glamorous woman on film, is perfect for facilitating the spectatorial action necessary for the fantasy of experiencing oneself as the object of the desiring gaze. In effect the female viewer in imagining herself as the model places herself as the beloved object (since, as Freud points out, investing in one's beauty is the main avenue to satisfaction open to women in an unequal world; Freud 1914: 88–9). But this desire to be the beautiful object of the fashion magazine is lesbian, since the viewer who gazes at the beautiful model is undeniably female, unlike film where the audience is assumed to be mixed.

This is in contrast to Laura Mulvey's analysis of the female gaze in relation to classic Hollywood films. For her, the female gaze, in order to be active, must become transvestite, since male characters are seen to control the action whilst female characters are constituted and presented to the camera as the passive recipients of a male gaze (Mulvey 1975, 1981). Therefore, for a woman viewer who wants a pleasure not based on a passive masochistic identification with the female character (which is how narcissism would be inflected here) the only alternative is to assume a transvestite positioning as male – there is no room in Mulvey's formulation for a woman to make an active identification as female let alone to actively desire a woman from a female position. It is interesting that Mulvey's notion of transvestism, in terms of the lesbian gaze, would adequately describe the classic Freudian description of the lesbian who desires other women from a masculine position: an identification with the father and a rejection of the mother's position. (As Elizabeth Wright points out, there is no space in Freud's scenario for a lesbian to desire other women as a woman, only as a man: 'there is no trace of female–female desire: rather female homosexuality is likened more precisely to male homosexuality' (Wright 1991: 216).)

Evans and Thornton argue that in the case of the fashion magazine, the female gaze at the fashion image can be identificatory *and* voyeuristic from a female position rather than – or indeed, as well as – transvestite and masculine (*qua* Mulvey): a 'desire to look' that vacillates between 'narcissistic identification' and 'voyeuristic pleasure' (Evans and Thornton 1989: 10). I would add that the identification is not just with the women in the picture (I want to look like that) but with their state of being looked

at (I want to be the object of the desiring gaze) by a female viewer. This radically re-situates John Berger's formulation, 'the surveyor of women in herself is male: the surveyed female', into a female surveyor of images of women whose pleasure lies in being the object and owner of a gaze that can only be female, and that is implicitly lesbian (Berger 1972: 47).

I think that we can use the example of fashion imagery to problematise negative pairings of narcissism and lesbianism by emphasising the plurality of narcissistic placings and lesbian identifications (see also Merck 1984). If we allow that the lesbian gaze is narcissistic – based on reflexivity, recognition, identification and being looked at – then we have a lesbian gaze in which the pleasure of looking is experienced simultaneously with the pleasure of being looked at by a woman. Indeed the narcissistic desire for identification is a desire to be the desired object of a female gaze at the same time as experiencing the pleasures of deploying the gaze. Thus we can postulate a female and lesbian gaze – at the female object – that can be active from a female position without recourse to transvestism. Evans and Thornton argue that the fashion image is double-coded, allowing for the simultaneous signification of two autonomous languages, so that both transvestite/masculine and narcissistic/feminine positionings can be achieved. I would argue, instead, that in the case of the lesbian viewer the fashion image is multicoded, in that it allows a reciprocity of pleasure that is about both desiring the image and desiring to be the image, that is, an object choice that is both anaclitic (relating to someone or something outside the self that recalls the early source of self-preservation, for example, the breast) and narcissistic. I make this move towards both anaclitic and narcissistic object choice, since to talk only of a narcissistic formation implies that there is only one kind of lesbian viewer. Psychoanalytic accounts see lesbianism as a process of desire for the same (implicit in the label of narcissistic) that does not allow for the differences between lesbians. Indeed, if we follow Judith Butler's lead (1990) in thinking about sex and gender as ambiguous and performative, then we can move beyond a polarised position that sees female transvestism as the temporary assumption of a male positionality. The transvestite denotes a gender that is ambiguous, being irreducible to either male or female. This means not only that the female viewer may look *as* a lesbian whether or not she actually is/considers herself to be lesbian, but that the self-identified lesbian viewer may look from a variety of borrowed and invented positionalities too.

When we begin to map a self-consciously lesbian viewer onto the discourses of fashion and psychoanalysis we introduce another set of identifications that problematise the heterosexual binarism of psychoanalysis. The varieties of lesbian positionings and forms of 'sexual consciousness', to borrow a phrase from Lisa Walker (1993: 16) raise other questions: how, for example, would a self-consciously butch lesbian react to the

prospect of being the glamorous model; do different images allow different narcissistic positions for different lesbians? Consuming fashion imagery may not involve identification with the image as one that is desired, so much as an investment in the activity of looking – and desiring – in itself. It is here that we need to think about what bell hooks, in her analysis of the black female film spectator, calls the 'pleasure of interrogation': an oppositional reading that recognises that whilst the racism and sexism of mainstream films refuse a pleasurable identification for black women viewers, the experience of watching such films whilst 'on guard' can afford an alternative pleasure and power in making a reading against the grain (hooks 1992). In our instance, we have a form of representation that is implicitly structured around a female narcissistic and identificatory gaze, but which can be read from a viewing position that refuses this invitation solely to identify and retains the possibility of desiring, or of experiencing, both forms of connection (simultaneously or in flux). And we know by now that the desire – though perhaps coded as such – is about more than just wanting a certain garment. Indeed, in hooks' analysis the collectivity of other black viewers engaged in similarly subversive modes of spectatorship is implicit in the pleasures of the interrogative gaze. For the self-consciously lesbian magazine reader, the knowledge/assumption of other subversive readers reinforces and claims as lesbian the homoerotic codes of the images.

This implicit recognition that the lesbian gaze does not operate alone or outside of the social context allows us to think about a variety of lesbian viewing positions (all of which may be occupied within the viewing experience of any one woman). In other words, the discussion of the lesbian gaze denotes a shifting spectatorship that can include both what we have characterised as a paradigmatically lesbian position (open, but not exclusive, to women coded as heterosexual) and, although I hesitate to use the word 'actual', a self-consciously, self-identified, lesbian viewing position (occupied by women conscious of themselves and others as lesbian). This latter positionality, which is in itself never singular or fixed, relies on both the codes of the images and the acknowledgement of a community of lesbian readers.[2] This, then, can also accommodate the significance of visibility in the lived experience of lesbians without ruling out the complexities of a feminist anti-fashion inheritance. The importance of dress as a signifier of sexual identity, and of looking as a social, identifying and *sexualised* activity in the lives of lesbians, coalesce to provide a supplementary pleasure to the activity of consuming fashion magazines. As Walker (1993) points out, 'looking like what you are' in terms of self-presentation is crucial for a recognisable lesbian identity and structurally central to the theorisation of marginal identities. In this instance, looking like a lesbian means viewing *as* a lesbian, but the demand for the imaged women to look like they *are* or could be lesbians remains important: not just any

image will do. Indeed, I wonder whether it is a prerequisite of exercising the desiring gaze that one also identifies with the idealised object: is it just the codes of the fashion magazine which allow this actively desiring lesbian gaze, or does the lesbian assume an identification with the idealised object even if the acknowledgement of it is suppressed?

Our straw poll and personal predilection centred on images which seemed to offer particularly lesbian pleasures. This is not to deny that the polysemy of all images would in theory allow for diverse visual pleasures, but that some images caught lesbian eyes more than others. This is where the experiential exigencies of looking, as part of lesbian lives and subcultures, come to the fore. Whilst the current interest in lesbians and high fashion is contingent – we would certainly not have written about this ten years ago – the habits of looking continue. One might expand the survey to include an assessment of how many lesbians who would never dream of reading *Vogue* have posters of kd lang on their walls or bought a copy of Sadie Lee's poster *Erect*.[3]

THE IMAGES

Looking butch (Figure 17.1)

The spread from *Vogue Italia* (top left and bottom right) sets up a narrative of multiple transgressions and/or subversions that opens it to the sort of self-conscious lesbian appropriation we have been discussing. Most obviously it centres on cross-dressing combined with a narrative of criminality and a racialised Italianate mafiosi setting. Unlike conventions of male impersonation, these figures make no attempt to pass as male – they do not hide their breasts – but read clearly as cross-dressed women. This reading is enhanced by the fact that the reader recognises these women (Naomi Cambell, Linda Evangelista, Christy Turlington) as supermodels: women with an iconic status as ideals of (hetero)sexual desirability. However, cross-dressing keys directly into lesbian traditions of butch in which, according to Joan Nestle, it is the wearing of male garments on a female body that functions to communicate an active lesbian desire:

> None of the butch women I was with ... ever presented themselves to me as men; they did announce themselves as tabooed women who were willing to identify their passion for other women by wearing clothes that symbolized the taking of responsibility. Part of this responsibility was sexual expertise.
>
> (Nestle 1987: 100)

The cross-dressing in this spread is set within a clearly articulated narrative that relies for effect on its two other themes: criminality and racialised

difference. The form of masculinity portrayed and parodied is clearly coded as Italianate gangster, drawing on styles and gestures associated with popular cultural representations of gangsters in general and the mafia in particular (pencil moustaches, sideburns, greased hair, heavy gold jewellery, vests). This brings with it not only a frisson of illicit activity and street-smarts (perceived now as one of the signifiers of butch bar-dyke culture of the 1950s) but also a culturally specific stereotype of masculine sexuality as aggressive, objectifying and public. Thus the presumed-to-be-female viewer of these images finds herself subject to a desirous/hostile appraisal by figures whose raiment and pose signal masculinity but who, in the last instance, cannot but be recognised as female. Moreover, the mode of masculinity they mimic is one that is regularly, albeit covertly, homoeroticised in popular culture, thus activating another set of transgressive associations.

Figure 17.1 Looking butch

Photograph: Simon Pattle

Gendered couples (Figure17.2)

Where *Vogue Italia* used gangster-style cross-dressing in an all-male
ensemble, a few months later British *Vogue* featured a gangster spread
(top left) by the same photographer (Peter Lindbergh) that involved a
clearly gendered couple: Bonnie and Clyde. However, whilst the theme
of criminality remains, the loss of the sexualised Italianate cultural cod-
ings and gritty, sweaty realism leaves these images clearly framed (literally)
and containable as innocent charades. That the same photographer
produces two so very different gangster spreads may be in part explained
by the different editorial policy of the two magazines: whilst *Vogue Italia*
is widely recognised as being at the cutting edge of contemporary fashion
photography, British *Vogue* has undergone a transformation to (safer)
American standards (Coleridge 1988). Thus, when the gendered couple
appears in *Vogue Italia* (bottom right) – as Napoleon and Josephine – the
narrative is, to us, far more effectively sexualised. This success may also
be due to aspects of the feature's styling – short greased hair, red lips,
strong features – which can be recognised by the urban/style-conscious
lesbian reader as elements of self-presentation popular within contempo-
rary lesbian communities. It should also be noted that both these spreads
key into long-established and potentially racialised codes within visual

Figure 17.2 Gendered couples

Photograph: Simon Pattle

culture, in which the active sexuality of the (male) partner is signified by swarthiness, dark hair and rugged looks, in contrast to the pale blonde passivity of the heroine.

Lesbian moments (Figure 17.3)

In these instances the lesbian referents are neither butch women nor gendered couples but historical eras, locations and figures which have a particular significance within accounts of lesbian history (Bloomsbury, inter-war aristocratic leisure, Vita Sackville-West) and/or associations with sexual deviancy within mainstream history (Weimar Germany, Brassai's Paris brothels, Sappho's Lesbos). In these spreads, whilst the women tend to look unproblematically feminine, the perception of a lesbian subtext is prompted by the combination of a lesbian evocative *mise en scène* and the relationships between bodies and gazes: enclosed spaces; physical

Figure 17.3 Lesbian moments

Photograph: Simon Pattle

proximity; bodily contact and caresses; and a sexually provocative yet challenging gaze directed at the reader. This gaze, which is a determining feature in most of the spreads we have selected, is transformed in this context by the emphatically feminised appearance of the models. Unlike the butch gazes of *Vogue Italia* which sexually assess the (female) viewer but keep her firmly excluded from their camaraderie, these women both challenge the viewer's voyeurism and invite her into the picture as a (lesbian?) participant.

In many of these images the look directed at the viewer is strongly reminiscent of that employed by models in mainstream soft porn. Given the frequency of the brothel setting, where does this leave the presumed heterosexual female viewer who, within this narrative, can surely only be positioned as either client or colleague? But, for the lesbian viewer, the enclosed spaces and enforced leisure pictured here raise the possibility of lesbian activity in a world without men. Scenarios which offer this reading tend to draw on two main cultural stereotypes, artistocratic leisured dalliance and commercial sexual deviance (figured here as prostitution and/or cabaret). For the lesbian viewer, versed in the subcultural reclamation of the brothel as a site for lesbian relationships, these images offer a supplementary pleasure in which the gaze from within the fashion image can be received as coming from a friend or lover, thus

Figure 17.4 Twinning

Photograph: Simon Pattle

bypassing the negative associations of viewing potentially pornographic imagery.

In addition these periods in history and their key characters have been publicised and popularised by mainstream and alternative cultural productions (for example, *Orlando, Vita and Violet, Cabaret*).[4] Contemporary versions of the fashion images associated with each of them have acquired an iconic status within lesbian material culture. Thus, in viewing these spreads, lesbians arc able to recognise a (recently constructed) narrative of the lesbian past along with popular looks from the lesbian present.

Twinning (Figure 17.4)

> Our heart is the same in our woman's breast,
> My dearest! Our body is made the same . . .
> With the power of my love, I understand you:
> I know exactly what pleases you.
>> Renée Vivien, 1877–1909
>> (Vivien 1982: 73)

This paeon to Sapphic sameness reminds us of other modes of lesbian coding. Whilst the issues of butch/femme and difference have recently been the focus of great debate and controversy within academic lesbian studies, the lesbian community and lesbian popular culture as a whole, it should not be forgotten that the current focus on difference that so tangibly informs our (lesbian) responses to visual culture is historically specific. Rather than evacuate sexuality from these images, which now might be read as sisterly rather than sexual, we can draw on the long lesbian tradition of eroticised sameness to recognise their possible lesbian visual pleasures.

Despite the possibility of lesbian sexuality these images are marked by an ambivalence that is more profound than in the other spreads. This is often determined by the look from the models to the camera and to each other: for example in *Elle* 1993 'Best Buys' (bottom left) the emphasis on girls having fun, and with boys in some shots (not illustrated), inflects the look as sisterly and friendly rather than sexual; however, the sultry, provocative and potentially challenging looks and clothing of 'Baby Belle' (*Elle* 1994, centre bottom) sexualise the images and play up the potential lesbian connotations. The use of similar dress and physical proximity in these images clearly constructs an emotional unity, but any tendency to read this as asexual is destabilised by the direct gaze of the models. Like Manet's *Olympia*, the impassive gaze that challenges the viewer bespeaks a knowing sexuality which, in these images, works to exclude the viewer from the private relationship between the two women. Thus, where 'Baby Belle' is provocative but open to the fantasy of viewer participation, the

Dolce and Gabbana advert (top right) and two spreads from British *Vogue* (top left, bottom right), present an image whose pleasure lies in empathy.

CONCLUSION

Having analysed the woman-centred visual pleasures offered to both heterosexual and lesbian women by mainstream fashion magazines, do we feel that the fashion spreads published within the recently emergent lesbian and gay lifestyle magazines (Figure 17.5) provide any additional pleasures? As self-confessed magazine addicts, we were both somewhat disappointed: whilst the financial constraints on the low-budget queer magazine cannot fail to impact, it seems that fashion is once again trivialised. Fashion operates as a side-show rather than the main event: the detail, luxury, styling and thought that produces such fecund visual pleasures in mainstream magazines is generally missing. However, what would a satisfying gay fashion spread look like? Are we simply hooked on the transgressive thrill of eliciting a lesbian pleasure from mainstream fashion images? Perhaps the discomfort and guilt about the exploitative base of the fashion industry that can be avoided by the activity of subverting the nominally straight aesthetic of the mainstream magazine are brought to the fore when the gay magazine invites an overt rather than covert

Figure 17.5 Overt pleasures?

Photograph: Simon Pattle

participation in fashion consumption? Both the newly recognised config-
uration, and buying power, of the pink pound and the 'critical mass' of
images of lesbians in the mainstream (Briscoe 1994) should be situated
as socially contingent (Hennessy 1993: 969). Lesbian chic and postmodern
theory have only highlighted what was already going on: that buying,
reading and sharing fashion magazines is for many an indispensable part
of being a girl.

NOTES

1 This chapter previously appeared in *Outlooks: lesbian and gay sexualities and
 visual cultures* edited by Peter Horne and Reina Lewis (Routledge 1996).
2 Of course, our characterisation of the self-conscious lesbian reader who is aware
 of other such readers does not rule out the readership of a woman reader
 conscious of her own same-sex desire, but who reads in social isolation, without
 a sense of the reality of other such readers. The 'I thought I was the only one
 who felt like this' syndrome common to many lesbians' experience would not
 preclude a heightened sense of same-sex eroticism in the consumption of the
 magazine image, but might militate against the additional pleasure of under-
 standing reading as an experience shared with other (unmet and anonymous)
 readers. Equally, though, the fantasy of a body of similar readers ('I hope I'm
 not the only one who feels like this') might produce a similar effect.
3 This painting of two seated lesbians was plastered all over London when it was
 used as the promotional image for the BP Portrait Award exhibition at the
 National Portrait Gallery in 1992. Copies of the poster soon sold out.
4 Apart from the long-standing deviant referents of the film *Cabaret*, the early
 1990s saw the release of Sally Potter's film *Orlando* based on Virginia Woolf's
 book, and British television screened the story of Vita Sackville-West's lesbian
 affairs in an adaptation of Nigel Nicolson's *Portrait of a Marriage*.

REFERENCES

Berger, J. (1972) *Ways of Seeing*, Harmondsworth: Penguin.
Briscoe, J. (1994) 'Lesbian Hard Sell', *Elle*, May, 57–60.
Brooks, R. (1982) 'Sighs and Whispers in Bloomingdales', *ZG*, 3.
Butler, J. (1990) *Gender Trouble*, New York: Routledge.
Coleridge, N. (1988) *The Fashion Conspiracy*, London: Heinemann.
Evans, C. and Thornton, M. (1989) *Women and Fashion: A New Look*, London:
 Quartet.
Freud, S. (1914) 'On Narcissism: An Introduction' in J. Strachey (ed./trans.)
 Standard Edition of the Complete Psychological Works of Sigmund Freud,
 London: Hogarth Press, vol. 14.
Hennessy, R. (1993) 'Queer Theory: A Review of the *Differences* Special Issue
 and Wittig's *The Straight Mind*', *Signs: Journal of Women in Culture and Society*,
 18, 4, Summer.
hooks, b. (1992) *Black Looks: Race and Representation*, London: Turnaround.
Merck, M. (1984) 'Difference and its Discontents', *Screen*, 28, 1.
Myers, K. (1982a) 'Fashion 'n' Passion', *Screen*, 23, 3–4.
Myers, K.(1982b) 'Towards a Feminist Erotica', *Camerawork*, 24.
Mulvey, L. (1975) 'Visual Pleasure and Narrative Cinema', *Screen*, 16, 3.

Mulvey, L. (1981) 'Afterthoughts on Visual Pleasure and Narrative Cinema, Inspired by *Duel in the Sun* (King Vidor 1946)', *Framework*, 15/16/17, Summer.

Nestle, J. (1987) *A Restricted Country: Essays and Short Stories*, London: Sheba.

Puckrick, K. (1994) 'Confessions of a Female Skirt-Chaser', *Elle*, March.

Vivien, R. (1982) 'Union' in R. Vivien *The Muse of the Violets: Poems by Renee Vivien*, Tallahassee FL: Naiad.

Walker, L.M. (1993) 'How to Recognize a Lesbian: The Cultural Politics of Looking Like What You Are', *Signs: Journal of Women in Culture and Society*, 18, 4.

Wright E. (1991) *Feminism and Psychoanalysis: A Critical Dictionary*, Oxford: Blackwell.

Part VI

CONSUMPTION AND IDENTITY

18

'POWER DRESSING' AND THE CONSTRUCTION OF THE CAREER WOMAN

Joanne Entwistle

In the British edition of his dress manual, *Women: Dress for Success*, John T. Molloy proclaimed that most women 'dress for failure': either they let fashion dictate their choice of clothes, or they see themselves as sex objects, or they dress according to their socio-economic background. All three ways of dressing prevent women gaining access to positions of power in the business and corporate world. In order to succeed in a man's world of work, the business or executive woman's 'only alternative is to let science help them choose their clothes' (Molloy 1980: 18). The science of clothing management which he practised and called 'wardrobe engineering' helped introduce and establish the 'power dressing' phenomenon of the 1980s, defining a style of female professional garb which has now become something of a sartorial cliché; tailored skirt suit with shoulder pads, in grey, blue or navy, accessorised with 'token female garb such as bows and discreet jewellery' (Armstrong 1993: 278). Whilst Molloy might not have been the first, and indeed was far from the only self-proclaimed 'expert' to define a 'uniform' for the business or executive woman, his manual remains a classic explication of the rules of 'power dressing'. Molloy's manual, and his 'power suit' as it came to be known, provoked a good deal of discussion on both sides of the Atlantic and spawned an array of articles in newspapers and magazines, all of which served to establish a discourse on how the so-called career woman should dress for work.

'Power dressing' was effective in producing a particular construction of 'woman' new to the social stage; it was also in part responsible for the emergence of a new kind of 'technology of the self'. First, the discourse on the career woman and her dress offered a particular construction of 'woman' constituted across a range of different sites: within the fashion industry the notion of a career woman opened up new markets and become associated with particular designers such as Ralph Lauren and Donna Karan. This career woman was also constituted within a range of

texts, from television, to advertising, to women's magazines, all of which produced a profusion of images of 'high powered' professional women. Some of the women in *Dallas* were to epitomise the style and she was to be found in the pages of magazines such as *Ms* and *Cosmopolitan*. Second, 'power dressing' can be seen as a 'technology of the self'. It was a discourse which was very effective at the embodied level of daily practice, rapidly gaining popularity with those women in professional career structures who were trying to break through the so-called 'glass ceiling' and providing them with a technique for self-presentation within this world of work. Photographs of the streets of Manhattan during the 1980s show women in the 'power-dressing' garb sprinting to work in their running shoes or sneakers. 'Power dressing' was to become embodied in the shape of such public figures as Margaret Thatcher, who according to *Vogue* was redesigned in the early 1980s in line with the principles of Molloy's 'dress for success' formula.

In this chapter, I want to outline the development of 'power dressing' and to suggest that it is significant for three not unrelated reasons. First, this sartorial discourse played an important part in bringing to public visibility the professional career woman who was, or sought to be, an executive or a business woman. Women have long held down professional jobs, but this woman was someone aiming to 'make it' to positions of power often in previously male-dominated career structures. The 'uniform' which the discourse on 'power dressing' served to establish was to play an important part in structuring the career woman's everyday experience of herself, serving as a mode of self-presentation that enabled her to *construct* herself and be *recognised* as an executive or business career woman. Indeed whilst the term 'power dressing' may have fallen out of use, the mode of dress associated with it, and perhaps more importantly the philosophy that underpinned it, have all become an established part of being a career woman in the 1990s. So prominent a part has this discourse on 'power dressing' played in the construction of the career woman that it would be hard for any professional or business woman today to escape its notice even if they chose not to wear the garb.

Second, I will attempt to show how this discourse on the career woman's dress fits into broader historical developments in the changing nature of work, especially the so-called 'enterprise culture' in the 1980s. In particular, 'power dressing' can be seen to fit with the neo-liberalism of the decade and the discourse on the so-called enterprising self. Finally, 'power dressing' is interesting because it marked the emergence of a new kind of consumption for women, who are traditionally associated with the 'frivolity' and aesthetics of fashion. What 'power dressing' served to inaugurate was a method for dressing which aimed to disavow fashion and which also necessitated the use of experts and expert knowledge for calculating what to buy.

SARTORIAL CODES AT WORK

How did a sartorial discourse mark out the career woman from previous generations of working women? For as long as women have been engaged in paid labour, dress has been a consideration at work. For example, the new department stores that developed in the nineteenth century were largely staffed by women, and their dress and overall appearance was under constant scrutiny from supervisors and managers. Gail Reekie in her history of the department store notes how female shop assistants were required to dress smartly on very modest incomes and this was a constant source of pressure and hardship for many women (Reekie 1993). The development of female white-collar work over the course of the nineteenth century also necessitated a wardrobe of suitable work clothes and may have likewise been subject to surveillance by managers and bosses. Over the course of the nineteenth century, as office work shifted from male clerks to female secretaries, there was an increasing proletarianisation and feminisation of clerical work. However, unlike the male clerk who preceded them, these new female workers had little hope of becoming the boss; indeed as Steele notes, 'their clothing – as workers and as women – set them apart from the upper-middle-class male employers' (Steele 1989: 83). This new breed of working woman could receive advice on how to dress from ladies' journals of the time. Steele notes how such journals at the turn of the century advised women to wear appropriate clothes that were smart but not provocative. There was, however, as yet no distinction between the dress of the female secretary and that of a female executive.

Many general fashion histories cite the war years as a significant moment in both the history of women's work and their dress. It is worth noting that during the Second World War we can find traces of the kind of female professional and business garb later advocated by Molloy: the tailored skirt suit with heavily accented shoulders. Joan Crawford in the classic film *Mildred Pierce* (1945) portrayed a tough, independent and career-minded business woman with a wardrobe of tailored suits to match; likewise in the same year Ingrid Bergman, as psychoanalyst Constance Peterson in Hitchcock's *Spellbound*, opts for attire which, like Mildred Pierce's, connotes toughness and masculinity. However, it is only over the last twenty years that representations of 'high powered', career-motivated women and their dress have gathered momentum. Discourse on 'power dressing' was a significant aspect in popular representations of career woman in the late 1970s and 1980s, serving to make her publicly visible. It is only at this time that we see a distinction being drawn between the female secretary and the female executive, largely through difference in the dress of each. The impetus behind Molloy's manual is precisely to make the female business or executive woman visible and distinguishable

313

from her secretarial counterparts. Thus many of his rules include advice about avoiding clothes which are associated with secretaries and other female white-collar workers: fluffy jumpers and cardigans are to be avoided in the office, as are long hair, heavy make-up and too much jewellery.

DRESS MANUALS AND
'TECHNOLOGIES OF THE SELF'

Important to the emergence of this phenomenon, then, was the dress manual where the rules of 'dress for success' were explicated. However, the dress manual is not a recent phenomenon and can be seen closely aligned with other kinds of self-help publications which have a longer history. We can find, in the eighteenth and nineteenth centuries, manuals on 'how to dress like a lady' and how to put together a lady's wardrobe on a moderate budget. The notion of successful dressing is in evidence in these, as in manuals on dress in the 1950s, for instance. What is different about the manuals on dress that emerged in the 1970s and 1980s was the *type* of woman they addressed (and thus the kind of success she sought) and the notion of *self* that they worked with. To take the first point, 'power dressing' marked a new development in the history of women and work; it addressed a new kind of female worker. It was a discourse that did not speak to all women; it did not address the cleaning lady or the manual worker or even the female white-collar worker, but a new breed of working woman who emerged in the 1970s, the university-educated, professional middle-class career woman entering into career structures previously the preserve of men: law, politics, the City and so on. The notion of success then was not about 'how to get a man and keep him', which was the implied success in many of the earlier manuals; it was about something previously the preserve of men, career success.

'Dress for success' 1980s style was also different in the notion of the self it conceived. A number of commentators have argued that a new type of self has emerged in the twentieth century which the dress manual can be seen to indicate (Sennett 1977; Featherstone 1991; Giddens 1991). Mike Featherstone calls this new self 'the performing self', which 'places greater emphasis upon appearance, display and the management of impressions' (Featherstone 1991: 187). He notes how a comparison of self-help manuals of the nineteenth and twentieth century provide an indication of the development of this new self. In the former self-help manual the self is discussed in terms of values and virtues, thrift, temperance, self discipline and so on. In the twentieth century we find the emphasis in the self-help manual is on how one appears, how to look and be 'magnetic' and charm others. The emphasis on how one looks as opposed to what one is, or should become, can be found in the 'dress for success' manuals of the 1970s and 1980s. This emphasis on the management of appearance is apparent in

Molloy's earlier manual of dress for men, *Dress for Success* (1975) as well as in his later one for women.

Such a discourse on what the career woman should wear can be seen to open up a space for the construction of a new kind of feminine subject. The sartorial discourse of 'power dressing' constitutes a new 'technology' of the feminine self. 'Technologies of self', according to Foucault,

> permit individuals to effect by their own means or with the help of others a certain number of operations on their own bodies and souls, thoughts, conduct and way of being so as to transform themselves in order to attain a certain state of happiness, purity, wisdom, perfection or immortality.
>
> (Foucault 1988: 18)

Following Foucault, Nikolas Rose argues for the need to develop a 'genealogy of political technologies of individuality' (Rose 1991: 217). He goes on to say that

> the history of the self should be written at this 'technological' level in terms of the techniques and evaluations for developing, evaluating, perfecting, managing the self, the ways it is rendered into words, made visible, inspected, judge and reformed.
>
> (ibid.:218)

The discourse of 'power dressing' did indeed render into words (and garb) this new 'careerist' woman, making her visible within the male public arena. It provided her with a means to *fashion* herself *as* a career woman. Molloy's manual offered women a *technical* means for articulating themselves as professional or business women committed to their work. The manual is full of detailed descriptions of the most effective dress for the professional and business work environment, and Malloy gives long lists of 'rules' as to what garments should combine with what. The detailed description is a formula for how to *appear*, and thus (if you are not already) *become* a female executive or a successful business woman. Hence his claim that:

> The results of wardrobe engineering can be remarkable. By making adjustments in a woman's wardrobe, we can make her look more successful and better educated. We can increase her chances of success in the business world; we can increase her chances of becoming a top executive; and we can make her more attractive to various types of men.
>
> (Molloy 1980: 18)

Whilst Molloy himself is careful to say 'can' and not 'will', the implications of his 'wardrobe engineering' are nothing less than the calculating construction of oneself as a committed career woman. As such they can be seen to constitute a 'technology of the (female, professional) self'.

DRESSING FOR WORK

This 'technology of the self' can be seen to correlate with new work regimes developing from the 1970s onwards, a technology of the self commonly referred to as the 'enterprising self' because it is produced by a regime of work which emphasises internal self-management and relative autonomy on the part of the individual. We can contrast it with the technology of the self I am calling the 'managed self', because it is produced within regimes of work characterised by a high degree of external constraint and management. It is important to point out here that I am using these two technologies of self as 'ideal types' which should be seen as two extremes on a continuum rather than discrete entities. Having said that, I want to outline what I see as ideal features of both, first looking at the technology of the managed self before moving on to consider the emergence of an enterprising self which forms the backdrop to a discourse on 'power dressing'.

The managed self

If we examine the managed self we find a high degree of management control and discipline, not simply over the labour process, but regarding the bodies, hearts and minds of the workers. Arlie Russell Hochschild's (1983) study of the world of the air steward, entitled *The Managed Heart*, gives us an example of the construction of a managed self. Her study of Delta Air found that all aspects of the recruitment, training, management, marketing and PR at Delta Air set out to produce a highly disciplined worker. The outcome of this intensive training and supervision of the steward is a highly disciplined self, or as Hochschild puts it, a managed heart, who is required to manage emotions, demeanour and appearance in order to project the principles defined by the corporation. The extent to which the stewards have to manage their emotions is summed up by the advertising slogan of one airline company, which goes, 'our smiles are not just painted on'; a request that does not call for a *performance* of happiness on the part of the steward, but the manufacture of genuine emotions. At Delta Air, the bodies and soul of the stewards are not simply a part of the service, they *are* the service and as such are subject to a high degree of corporate management. At least for the time that they are at work, the image and emotions of the stewards are not their own but part of the corporate image that Delta Air seeks to project.

What part does dress play in the construction of a managed self? Dress can be seen as an important aspect in the management and discipline of bodies within the workplace. Within many different spheres of work, strict enforcement of dress codes can be found. The high degree of corporate control within such spheres of work often involves the enforcement of a

uniform which enables the image and identity of the corporation to be literally em*bodied*. Even where a strict uniform is not enforced, management exerts a significant influence over the dress of its workers. Many shop workers not required to wear a uniform are, however, often required to purchase clothes from the shop at a reduced cost in order to look appropriate.

Carla Freeman's (1993) study of women data-process workers in Barbados gives us one empirical example of how the enforcement of a dress code can be seen as part of a corporate technique of discipline. In her study she looked at corporate management in one American owned data-processing corporation, Data Air. Staffed predominantly by women, Data Air was marked by a high level of corporate discipline exerted over every aspect of the labour process: from how many airline tickets the women could process in an hour, to how long each woman took for lunch, to how many times they went to the loo, and how they dressed for work. Such discipline required a high degree of surveillance and this was made possible by the careful layout of the open-plan office. The design of the office enabled the panoptic gaze of supervisors and managers to monitor the performance, conduct and dress of the female workers. The enforcement of what Data Air called a 'professional' dress code was so strict that it was not uncommon for women to be sent home by their supervisor for not looking smart enough. However, whilst the corporation demanded 'professional' dress and conduct, the work performed was anything but professional.

Freeman argues that the enforcement of a dress code enabled Data Air to discipline its female workers into projecting a positive image of the organisation, both to the women within and to those outside, one that belied the fact that the women were locked into a non-professional occupational structure which was low paid, boring and repetitive and offered very few opportunities for promotion. The women at Data Air carried an image of the corporation to the world outside which worked to create an illusion of glamour and sophistication so that even if they were paid no more than female manual workers in Barbados, and indeed less than many female agricultural workers, they were the envy of many women outside who longed for the opportunity to work in the sophisticated air-conditioned offices. Despite low wages, Data Air was never short of keen female labour. One of the things that is notable within this regime of work is the high degree to which workers' bodies and souls are subjected to corporate management. As with the air stewards at Delta Air, the bodies of the women at Data Air are disciplined into *embodying* the message of the corporation.

The enterprising self

It is at this point that we can begin to sketch out the features of the technology of self, referred to by a number of commentators as the enterprising

self, which corresponds to a rather different regime of work. This 'enterprising' worker emerged out of historical developments commonly theorised in terms of post-Fordism and neo-liberalism and was to become the focus of New Right rhetoric in its proclamations about 'enterprise culture'. The term 'enterprise culture' is problematic, as indeed is the claim that Western capitalism has moved from a Fordist to a post-Fordist mode of production (see discussions of these problems in Cross and Payne 1991; Keat and Abercrombie 1991). However, the 1980s did see a significant growth in self-employment and, perhaps more importantly, the emergence of a powerful rhetoric of individualism and enterprise.

The restructuring of work which began in the 1970s served to sever the worker from traditional institutions and organisations (one element in the New Right's attack on 'dependency' culture; for more details see Keat 1991), so that by the 1980s individuals were called upon to think that they were not owed a living, but were embarked upon a career path of their own, and not the corporation's, making. From the 1970s onwards this new regime of work gathered momentum, replacing 'corporation man' (*sic*) and producing, in ever-increasing numbers, the worker who is a free-lancer, or an entrepreneur, or a 'self-made man'(*sic*). However, as well as producing a shift in the organisation of work, the rhetoric of 'enterprise culture' aimed to stimulate a new attitude to work and as such gives considerable prominence to certain qualities and according to Rose

> designates an array of rules for the conduct of one's everyday existence: energy, initiative, ambition, calculation and personal responsibility. The enterprising self will make a venture of its life, project itself a future and seek to shape itself in order to become that which it wishes to be. The enterprising self is thus a calculating self, a self that calculates *about* itself and that works *upon* itself in order to better itself.
>
> (Rose 1992: 146)

Rose argues that one result of neo-liberal calls to make oneself into an enterprising self is the increasing incursion of 'experts' into private life to help one attain success and find fulfilment. The increasing pressure for self-fulfilment has necessitated the rise of new 'experts' to tell us how to live, how to achieve our full potential, how to be successful, how to manage our emotions, our appearances, our lives.

What is significant then about 'power dressing' as it develops in the 1980s is the degree of fit between this discourse on the presentation of self in the workplace and the emergence of an enterprising self. The rallying call to 'dress for success' or 'power dress' is a call to think about every aspect of one's self, including one's appearance, as part of a 'project of the self'. The mode of self advocated by the rallying phrase 'dress for success' is an enterprising one: the career woman is told she must be

calculating and cunning in her self-presentation. Molloy's manual is one which seeks to encourage *responsibility* on the part of the female professional for her own success; one that demands the conscious *calculation* of her self-presentation; and calls on her to *work* upon herself in order to produce an image which makes visible her commitment to the life (and lifestyle) of an executive or business woman. Thus we can see that 'power dressing', with its rules, its manuals, its 'experts' or image consultants, in both philosophy and rhetoric, fits with that of 'enterprise culture'. 'Power dressing', then, can be thought of as a practice of dress which opened up a mode of sartorial presentation for the enterprising self of the 1980s.

Managed versus self-managed dress

If 'power dressing' did not abolish dress codes and sought the establishment of a 'uniform', how then does it differ from the dress codes enforced in the office and the department stores? What distinguishes these professional occupations from less 'high powered' occupations is the way in which dress codes are enforced: it is very unlikely a female executive will be told to go home and dress more appropriately by a supervisor. On the contrary, companies expect their professional female workers to have internalised the codes of dress required by the job. Rather than send her home, a company is more likely to suggest, or even purchase, the services of an image consultant to work with the woman. The difference then between the smart dress of a data processor in Barbados and a 'high powered' female executive is not that the first woman is exposed to a dress code and the latter not, it is a matter of different modes of enforcement: the career woman is expected to manage her dress to such an extent as to make external pressure unnecessary.

A further difference arises out of the issue of intent. What identifies the power dresser as different from her counterpart in the typing pool or office is a different attitude towards dress and self-presentation, an *intentionality* signalled by her attention to dress as much as by what she paid for her clothes and where she bought them. Once an individual has internalised the concept of a career as a project of the self, fewer external management constraints are required. As it became established as a uniform, the 'power suit' became a more or less reliable signal that a woman was taking her job seriously and was interested in going further. The woman who went out and bought the 'power suit' was already an enterprising self, if only that in order to think about one's career success in terms of personal presentation, one needed to be enterprising and subscribe to a notion of the individual as self-managing, responsible and autonomous. Closely related to the issue of intention is the issue of autonomy. Professional occupations can be characterised as granting

319

greater autonomy to the worker. However, this is not freedom as such, rather the autonomy granted to the professional requires simply a different regime of management, in this instance not exerted by corporate surveillance and management, but shifted to the internal level of self-management.

'Power dressing' offered women a conception of power located at the level of the body and rooted in individualism. Unlike the secretary or the shop assistant, the career woman's dress does not simply transmit information about the company or corporation she works for: her appearance is important because it tells us something about *her*, about her professionalism, her confidence, her self-esteem, her ability to do her job. The role played by clothes in transmitting information about the woman is demonstrated in the film *Working Girl* which stars Melanie Griffith. In this 1980s film we witness the Griffith character effect a transformation from secretary to 'high powered' executive. In the beginning of the film Griffith is seen as a gauche, gaudily dressed but bright young secretary no one will take seriously and who is harassed by all her male employers as an object of sexual fun. It is only when she starts to work for a female boss, played by Sigourney Weaver, that she begins see the importance of dress in her professional presentation and learns the codes of 'power dressing'. What might have been a nice feminist tale of female bonding quickly turns nasty when Griffith finds out that her boss has stolen a bright idea she has for a take-over bid, and the ensuing tale sees Griffith take on her boss whilst at the same time developing a very similar taste in dress. The moral of this story is a highly individualistic one which emphasises that all a girl needs to succeed is self-motivation and good standards of dress and grooming. The message Griffith conveys is not a corporate image but an image of her as an enterprising, autonomous and self-managing subject.

WORKING AT DRESS

The great female renunciation?

'Power dressing' may be underpinned by an enterprising philosophy which fits with the individualism of neo-liberalism; however it was not about expressing individuality in dress. 'Power dressing' did not set out to rock any boats, its main aim was to enable women to steer a steady course through male-dominated professions, and it therefore sought to work with existing codes of dress. In this respect 'power dressing' was inherently conservative, recommending women to wear the female equivalent of the male suit, and to avoid trousers in the boardroom at all costs since these are supposedly threatening to male power. As I noted earlier, the aim of Molloy's manual was to establish a 'uniform' for the executive or

business woman, one that would become a recognisable emblem. As such, it should be resistant to change in much the same way as the male suit. Fashion, with its logic of continual aesthetic innovation, is therefore deemed inappropriate for the business and corporate world and must be disavowed by the determined career woman.

Indeed, much of Molloy's book is given over to a condemnation of the fashion industry. Molloy's call for the disavowal of fashion on the part of the career woman can be heard echoing an earlier renunciation on the part of bourgeois men when entering the new public sphere opened up by the development of capitalism. The 'great masculine renunciation' noted by Flugel resulted in the rejection of elaboration and decoration, which had been as much a part of male dress as female dress prior to the end of the eighteenth century, and which, according to Flügel, had served to produce division and competition in terms of status (Flügel 1930). The sober dress of the bourgeois man aimed to diminish competition and bond him in new ways to his colleagues. In much the same way that bourgeois men donned themselves in sobriety, the executive and business woman is thus called upon to reject the divisive 'frivolity' of fashion. In doing so, these women will not only get on in the male world of work, but will like-wise have a code of dress which will hopefully see them unite. Indeed Molloy suggests that 'this uniform issue will become a test to see which women are going to support other women in their executive ambitions' (Molloy 1980: 36).

'Wardrobe engineering': a 'science' of dress

Since women, rather than men, have traditionally been seen as the subjects of fashion, Molloy's manual heralded, at least in theory, a new era in the relationship between women and dress, which is perhaps something of an inversion of convention. He calls upon women to make their clothing deci-sions on the basis of 'science' and not aesthetics or emotion, which might have previously guided their decisions. Molloy's dress formula was the result of years of testing and monitoring of clothes. A strict positivist, the only validity he claims to be interested in is 'predictive validity' and only arrives at statements on what dress works for women if he can predict with accuracy the effects of clothes on the attitudes of others. The main 'effect' he is aiming for is 'authority'. This employment of technical means or 'wardrobe engineering' promised to reduce the problem of what an ambitious career woman should wear to work to a purely technical matter of knowledge and expertise.

We can note therefore that what distinguishes the discourse on 'power dressing' as it addressed the new career woman is the way it applies *technical rationality* to what is in effect a question of consumption: the appeal of Molloy's 'wardrobe engineering' is that it provided many women with

a reliable shopping tool when purchasing a wardrobe for work. Problems of time and money are hopefully eliminated, as is the possibility of making mistakes and buying items of clothing that do not suit you, work for you, or fit in with the rest of your wardrobe. One of the rules he outlines in the manual is 'use this book when you go shopping', the aim being to make irrational or impulse buying a thing of the past.

'Power dressing' in the 1990s

'Power dressing' and 'dress for success' may sound rather dated today and therefore no longer of any import. However, the principles erected by this discourse on dress, and the subjectivity they helped to establish, have not disappeared. On the contrary the technique of 'dress for success' and the enterprising self it adorned have become institutionalised and integrated, not only into the personal career plans of individual women, but into the structure of corporate planning. From the publication of Molloy's manual in 1980 we have seen, in the 1990s, a steady rise of this new 'expert', the image consultant whose services are bought in by individuals who are either under-confident about their image or simply too busy to think about it; or by big businesses and organisations who are keen to up the profile of their female executives. From the 1970s onwards, Molloy's knowledge and expertise, along with the knowledge and expertise of a growing number of image consultants, was quickly bought by big organisations who were concerned about the small number of women reaching the upper echelons of management and wanted to be seen to be doing something about it.

Image consultancy is a generic word for a whole range of different services from manuals on dress, to consultants who advise on how to plan and budget for a career wardrobe, to specialist services which advise people on what to wear when going on television, to shopping services offered to the career woman with no time to lunch let alone shop. The combination of services that is offered by image consultancy marks a development in a new *method* of consumption; it also marks a new *attitude* to consumption. The career woman who buys in the services of a consultant to plan and purchase her wardrobe treats consumption as *work* and not as leisure (and therefore pleasure) as it is commonly experienced. This attitude to consumption requires the same application of instrumental rationality to consumption that is required by work. Molloy not only advocates a formula of dress for the business and executive world of work, he advises career women to treat their dress as part of the work they must put in in order to increase their chances of career success. There may of course be pleasures associated with buying in a consultant, but these pleasures are themselves new and are distinct from the traditional pleasures normally associated with shopping.

To conclude, the development of a discourse on the career woman's dress throughout the 1980s and 1990s marks the emergence of a new 'technology of the self', a self who demonstrates that she is ambitious, autonomous and enterprising by taking responsibility for the management of her appearance. The fact that so many women buy in the services of a consultant is also testimony of the extent to which this modern woman is an enterprising self. In seeking out an expert to guide her in her self-presentation, the career woman demonstrates her own commitment, initiative and enterprise. It also marks the emergence of a new pattern of consumption: the use of clothes manuals, the buying in of expertise in the form of image consultants and the purchase of shopping services mark out a new attitude to consumption which sees it as serious labour requiring the application of technical rationality and knowledge to make decisions about what to consume.

REFERENCES

Armstrong, L. (1993) 'Working girls', *Vogue*, October.

Cross, M. and Payne, G. (eds) (1991) *Work and Enterprise Culture*, London: Falmer Press.

Featherstone, M. (1991) 'The body in consumer society', in M. Featherstone, M. Hepworth and B. Turner (eds), *The Body: Social Process and Cultural Theory*, London: Sage.

Flügel, J.C. (1930) *The Psychology of Clothes*, London: The Hogarth Press.

Foucault, M. (1988) 'Technologies of the self', in L. Martin, H. Gutman and P. Hutton (eds) *Technologies of the Self: A Seminar with Michel Foucault*, Amherst MA: University of Massachusetts Press.

Freeman, C. (1993) 'Designing women: corporate discipline and Barbados' off-shore pink collar sector', *Cultural Anthropology* 8, (2).

Giddens, A. (1991) *Modernity and Self-Identity: Self and Society in the Late Modern Age*, Cambridge: Polity.

Hochschild, A. (1983) *The Managed Heart: Commercialisation of Human Feeling*, Berkeley CA: University of California Press.

Keat, R. (1991) 'Starship Enterprise or universal Britain?' in R. Keat, and N. Abercrombie (eds) (1991) *Enterprise Culture*, London: Routledge.

Keat, R. and Abercrombie, N. (eds) (1991) *Enterprise Culture*, London: Routledge.

Molloy, J.T. (1975) *Dress for Success*, New York: Peter H. Wyden.

Molloy, J.T. (1980) *Women: Dress for Success*, New York: Peter H. Wyden.

Reekie, G. (1993) *Temptations: Sex, Selling and the Department Store*, St Leonards, Australia: Allen and Unwin.

Rose, N. (1992) 'Governing the enterprising self', *The Values of the Enterprise Culture: The Moral Debate*, in P. and P. Morris (eds) London: Routledge.

Rose, N. (1991) *Governing the Soul: The Shaping of the Private Self*, London: Routledge.

Sennett, R. (1977) *The Fall of the Public Man*, New York: Alfred A. Knopf.

Steele, V. (ed.) (1989) *Men and Women: Dressing the Part*, Washington DC: Smithsonian Institute Press.

19

CONSUMPTION AND IDENTITY BEFORE GOING TO COLLEGE, 1970–93

Michael Smee

This chapter explores changes in consumption from the early 1970s to the 1990s in the area of cultural participation by young people on the threshold of higher education: their reading, viewing, listening and general leisure interests. Two empirical studies are drawn upon, from 1970–1 and 1993.[1] These had comparable samples of over one hundred young Londoners taking A levels at three institutions which differed in the class profile of their students. The opportunity is offered for both a synchronic and a diachronic analysis of cultural distinctions and how they alter, using the work of Bourdieu (1984) in the light of recent postmodernist writing.

SOCIAL CHANGE AND CULTURAL CONTEXTS IN POSTWAR BRITAIN

Up to the early 1960s, cultural involvement by the young, along with educational opportunity, was thought to operate along structural lines of class and gender (Abrams 1959; Hall and Jefferson 1976; Brake 1980). In the 1960s and 1970s, youth appeared to transcend class through style (Hebdige 1979), though class framed the underlying parent culture (Bernstein 1975; Hall and Jefferson 1976). In the 1980s and 1990s, class is decreasingly seen to be the determining factor in cultural experience as new and multiple identifications predominate, based on age-group, ethnicity, gender and lifestyle (Hebdige 1988; Nava 1992; McRobbie 1994). These recent changes have been defined as part of a more general move to postmodernism in which identities are fragmented and consumption diverse. 'Distinctions' derived from class are replaced by non-invidious 'differences' in this version of culture (Lash 1990: 21–5).

Consumption and habitus

In *Distinction* (1984) Bourdieu demonstrates that particular preferences in consumption are associated with class fractions – occupational

subgroups with their characteristic dispositions (Featherstone 1991: 18). Central to Bourdieu's work is the concept of habitus, which he originally defined as 'a "system of dispositions" acquired in crucial socialising contexts, initially family, then mediated through school and peer group, that is the cultivating field for cultural competence for a particular social class fraction or group' (Bourdieu 1984: 2–3).[2] Through the habitus, class fractions mark out symbolically the best locus for their particular investments of cultural competence (Harker et al. 1990; Robbins 1991). Those rich in economic capital value forms of consumption which express and display distinctions of wealth. Those with high levels of education value cultural capital. Their consumption displays distinctions of critical awareness, 'good taste' or creativity. They are, typically, academics and cultural producers[3] with a modernist sensibility, whether towards 'high' culture or the avant-garde.[4] Cultural distinction is valued more among the petite bourgeoisie, schoolteachers and public sector administrators than among middle managers and self-employed proprietors (Bourdieu 1984: Chapter 6), though they exhibit a less assured command of it than the intellectual elite. Bourdieu's topography of distinction includes 'legitimate' (high) culture at the top and 'barbarous' (popular) culture at the bottom, with 'middlebrow' and 'autodidact' in between (ibid.: 16). The latter aspire to legitimate culture but lack cultural capital (ibid.: 84). These variations will emerge as significant in my findings.

Modernism and postmodernism

This chapter examines evidence for the postmodernisation of consumption among those entering the modernist world of higher education. The modernist cultural mode, whether high or avant-garde, is termed 'discursive' by Lash (1990: Chapter 7) as it assumes a literary and didactic sensibility. It is characterised by levels of knowledge and understanding in the distinct spheres of art, literature, music, film and theatre. Consumption affords distance from and reflection upon everyday life, with boundaries between 'culture' and mundane leisure. In contrast, the postmodernist cultural mode is termed 'figural' by Lash: this is an audio-visual sensibility which is non-didactic, readily accessible, playful, even irreverent. The different media overlap in their references and lose their distinctiveness for the consumer (McRobbie 1994). Consumption is characterised by immersion in pleasure and fantasy, with loose boundaries between culture and everyday life.

Distinction and difference

Bourdieu's (1984) analysis of distinction applies best to relatively stable societies, where discriminatory judgements of taste identify group membership

to others as readable signs of social status. The implication of the post-modernist analysis is that contemporary society is moving away from fixed status groups towards a postmodern consumer culture whose cultural practices cannot be ultimately stabilised or hierarchised (Featherstone 1988; Connor 1989). In Bourdieu's terminology, if the boundary between groups is no longer clearly marked, then there are no cultivating habituses for consumption to make distinctions.

Lash (1990) has proposed that postmodern culture is a central feature of disorganised, post-Fordist or post-industrial capitalism: an economy of flexible production and segmented specialist consumption. More people are seen to be employed in a cultural mode of work, and people increasingly gain their identity from consumption rather than occupational status (Lash and Urry 1987; Connor 1989; Featherstone 1988, 1991; Rose 1991; Lash and Friedman 1992; Esping-Andersen et al. 1993).[5] Featherstone suggests, however, that the changes identified by postmodernists amount to a new move within the structure of social relations, rather than to the diminishing significance of class. Bourdieu (1984) recognised that distinction-making oppositions were not fixed, but were subject to change as the economy altered the relative social position of existing class fractions and led to the creation of new ones. In consequence, it must be that different modes of identity and habitus-formation and de-formation are emerging, which make the class-distinguishing features of taste and lifestyle choice more blurred and less obvious, along the lines of the postmodernist thesis.

Bourdieu (1984) identified three dimensions of social change, which Lash (1990, 1993) and Featherstone (1991) have compared with other theories. First, there is a decline in the secure hierarchy of managers, administrators and skilled workers in the ('Fordist') manufacturing and public service sector, to be replaced by the more casualised workforce in the post-industrial sphere.[6] Second, three new middle-class fractions emerge within the new cultural economy. These are the new bourgeoisie in the media and communication services,[7] the new petite bourgeoisie of 'cultural intermediaries'[8] and 'expressive professionals',[9] and third, technical and administrative aides to these groups. The third change is the heightened importance of age, gender, ethnic and other cultural differentiations and identifications apart from class, which is more closely felt by the young, the cosmopolitan-urban and those in the newer cultural occupations (Featherstone 1991).

From this point of view, postmodern culture is not so much about the disappearance of class as the emergence of a new sensibility, for which hierarchical distinction is no longer salient. Featherstone (1991) suggests that postmodern culture should be considered less of a cultural change for all, than an aspect of the habitus of the new middle-class fractions, who, like any social group, want to legitimate their own dispositions (Bourdieu 1984). This amounts to discarding and discrediting the old

distinctions and symbolic hierarchies that revolve around the high culture/popular culture axis, since they work in fields closer to popular cultural consumption.

TWO SURVEYS: 1970–1 AND 1993

The empirical investigations involved sampling by questionnaire two cohorts of London students taking the first year of A level courses in two school sixth forms and an FE College; the three institutions will be referred to as 'North School', 'East School' and 'FE College'. The samples took place in 1970–1 and 1993[10] and there were, respectively, 131 and 141 students in each sample. By choosing A level students, the educational level was a controlled factor. I was looking for the extent to which distinction based on class had been replaced by a cultural outlook of non-invidious differences for those entering the modernist framework of pre-university education.

The sites were chosen for their different social-class intake to provide a range of parental background and associated habitus. In spite of changes in catchment and institutional organisation,[11] the pattern of class difference remained the same for the two cohorts. North School had a sixth form that was around 90 per cent middle class (As and Bs), East School around 70 per cent lower middle class (Bs and C1s). The FE College had the greatest mix in both years, but was much nearer to the class profile of East School than North School. It was distinguished from East School by its different college ethos, with weaker classification and framing of the students' educational careers (Bernstein 1975). In relation to A level selection, the two cohorts also remained similar. North School had remained predominantly humanities-based, the FE College a mixture of social sciences and humanities, and East School was strong in maths, but in 1993, more linked to business studies than science. The pattern of difference was not unrelated to the profile of parental occupations.

It is the changes within class fractions we are concerned with here. Between the two surveys, North School had increased its proportion of parents who were new middle class in the cultural fractions defined above. The proportion of graduate parents was high in both years at North School, but had significantly increased in 1993 at the two east London sites, particularly the FE College. The changes at both east London places were in the post-industrial, post-Fordist direction away from Fordist type occupations, together with some increase in Bourdieu's category of executant petite bourgeoisie: teachers and public sector administrators.

In 1970, two-thirds of the homes of the North School students were characterised as upper professional and managerial or 'A' on the market research type scale of A–E, equivalent to Bourdieu's *haute bourgeoisie*, within which he distinguished four subclass fractions. This sample

327

contained a nearly even distribution of all four: executives, established professionals, academics and the new cultural bourgeoisie. By 1993 at North School, the proportion of As was slightly less, and the balance of the four middle-class groups had changed towards the cultural group: there were only two executive parents and fewer professionals. The Bs in 1993 accounted for over a third of the sample (whereas they were 20 per cent before), and were predominantly in the expressive or cultural sectors (as teachers,[12] counsellors, therapists, social workers or in artistic and creative occupations). There were also some executant public sector administrators.

At the FE College and at East School, the middle-class parents for both years fell into the B and C1 category, and the analysis by Bourdieu of the difference in class fractions among the petite bourgeoisie is relevant. In 1970, there was a high proportion of fathers who were managers, technical and financial personnel in manufacturing industry (non-graduates) who lived in the outer suburbs. There were only a few in the educational or media field. In 1993 the profile was different with a decline in employment in manufacturing. The Bs were now largely the executant petite-bourgeois workers in the public service sector (teachers, health professionals, local government officers). They had higher educational levels than their equivalents in 1971 and lived in the intermediate London boroughs rather than the outer suburbs. There were only a few freelance technical and creative workers. In 1971, the C1s and C2s were largely in Fordist industrial and commercial settings, as clerical, supervisory and technical and skilled craft workers. In 1993, they were more likely to be working for small employers or self-employed in post-Fordist subcontracting businesses. There was a greater sense of precariousness and casualness in the job-market.

In the surveys of school students, careful note was taken, therefore, of the occupational category of parents. Obviously 17-year-olds are not determined exclusively by the particular habitus of the home: Bourdieu's habitus also included the school and the peer group. However, the dispositions of students will be influenced by the outlooks of the *predominant* class fractions entering a school or college. It is this overall social ethos which operates culturally rather than the individual influence of the parent on the child. I am investigating whether consumption changes in the direction of postmodern culture can be related to the increased prominence of the cultural fractions among the parents, along the lines proposed by Featherstone (1991).

The changing cultural consumption of pre-university students

In 1970–1, the profile of consumption across the three institutions revealed a pattern of distinction in process. In music and style of dress, students had common generational identification to distinguish themselves from

older age-groups; and their A level status differentiated them from non-A level youth. However, these were mediated by their membership of the different class fractions associated with their residential and parental background.

The area where distinction as a reflection of home background was most strongly predicted was in newspaper and magazine reading. In 1970–1, the comparison between the two schools demonstrated the class and educational level of parents, as many of the magazines mentioned by students were those read at home. At North School, students read the serious news and features weeklies such as the *New Statesman*, *New Yorker*, *Newsweek*, the Sunday colour supplements and also glossy magazines for women such as *Vogue*, *Nova* and *Queen*. In contrast, at East School students read magazines such as *Titbits*, *Weekend* and *Reveille* and, for girls, *Jackie* and *Woman* rather than the upmarket glossies. The FE College was intermediate between the two, but had a stronger readership than North School of music scene or counter-cultural magazines.

The area predicted to indicate the least distinction was music. A shared generational taste was expected for popular music, which Steiner (1970) has described as the lingua franca of youth. Although there was evidence for this, there were in fact definite distinctions discernible here in 1970–1.[13] Students at East School identified the most with commercial pop music, whilst those at North School identified the least. North School students had the highest declared interest in music of all kinds (45 per cent), particularly classical, but also folk and progressive rock. The highest level of interest in jazz, blues, rock and folk was at the FE College. This enabled us, in Bourdieu's terms, to view North School as a site for participating in legitimate culture, both traditional and avant-garde, by those who had acquired it as cultural capital from family habitus. The FE College contained a strong element of autodidacts who aspired to legitimate culture along the more avant-garde dimension, and East School had a predominant ethos of middlebrow culture.

At North School in 1970, interest in film, art, music and literature was the broadest, and the most clearly *distinguished* from commercial forms.[14] A larger proportion than elsewhere expressed an interest in the high culture of ballet, opera and classical music alongside more avant-garde and popular forms. As a result of their proximity to central London, and their parents' interests and tastes (and income), they had greater ease of access to concert halls, theatres and clubs, cinemas (including independents), galleries and bookshops in the West End and North London. In viewing films, they were more interested in 'auteur cinema' and referred to directors in the interviews. Bourdieu (1984: 26) cites the knowledge of directors and their style as characteristic of cultural capital, as distinct from a concentration on the action, actors and plot. The counter-cultural leanings of many North School students in their exploration of

the avant-garde expressive side of music, film and art was compatible with a classical musical, literary and art education. It could be seen as a different dimension of legitimate culture, expressing cosmopolitanism rather than localism and modernism rather than classicism.

In their taste in reading, in 1970–1 there were more references to non-course classic authors[15] at North School and the FE College than at East School. These included nineteenth-century authors like Tolstoy and Proust, early twentieth-century authors like Joyce, Woolf and Lawrence and modern authors like Iris Murdoch and Solzhenytsin. At North School, there was a greater congruence with parental reading, and some of the books would have been borrowed from parents' shelves – a material form of cultural capital. Significantly, students seemed to be familiar with authors they had not even read. At the FE College there was more dependence on libraries, second-hand bookshops and borrowing from friends, and the reading did not have the depth and range of the North School students.

In 1971, the FE College was a prime site for autodidacticism about music, cinema and literature for those from homes with little cultural capital. Talking about esoteric jazz recordings or a newly discovered author (the discovery having been made at a second-hand bookshop), comparing guitar riffs of blues artists, or enjoying a film buff reputation are just the kind of detailed knowledge Bourdieu (1984: 26–9) uses to characterise an autodidact's eagerness for cultural knowledge. It also reflects an aspiring cosmopolitanism among those who felt themselves trapped in suburbia. It is, however, to be distinguished from the more relaxed and assured familiarity with cinema, music, art and literature of many of those at North School, in spite of the latter's younger age.

In contrast, when we turn to East School, the preference was decidedly more middlebrow, in terms of Bourdieu's categories, reflecting their petite-bourgeois home background. The declared taste in music was for quality commercial chart pop or folk-ballads. East School students positioned themselves between highbrow or avant-garde on the one hand and pop-'barbarous' on the other. They appreciated quality of melody, lyric and musical complexity in the pop they liked, but wanted nothing too demanding: music was primarily for relaxation and entertainment. They also saw a narrower range of films on general release at the local cinema, and their interest in art was narrow. In literature, a small number of students did read beyond the set books, in classical and modern writing, and aspired to university and a different ethos from the school, but they were a self-conscious minority. Overall, there was a localism detectable in the East School students to set against the cosmopolitan focus at North School and the aspirations of some of those at the FE College.

Television-viewing in the 1970s was also found to be a distinguishing feature between the three establishments: nearly half at East School were

regular viewers, only one-fifth at North School and less than one-tenth at the FE College. What was evident about the 1970s ratings was the greater discrimination exercised by North School students compared with those at East School. North School students were disdainful about most popular television and adopted a quality-rating perspective on what was broadcast, in which news, current affairs, documentaries and arts programmes featured highly. At East School, for the most part there was broad acceptance of television as a valid cultural medium for information and entertainment, but students sought to restrain themselves from its distractions in order to study.[16] Most of the FE College students seemed indifferent to television, and claimed to spend their evenings in other ways.

The overall picture in 1970–1, then, was of hierarchical distinction, although refracted through a differentiation between cosmopolitanism versus suburbanism. How far was it to change over the following twenty years in line with the postmodernist thesis?

When we look at the 1993 data for comparable patterns of distinction derived from parental consumption, it is still there in the area of newspapers and magazines, but to a much lesser extent. For example, the glossy women's magazines were only found as top-ranking choices at North School, whereas the teenage magazines *Just Seventeen*, *Ms* and *More* featured more at the two east London locations.[17] The reading of newspapers seemed to have declined across the board, so parental choice here appeared to be less significant.

Between the 1970s and 1993, there was a decline in the consumption of serious issues on television and in magazines and newspapers. For favourite television-viewing, only a small proportion of students opted for news, current affairs, documentaries or arts and science programmes. Similarly, with magazines and newspapers, the 1993 survey no longer included the *New Statesman*, *New Scientist* or the Sunday broadsheets in the top rankings (as was the case in 1970–1). There was nothing comparable to the range of general-interest, political and current affairs papers consumed by students at North School and the FE College in the earlier study. Popular television programmes in 1993 were those with featured presenters and a humorous or parodying tone, such as *Have I Got News for You* and *The Big Breakfast*. Reading patterns had also changed. In 1993, there was a heavy consumption of magazines aimed at the youth market, as well as special-interest leisure and lifestyle magazines such as those about popular music and film, computers, cars, sport and health and beauty. The growth of the ethnic press should also be noted.

These trends support the case for a postmodernist change towards casual and segmented viewing and reading, along the lines outlined in the literature. The 1993 survey showed little significant difference between the schools in the popularity of television: about one-sixth were regular viewers, about half watched selectively and one-third watched very little.

One can conclude that television-viewing is more of a shared cultural phenomenon in the 1990s than it was in the early 1970s, and now elicits fewer distinctions of taste. Only two students at North School, the most academic, said they never watched television and only two others said 'very seldom'. The most popular programmes for all students were soaps; particularly those geared towards young people, such as the examples from Australia. Programmes which deal with personal relationships and parent/adolescent conflicts were also popular, particularly those which involve humour or satire, such as *Roseanne* and *Blossom*. The urban multiracial cultural mix was demonstrated by the popularity of programmes like *The Real McCoy*.

So does this postmodernist turn apply also to music, film and novel-reading? At first sight there does seem to have been a decline in distinction, with the increase in quantity, range and variety of outlets since 1970. In musical taste, the 1993 survey showed a marked decline in the reverence for classical music: *difference* prevailed in taste, and style had become more important than *distinction*. For literature, in 1993, there again seemed to be a relative decline; compared with 1970–1 there no longer seemed to be any bookworms devouring all from the classics to light fiction. Students read more selectively, and the classical literary canon had noticeably declined in favour of modern authors. The questionnaires showed more of a postmodernist approach, rating the different forms, levels and genres of writing as equally valid accounts of life.[18]

However, beneath the surface, some more subtle distinctions were at work in relation to music, film and reading. Preferences in musical form showed a class relationship, in that indie rock was predominant at North School, while commercial dance music predominated at East School,[19] while both sets of musical preference co-existed at the FE College. The distinctions represented a differentiation between urban/cosmopolitan/avant-garde and local/suburban/middlebrow tastes, which as we have seen were characteristic of different fractions of the middle class in 1970–1.

A similar pattern is evident with film-viewing, where the proportion of films seen at the cinema compared with on video varied, as did the total number of different films seen. At East School, 72 per cent of the films were seen on rented video; at FE College, 60 per cent; but at North School only 40 per cent. The strongest interest in cinema-going as a leisure activity was at North School, followed closely by the FE College. Further, the cosmopolitanism versus localism evident in the 1970s was just as marked in 1993. At North School, the bulk of the most-viewed films in the survey were newly released films. It was still a part of the cultural capital of North School students to see new films at West End and North London cinemas (including independents) which had middle-class adult audiences. These were very different from suburban cinemas with their young and noisy

audiences, or the practice of watching a hired video with the family or a group of friends.

With literature, the gradient of distinction was similar. There was a much-reduced reading of the classics overall compared with 1970–1, but this was not uniform and ranged from none at East School, to a few titles at the FE College,[20] to a familiarity beyond set books at North School. In relation to modern novels, there was evidence that at North School an interest in reading has been more firmly maintained,[21] though probably not at the level of North School students in 1970: this generation is more multimedia in orientation. By contrast, at the FE College, there were about half as many titles and authors in 1993 as there had been in 1971, and noticeably fewer than at North School. The North School students appeared to have a broader habitus of familiarity with contemporary writing, along with film and theatre. The FE College students were not without this altogether, but they lacked the range of many of the North School students. At East School, even fewer modern titles were read in 1993 than in 1970; substantially fewer than at the FE College. There was no discernible subgroup of literary enthusiasts as there had been in 1971.

The decline of the book?

This warrants particular attention; for it should be remembered that these are students on the threshold of higher education. There has been much speculation about the decline of a reading culture among school pupils in the last decades in the face of expansion in the consumption of audio-visual media such as music, film, television and video (see, for example, Steiner 1988; Hoggart 1992 and Kitchin 1992). The material outlined above suggests some evidence of an overall decline in reading, but it also shows that differentiation between the schools persisted and that the pattern of distinction was much the same in 1993 as it was in 1970–1.

In relation to light fiction, there was both an overall decline between 1970–1 and 1993, and a change in the popularity of genres. The main differences were the disappearance of the classical detective novel, the historical novel and science fiction and their replacement in a smaller way by modern thrillers, adventure-romances, satirical fiction and fantasy. The one genre which held up and indeed expanded was horror. The cultural significance of these changes needs to be examined. The modernist genres of science fiction and the detective 'whodunit', with their rationalistic and narrative forms, were displaced by genres which focus more on disconnected psychological states, sensational imagery and non-narrative forms. One could make something here of the shift from modernist fictional themes and discursive form, to a postmodernist figural theme of horror, fantasy, sensational adventures and extreme psychological states. This is the pattern of changing tastes in film and television as well.

Summary

The research has shown that since the 1970s there have been two conflicting tendencies. There is some evidence for the postmodernisation thesis, but also much confirmation of continuing, though weaker, cultural distinctions. For the former, we can cite first a levelling tendency in the students' cultural participation compared with 1970–1, most noticeable in television-viewing. Second, there have been changes in the genres that are popular in light reading, towards those books with greater postmodern imagery and content. Third, there has been segmentation into differentiated, non-hierarchical taste clusters for the consumption of books, magazines, video and music which is particularly targeted at youth. However, against the postmodernisation tendency, distinctions persist in the overall patterns of taste for music, film, magazines and papers and most particularly in book reading.

Comment

We can see a continuation of a trend already apparent in the 1970s, rather than a new phenomenon. What is evident is a distinction at work along the lines of the cosmopolitan/local divide which maps onto the contrast between the habitus of the newer cultural middle-class fractions and the habitus of the older ones. The latter are those termed the 'declining' and 'executant' petite bourgeoisie by Bourdieu: those living through the post-Fordist changes of declining job stability in the manufacturing, financial and public service sectors. One way of conceptualising this is to adapt an approach developed by Morley (1992: Chapter 11) using the term 'articulation'.[22]

In 1970 at North School, a cosmopolitan outlook articulated with both the high and the avant-garde legitimate culture to constitute a broad modernist sensibility, making critical distinctions in opposition to the suburban, the popular and the mundane. In the 1970s, this represented a shared outlook on all three sites for those aspiring to university and a professional or equivalent career. However, the North School students had greater cultural competence in realising this. Their cultural consumption reflected the mix of middle-class fractions among the parents. By 1993 at North School, the cosmopolitan form of distinction had become disarticulated from the avant-garde form of modernist sensibility to become articulated, instead, with 1990 postmodernist sensibilities acquired from both leisure and the parental habitus. Consequently, class advantages were still evident when North School students were compared with those at East School and the FE College:[23] but of a more subtle kind than the concept of distinction conveys. The 1993 North School sample shared a cultural field with the other students, as media consumers and youth-culture participants, to a greater extent than in the 1970s. On the other

hand, they were more familiar with the multimedia sophistication of the postmodern world as a result of the habitus of cosmopolitan location, parental occupation and associated lifestyle. They had greater prospects of turning this cultural capital into the social capital of future employment in the expanding culture, communications and related industries, and of becoming producers or distributors in a field in which the students from East School would remain merely consumers.

The East School questionnaires revealed a clearer dichotomy between the values of leisure and work. In leisure, the postmodern sensibility of immediacy, fantasy and play predominated; in work, the petite-bourgeois values of focused effort and steady scholastic[24] application prevailed, derived from the parental habitus and the ethos of the school. Many of the parents and teachers feared that students' cultural consumption would distract them from success.[25] For the North School students, there was continuity rather than dichotomy between study and cultural consumption – an aspect of postmodern sensibility. They were more likely to blend contradictions and confusions into a strategy[26] to be used at university and in future careers as cultural workers.[27] In Angela McRobbie's (1994: 2) phrase, they were closer to 'living along the fault lines of the postmodern condition' than the east London students.

Following Bourdieu's analysis, the success of any strategy adopted depends on the objective opportunities available and the cultural resources and competences a person can draw upon as capital. The educational press in recent years has emphasised how students today are more dependent than previously on making use of factors other than simply grades and qualifications. That is, they need the less tangible personal qualities, aptitudes and outlooks, which, as Bourdieu has shown us, can be related to the cultural dispositions differentially shaped in different habituses. It is not just a matter of contacts and knowledge imparted by parents and teachers, but the qualitative competences students differentially realise. If this is the case it might be a matter of *plus ça change*: that beneath the apparent postmodernist equalising process of differences lurks a new version of old distinctions.

NOTES

1 Data from these surveys are taken from Smee (1979, 1994).
2 Bourdieu modified his concept of 'habitus' in later writing. After *Distinction* (1984) he reconceptualised habitus as the *sens pratique* or logic of practice (Robbins 1991). The structuralist notion of the reproduction of a structure of class relations is changed to the more structurational (Giddens 1984) agency-focused concept of 'strategy'.
3 Such as writers, artists, broadcasters and journalists.
4 There are alternative claims to legitimate culture as avant-garde from fractions of the bourgeoisie who are more cosmopolitan and/or working in the

cultural rather than professional field (Bourdieu 1984: 294). Bourdieu does not use the term 'cosmopolitan', but the sense is there in his analysis.

5 Modern production is taken to be design intensive, with commodities taking on symbolic or lifestyle significance, so that there is a constant need for innovation and new marketing. The acceleration of this process increases the output of symbolic material around which tastes and identifications form.

6 In Britain between 1971 and 1981, post-industrial occupations increased by 5 per cent – professional and semi-professional jobs particularly – but routine clerical and skilled manual work declined and management jobs remained static (Esping-Andersen 1993). This tendency has been even more marked since the 1980s, but national data are not yet available. The figures quoted are drawn from the censuses of 1971 and 1981.

7 They constitute a non-elitist intelligentsia and directorate class who are employed on the production and distribution of a broad range of symbolic goods: for example, in the media, design, fashion, tourism, public relations and advertising.

8 Bourdieu (1984: Chapter 6) distinguishes the *declining*, the *executant* (teachers and public sector administrators) and the *new* petite bourgeoisie: technical, creative and organisational people who mediate between ideas and cultural production.

9 Martin (1981) employs the term 'expressive professions' and Bernstein (1975) 'repairers and diffusers': social workers, counsellors, therapists and teachers who see their work as facilitative rather than didactic, and operate with non-hierarchical paradigms of intervention.

10 There were supportive interviews in all three establishments in 1970–1, informal discussions in 1993 and additional questionnaires to some BTEC and Access students in 1993.

11 North School had changed from selective grammar to a highly over-subscribed (voluntary-aided) comprehensive. East School was a composite of two different schools, since the 1971 school no longer existed in 1993. The 1971 school was a technical high school drawing on an outer east London borough, and the 1993 school was the flagship comprehensive, a former grammar school, for an adjacent intermediate east London borough. The FE college was the same institution for both years, but its catchment intake had shifted by 1993 from the outer to the inner suburbs, and the age-profile and previous schooling-profile had changed. There were no longer mature students in their twenties (one-tenth of the sample in 1971) or 'grammar-school escapers' from the outer suburbs, choosing the freer regime of the college. In 1993, the Access courses took the former, and schools were retaining more students in sixth forms. All sites in 1993 had a substantial ethnic minority population (20–30 per cent) absent in 1970–1: at East School this was largely Asian, at the FE College it was predominantly African-Caribbean and African, and at North School it was mixed.

12 Teachers fell into both categories (the expressive professionals or executant petite bourgeoisie) depending on their dispositions and affiliations. It was a general tendency that North School parents who were teachers were more like the former, and east London teachers more like the latter. Particular factors were their partner's occupation and their residential area and social milieu.

13 Bourdieu (1984: 19) believes music to be 'the most classificatory practice'.

14 Thirty-one per cent of the North School students described cinema as an interest, compared with 20 per cent at the FE college and only 6 per cent at

East School. North School students saw a much broader range of films, not just at local cinemas, but in the West End, at independent cinemas, at the National Film Theatre and Institute of Contemporary Arts. They also had by far the highest numbers who visited art galleries.

15 In the surveys, students were asked about the books they had recently read. The book titles were classified into categories. The question of categorising books is a thorny problem in the sociology of culture. I want to avoid the impression of making cultural judgements about levels of literature, or of assuming that only the received canon of classics is good literature. One does not know from the mention of a book, the meaning of it to the reader, or how it is read. However, it is the overall pattern we are interested in, rather than the specifics of authors and titles.

16 The university-aspirers were a more consistently restrained group than the (teaching) college-aspirers, and some of them shared the approach of the North School or FE college students.

17 The FE College seemed more like East School in its reading than the equivalent institution did in 1971.

18 At the FE College and particularly at North School, stronger distinctions were made by students in relation to their own reading in 1970–1 than in 1993. In 1970 light reading was seen as merely distraction reading, alongside other more serious reading. A typical remark in interview was: 'I sometimes read trashy novels for light reading – and then I feel guilty I've wasted time when I could have been reading something worthwhile'. In 1993, a typical comment at North School was: 'I like to feel I've read all kinds of books – not just those that are supposed to be "good literature" because they're on set lists' .

19 Although there were strong minorities for black rudie music, heavy metal, hardcore rave and bhangra at all locations, indicating the segmental markets of the postmodernist thesis.

20 At the FE college, there was a substantial decline compared with 1971 in the literary culture of the classics; the English lecturers commented on a changing literary awareness.

21 For example, novels by Isabel Allende, Martin Amis, Margaret Atwood, Julian Barnes, Angela Carter, Paddy Doyle, Kazuo Ishiguro, Hanif Kureishi and Jeanette Winterson.

22 Morley used it to explain the changing articulation of gender with technology in the home.

23 The FE College students, as in 1971, were intermediate culturally between the two schools – but for different reasons. In 1971 it was because of the presence of ex-grammar school and mature students; in 1993, it was because of the greater numbers with graduate parents in the executant petite-bourgeois public service jobs. There is a similar parallel in another way: their ambitions and interests are closer to North School, but their cultural competences do not provide them with the same confidence or likelihood of success.

24 This was Bourdieu's term for the approach to studying by those who lacked cultural capital.

25 Their ambitions were mainly for law, accountancy, computing and systems – which are congruent with the home habitus, but which are heavily over-subscribed subjects at university, adding to career uncertainty and the pressure for good grades.

26 Bourdieu's reconceptualisation of habitus as strategy is compatible with this disposition (see note 2 above).

27 The most popular ambitions were for writing, journalism or 'something in the media' – which again reflects home habitus. The minority of working-class and ethnic-minority students had ambitions more like the East School students.

REFERENCES

Abrams, M. (1959) *The Teenage Consumer*, LPE Paper 5, London: Routledge and Kegan Paul.

Bernstein, B. (1975) *Class, Codes and Control*, vol. 3: *Towards a Theory of Educational Transmissions*, London: Routledge.

Bourdieu, P. (1984) *Distinction: A Social Critique of the Judgement of Taste* (translation by Richard Nice), London: Routledge.

Brake, M. (1980) *The Sociology of Youth Culture and Youth Subcultures*, London: Routledge.

Connor, S. (1989) *Postmodernist Culture: An Introduction to Theories of the Contemporary*, Oxford: Basil Blackwell.

Esping-Andersen, G., Assimakopoulou, Z. and van Kersbergen, K. (1993) 'Trends in contemporary class structuration: a six-nation comparison' in G. Esping-Andersen (ed.) *Changing Classes: Stratification and Mobility in Post-Industrial Societies*, London: Sage.

Featherstone, M. (ed.) (1988) *Postmodernism*, London: Sage.

Featherstone, M. (1991) *Consumer Culture and Postmodernism*, London: Sage.

Giddens, A. (1984) *The Constitution of Society: Outline of the Theory of Structuration*, Cambridge: Polity.

Hall, S. and Jefferson, T. (eds) (1976) *Resistance through Rituals: Youth Subcultures in Post-war Britain*, London: Hutchinson.

Harker, R., Mahar, C. and Wilkes, C. (eds) (1990) *An Introduction to the Work of Pierre Bourdieu*, London: Macmillan.

Hebdige, D. (1979) *Subculture: The Meaning of Style*, London: Methuen.

Hebdige, D. (1988) *Hiding in the Light*, London: Routledge/Commedia.

Hoggart, R. (1992) 'Where have the common readers gone?' *Times Supplement*, 6 May.

Kitchin, L. (1992) 'Spelling it out: on the shrinking of literacy', *Times Higher Education Supplement*, 14 August.

Lash, S. (1990) *Sociology of Postmodernism*, London: Routledge.

Lash, S. (1993) 'Pierre Bourdieu: cultural economy and social change', in C. Calhoun, E. LiPuma and M. Postone (eds) (1993) *Bourdieu: Critical Perspectives*, Oxford: Polity.

Lash, S. and Friedman, J. (eds) (1992) *Modernity and Identity*, Oxford: Blackwell.

Lash, S. and Urry, J. (1987) *The End of Organised Capitalism*, Oxford: Polity.

McRobbie, A. (1994) *Postmodernism and Popular Culture*, London: Routledge.

Martin, B. (1981) *A Sociology of Contemporary Cultural Change*, Oxford: Blackwell.

Morley, D. (1992) *Television, Audiences and Cultural Studies*, London: Routledge.

Nava, M. (1992) *Changing Cultures: Feminism, Youth and Consumerism*, London: Sage.

Robbins, D. (1991) *The Work of Pierre Bourdieu*, Milton Keynes: Open University Press.

Rose, M.A. (1991) *The Post-Modern and the Post-Industrial: A Critical Analysis*, Cambridge: Cambridge University Press.

Smee, M.A. (1979) 'Reading: A Sociological Analysis', unpublished PhD thesis, London: Council for National Academic Awards, completed at North East London Polytechnic.

Smee, M.A. (1994) 'Culture and identity before going to college: the cultural consumption of pre-university students 1970s–1990s', unpublished manuscript, Department of Sociology, University of East London.

Steiner, G. (1970) 'In a post-culture' in G. Steiner (ed.) (1975) *Extra-Territorial*, Harmondsworth: Penguin.

Steiner, G. (1988) 'The end of bookishness', *Times Literary Supplement*, 8 July.

WHEN THE MEANING IS
NOT A MESSAGE

A critique of the consumption as
communication thesis

Colin Campbell

INTRODUCTION

It has become quite usual for sociologists to suggest that when individuals in contemporary society engage with consumer goods they are principally employing them as 'signs' rather than as 'things', actively manipulating them in such a way as to communicate information about themselves to others. It is also commonly assumed that these individuals, in their capacity as consumers, engage with goods in order to achieve 'self-construction' (Langman 1992: 43), or as Bauman expresses it, for the purpose of 'fashion[ing] their subjectivity' (Bauman 1988: 808). Consequently it is not unusual to encounter claims like that made by John Clammer to the effect that 'Shopping is not merely the acquisition of things: it is the buying of identity' (Clammer 1992: 195), or Beng Huat Chua's assertion that clothing 'is a means of encoding and communicating information about the self' (Chua 1992: 115). In other words, the perspective regards consumption as an activity in which individuals employ the symbolic meanings attached to goods in an endeavour both to construct and to inform others of their 'lifestyle' or 'identity', and hence that 'consumption' is, in effect, best understood as a form of communication.

In essence, this thesis consists of five linked assumptions. First, that in studying the activity of consumption sociologists should focus their attention, not on the instrumentality of goods, but rather upon their symbolic meanings. Second, that consumers themselves are well aware of these meanings (which are widely known and shared) and hence that the purchase and display of goods is oriented to these rather than the instrumental meanings of goods. Third, and following on from this, that these activities should be regarded as being undertaken by consumers with the deliberate intention of 'making use' of these meanings, in the sense of employing them to 'make statements' or 'send messages' about themselves

to others. Fourth, the content of these 'messages' that consumers send to others through their purchase and use of goods are principally to do with matters of identity (or 'lifestyle'). Fifth and finally, the reason for sending messages to others is to gain recognition or confirmation from them of the identity that consumers have selected.

This argument has become virtually taken for granted by many sociologists, who therefore automatically adopt a communicative act paradigm when focusing on consumption. This results in consumer actions being studied, not as physical events involving the expenditure of effort, or for that matter as transactions in which money is exchanged for goods and services, but rather as symbolic acts or signs, acts that do not so much 'do something' as 'say something', or perhaps, 'do something through saying something'. This communicative act paradigm – in which talk, or language more generally, is the model for all action – is widely employed throughout sociology, being common to theorists as diverse in other ways as Veblen, Goffman, Bourdieu and Baudrillard. Hence it is this perspective, especially as applied to consumption, that I wish to examine in this paper. I intend to examine each of the above five assumptions in turn, and in order to give the thesis a fair test, I shall take as an illustration of it a genre of products in relation to which this argument is more commonly advanced than any other, that of clothing. In other words, I shall consider the thesis that, when it comes to the selection, purchase and use of clothing, these activities are best viewed as efforts by consumers to communicate messages about themselves (especially about their identity) to those who are in a position to observe them.[1]

CONSUMERS AND THE SYMBOLIC MEANING OF GOODS

The consumption as communication thesis clearly requires that sociologists should demonstrate first that consumer goods possess symbolic as well as instrumental meanings, second that consumers have a common understanding of these meanings, and third that their consumption activities are guided by them. In other words, to speak of the symbolic meanings carried by clothes is to presume the existence of a shared system of symbols; one known to wearer and observer alike, and hence one that allows the acts of selecting and displaying certain items of clothing to serve as a means of communication, such that a message is passed between the wearer and observer(s). Such assumptions are, of course, necessarily implied in any reference to a 'language of clothing' (Lurie 1981). If it is assumed that consumer goods do possess symbolic meanings the first issue to be confronted is the question of whether whatever symbolic meanings or associations goods possess can be said to be shared to the extent that successful communication of messages is indeed possible.

One of the first difficulties here is that of the sheer variety of languages which it has been suggested clothing constitutes or 'carries'. The issue is less that consumer goods, such as clothing, may constitute *a* language, but rather that they may constitute multiple or even overlapping languages or language codes. For example, Veblen (1925) was one of the first theorists to suggest that an act of consumption might be intended to send a message and he was very explicit about what that might be. He considered that it indicated something about the consumer's 'pecuniary strength'. In other words, observers, because of their knowledge of how much things cost, would be able to assess an individual's wealth – and hence their social status – from the purchased goods that he or she displayed. This could be said to be one 'language' – the language of wealth – since the price of a good is a symbolic attribute like any other, even if it does have a direct connection with material resources.[2]

But there have been other claims concerning the nature of the language of clothes. There is, for example, the obvious suggestion that one may 'read' someone's clothes in terms of their fashion status or style, qualities which may be relatively independent of wealth. Then there is the increasingly common assumption (as mentioned above) that clothing can be 'read' in terms of the 'lifestyle' it manifests and hence for the 'identity' that the wearer has selected. Finally, one might mention the fact that several writers, often inspired by the work of Freud, have claimed that clothing constitutes a language of sexuality, such that one may 'read' particular fashion phenomena and styles of dress as indicators of sexual assertiveness or submission, availability or non-availability, or of gender ambiguity (Konig 1973) (although here there is often the suggestion that the wearer is not fully aware of the message he or she is sending to others). It follows from this that before any observer can hope to begin 'reading' whatever message a particular individual may be 'sending' by means of his or her clothing, it is first necessary to correctly identify the 'language' that is being 'spoken'.[3]

However, where there are grounds for assuming that speaker and listener (that is to say, wearer and observer) are 'speaking the same language', there is still the question of how conversant each might be with that particular tongue. For obviously sender and receiver need to have sufficient knowledge to 'interpret', and to 'send', a message in that language. It is not enough to know which language is being spoken; it is also necessary to be a competent speaker. Thus, in the Veblen example, if a successful message is to be communicated, both sender and receiver of the message must be familiar not merely with the product concerned but also with its price. The same thing obviously applies to the other 'languages' mentioned; hence one must be knowledgeable and up to date concerning the ever-changing world of fashion in order to send and receive messages successfully in that language.

How reasonable is it to assume that the necessary linguistic competence is widely shared? Research has yet to be undertaken to provide all the data needed to answer this question, but what information is available does suggest grounds for scepticism. For example, it would appear that it is not unusual for there to be a lack of agreement among the public at large of the sort necessary before a 'language' of fashionability could be said to exist; that is to say, concerning those items of clothing (or features of clothing) that are actually 'in fashion' or 'out of fashion' at any one time. Thus Gallup, in their *Social Trends* survey for June 1991, found that 45 per cent of people interviewed thought that turn-ups on men's trousers were 'in fashion' at that time, whilst 43 per cent thought that they were actually 'out of fashion'. This suggests that, in that year, few observers of male attire would be in a position to make a confident interpretation of the 'message' they were receiving. Similar sizable differences of opinion were found when consumers were questioned about other items of clothing.[4] Admittedly, the same survey did suggest a degree of consensus on some items. Thus two-thirds of respondents thought that mini-skirts were in fashion, whilst 80 per cent thought that this was also true of blue jeans. However, even in these cases sizable minorities disagreed, or claimed not to know. What this suggests is either that the world of fashion is itself confused, with 'experts' in disagreement with one another (unfortunately Gallup did not back up this survey with questions directed at the gurus of fashion), such that, in this respect at least, clothing represents a 'tower of Babel'; or, alternatively, that most people are simply not sufficiently conversant with the 'language of fashion' to be successful in either sending or receiving a message in that language.

One could claim that this overall lack of agreement about fashionability is somewhat misleading, as the figures given are for the population at large, whilst those items deemed to be 'in fashion' at any one time will vary from one social group or subculture to another. Unfortunately Gallup did not break their results down in this way. However, if this is true, then it does constitute a significant modification to the general thesis that consumer behaviour should be understood as an attempt to convey messages to others by means of the symbolic meanings attached to goods. For if one accepts that the 'meaning' of any one particular item of clothing displayed will differ depending on who witnesses it – and may indeed be 'meaningless' to some observers – then the scope of the theory is significantly modified. For the general thesis includes the assumption that everyone in society is equally conversant in the 'language of clothes', and consequently that this constant 'talk' is understood by all who 'hear' it. That is to say, what is being 'said' is capable of being interpreted by everyone and in approximately the same way. If, however, we now have to admit that this is not true, and that only those who share the values and attitudes of the wearer speak the same 'language', then much of what

is being 'said' is necessarily the equivalent of double-Dutch to many who 'hear' it. Or, at least, even if the majority of 'hearers' do profess to 'understand' what the wearer is 'saying', there would be good reason to believe that this does not coincide with what the wearer believes that he or she is 'saying'. Successful communication to some people – presumably the target audience for one's 'message' – is thus only likely to be achieved at the expense either of a lack of communication with others, or of sending them a message which is not what was intended.

Of course, people may try to overcome this problem by only wearing the message-carrying clothes when in the company of their target audience. Occasionally this may be possible. On the other hand, such successful segregation of audiences is often not easy to achieve, as one may need to travel by public transport to the opera, or wear to work what one is going to wear that evening to the party, etc. In these cases the 'meaning' of one's ensemble is necessarily ambiguous. If, however, the meaning cannot be read successfully without knowledge of the context in which the clothing is intended to be worn, then the analogy with language breaks down. For although the meaning of particular words and phrases may also change with context, here what one needs to know is not simply the context of use, but rather the *intended* context of use. For example, we see a man on the underground in evening dress. Is he perhaps a waiter on his way to or from work, a guest going to or from a formal social occasion or a musician on his way to perform in an orchestra? The context in which we see him wearing these clothes – making use of public transport – does not help us resolve these questions. For what we need to know is the *intended* context of use. Finally it should be noted that what such spatial and temporal segregation of clothes display suggests is not merely that the 'meaning' of clothes is typically situated, but that it is crucially dependent on the *roles* that people occupy. What the observer tends to 'read' is less the clothes themselves than the wearer's role.

SENDING A MESSAGE

In assessing the claim that the clothes people wear should be 'read' as if they constituted a 'text' containing a message, it is profitable to consider the issue from the perspective of the would-be communicator. How exactly would individuals set about 'sending a message' to some one or more other people by means of clothes alone, should they wish to do so? What kind of messages could they hope to send, and how indeed would they know whether or not they had succeeded? Now there are situations in which people often want to do just this. The typical job interview is a case in point. Individuals may indeed spend some time prior to such an occasion thinking about the impression that their clothes (and the manner in which they are worn) might make on a prospective employer. The

'message' they might want to get across may well vary, but it will probably focus on conveying the idea that the applicant is a 'smart', 'tidy' or at least 'respectable' person; someone who 'cares about their appearance'. It is important to note three things about this example. First, there is little possibility of conveying any very detailed or specific message – only a vague 'impression' is possible. Second, in most cases the applicant will have little idea of how successful, if at all, they have been in getting their message across. They may discover this if they get the job (although success in itself would not prove that their exercise in 'impression management' played a critical part in the outcome), as they may be told that they 'made a good impression' with their clothes at the interview. Alternatively they may learn this in those organisations where interview de-briefings are held for unsuccessful candidates. But often the applicant will have no feedback at all and hence have little idea whether successful 'communication' occurred. Third, the 'language' that individuals are attempting to use in such cases is not one of those mentioned earlier; indeed it is not one sociologists usually discuss at all. Typically a job applicant is not attempting to convey wealth, status or even fashion-consciousness to prospective employers, but personal qualities of ethical or moral significance. In other words these occasions represent attempts to use clothes as a 'language of character'.

A rather better example of a situation where an individual attempts to convey a specific message through clothing would be that of the prostitute, or, more precisely perhaps, what used to be called the street-walker. Here we have a situation in which there is a need to convey a very specific message – that sexual services are available for a price – largely by means of clothes alone and virtually at a glance. In reality of course make-up, demeanour and general appearance all contribute to the sending of this message. One must presume that most of those individuals who do attempt this have a high degree of success in conveying the message or they would not continue long in their chosen profession. Interestingly, this need to succeed means that the typical dress of a prostitute virtually approximates to a 'uniform', and is relatively unchanging over time in its fundamentals (high-heeled shoes, black stockings, short skirts, etc.). Even here, however, mistakes in reading this 'language' are still common enough, as is witnessed by the well-known phenomenon of 'respectable women' who live in or near a red-light district, regularly being accosted by men who mistake them for prostitutes; a mistake that one would assume should be rare if there was such a thing as an unambiguous 'language of clothes'.[5]

NOT SENDING A MESSAGE

We can also profitably invert this imaginary exercise and ask ourselves what individuals would do who do not wish to send messages to others

via their clothing at all: where they desire, in fact, to be inconspicuous. Classic examples might be the undercover policeman, the spy, or even the pickpocket. Here the ambition is less to convey a given message than for observers to treat the individual as so much 'part of the scenery' that they do not really register their presence. One way to do this might be to hide behind a uniform (that of a postman or traffic warden, for example), but where this is not possible then a suitably universal, which is to say, 'anonymous', form of dress will be adopted. The extent to which this is actually possible might be considered a good guide to whether there really is a 'clothing language' in society.

Yet there is a more important point here. For the ability to 'send a message' in any true language is critically dependent on the possibility of *not* sending one. In order to be able to say something meaningful it is essential to be able to stay silent. Such a contrast is essential to all forms of communication. Consequently one of the most forceful objections against the claim that goods (and especially clothes) can be used to send messages is the fact that this possibility rarely exists. For it is a strange feature of this so-called 'language' that you are only allowed to pause for breath when you no longer have any listeners. Unlike language proper, the so-called 'language of clothes' is one that consumers are only able to stop speaking when they are no longer observed; or, when in the company of others, if they take the drastic step of removing all their clothes (although one suspects that in practice this would actually be 'read' as a statement of some significance). In other words, not only is it impossible to have 'nothing to say', but most of the time individuals are simply repeating themselves endlessly to anyone who is in a position to 'hear' them.[6]

It is clear from this discussion that there are few grounds for claiming that clothing constitutes a 'language', and that such assertions should really be regarded as purely metaphoric. The claim is inappropriate as there are no fixed, rule-governed formulas, such as exist for speech and writing. That is to say, there is no grammar, syntax or vocabulary. What is more, the essentially fixed nature of a person's appearance renders any 'dialogue' or 'conversation' through clothes an impossibility, with the consequence that individuals typically 'read' clothing as if it were a single gestalt, whilst they employ a very limited range of nouns and adjectives to categorise those portrayed. In addition, no one ever attempts to 'read' outfits in a linear sense or to detect novel messages. Indeed, as Grant McCracken's research has shown, the more individuals try to employ clothing as a language, that is by making their own combinations of items to construct a personal 'ensemble', the less successful it is likely to be as a means of communication (McCracken 1990: 55–70). It is only when individuals wear conventional outfits of the kind that correspond to existing social stereotypes (such as, for example, 'businessman', 'beggar' or 'prostitute') that

anything approaching a 'language code' can be said to exist at all. If one adds to this the fact that whatever 'meanings' or associations an item of clothing may have are themselves highly context-dependent as well as subject to rapid temporal change, then it becomes quite clear that there simply cannot be a 'language of clothes'. Indeed, even Davis' (1992) suggestion that clothing should be seen as a 'quasi-code' in which ambiguity is central is probably claiming too much.[7]

Davis goes on to suggest that, when viewed as a vehicle for communicating meaning, clothing is rather like music in possessing the ability to convey powerful associations while being utterly unable to communicate anything resembling a precise message. Hence, whilst it is impossible to agree on what 'meaning' should be attributed to the fact that a particular individual has purchased a pair of blue jeans or chooses to wear them to go shopping – in the way, for example, that in British society, the decision of a bride to wear a white dress on her wedding day can be said to have a specific and widely understood meaning – this is not to say that blue jeans do not carry a range of cultural associations. Indeed market researchers devote a good deal of time and effort to discovering precisely what these might be. Thus, just as music could be said to convey moods (such as sadness, melancholy or joy, for example), so one might claim that clothes could 'indicate' such qualities as informality, restraint or exuberance. However, such an analogy hardly supports the consumption as communication thesis; rather it supports the suggestion that clothing functions as a means of personal expression, and hence should be regarded as an art form.

This should serve to remind us that language and the arts are designed to fulfil rather different functions. Consequently if clothes are used as a means of 'expression' (artistic or not), they can hardly be employed at the same time to convey a message that others will understand. For in choosing items to meet their emotional needs individuals are unlikely to be abiding by the standardised requirements of a social code. Nor is this objection overcome by assuming that if clothes perform an expressive function then it must follow that what they express is the self, and hence can be regarded as indicative of a person's identity. For what clothes may well express could be no more than a mood, whim or temporary need, largely unrelated to the basic personality, let alone the social identity, of the wearer. Thus, just because an individual dons casual clothes one weekend, an observer would be mistaken in assuming from this that he or she is a 'casual' sort of person. For all it might indicate is that he or she experienced a need to relax that particular weekend.

In fact whilst clothing may reasonably be compared with an art form, music is not a good parallel. In the first place, although there is no agreed language for translating sounds into ideas, there is in Western music a very precise musical language, that of notation, one which any musician

working in this tradition must be able to read. There is no similar agreed system of abstract symbols for translating ideas about clothing into garments. More important, since music is a temporal art it is possible to say nothing – that is to have silence – using this medium. Finally, music is usually purely expressive in character, whilst clothing does fulfil an important instrumental function. Hence a better parallel might be architecture, for houses, shops and offices serve instrumental functions while also having expressive properties; but here too there is no commonly accepted 'language' that would enable these artifacts to be interpreted as messages.

The puzzling question which arises from this discussion is why, given such powerful objections, does the clothing as language argument, as well as the consumption as communication thesis more generally, still continue to find favour among sociologists? One possibility is that it stems from a common tendency to link three doubtful assumptions in such a manner as to construct an attractive yet specious argument. These assumptions are first, because people generally find an individual's appearance 'meaningful' it is presumed to have *a* meaning. Second, since it is generally assumed that people choose to wear what they wear, it is assumed that this 'singular' meaning is intended. Third, since clothing is usually displayed, in the sense of being worn in public, it is assumed that individuals must be 'making a statement', or 'conveying a message' to those in a position to observe them.

In reality of course objects can be meaningful without having a symbolic meaning (that is, like a paper-clip, their meaning is effectively equivalent to their use), just as they can be regarded as symbolically meaningful without having a single unambiguous meaning (as is the case with most works of art, for example). Yet the biggest mistake in this chain of reasoning is the tendency to infer conscious intent from the apparent presence of design. In this respect, the problem here is reminiscent of the nineteenth-century 'argument from design' that was popular among those keen to defend Christianity from the attacks of atheists and sceptics. The proponents of that argument suggested that the presence of what looked very much like 'design' in the natural world implied not merely the work of a conscious designer, but of a 'purpose' behind all things: in other words, God and God's purpose. We now know that the apparent 'design' in nature owes nothing to the conscious actions of a divine being, but is actually the product of the interaction of processes of mutation and natural selection operating over millions of years. A similar false inference is commonly drawn with respect to the clothes people wear. An observer scrutinises an individual's outfit, perceives a 'meaning' of some sort and thus infers that the wearer must be the 'creator' of that meaning, and what is more, must have created it for some purpose. Consequently they go on to infer that the outfit represents a 'message' that the wearer intends

to send to whoever happens to be in a position to receive it. Yet here too the inference of purpose (if not entirely that of design) is frequently unwarranted.

The critically important point is that, as noted above, since consumers cannot avoid wearing clothes they are unable to prevent others from 'reading' meanings into the clothes they wear. Now they may be well aware of this: that is to say, they may anticipate that the wearing of an old, worn suit is likely to lead others to assume that they are relatively poor. But it does not follow from this that because they wear it they therefore *intend* to send such a message. Other considerations may have dictated the choice of clothes on this occasion. In this context it is important to remember the criticism that has been made of Merton's famous manifest–latent function distinction, which is that he failed to distinguish the separate dimensions of intention and awareness (Campbell 1982). For individuals may intend to send a message and be aware that this is what they are doing; they may, however, be aware that they are sending a message, even though it is not their intention to send one, just as they may succeed in sending a message even though they neither intend to do so nor are aware that they have done so. In addition, some individuals may intend to send a message and indeed believe that they have succeeded when in fact this is not the case.

We can end by noting that the belief that people's clothes can be 'read' for the intended 'messages' they contain will probably continue to persist as long as no attempt is made to falsify it. Like most dubious beliefs it is not abandoned simply because it is rarely if ever put to the test. One can be quite certain that if clothing were a true language, and consequently individuals had to understand and respond correctly, then they would quickly discover the full extent of their failure to 'read' the clothing of others. As it is, individuals can be confident in asserting that they 'understand' the meaning of someone else's ensemble, secure in the knowledge that their understanding is unlikely to be challenged. In a similar fashion sociologists can continue to assert that acts of consumption constitute 'messages' until such time as this thesis is put to the test.

NOTES

1 This is not intended as a critique of semiotics. It is clear that goods can be analysed as if they constituted 'texts'. Although I am doubtful of the value of any analysis that does not make reference to the views of consumers, it is possible that there is something to be gained from treating commodities and consumption acts as if they were plays, poems or paintings. The object of this critique is the thesis that includes the presumption that individual consumers *intend* their actions to be interpreted by others as 'signs' or 'signals'. For this is necessarily to suggest the presence of communicative intent and hence to imply that consumption activities should be understood as constituting 'messages'. In other

COLIN CAMPBELL

words, it is one thing for academics to 'discover' symbolic meanings attached to products; it is another to assume that the conduct of consumers should be understood in terms of such meanings. Apart from the fact that this latter claim requires evidence (and is hence refutable) in a way that the former does not, it also begs a series of important questions.

2 Unlike many of the other proposed clothing 'languages' there are reasonable grounds for believing that many people will be familiar with this one, as it is usually displayed on products themselves at the point of sale.

3 A *nouveau riche* person may be 'speaking' the language of pecuniary strength, attempting to send the message 'I am a wealthy person', only to have his or her 'listeners' 'hearing' the language of fashionability, and concluding that he or she is 'old-fashioned'. Or, a young person in a nightclub may be trying to speak the language of sexuality, attempting to send the message of youthful virility, only to have the other clubbers 'hearing' the language of pecuniary strength, and reading the message 'poor' and 'not well-off'.

4 Bermuda shorts and lace tights were among the other items mentioned. Up to a third of respondents admitted that they did not know whether these items were fashionable or not.

5 It is interesting to note that when it is necessary to convey something about a person quickly through clothes alone, as is often the case on the stage, this is done by making use of long-established, generally unchanging and simple, traditional 'codes' or understandings, such as the colourful and ill-fitting trousers that denote a clown, or the black cloak and hat that indicate a villain.

6 If clothing alone can be used to communicate a message, one wonders why beggars find it necessary to place pieces of cardboard on the pavement in front of them announcing that they are 'unemployed and homeless', or 'hungry and homeless'. Should they not be able to communicate these facts through their clothes alone?

7 Davis observes that the 'fashion-code' in modern Western societies is heavily context-dependent, in 'having considerable variability in how its constituent symbols are understood and appreciated by different strata and taste groupings', and by being 'much more given to "undercoding" than to precision and explicitness' (1992: 8). What is surprising, having admitted all this, is that he still seems to believe that an identifiable 'code' exists.

REFERENCES

Baudrillard, Jean (1975) *The Mirror of Production*, St Louis MO: Telos Press.
Baudrillard, Jean (1981) *Towards a Critique of the Political Economy of the Sign*, trans. C. Lewin, St Louis MO: Telos Press.
Baudrillard, Jean (1983) *Simulations*, New York: Semiotexte.
Baudrillard, Jean (1988) 'Consumer Society', in M. Poster (ed.) *Jean Baudrillard: Selected Writings*, Oxford: Polity Press.
Bauman, Z. (1988) *Sociology and Modernity*, Cambridge: Polity.
Bauman, Z. (1992) *Intimations of Postmodernity*, London: Routledge.
Bourdieu, P. (1984) *Distinction: A Social Critique of the Judgement of Taste*, translated by R. Nice, London: Routledge and Kegan Paul.
Bowlby, R. (1985) *Just Looking: Consumer Culture*, London: Methuen.
Campbell, Colin (1982) 'A Dubious Distinction? An Inquiry into the Value and Use of Merton's Concepts of Latent and Manifest Function', *American Sociological Review*, 47, 29–44.

Campbell, Colin (1987) *The Romantic Ethic and the Spirit of Modern Consumerism*, Oxford: Blackwell.

Campbell, Colin (1992) 'The Desire for the New: Its Nature and Social Location as Presented in Theories of Fashion and Modern Consumerism', in Roger Silverstone and Eric Hirsch (eds) *Consuming Technologies: Media and Information in Domestic Spaces*, London: Routledge.

Chua, Beng Huat (1992) 'Shopping for Women's Fashion in Singapore', in Rob Shields (ed.) *Lifestyle Shopping: The Subject of Consumption*, London: Routledge.

Clammer, John (1992) 'Aesthetics of the Self: Shopping and Social Being in Contemporary Urban Japan', in Rob Shields (ed.) *Lifestyle Shopping: The Subject of Consumption*, London: Routledge.

Davis, Fred (1992) *Fashion, Culture and Identity*, Chicago: University of Chicago Press.

Dittmar, Helga (1992) *The Social Psychology of Material Possessions: To Have Is To Be*, Hemel Hempstead: Harvester Wheatsheaf.

Douglas, Mary (1992) 'In Defense of Shopping', *Monograph Series Toronto Semiotic Circle* no. 9.

Goffman, E. (1990) *The Presentation of Self in Everyday Life*, London: Penguin.

Langman, Lauren (1992) 'Neon Cages: Shopping for Subjectivity', in Rob Shields (ed.) *Lifestyle Shopping: The Subject of Consumption*, London: Routledge.

Lurie, Alison (1981) *The Language of Clothes*, New York: Random House.

McCracken, Grant (1985) 'Dress Colour at the Court of Elizabeth I: An Essay in Historical Anthropology', *Canadian Review of Sociology and Anthropology* 22, 4.

McCracken, Grant (1990) *Culture and Consumption: New Approaches to the Symbolic Character of Consumer Goods and Activities*, Bloomington IN: Indiana University Press.

Rudmin, Floyd (ed.) (1991) *To Have Possessions: A Handbook on Ownership and Property*, a special issue of the *Journal of Social Behavior and Personality* 6, 6.

Shields, Rob (ed.) (1992) *Lifestyle Shopping: The Subject of Consumption*, London: Routledge.

Veblen, T. (1925) *The Theory of the Leisure Class*, London: George Allen and Unwin.

Warde, A. (1990) 'Introduction to the Sociology of Consumption', *Sociology* 24, 1.

351

INDEX